SISTERS

SISTERS

TENTH ANNIVERSARY EDITION

by Carol Saline and Sharon J. Wohlmuth

RUNNING PRESS

PHILADELPHIA · LONDON

9 8 7 6 5 4 3 2 I
Digit on the right indicates the number of this printing

Library of Congress Control Number: 2004090639

ISBN 0-7624-1788-9

Cover design by Alicia Freile

Interior design by Alicia Freile
Edited by Jennifer Kasius
Typography: Centaur MT

This book may be ordered by mail from the publisher.
Please include $2.50 for postage and handling.
But try your bookstore first!

Running Press Book Publishers
125 South Twenty-second Street
Philadelphia, Pennsylvania 19103-4399

Visit us on the web!
www.runningpress.com

Contents

Introduction

11

Anna Margaret and Hannah Marie: The Klales Sisters

14

Eli and Liz: The Martinez Sisters

19

Coretta and Edythe: The Scott Sisters

20

Anna, Jane, and Kate: The McGarrigle Sisters

25

Maria and Michele: The D'Ambrosio Sisters

28

Erin, Kelly, and Christy: The Turlington Sisters

31

Lindsey and Eryn: The Elkin Sisters

34

Nancy and Becky: The Young Sisters

39

Aimee and Amanda: The Hector Sisters

40

Joan and Ann: The Petitt Sisters

47

Haydee and Sahara: The Scull Sisters

50

Midge and Dixie: The Carter Sisters

55

Janet and Julie: The Johnson Sisters

58

Linda and Susan: The Karlin Sisters

65

The Luong Sisters

70

Millie, Gerry, and Anne: The Adelman Sisters

75

Nancy and Rhea: The Lemmerman Sisters

78

Sister Catherine and Sister Mary: The Glackin Sisters

85

Donna, Debbie, and Shirley: The Masiejczyk Sisters

86

Sheryl and Nancy: The Glass Sisters

91

Janice and Elizabeth: The Coffey Sisters

96

Bloomie, Dotty, and Minnie: The Green Sisters

101

Tangra, Karen, Claudia, Linda, and Aulana: The Pharis Sisters

106

Sandra, Georgette, and Wendy: The Wasserstein Sisters

111

Katie, Charlene, and Julie: The Cunningham Sisters

114

Kim, Sandra, and Sheryl: The Blackie Sisters

119

Clare, Chris, and Jeanne: The Evert Sisters

122

Kay, Loretta, and Loudilla: The Johnson Sisters

127

Kristin and Laura: The Beck Sisters

130

Bernetta and Margaret: The Crommarty Sisters

136

Irlene, Louise, and Barbara: The Mandrell Sisters

141

Clementine and Melba: The Moorman Sisters

144

Whitney and Becky: The Williams Sisters

151

Tamara and Deborah: The Hadley Sisters

154

Pat and Gail: The Henion Sisters

159

Hope and Mary Binney: The Montgomery Sisters

162

Introduction

Thirteen years ago on an August afternoon at the beach, we hatched an idea for what we thought would be a wonderful book: a poignant collection of photographs and essays about sisters. We'd personally experienced the beloved bond that sisters share through our love for our own sisters, Beth and Patsy. Because we understood in our bones the intensity of this sister connection, we believed that, slowly, over time, a book exploring the many aspects of this relationship could build a large audience through word-of-mouth. To our surprise, we had a hard time finding anyone who agreed with our vision. With the exception of Running Press, nearly two dozen publishers contacted by our agent turned down our proposal. Although they praised it as a "charming" concept, they doubted that women would be motivated to buy a book that celebrated sisters. Were they ever wrong!

All authors harbor fantasies about the potential success of their books. Even in our wildest dreams, we could not have imagined the way women would take *Sisters* into their homes and their hearts. Immediately after its publication in the fall of 1994, the first printing flew out of the stores, to be followed by a dozen more. Eventually *Sisters* would sell well over a million copies and spend an unprecedented 63 weeks on *The New York Times* best-seller list. Nobody was more amazed or ecstatic than the two of us. *Sisters* not only exceeded our expectations, it expanded our world and changed our lives. We remain deeply grateful in every possible way for the overwhelming response to our work.

As we journeyed around the country signing books, and appearing on television and radio programs from *Oprah* to NPR, we saw how our book provided an outlet for all kinds of emotions that sisters had always felt but rarely expressed.

We found ourselves becoming social anthropologists as the women we talked to in our travels and interviews helped us create a living archive of sister stories. Those, along with the flood of touching letters we received, validated the richness and complexity of this most primal female bond. It seemed our book took sisterhood from the shadowy world of female secrets and established its importance front and center as a central human value. *Newsweek* even credited us with "starting the trend on books about platonic female intimacy."

Of the many relationships in a woman's life, the mystical connection between sisters is unique. It stretches and bends through periods of closeness and distance, but it cannot be broken. In any language, be it *schwester, sorella,* or *soeur,* the meaning of the word sister is universal: a sister is a forever friend. Sisters act as safety nets in a chaotic world simply by being there for each other. Sisterly ties have far fewer knots than those between mothers and daughters, and while brothers share a biological link, they're—well—just different. There seems to be a special glue that bonds girls who grew up under the same roof and who share an intricate meshing of heart, soul and memories.

There are physical memories: Bathtub playtime, good-night kisses and snuggles, the development of girl to woman as young bodies grow and change, the petty jealousies over who got bigger breasts, slimmer hips, prettier hair, better skin. . . . There are social memories: boyfriends, the first kiss, battles over clothes, shopping sprees, school plays, ballet lessons, family outings. And there are priceless emotional memories: heartfelt advice, unquestioned loyalty, late-night phone marathons, family battles, holidays with grandparents, endless discussions

of who got more attention and who felt rejected. Surely no one understands better than your sister exactly what you mean when you complain about your mother and father. This patchwork of funny, joyful, angry, painful and historic memories creates the foundation—solid or shaky—that supports every sister relationship.

Meeting thousands of women as we toured the country reinforced something that we instinctively knew when we started: women love to talk about their sisters. We witnessed the light and love in their eyes as they finally had the opportunity to pay homage to the magic of this relationship. From those women who had the warmest and closest attachments to their sisters, we gleaned some common characteristics. They all had parents committed to having their daughters grow up as friends. These loving sisters consistently exhibited a high regard and respect for each other. They recognized their relationship as something precious that was to be nurtured and never taken for granted. Regardless of where they lived, how much contact they had or whether there were disparities in lifestyle, income or achievement, in their hearts they felt like equals. Depending on which sister was in need, the other could become the caretaker or the caregiver. This ability to rely on a sister

in a time of need—as well as to share good news and good times— was a cushion and a comfort that became even more significant as sisters aged. As Margaret Mead observed, "Sisters are probably the most competitive relationship within a family but once sisters are grown, it becomes the strongest."

We encountered some women who had the lifelong yearning for a sister and ruefully confided to us that even a best friend could not replace this missing genetic link. Certainly some of our saddest moments occurred when a woman would pour out her heart to us with a story of estrangement. Did we have any advice? Did we think that sending her sister the book along with a note might trigger a reconciliation? We still remember the woman who said she hoped the sister who wasn't speaking to her would see the tearstains in the right places. Over and over we witnessed the pain and disappointment of sisters who couldn't get beyond the emotional baggage they'd been lugging around since childhood. If sisters hadn't solved their sibling rivalry issues by their twenties, it seemed they were likely to wrestle with them the rest of their lives. Typically they felt exploited or depleted. Inevitably one of them was perceived as having too much of something—money, vanity, parental approval,

selfishness—while the other felt cheated or resentful. As one well-coifed, fiftyish woman told us, "Nobody can love you more than a sister, but nobody can hurt you more either."

In the publishing world, a decade is a very long shelf life for a book, and the fact that *Sisters* continues to evoke such a warm response from women is one of the reasons we decided to update the original with this very special edition. It gave us an opportunity to revisit twelve sets of sisters we hadn't seen for years and to explore the impact of life's passages on this primary relationship. In addition, here was a chance to reach a new audience of girls too young to have been aware of us the first time around.

To be honest, we were unprepared for how moving these reunions turned out to be. Each time the door opened and we embraced a sister who'd graced our book ten years ago, we were spiritually transported back to the intimacy of our earlier encounters. We spontaneously fell into ardent hugs as if greeting old, beloved friends. Little girls had grown into intelligent young women. Illness and age had etched its worry lines. Some sisters had died, leaving their survivors with bittersweet memories and the unquenchable loss of a piece of themselves. A few old conflicts had been resolved

—or at the least, diffused. We were struck how in ten years everything had changed—while nothing had changed at all.

We were particularly impressed by how life's troubles as well as its blessings impacted relationships in unexpected ways. Except for the teenagers still wrestling with sibling issues, time and maturity had taken every set of sisters to a place of greater acknowledgement and affection. As life's experiences united sisters—whether to cope with crisis or to celebrate a milestone, whether to lean on or to laugh with—what we observed over and over was a deepening appreciation of their good fortune to have each other for sharing and support.

We welcome all of you to our tenth anniversary edition of *Sisters*. Some are new friends coming to our work for the first time; others are old friends returning for a second visit. Perhaps these photographs and stories will be a catalyst for you to reflect upon your own changing lives and the enduring bonds that sisters share. This book is our gift to all women blessed with sisters who have made the highs in life more meaningful and the lows more bearable. Thank you for making us part of your family.

— Carol Saline and Sharon J. Wohlmuth
February 2004

Anna Margaret and Hannah Marie:

The Klales Sisters

Once upon a time there was a six-year-old girl named Anna who looked just like a Pre-Raphaelite principessa. Anna lived with her parents in a big house near the woods, and although she was happy drawing and coloring by herself, sometimes she was just a tiny bit lonely for a playmate. Then, one day, her mother had wonderful news. She was going to have a baby! "Well, it had better be a sister," said Anna. "If it's a boy, we'll give it away."

That night, alone in her room, she tried to imagine what it would be like to have a sister. She knew exactly what she wanted for the baby's name: Hannah. She'd chosen it because she could already spell it by adding an "H" to the beginning and end of her own name.

"Well, let's see," Anna said to herself as she lay in the dark. "As soon as Hannah comes home, I'll hold her and feed her and give her a bottle. Later on I'll teach her how to walk, and when she gets a little older, I'll give her my tricycle. And we'll play games like hide-and-seek, and I'll show her how to be good in school.

"We won't be just friends. We'll be sisters. Alike. Only one of us will be bigger than the other. Sometimes we'll fight but I'll give her one of my dollies and that's how we'll make up. We'll tell each other secrets, and Hannah will love me as big as the world."

Anna snuggled down in her canopy bed, her curls spread over the pillow, and fell asleep, dreaming about how she and Hannah would live happily ever after.

Several months later, Anna nestled alongside her mother, gingerly cradling her tiny, pink, hour-old sister in her arms.

"Am I dreaming, Momma?" she whispered. "See how her eyes are closed. She must be tired. I think we should keep her. She's too cute to give away."

Suddenly, Hannah began to cry. Anna, her little heart filled with the joy of having her very own baby sister, wept, too. And so began their lifelong journey of sharing each other's happiness and comforting each other's tears. . . .

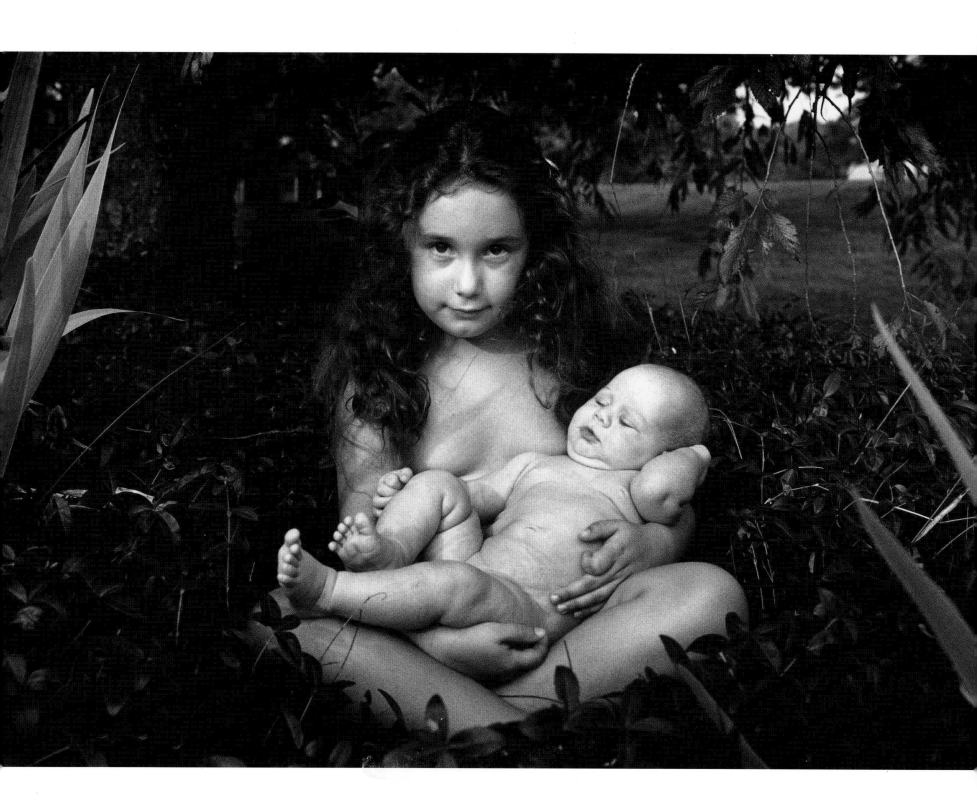

It didn't take Anna very long to come to the conclusion that her real baby sister wasn't exactly who she'd envisioned. Hannah didn't turn out to be a doll she could dress up and play with, or a perfect angel who'd follow her around, absorbing the pearls of wisdom she'd drop willy-nilly into her lap. Nevertheless Anna wasn't at all disappointed. Quite the opposite. Although they have their spats, she doesn't want to change her sister the least little bit. The older they get, the less important the six years separating them becomes. Hannah is more creative, and Anna is more logical, but they enjoy the same kind of music—goofy songs like the ones Weird Al Yankovic sings and certain classical symphonies. They like to sit side-by-side drawing or playing word games and to compete at ping-pong. In fact, they probably have more fun with each other than with just about anybody else.

Anna even discovered that Hannah could end up teaching her a thing or two, especially in the area of self-confidence. Anna is one of those kids who worries a lot about what people think of her. Back in middle school, when she got teased about her unruly curls, she'd come home crying. Hannah, on the other hand, couldn't care less about such nonsense and advised Anna to ignore the meanies. When a classmate told Hannah she was ugly, Anna saw the way she laughed off the insult. Who'd have thought that her younger sister would be the one to demonstrate the importance of accepting herself? Or that she'd cherish the times when the two of them break down into utter silliness, because that's when she can be completely natural—and Hannah doesn't care.

Now that Anna has grown into a slender, studious 16-year-old, she has a very different view of what she wants in a sister. Sure, it's fine to have a pal, but it's more important to have somebody you can depend on, who can make you feel better when you're upset. "I know if I ever needed anything, Hannah would help me get it," she says. "I can talk to her more easily than anyone else— although there are obviously things I wouldn't discuss until she gets older."

Hannah may only be ten, but she already appreciates that your sister is the one person besides your mom who you can totally trust. "If you have a friend at school, you can get mad at her and never be friends again," she says. "But a sister will always be your friend no matter what, even though she sometimes orders you around and hogs the Internet." Life without a sister would be boring. Who would be there to sing funny songs with or talk to or share jewelry and books with and the shirts that fit both of you? "With your sister, you can be yourself," Hannah says, "and she won't judge you. She'll like you however you are."

Just as Anna dreamed so long ago, she and her sister "love each other as big as the world." They plan always to be the best of friends, forever sharing the letters of their name and whatever else, good or bad, that life delivers. ■

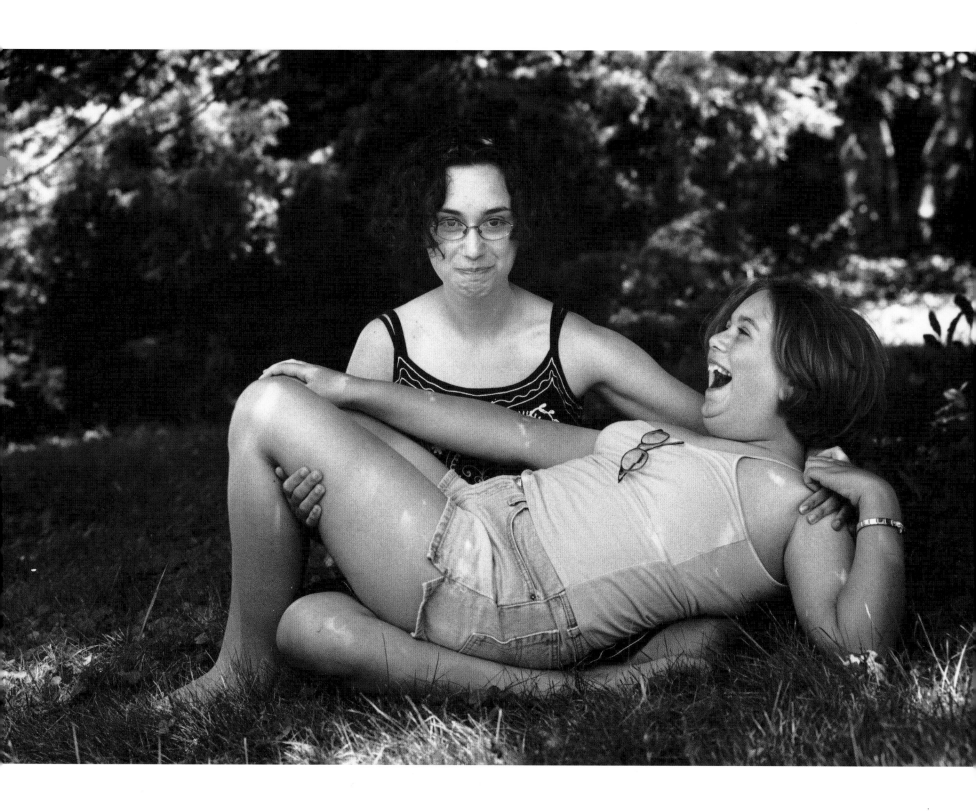

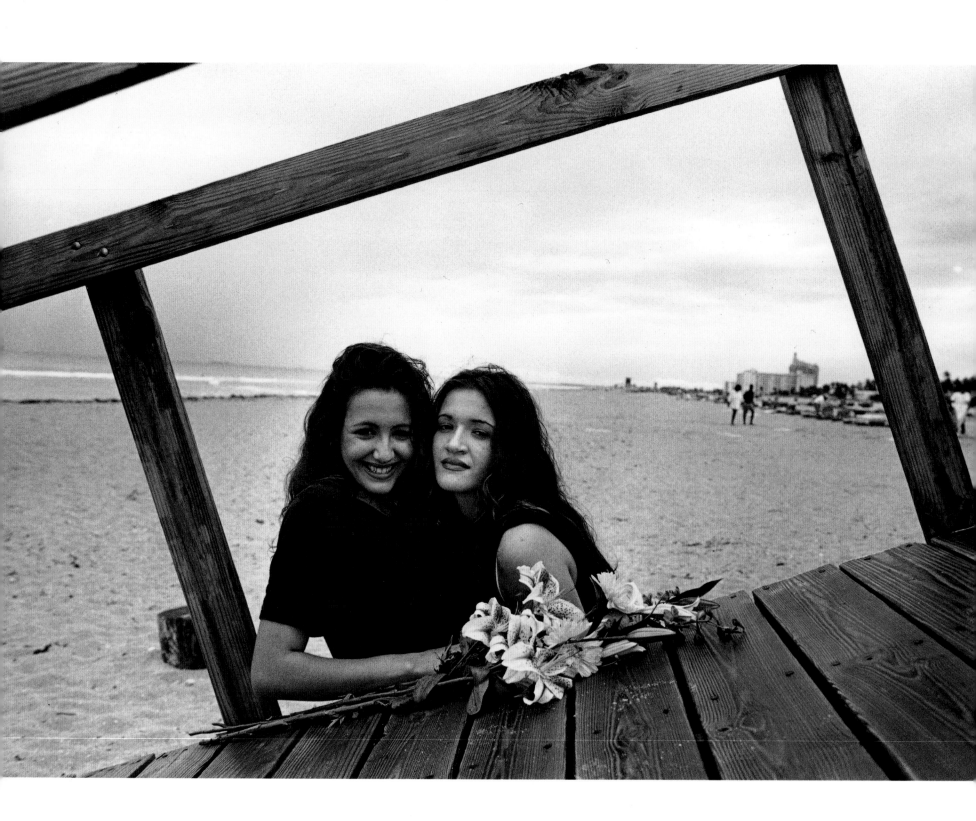

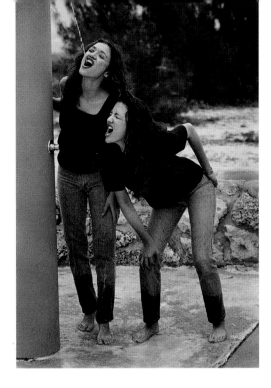

Eli and Liz:

The Martinez Sisters

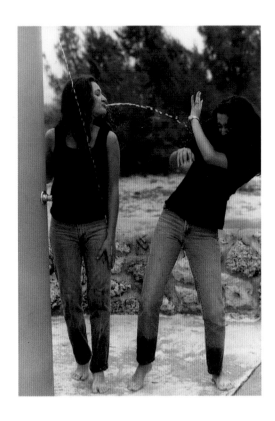

A s little girls, Eli and Liz liked nothing better than to make pretty bouquets from the flowers in their grandmother's garden. As big girls, nothing has changed: they work side by side every day at their elegant flower shop in Miami's hip South Beach. "We've just always been together," says one or the other— it's hard to tell which, because they look, think, and speak so much alike. "It's just like one life," says Eli. (Or is it Liz?)

Both agree there are no feelings left unexpressed between them. "If we get mad at each other, it lasts two minutes and we forget the whole thing," Liz says. Yet once, when Liz had a potentially life-threatening accident, what both feared most was that something they needed to say had been left unspoken.

"It was not long ago," Eli says, "very early in the morning. Liz had fallen in the tub and hurt a gland in her groin. She was in terrible pain. Mom called me right away and said, 'You've got to come *now*.' I told my husband that Liz was hurt, threw on some clothes and ran the block to their condo. Liz was pale, really pale. Her groin was swollen up, all black and blue. I convinced her she must go to the hospital, and I rode in the ambulance. I remember they were playing a Rod Stewart song, "Some Guys Have All the Luck," and I thought that this song would always remind me of Elizabeth in pain.

"They had to operate right away. I remember telling the anesthesiologist, 'This is my one and only sister. Please, please take special care of her.' As they wheeled her away on the stretcher, she was so weak she could barely wave. Suddenly I realized, 'Oh my God. I didn't get to talk to her. I didn't say *I love you*.'"

Liz cuts in. "I was lying there thinking the exact same thing. That here I might die and I didn't get to say good-bye to my sister. I needed to tell her how much she meant to me. I thought of all the great moments we'd had together and all the things I should have said. So I want to tell her now, 'You're the best thing in my life.'"

"You, too," Eli says, smiling. "You, too. You, too." ∎

Coretta and Edythe:

The Scott Sisters

My dear sister Coretta,
I am sitting here tonight thinking about us. How close we were as children, sharing everything, doing everything together, always the leaders, always picked for the plays and the concerts because we were talented and attractive. The kind of kids teachers just knew would cooperate. When I went to Antioch before you, I learned about sibling rivalry in one of my courses, and I didn't believe there could be such a thing. We certainly never competed or were jealous—even if you did have more boyfriends. And you've forgiven me for telling you there was no Santa Claus.

Do you remember when you were five, already so physically strong, and you helped me pull the first bucket of water from the well outside of our house? That became a metaphor for our lives. All these years we've pulled each other up, supported each other, and taken care of each other. Even Martin saw that. He called us the twins. He'd be giving a speech in some big auditorium and he'd say, "My wife isn't here tonight. But her sister is in the audience—so if I want to see Coretta, I just look down there at Edythe."

I've never told you this, but Martin comes back to me in my dreams. It's always when we're up against the wall and we don't know what to do. He comes to me smiling and joking and says it's going to be all right. That's when I call you and get very positive and tell you we'll find a way. Sometimes I think we would have been even closer if Martin hadn't died. You were my best friend for so long, but now there are always so many others around you, wanting a piece of you, there isn't always as much room for the two of us.

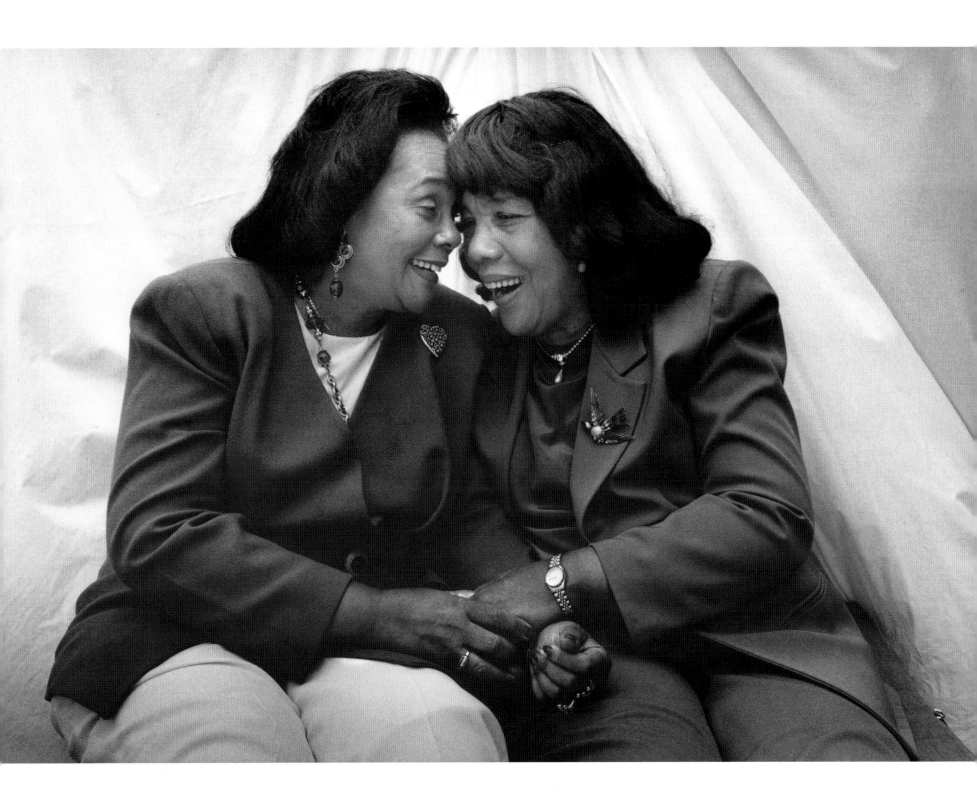

When we were growing up you always told people you thought I was the smarter one, that I knew everything. But I have learned from you. You've taught me to live each day as fully as I can, because no one knows what tomorrow will bring. You taught me to rely on the spiritual force in the universe, how not to worry or to be afraid. And I hope I've made you laugh and brought some joy into your very serious life.

I was trying to explain to someone what keeps our relationship working and I used that phrase from *The Prophet* by Kahlil Gibran: I said, "We have spaces in our togetherness." Doesn't that describe us well? We've never been the kind to say things; we just do for each other. So, for once, I wanted to tell you how blessed I feel to have a sister that I'm comfortable with and that I like as well as love.

<div align="right">Edythe</div>

Dear Edythe,

Your beautiful letter carried me back to those days when it was more common for us to pick up a pen than a telephone. I particularly remembered a letter you'd written to me when I was in Boston studying music at the New England Conservatory. I hadn't told you that Martin had proposed to me on our first date, several months earlier. Because this was the most important decision I could make in terms of my future, I wanted to make it myself, without your influence. I prayed and struggled and then I had a revelation in a dream. I saw Daddy King, Martin's father, smiling at me approvingly. The next morning I woke up with a sense of inner peace that I interpreted to mean the relationship would work out. Right after that, your letter came, as if you'd read my mind. "Don't be silly, girl," you wrote. "You know how difficult it is to find intelligent, stable, well-adjusted men"—a whole string of adjectives. And then you wrote, "You won't have your career as you dreamed it, but you will have your career."

That summer you came to live with me in Boston and we used to play games with Martin on the phone because he couldn't tell us apart. And remember how he wanted to test me on my cooking? You and I prepared this fine dinner for him. We really were old-fashioned girls who knew how to cook. Afterwards he'd tell people, "I asked Coretta to cook a meal for me and she dispatched Edythe. The two of them teamed up on me!"

You've always known instinctively just how to make me comfortable and support me. I will never forget the day after Martin's funeral, when you packed up your son and

came to stay with me. The fact that I never had to ask meant so much to me. You just knew ahead of time how deeply I was going to need you and you were there. I will always be grateful for your foresight and your presence. Having you, my sister, in the house for two years with me and as a surrogate mother to my children, especially when I had to be away so often, was a comfort no one else could have provided. And when there were little frictions among my staff, you were always careful to keep negative things away from me so that I wouldn't worry.

I'm so glad you've been with me whenever anything important has happened, although I still regret that you were ill and couldn't come to Oslo for the Nobel Peace Prize. But I have wonderful memories of all the times you traveled with me on special occasions, giving advice and helping me write letters and speeches. Writing was never my forte, but you had that talent back in high school when you were editor of the paper. I always admired that you had such a good mind and a grasp of things. You did so much reading and thinking. I was more an activist kind of child. It seemed to me you always had so much information—you had that way of eavesdropping on the adults—and I loved when you'd tell me things and share the secrets you'd found out.

If you hadn't gone to Antioch College first and made a place for me and pulled me in, I'd have missed having the experience that prepared me for my role today. The emphasis on multiculturalism and the democratic community there were the perfect training for my life's work.

I wish that your teaching commitments at Cheyney State and my busy schedule would allow us to visit more often. When you're around I laugh more, and I need that because I tend to be so serious-minded. You have a way of finding humor in anything. You can pull the theater out of life. Being with you, I can be completely myself. You appreciate the stresses I have being a public figure, meeting people's expectations, fulfilling a role. When it's just us, I can be myself and know you'll love and understand me no matter what. You don't want anything from me except my happiness.

I'm very lucky. I don't have a husband, but I do have a sister. A sister I can talk to about personal things I wouldn't tell anyone else. A sister who does things for me, consoles me, comforts me. A sister with whom I can share my burdens and my joys. It's very hard in this world to find someone who can walk in your shoes, but you come closer to that than anybody. A lot of sisters are not friends. You, Edythe, like Maya Angelou has said, are my sister-friend.

Coretta ■

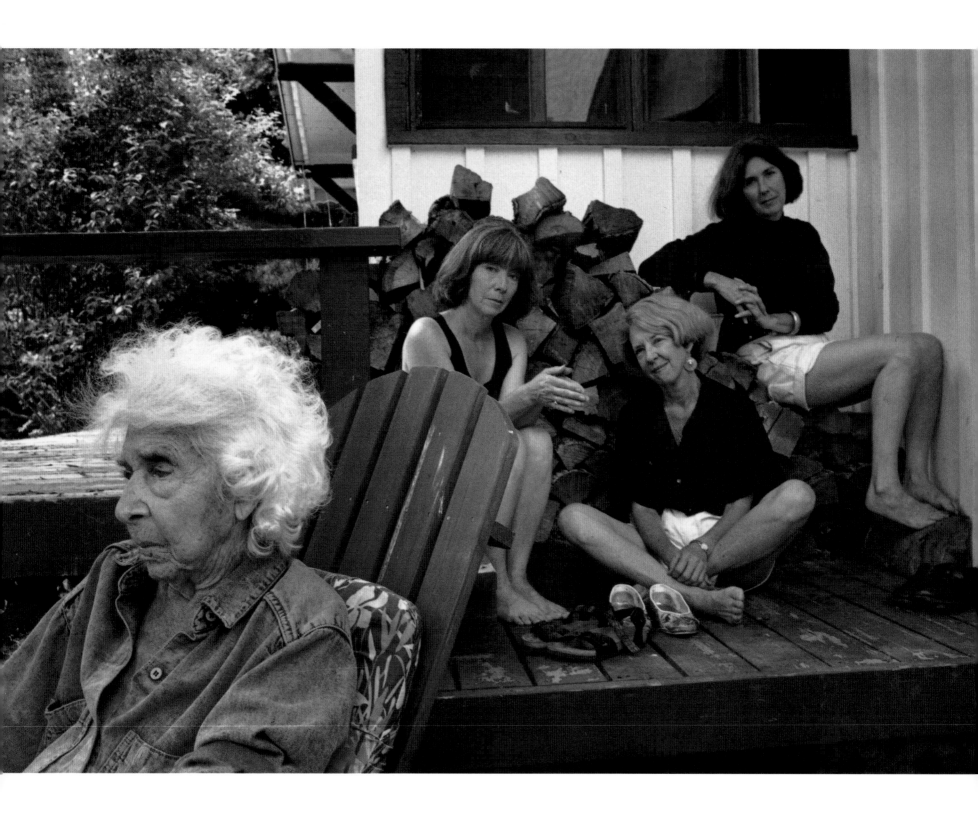

Anna, Jane, and Kate:

The McGarrigle Sisters

J ane was expected to be the brilliant musician: she was a church organist at 14, and also excelled in school.

Anna would be the socialite, flitting about at lovely parties where the ladies wore gloves and hats, sipped champagne, and ate strawberries.

Kate was slated to become the engineer.

Those were the roles Frank McGarrigle chose for his three daughters—but it didn't turn out quite the way he planned. Had he lived to see Kate and Anna become internationally-known folk singers, though, he might have taken some of the credit. After all, wasn't he the one who had them harmonizing around the 1883 Steinway in the living room as soon as they could carry a tune? Didn't he encourage them to play any old broken-down instrument that fell into his hands—a banjo, an accordion, a guitar, a zither? Music was the air these sisters breathed, their fun and their entertainment through the long cold winters in a tiny, isolated mountain town outside Montreal. And the first one to get to the piano didn't get stuck in the kitchen doing dishes.

"We had this ridiculous background growing up as bohemian Anglos in a French village. Everybody else ate dinner promptly at six; we ate whenever the food was ready. Our parents never wanted us to be ordinary," Kate says with great affection. "Maybe because there were no boys, we were taught we could do anything we wanted without limits. They designed us to be well-versed in many things, to be good thinkers and to be close friends."

As they huddle around the wooden kitchen table of the cozy house where they grew up—and where they still return on weekends to visit their 90-year-old mother—it's quite obvious the McGarrigles are more than just sisters and business partners.

"When we're not around each other, we have these other roles," Anna says. "We're this one's mother or that one's wife. But when the three of us get together, wherever it is, we immediately revert back to being the sisters we were growing up: Jane's the oldest; Kate's the youngest; I'm forever in the middle."

"I've had the feeling from different men I've been with," Jane says, "that no matter how devoted or loyal I am to them, they think my sisters have a kind of priority. They sense that we are more important to each other than to anyone else."

"Anna's husband thinks we're interchangeable," says Kate. "That any coupling of the two of us is equally as good as any other coupling of the other two. In fact, we really do have different things with each other. When Jane and I are driving on a trip, we love to talk business and money. When Anna and I are together, we're having fun and doing music or she's reading Jack Kerouac to me or we're planning to stop somewhere to buy stupid dresses or books on art and architecture. The nicest part of all for me is when I come to Anna or she comes to me and says, 'I've written a song. Do you want to help me work it out musically?' And for hours we just sit there and try things."

"All three of us have this incredible physical closeness," Anna says. "When Kate and I are on the road we never have our own rooms, although we could. We always share. It's like a marriage without sex."

"I know what she likes and what she doesn't," Kate says, "She doesn't have to tell me when I'm pushing or pulling too hard. For instance, Anna is much more reasonable and grounded than I am. I wanted to go further in our careers than she did. Go on the road more. Follow the formula for success. I saw the possibilities for us and tried to drag her along. But some people won't be dragged. At one point Anna asked me, 'Do you want to do it by yourself?' But I wouldn't, because it isn't fun without her company. For us, working together is like going on a vacation or being in summer camp. It's not the same alone."

"Wherever we go in the world, we filter our experiences through a similar lens," Jane explains. "We will collapse

with laughter at something nobody else finds funny. We always seem to get a big kick out of the same things. It's impossible to keep our business and our lives from running all together. When I first started managing my sisters, I tried very hard to be structured, to schedule meetings and such. But then I'd call Kate to discuss a problem and she'd be making gazpacho and we'd wind up trading recipes. There's this thing that flows through whatever we do, whether it's visiting, cooking, working, shopping."

"Actually Anna buys a lot of things for me because she knows I hate to shop," Kate says.

"But, Kate," Anna demurs, "you're the one who might all of a sudden send us a hydrangea or decide to buy everybody underwear."

"I think," Kate replies, "that we're just always in each other's minds."

And certainly in each other's hearts. When Kate was going through a messy divorce, Anna wrote a song for her:

No scheme and no direction
with only one way to turn.
Pack up all your children,
come home to our love and concern.
Kitty, come home.

"We've sat around this kitchen table for 45 years echoing the message of that song," Jane says.

"Yeah," Kate replies. "My guess is we'll last longer than our careers."

"The career thing is just a blip," Anna says. "Maybe our songs will go on. Maybe not. But this sister thing we have will go on as long as we live." ■

Maria and Michele:

The D'Ambrosio Sisters

Michele and Maria are each other's favorite people. They have never fought for longer than three hours. They exchange extravagant gifts, wear each other's clothes, vacation together, and jabber on the phone at least ten times daily—and that's in addition to the three days a week they work side by side in Michele's gourmet food business. Orphans since their teens, both insist that raising each other for the last twenty years has made them inseparable.

Maria says, "When people tell me, 'What a shame you don't have parents,' I always say, 'But I have this incredible sister, Michele, who nurtures all my needs and fulfills me.' I don't even mind that she worries about me all the time. It's just so nice to know somebody cares."

Michele echoes those sentiments. "I survived the death of our parents, but I can't imagine surviving without my sister. I wouldn't want to be alive without her."

Without Maria, Michele would have no one to validate her history. "Everything I know, from as far back as I go, she knows, too. When I see a chocolate donut, I can say to Maria, 'Remember how Daddy loved chocolate donuts?' and she knows exactly what I'm feeling."

Their closeness defines not only the meaning of family, but also the meaning of friendship. "My sister is the friend who shows me what I want from other friends," says Michele. "She sets the standard everybody else has to match."

For Maria, Michele simply outweighs any other priority.

"I was once involved with a Frenchman, and I'd gone to Monaco for six weeks. Michele took a vacation in Spain with the man she lives with and drove twelve straight hours to visit me. The minute she arrived I realized I was more excited to see her than to stay with this guy in France. It wasn't an easy choice. Philadelphia can't compare to the beaches of Monaco. But marrying him meant I'd have to live far away from my sister. So I left." ∎

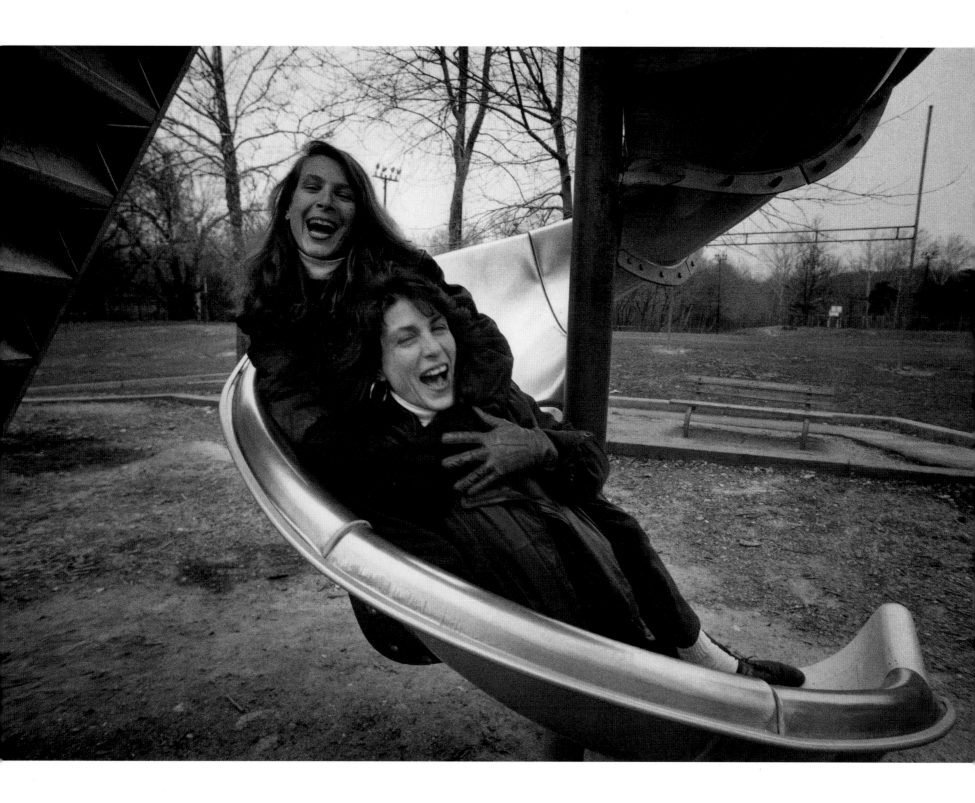

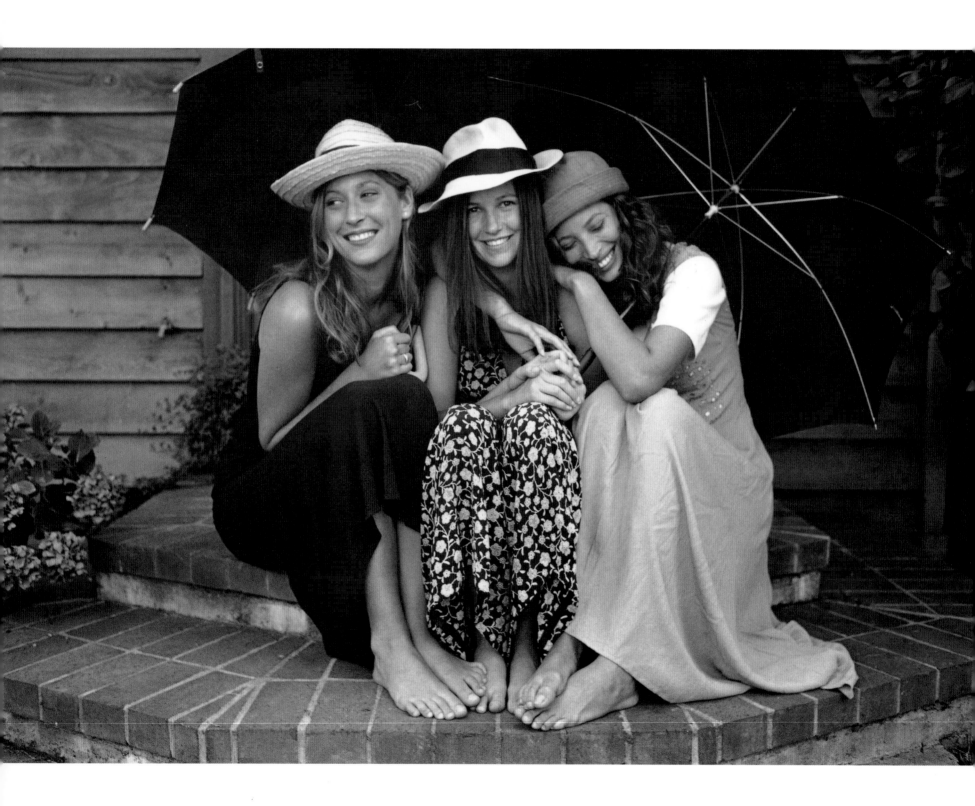

Erin, Kelly, and Christy:
The Turlington Sisters

"People ask us what it's like to have a famous sister," Kelly says, talking about Christy, the supermodel. "We just don't notice any difference. When she comes home to visit, she still cleans out our closets, tells us what to wear, gives us expensive clothes she's worn only once or twice. She's the most generous person you could imagine. Takes us on vacations to Aspen, Jamaica. When we visit her in New York, she makes us a part of her crowd."

Erin could not agree more. "The three of us are still best friends. If there were anyone in the world I could spend time with, do anything with, it would be my sisters. We have qualities that balance each other. Like Christy is so open and friendly and Kelly is cute and smart."

"And you have good judgment about people and you're very funny and silly," says Kelly.

For Christy, her sisters represent a constant in the whirlwind, demanding world of international modeling. "They are my best friends," she says, echoing Kelly. "The people I talk to most often. The people who make me feel most comfortable. I'm with different groups of people all the time, which means I don't have a chance to get all that close and, to tell the truth, I'm not sure I'd want to.

"Even growing up, I started and stopped relationships a lot. We lived in Danville, California, then Miami for four years, then back to Danville, then I went to New York. Only my sisters have been with me the whole time. We've shared everything. Without using words, we just know things about each other. There's a security in that."

These three girls, born roughly a year apart, were raised more like triplets. Whenever one developed an interest in something, their parents saw to it that the others got involved. That meant everybody camped out in the backyard, went hunting with their dad, took piano and ballet lessons, rode horses, and played soccer and softball.

"Oh, they bickered sometimes," their mother remembers. "But they always made excuses for the other, stood up for each other. Their personalities were different, but they had a real appreciation for each other's assets. You could just see the bond. It was always them against us."

They were so much The Three Musketeers that once, in a fit of teenage rebellion, they even ran away from home together. Of course, being good girls at heart, they had someone call their parents to report that they were fine and were staying with friends. After two weeks, on Thanksgiving Day no less, they ended their adventure—just in time to be reunited for a turkey dinner.

Even when Christy was chosen over Kelly for a modeling career, there wasn't a ripple of jealousy. The girls had been horseback riding at a stable in Florida when a photographer on a magazine assignment spotted them and asked if they'd like to pose for a photo shoot. Kelly was more at ease in front of the camera, but the agency preferred Christy, because at 14, she'd already reached a model's height of 5'9" while Kelly, at 16, had peaked at 5'6". Kelly, pretty and popular as a prom queen, was much too busy fending off the boys to feel slighted. "I was just happy for my sister's success," she says.

Today, Kelly is living in Los Angeles, married, and about to make aunts of her sisters. Erin has opened a jazz club and restaurant in San Francisco, made possible in part by Christy's investment. And Christy is soaring all over the globe on assignments. Yet they remain as close as when they were little girls playing with their Barbie dolls.

"My sisters are guaranteed friends for life," Kelly says. "I know it doesn't necessarily have to be that way. But that's how it is with us. We have friends with sisters who don't get along. Like them, we know what buttons to push. But out of respect we don't push them. There's never a reason to hurt your sisters. Never was, never will be." . . .

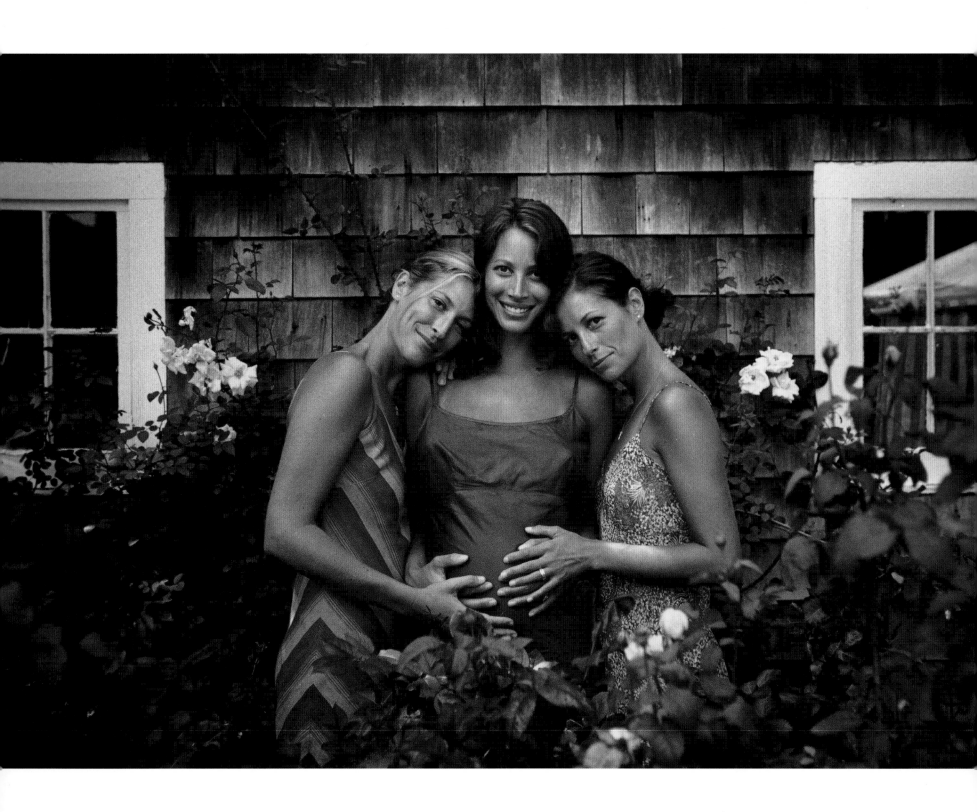

A decade earlier, Erin, Kelly and Christy would have sworn they couldn't possibly be better friends. Since then, two significant events have taught them that as sisters mature and navigate adult passages, even the best relationships can develop more profound meaning. The first transformation came from the evolution of the Turlington sisters into the Turlington mommies, bringing them a whole new dimension of things to share. Between them they can count five children: Kelly has James and Cameron; Erin has Greer and Beatrice. And last year, Christy brought Grace into the world. All the kids view their aunts as surrogate moms. "We're practically interchangeable," Christy says. "Sometimes they call me Mommy Number Two."

The second, more sobering milestone was enduring the death of their father seven years ago. "Dad was the patriarchal male figure in a family of girls," Christy explains, "and after he died we rose up to another level of independence and responsibility. When you lose a parent, you sense your own mortality and decide what's important and what isn't."

"Although we've always realized and appreciated how lucky we are, it definitely brought us together at another level," Kelly elaborates. "None of us takes what we have for granted or takes it lightly."

Kelly and Erin are full-time moms. They live in neighboring California towns and see each other almost daily. Christy is either globe-trotting for business or at home in New York with her husband, filmmaker and actor Ed Burns. (Kelly masterminded their wedding.) Because of the geographic separation, the sisters work at maintaining closeness by scheduling regular sustained visits. Thanksgiving is traditionally spent on the East Coast. In the summer they meet for at least a month with their kids in Italy, Mexico, or the Hamptons. Their mother isn't included, and husbands can join them only briefly. These designated summer sojourns are sister time to hang out, jog, do yoga and joke about how differently they parent. "I probably see my sisters more often and for longer chunks of time than people who have their families nearby," Christy says, acknowledging the effort they make to be together.

She continues to go out of her way to include her sisters in her glamorous lifestyle. "It's only fun when you can share it," she says. "You want to be some place fabulous and look at your sisters and say, 'Isn't this amazing.' And when I travel, I always get them stuff from different countries."

"We never have to go shopping," Erin says. "We just walk around Christy's closet and she gives us clothes. What she shares with us is huge. It's great."

Their lives may have gone in different directions, but trust keeps them intensely connected. "I have lots of friends, but nobody knows me like my sisters," Christy says. "In the end, nobody else would tell me when I'm off base or when I'm right on. That's really important to me. I get enough BS in my career. And having the three of us is great because, depending on what advice I need, I can go to Erin or Kelly, or I can talk to both of them about the same thing, get totally different reactions, and draw my own conclusions."

"I could never have with my friends what I have with my sisters," Erin adds. "There's no one I would rather spend time with. They are the first people I want to call about anything. We have such a wonderful, protected little family. I really appreciate that."

Kelly chimes in, "There just isn't anyone else who's had the same experiences. From day one to our dad's passing away to our having children, we've been there for every single thing—and it will always be like that. In another ten years and another and another." ∎

Lindsey and Eryn:

The Elkin Sisters

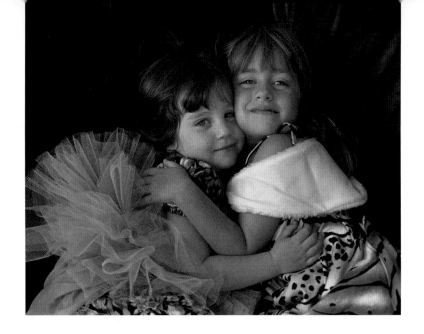

"Wanna play dress-up, Lindsey? I'm gonna be the mommy and the movie star."

"Then I wanna be a fairy."

"Okay. You can wear the blue dress because I wore it last time. Those shoes are too high for you. You'll fall down. Look, these are gooder."

"You live in a castle, Eryn, and I live in a fairy house. I'm gonna drive my car to visit you."

"You should fly 'cause you're a fairy. You know, like a butterfly with wings. And you're coming to visit me because we're sisters and we haven't been together in a long time and we're sad because we miss each other."

"I'll fly in through a special hole and give you a big hug. It makes me feel nice when I hug you."

"Well, Mommy hugs are a little better. Sister hugs are second."

"That's not fair, Eryn."

"But she's a grown-up; you're a kid. It doesn't mean I don't like your hugs."

"Then I don't like your hugs either."

"Oh, silly. I love your hugs. See. I'm hugging you tight. Now let's have a tea party." . . .

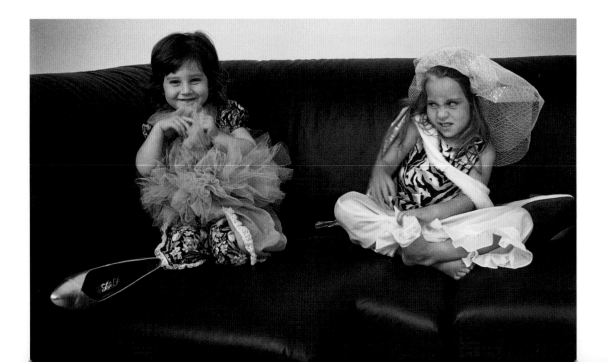

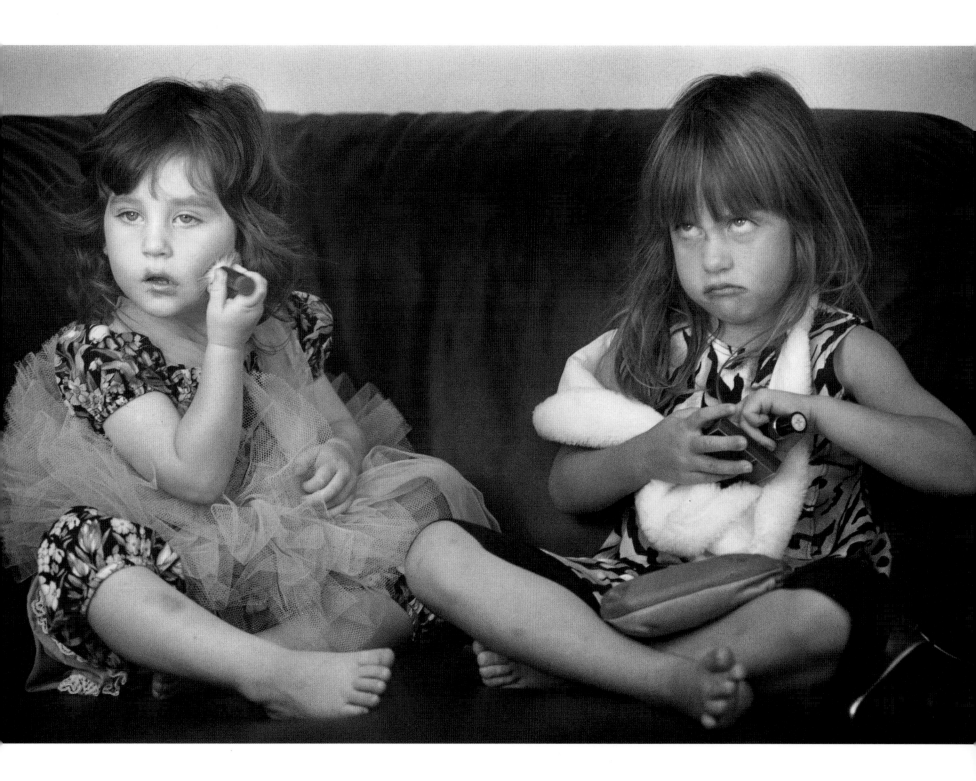

Lindsey and Eryn haven't played dress-up in years. Now they sneak clothes out of each other's closets and conveniently forget to return them. They'd as soon hug each other as embrace a porcupine. They don't share confidences or whisper secrets. "I would tell her things if she would tell me things," Lindsey whines, "but I can't trust her. Like I told her I kissed a boy, and she told Mom!"

They don't do schoolwork together, either. "When I try to help her with assignments, she yells at me," Eryn says.

"Because you do it all wrong," her sister snaps back.

Ask Lindsey what she wants from Eryn, and she answers, "Not to borrow my shirts because she stretches them out."

Ask Eryn and she responds, like a typical older sister, "Respect. A lot of things I do that annoy her, I'm only trying to help."

Pick. Pick. Pick. Icky. Icky. Icky. It drives their mother crazy. Lindsey will loudly chomp her food in Eryn's ear just to aggravate her, and they're off into another catfight. "It's all stupid stuff," Eryn admits. "Like we say, 'Oooh, I hate you. You're sooo annoying. You're so ugly. I'm gonna kill you.' But we never really mean it. It's never vicious."

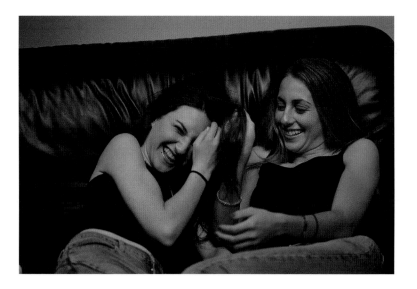

"We never get so mad that we despise each other or don't talk," Lindsey explains. "Some days we don't fight at all. In the summer, when our dad makes us go on vacation to national parks and stuff like that and we're really bored, we go hiking and rock climbing together and have fun. Sometimes we're okay. Just not a lot."

Welcome to the teen years, when adorable little girls who played together like happy kittens grow into long-legged, squabbling adolescents whose idea of a sister is a royal pain in the neck—at least for the present.

"I'm guessing it will be different when we're older or when we have families or when I'm in college and we're not together so much," Eryn says, chewing on a piece of her shoulder-length, perfectly blow-dried hair.

Lindsey agrees. "My mom and her sister have such a strong bond and talk about everything, so I think when we're older we'll appreciate each other more and consider ourselves more like best friends. I mean, it's not that I don't love my sister."

"Yeah, I love my sister," Eryn hastens to add. "I just don't like her."

"Well, I like *you*." Lindsey retorts.

And they're at it again. ■

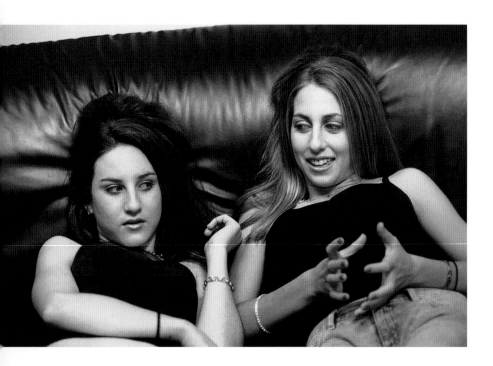

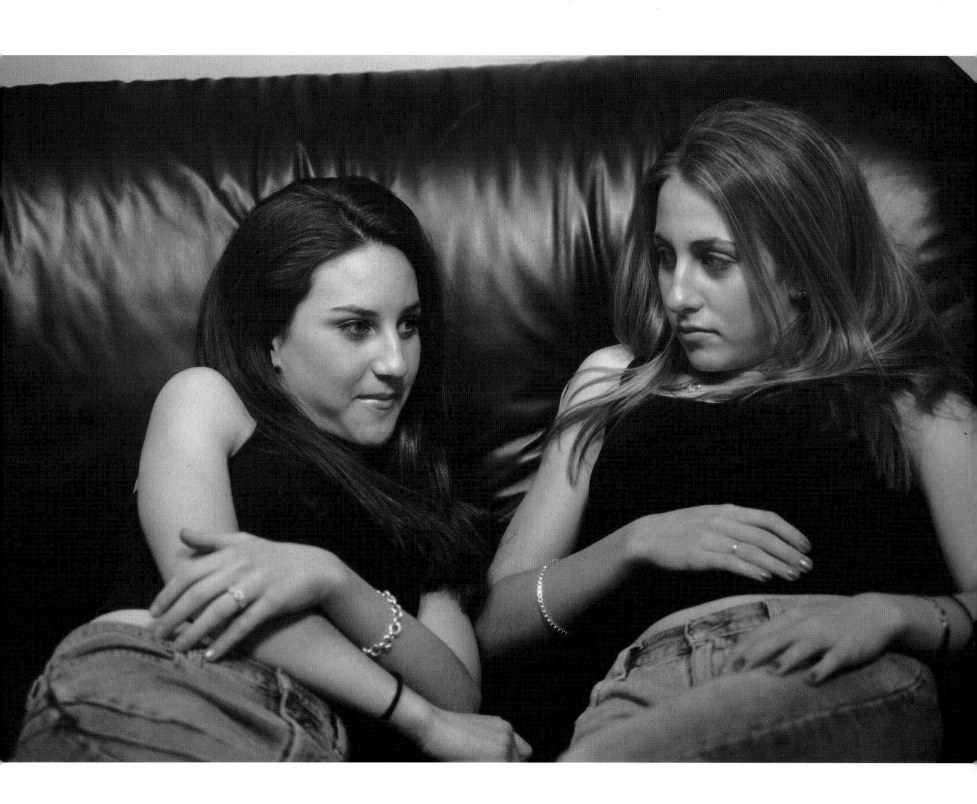

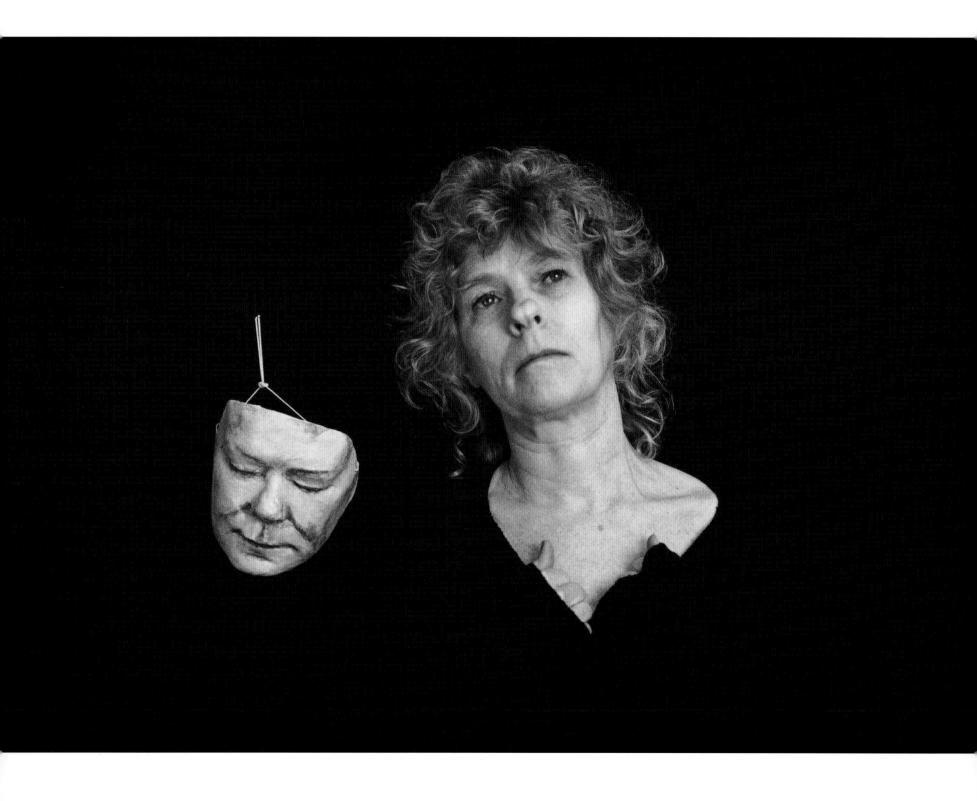

Nancy and Becky:

The Young Sisters

Becky Young and Nancy Matheson, identical twins, were born in 1939, ten minutes apart. In their 49th year, Nancy, a heavy smoker, was diagnosed with inoperable lung cancer. Becky immediately put her life as a teacher and photographer on hold to help her sister die. Nancy chose to spend her last days as she'd spent her first, so the twins moved home with their parents in the little town in western Massachusetts where they'd grown up.

"Toward the end," Becky haltingly recalls, "the cancer got to Nan's brain. She was full of morphine. Really out of it and not making much sense. Yet when I asked her, 'What's your name?' she said, 'Becky-Nanny.' How strange she remembered that. Becky-Nanny was what we used to call ourselves as kids.

"Then, one night, I heard her breathing change over the intercom. Immediately I knew that something was wrong. Our parents had gone to bed and I slipped into her room alone. She'd been sleeping all day, but now her eyes were open with only the whites showing.

"I'd made a pact with Nan that no matter what, she'd depart this world like she came into it, beside me, the way we'd been together in the womb. I crawled in bed with my body up against her, holding my sister in my arms, the closest person in my life. And very softly I began to sing "You Are My Sunshine, My Only Sunshine."

"I'd started singing that song to cheer her up one afternoon in the hospital when she was scared to go for some kind of test. It made her smile, and we harmonized like we'd done when we were kids. After that, our singing became a kind of nightly ritual. I told her that when the time came she didn't harmonize with me, that's how I'd know she was gone.

"For about twenty minutes I sang and sang and counted her breaths. They got less and less, and my Becky-Nanny never sang back." ■

Aimee and Amanda:

The Hector Sisters

When the Hector twins were three years old, one fell off the bed. The other, playing downstairs, suddenly began to cry. When they were eight, Amanda tumbled down the basement stairs, and Aimee, up in the bedroom, felt a sharp pain in her rear end. And once, Aimee injured her knee in a gym class accident and had to be rushed to the hospital. Amanda, completely unaware of her sister's injury, limped around the school all afternoon complaining that her knee hurt.

Twins are truly sisters under the skin, two bodies joined by a common soul. Without each other, the Hector girls actually feel incomplete. Amanda was once invited to a bar mitzvah by a boy in her science class who didn't know Aimee. "I went by myself but it wasn't fun. Something was missing. Being around other people without my sister is hard." When Amanda got sick at summer camp and had to come home, Aimee insisted on leaving with her.

They knocked down a wall in their house so they could share a bedroom. "Sometimes we climb in bed together," Aimee says. "I love Amanda so much. If I'm scared about something, she's right there next to me."

Do they fight like other sisters? Of course. "When we get really mad, we divide our room with a piece of tape. It never stays up more than ten minutes."

"And when we have a fight with a friend, we automatically take each other's side. It makes it hard on our friends, because our loyalties are always first to each other."

Are they ever jealous? "Well, when Aimee did so excellent in soccer and got all those goals, I was kind of jealous she was getting so much attention."

"But Amanda, you're a better singer and more artsy. You get to do the solos in our singing group."

"And how about the time we tried out for the school play, and the teacher said we could share the part. That was so stupid. Everybody else gets their own part and we have to share." The one area where sharing isn't a problem is their modeling career, a profession they've been pursuing since they were toddlers. "If someone doesn't want both of us for a job, we take turns," Aimee says, and Amanda finishes, "They don't know who they're getting anyway."

Do they ever get bored spending so much time together?

"Are you kidding? It's like having a best friend around for your whole life." Still, Amanda admits that every now and then, "It's fun to be home sick and all alone with Mommy." But by lunchtime they can no longer endure being apart, and they must talk on the telephone.

In an effort to make the twins less dependent on each other, their mother enrolled them in different classes when they started school. Recently she persuaded them to stop dressing as twins by promising to buy them individual wardrobes so that, between them, they'd have twice as many clothes.

"We liked to dress alike because it gave us attention and at first, we were afraid that without matching outfits no

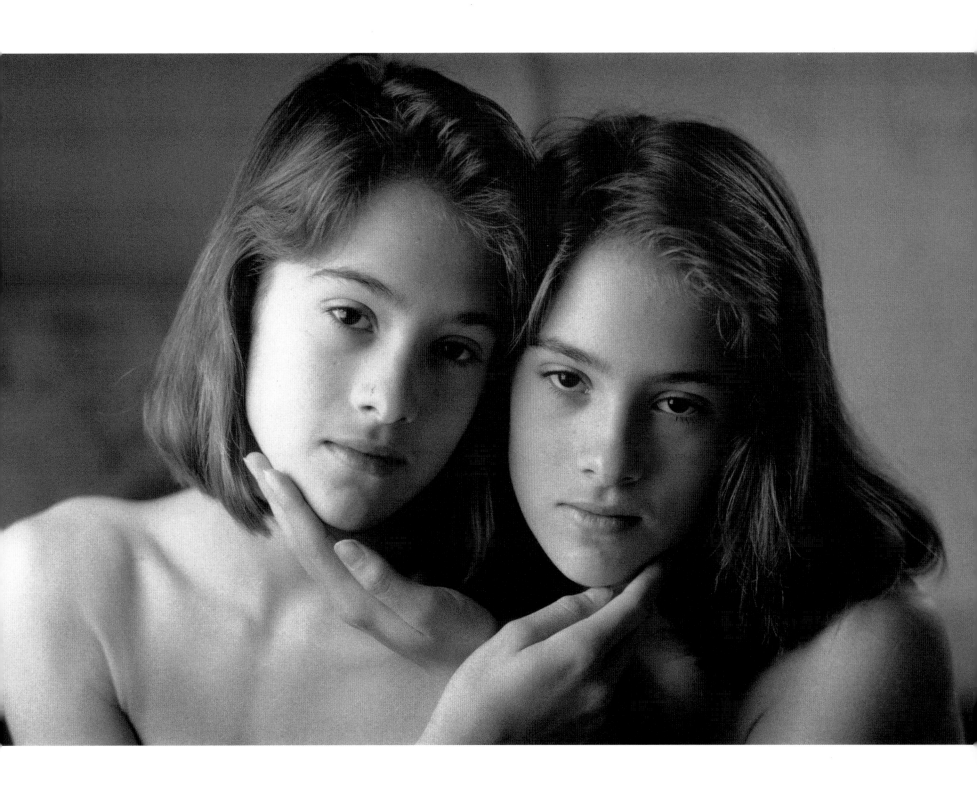

one would. . . ." Amanda says. ". . . notice us anymore," Aimee continues. "But that didn't happen," they both chime in.

"I had this idea yesterday," Aimee says, "and I couldn't wait to tell my sister."

"But when she started telling me," Amanda picks up, "I already knew what her idea was before she said it."

"Like the time we had that course together," Aimee goes on, "and you would raise your hand to ask a question, and it would be the same question I was ready to ask. It got so, if I saw her hand up, I just lowered mine."

Amanda jumps in. "Sometimes, in a mirror I think I'm seeing Aimee when it's actually me. I remember once we were alone in a hotel, just the two of us in the room. I got up to go to the bathroom and on the back of the door was a mirror that I didn't know was there. When I went by, I thought I saw Aimee's reflection, but that was impossible because she was back on the bed. Then I realized I was really looking at myself. Isn't that weird?"

"I guess it's hard to understand our relationship," Aimee says. "We're attached beyond regular sisters. Once I was

Amanda. We were one; now we're two, but we're still part of each other. We're the same, even if our personalities are different. I love her not because she's like me. She *is* me."

They think so much alike that in conversation, their words are practically interchangeable. Ask them what would happen if they both fell in love with same boy? "We'd shoot it out for winners like we do everything else."

How about if one got accepted into a better college than the other? "We'd both go to the same place.

We'd never let something like that come between us."

Do they think they'll get married some day?

"Yes, but maybe we can have a big house and live in different wings. It's hard to imagine having a relationship with anybody that's closer than ours."

When you're 14-year-old twins who've never spent a night apart, it's even harder to imagine being old and, worse yet, alone. Aimee muses, "I think that when we grow up and get old, if one of us dies, the other one will die pretty soon after that. I hope we're lucky enough to die at the same time."

"Me, too," says Amanda. "I want us to die together." . . .

Ten years ago, when Aimee and Amanda were teenagers, they couldn't conceive of ever living apart from each other. By the end of high school, they still weren't ready to cut the cord. Fortunately both of them had superior grades which enabled them to go off and room together in a suite at Princeton University. "I don't know what we would have done if one of us had gotten in and the other didn't," Amy recalls.

They might have parted ways over the choice of a career, but once Amanda started thinking about becoming a lawyer, Aimee liked the idea, too. "That made both of us feel it was a good choice," Amanda says. "We definitely influenced and reinforced each other." They applied to the same four law schools and steeled themselves for an impending split. Aimee was accepted early at Yale and actually cried when she received the letter, because she was certain she'd be there alone. "I knew if I made it to Yale, I absolutely had to go, but what were the chances they'd also take Amanda? Pretty slim—and going without her would be really hard." Then a few months later, to their amazement, Amanda's invitation to the freshman law class at Yale arrived and off they went together again. Later, they learned that Yale had no idea it had admitted twins.

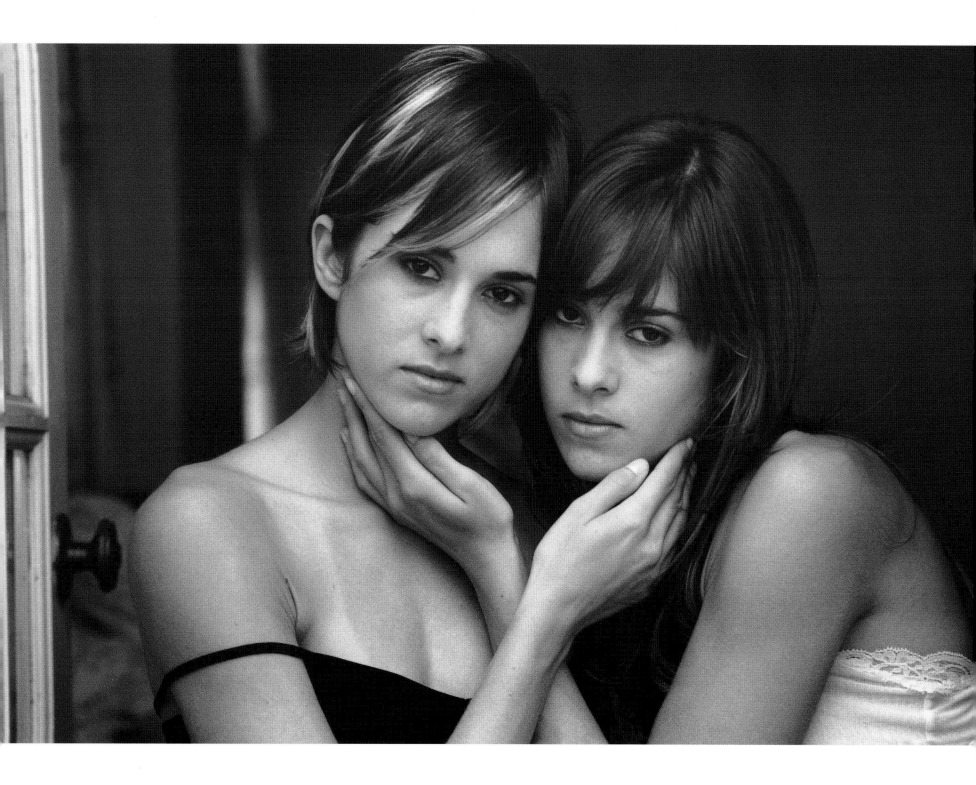

Now these beautiful, bright young women are about to embark on judicial clerkships. After applying to three different federal courts, their luck held again, and they wound up receiving offers in the same city. When their clerkships end, they plan to share an apartment in New York—but they definitely will not work in the same law firm. For these intensely connected sisters, separating will always happen one small step at a time.

Having unrelated jobs is one of the ways they can begin to chip away at their dependence. "There's something nice about people at our office not knowing we're twins, and not making it the main topic of conversation," Aimee explains. Amanda, completing her sister's thought as they have been doing all their lives, adds, "That's not to say the benefits of having a twin don't completely and utterly outweigh the annoyance."

Those benefits go far beyond friendship. "As people get older, especially women, they often have deep-seated insecurities that are impediments to their lives," Amanda points out with an insight beyond her years. "But we've always had a special security that comes from your twin standing behind you, helping you to be a more confident person. Other people don't have a partner until they get a husband or wife. But we've always had each other giving us the confidence to do things."

Aimee picks up the thread: "All our accomplishments, all the things we've done are shaped by this base of security formed by having a twin sister going through everything with you. Knowing that even if she disagrees, she'll always be in your corner to back you up when you need it."

Amanda adds, "I'm sure we'd be very different people if we'd been born without a twin."

Lest they sound too perfect in their admiration, Amanda admits to experiencing a bout of envy when Aimee was the first to have a serious boyfriend invade their union. When the romance ended, both of them felt they'd learned something new about themselves. "Granted, I'll never have the same relationship with a partner that I have with Aimee," Amanda says, "but being twins has taught us how to be totally selfless with another person. We know what it means to truly not think of yourself first. That gives us a willingness . . .".

"To feel comfortable with vulnerability," Aimee jumps in. "To give yourself over to someone and not be afraid. That's a real plus."

In fact, the only minus that tarnishes their relationship comes when the outside world forgets they really are individuals. "Even though we don't spend much energy fighting to prove we're not one entity," Amanda says, "it's very important to us that people know we are extremely, extremely different and have different personalities. For example, Aimee's more laid-back and responsible. She's the one who's always got the car keys and is asking me if I remembered my wallet. I'm more sensitive and get upset more easily. But we still have this incredibly special relationship . . ."

"That very few people have," Aimee goes on.

Amanda's turn. "Or would understand."

"And that," Aimee says, finishing her sister's sentence, "completely compensates for any aggravation from people viewing us as one thing."

Just for the record, they no longer plan to live in two wings of the same house when they get married—but side-by-side rockers on the porch of the nursing home are an absolute possibility. ■

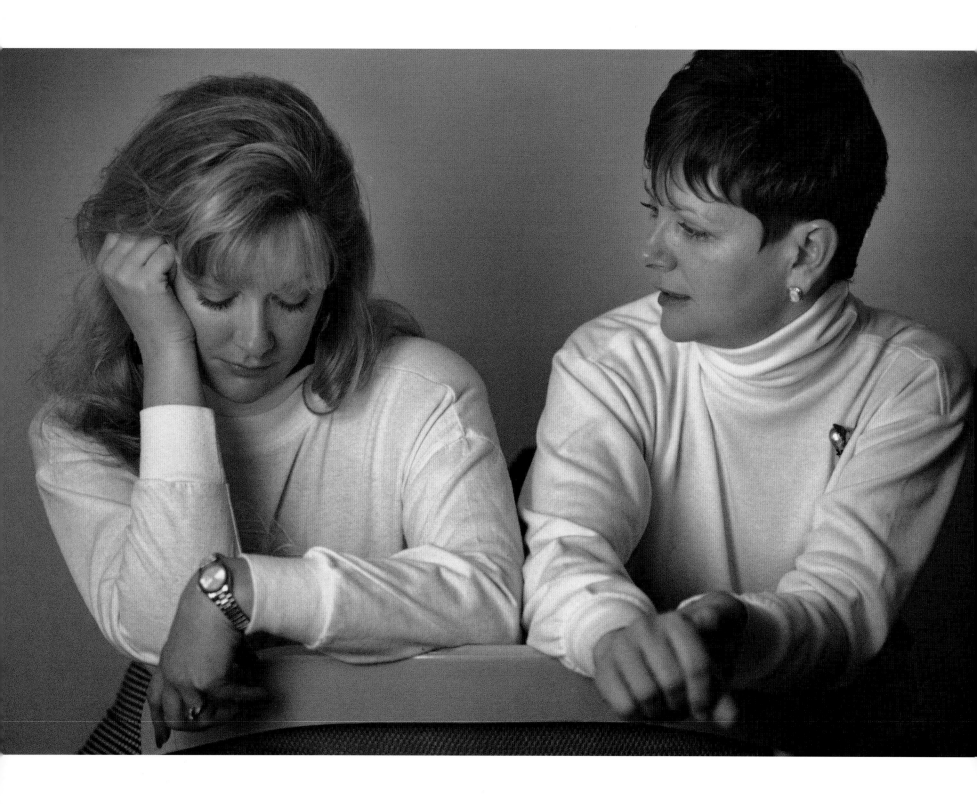

Joan and Ann:

The Petitt Sisters

Joan and Ann grew up together in different worlds. They ate at the same table under the same roof, had the same five brothers, the same parents—but for nearly forty years, that was about all they thought they had in common.

"I really wasn't aware of her," Ann says. "It was like she grew up in another family. I never knew she wanted a sister, and I never knew I needed a sister."

What Ann might have labeled indifference, her younger sister Joan read as loathing. "I didn't think she liked me at all, and if my own sister didn't like me, I must be defective. That affected me all my life. She made fun of me because I had blonde hair, because I wanted her to play Barbie dolls with me, because I took ballet lessons. I figured these must all be things wrong with me."

"I was jealous of her ballet thing," Ann says. "Joan represented what pretty girls were supposed to be—the favorite, the chosen."

"And I was afraid of Ann. She was too loud, rowdy, and mean, causing fights in the house. Because she scared me, I stayed away from her. I felt maybe if I wasn't in her face, she'd like me better."

There were few healthy attachments in their tempestuous family. Mother was an alcoholic; Father, a compulsive eater and workaholic whose mistress was an open secret.

"I felt like an outsider," Ann says, "attacked by everyone in the family because I *liked* my dad. He was my buddy. I survived by spending a lot of time outside alone hiding out in the grass, watching the bugs and being peaceful. I don't remember doing anything with Joan."

Joan was certain she'd been adopted. "At least that would have explained everything. But I coped by being careful not to make waves, by tap-dancing around everything and jumping to do what people wanted. And what I wanted most was a big sister. I'd watch my girlfriends who had close sisters and think, 'Why can't I have that?' Funny thing was that as much as I tried to stay away from anyone who reminded me of Ann, I kept being drawn to women like her, and I would do everything I could to win them over."

Eventually, Joan's desire to understand her fears and insecurities led her to counseling. "After I worked out my issues around males, there was still this big hole inside me, and I realized I was looking for my sister."

By then, Ann had moved from Cleveland to Charlotte, North Carolina, toting with her the family baggage. "I had to get away so I could work on who I really was and find my identity." Years passed with minimal contact, although Joan wrote now and then and sometimes sent a little present. "I still wanted Ann to like me."

Ann read the letters and thought, "Joan has this nice life, nice husband. She's building a career. I was real proud of her. I knew she'd left school, then gone back, and that was kind of an inspiration to me." But Ann never put her feelings on paper or reached for the phone. And on the rare occasions when she did come home to Cleveland and the sisters saw each other, the old hostilities flared up.

Joan isn't quite sure why, two years ago, she accepted her brother's invitation to drive five hundred miles to visit Ann for the weekend. "I guess I had to slay this dragon. I thought,

'There's got to be something good there I'm missing. My brother thinks she's terrific and she *is* my sister.'"

Ann was thrilled when she heard that Joan and her brother were coming. "I'd figured none of them cared about me. I was just the pain in the ass who'd left home. The only time they ever visited was on the way to Florida. So I was elated and honored they were coming now—just to see me. I felt accepted."

For once, life followed the fairy tale. "We weren't there five minutes," Joan says, "when I realized Ann wasn't the same person. She was warm, wonderful, and loving. We ended up leaving the hotel and camping out at her apartment, like a slumber party, and before long we were saying, 'My God, we're so much alike.' I can look at her and laugh because we have the same hips. I guess most sisters do that, but we never did."

The next day they went hiking in the mountains and gave each other an uninterrupted hour to drop their defenses and swap stories. Ann learned about "the trauma Joan had in her abusive marriage. I had no idea what crap she'd been

through and it hurt. I wanted to cry and hold her and comfort her and say how sorry I was that I never knew."

"You *did* say that," Joan reminds her. "And you made it so much better. When you told me that you barely knew I existed as a kid that took a lot of the pain away from me."

Together, they began to unlock their past and build a future. "I'd blocked out so much," Ann says. "Now I have memories and someone to reference things with. Joan is teaching me to see a side of my mother that logic tells me had to exist, but I never saw. We're remembering some of the good, crazy stuff we did as a family. The laughing. Building forts in the living room. It wasn't all bad. This has helped me to center, to find a part of my life I'd lost. I realize there is a bond here connecting us that you can't have with anyone else but a sister, and that's real good for me. I feel I've walked through a doorway into a new world."

Joan has found that by uniting with Ann, she's improved her other relationships. "I'm no longer trying to suck everybody dry because of what I evidently needed. I don't

have to be afraid anymore. Now that I know Ann didn't dislike me, I must not have been so bad after all. I feel I have a real sister now, somebody I can call and say this hurts or feels good and she's not going to make fun of me."

Ann replies, "I always knew I had sisters, but now I have a friend in Joan, and that's more valuable to me." (An older sister, Mimi, remains on the fringe of this reconciliation until, Joan says, "she realizes that healing can take place in a family.")

In the meantime, Ann and Joan are catching up on the childhood they never shared. Recently they met for a weekend in New York. "We were walking down the street," Ann says, "laughing in the rain—two soggy rats, soaking wet. People were staring at us because we were having so much fun." Later, back in their hotel room, they pardoned each other for the past.

"I forgive you, Ann, for the little girl part of me you hurt," Joan whispered.

"I love and accept you just as you are," Ann answered. "I'm so grateful we've rounded the bend." ■

Haydee and Sahara:

The Scull Sisters

Aiii . . . ai . . . ai . . . *caramba. Presenting to you those Cuban bombshells, the fabulous Scull twins, talking about their lives and their art—which, truth to tell, are hard to distinguish.* They paint much the way they live, side by side, in brilliant technicolor and boundless optimism. Their highly praised folk art—large canvasses full of humor and energy, featuring three-dimensional clay figures—often depicts scenes from the pre-Castro Cuba of their childhood. The recollections of Haydee fill in the gaps left by Sahara, and vice-versa.

"Always, since we are chiquita, our art very elaborate. Our minds like cameras, full of ideas. One remember what the other forget."

Now here they come, bouncing into the room, aging Kewpie dolls with scarlet lips, tippy-tapping on their three-inch, spike-heeled sandals, dyed red this very morning to complement the outfits they whipped up on their little sewing machine. Their bedroom doubles as an open closet for the vast wardrobe of costumes they call their clothes—tight-fitting, colorful, scoop-necked dresses that hug their broad, sashaying hips and emphasize their ample bosoms.

Happy, they surely are! Happy to be alive. Happy to be safe in Miami. Happy to be painting what they want, beyond the reach of a dictator. And, most of all, happy to close their eyes each night in their big double bed, jabbering endlessly about their plans for the future and their memories of the past . . . until one of them falls asleep.

"We can never be separate," says Haydee. "She inside me. I inside her. We always inside here, in the heart."

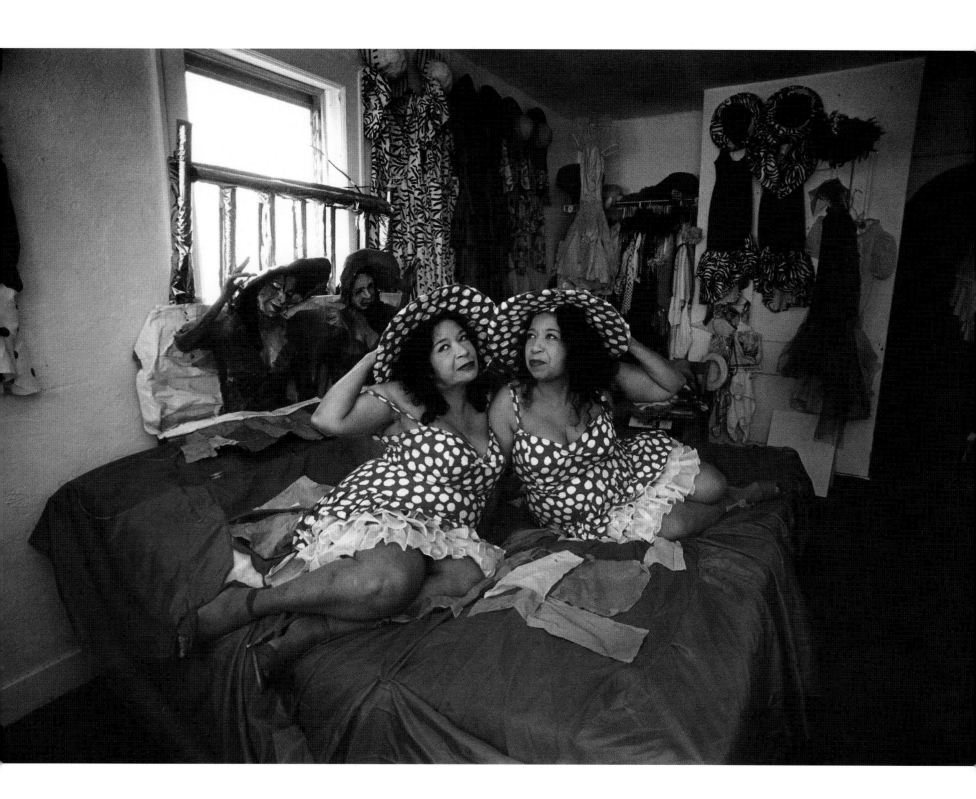

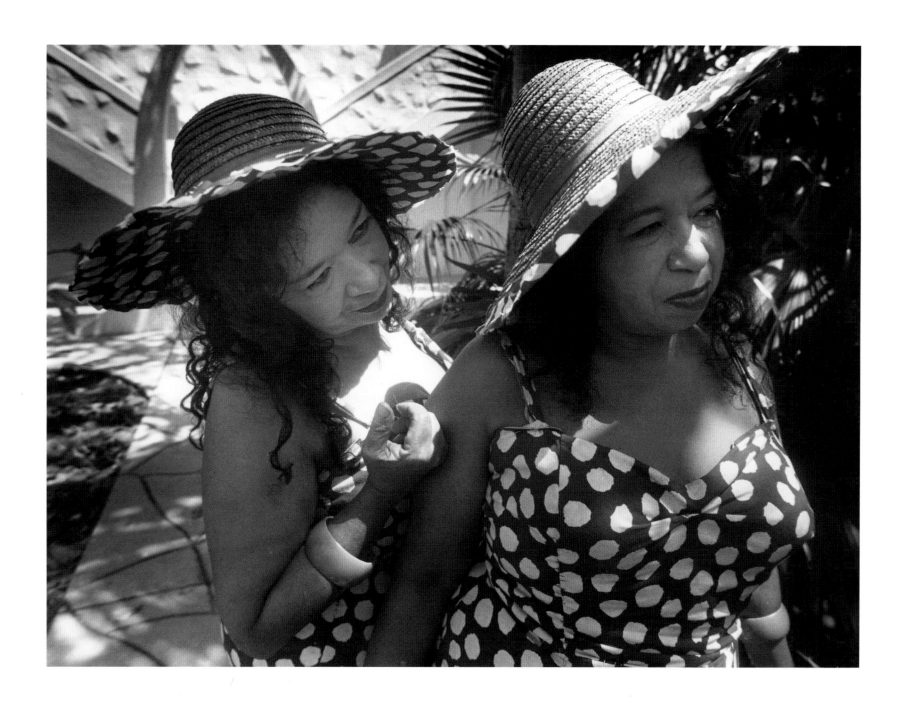

That spiritual thread connected the twins the one and only time that circumstances erected a physical barrier: In 1969, desperate for artistic license, Haydee left Cuba with her two children on a freedom flight. Sahara stayed behind to care for her dying husband and didn't escape until three years later. On the rare occasions they managed to speak on the phone, Haydee would ask Sahara what she ate that day. "If she eat fish, then I eat fish, too. That make me feel close.

"We are very lucky girls. Always very *affinidad*. Never disco dance separate. Life for us is pink. A happy color. And together makes us strong. Four arms. Four legs. One heart. One mind. One soul. Siempre. Always." ■

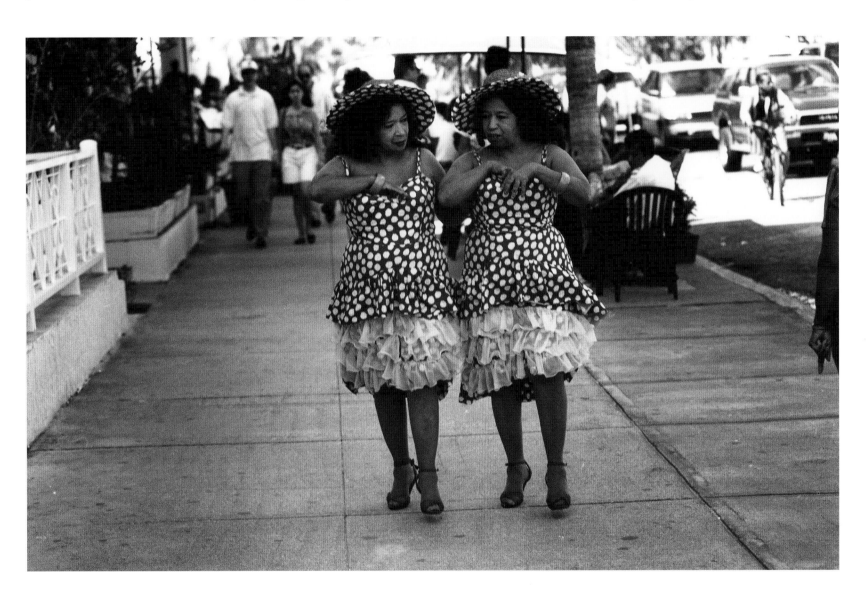

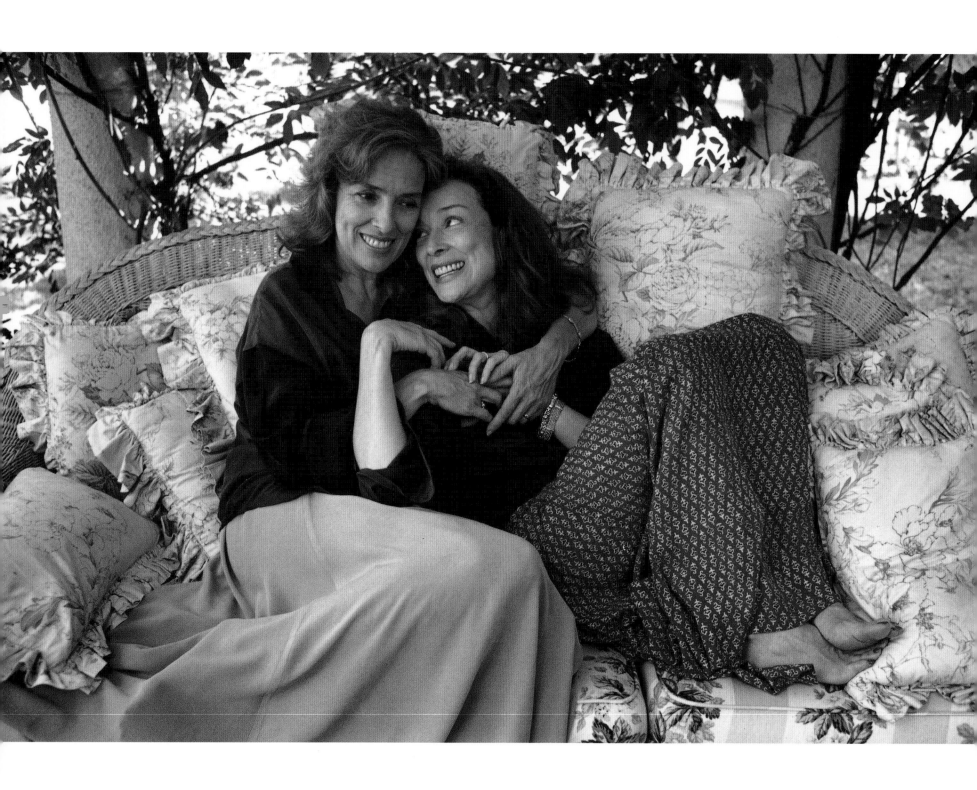

Midge and Dixie:

The Carter Sisters

The day was warm, the air fragrant with the scent of flowers. Four-year-old Midge Helen, and her six-year-old sister, Dixie Virginia, nicknamed Diddie, were planning a major social event. They raided Mother's closet for pretty, colorful scarves, and tied some around their waists, draping others over the peach trees to fancy up the garden. With exquisite care they laid out tiny cups and saucers brought home from the toy department of Daddy's big store in town. Then, with great ceremony, they invited Gina, their mother, and Mama Carter, their grandmother, to join them for tea and lemonade.

Playmates were scarce in McLemoresville, Tennessee (population two hundred), but that barely accounts for why Dixie and Midge are such deliciously dear friends.

"Oh my. I can't remember a time we didn't get along," Dixie says without hesitation. "Mother had a rule that if we fought, no matter who started it, she'd spank us both. We'd go to laborious pains to sneak off for a fight somewhere she wouldn't catch us, and by the time we got to the barn or wherever, we'd lose our steam and forget about it. We even divided the icing when Mama baked a cake. She'd call us in, her little lambs, to lick the pan, and we'd draw a line right down the middle to make sure the other one got enough. Our parents always made a big point of being sure we got equals.

"We slept in the same bed from the time we were born until we moved to town (Huntington, population three thousand) because the school was better. Then we had twin beds in the same room. Our wonderful house in McLemoresville had nothing but fireplaces downstairs to heat it. In the winter, before we went to bed, Mama Carter would come over from her house next door and hold up a blanket in front of the fire. Gina would hold the other blanket up, and they'd tell us stories. When the blankets got hot enough, Midgey and I would scamper up the stairs ahead of them, and they'd wrap us up together, pile more quilts on top, and we'd go to sleep under all this weight, curled up like two little spoons."

Decades later, the sweet spirit of their childhood glows in their adult eyes when they sit down to talk about each other. They cuddle up; their Southern accents thicken; the years melt away and they become as tender as little girls.

"Long after Gina stopped dressing us alike," Dixie continues, "we were allowed to dress as we wanted, and we still chose to dress the same. Miss Eunice, a wonderful seamstress, made all our clothes. We'd be taken in the beginning of the season to the piece goods department in Daddy's store and—would you believe—we'd pick the very same material and patterns, at different times. And—cross my heart this is the truth—at least once a season on different sides of the country we bought our daughters dresses of the exact same fabric. It happened over and over again.

"When we'd gone our separate ways after college, we'd write letters home that would arrive at the same time and say pretty much the same thing. Our children still say that when they were little and we came up behind them, they couldn't tell which one of us it was because our hands felt the same. Isn't that extraordinary?"

"What I find amazing," Midge remarks, "is how Dixie has this very psychic way of reaching out to me emotionally, especially when I'm down. Before my third child was born, she was doing summer stock in North Carolina. Out of the blue, she called home and told Gina, 'I think Midgey needs me.' She flew to California and by the time she got to my house, I'd fallen down the front steps and broken my ankle. It being close to my due date, she just stayed to help. Now, Dixie does not love to do housework, but she cleaned my house from top to bottom and then went off and bought every single thing in the grocery store. Food to cook, a thing to hold paper cups, a new toilet brush. She went nuts."

"But you are the most loving, unselfish sister anyone ever had," Dixie interrupts. "Midge despises crowds," she explains. "Her idea of a huge party is four people. But she came to New York to support me when I was trying to get my career started. She applied for a job at American Express, and she was so cute and pretty they made up some receptionist position for her. She worked every day and brought home money so I could study and audition."

"In retrospect, I didn't like my job a whole lot," Midge

admits. "But I wanted to go to New York and be with you in that wonderful little sublet in Greenwich Village."

"Where all we had to do was water the African violets for forty dollars a month."

"Then the sublet ended and we basically had nowhere to stay except that horrible hotel for a couple of nights."

"At Fifth Avenue and 5th Street," Dixie remembers.

"We put a chair under the doorknob."

"Do you remember that terrifying mouse in the closet?"

"Oh, Dixie," Midge sighs. "You always were a scaredy cat. When we were real little you'd ask me to go upstairs ahead of you because you were afraid. On the other hand, when I was in seventh grade and you were in ninth, I was deathly afraid of spiders, and you came along at a picnic and wildly chased some friends who were scaring me with a spider. We've always taken care of each other."

"You came to New York to save me when my first marriage was breaking up," Dixie reminds her. "I called and said, 'You must come.' You took your two little children, got on the plane, and when I came home from my soap opera, there you were."

"That was so different from the other time we lived in New York," Midge recalls. "This time you had a posh apartment, and we both had little children who were at a wonderful age to do things with. The circumstances were unfortunate, but we actually had a lot of fun, just the two of us together again."

"And you, looking after me in a big way." Dixie rubs her sister's arm. "I can barely talk about how much I love you without going into tears, into big middle-aged weepers."

"I feel like you are an extension of me, though we are quite different," Midge says. "You seem to think whatever I do is grand, and I get the vicarious excitement of being out in the world from your being there for me. Do you want to tell our dream?"

"You mean about our long-range ambition?" Dixie asks. Midge nods.

"Well," Dixie pauses and takes her sister's hand. "When we get to the rocking chair stage, we plan on living in very close proximity, either side by side or in the same house."

Just like they were way back in McLemoresville, giving tea parties among the peach trees. ■

Janet and Julie:

The Johnson Sisters

"Would I have a baby for a best friend? I'm not sure," Julie says, patting her belly. "But I had no reservations about doing it for my sister and her husband.

"Some people who have heard what I'm doing have said to me, 'There is no way I could do something like this for my sister.' I can't understand that. To me it seems, gosh, well why wouldn't you, if that's what your sister and her husband need? I knew how badly they wanted a child and they couldn't have one. If it took me to do it, that's fine. I don't know what kind of relationship other sisters have but this seems normal to us. It's just not a big deal."

These sisters tend not to be demonstrative about their affection for each other. When someone once suggested that Julie was presenting Janet with the ultimate gift, she replied, "It would embarrass me to think of it that way."

At the time this photo was taken, Julie, a lieutenant in the United States Navy who taught in the ROTC program at North Carolina State, was one week away from delivering a baby she offered to make from her own egg and a sperm donated by her sister Janet's husband.

"We were in the kitchen of Julie's apartment just after swimming at her pool," Janet recollects. "The whole family knew we'd been trying to have a baby for several years, and Julie just asked, 'Would you want me to have a baby for you?'"

Two years would pass before Janet, who has a doctorate in math education, was ready to consider her sister's proposal. By then, she'd been through the fertility clinic routine and thousands of dollars worth of low- and high-tech procedures, including in-vitro fertilization.

"I'd reached the point of being pretty down," Janet says, "when I read an article in a science magazine about depression being a signal for humans to give up things that weren't working for them and try other options. After eight years of trying, I figured maybe it was time to accept Julie's offer."

They had every intention of using a doctor for the artificial insemination, but ran into difficulty finding a physician willing to assist them. That's when Janet remembered *the turkey baster*.

"I was watching one of those horrible Geraldo shows about an older husband and younger wife. They couldn't have children because his sperm count was low. So they used the sperm of his teenage son. It was casually reported they'd done the fertilization with a turkey baster. I was in my data-clipping mode and filed that as an option. Turkey baster? Mmmmmmmm."

It's okay to laugh. At the time they thought it was pretty hilarious, too. Nevertheless, Janet and her husband went baster shopping at a kitchen supply store. Mark preferred a metal model, thinking it would be more sterile; Janet, concerned about her sister's comfort, thought it would be

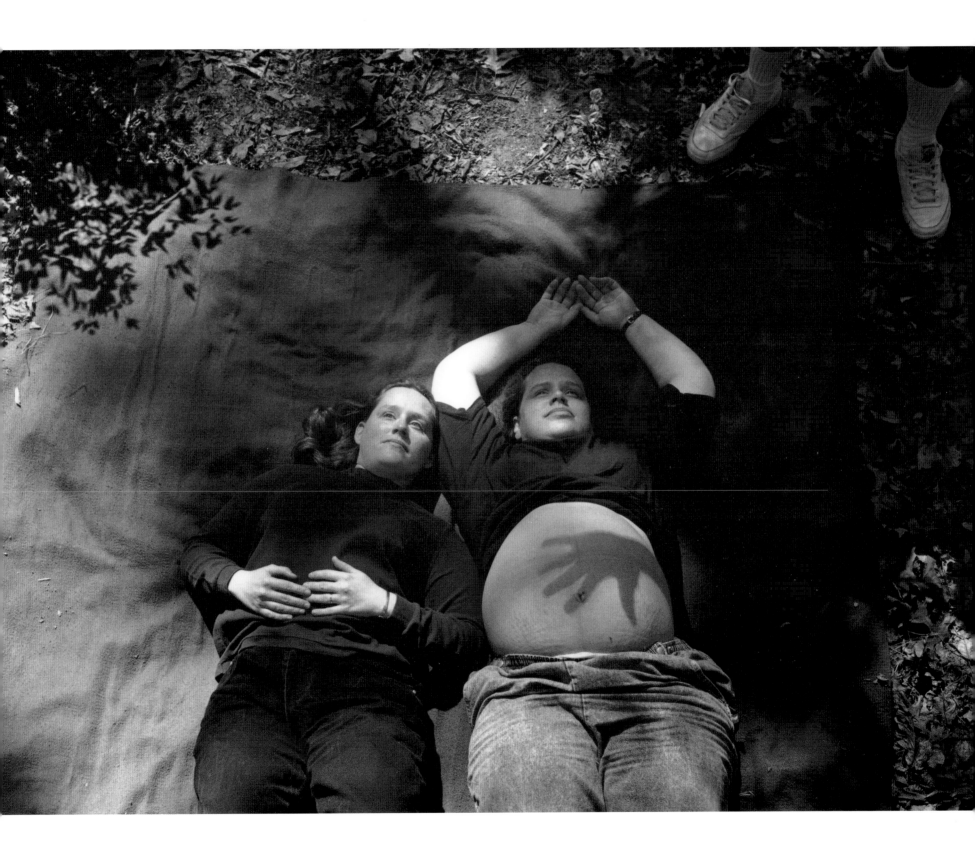

too cold, so they settled for a plastic bulb baster which they sterilized in their dishwasher. With the help of an ovulation kit, they figured out the right time of the month, and on the appointed day Julie came to their house.

"Mark did his thing," Janet says with a big grin on her face, "and he handed me the baster. I'd never used one and we hadn't practiced how it worked, so when I took hold of the bulb I accidentally squeezed it and half the sperm came out. I thought, 'well, so much for this idea.' But I gave it to Julie anyway and told her to keep her finger over the tip. We were all laughing."

Julie went into the bedroom by herself. "I didn't need any help. It was easier than putting in a tampon. Then I stood on my head up against the wall, and I played little mind games with myself not to get bored. After twenty minutes Janet came in and then we ate dinner."

"We were all making jokes about what a fiasco it was, such a comedy of errors," Janet says. "We called it premature basting." But they repeated the whole thing the next day, just in case it might work after all.

One month later, Julie's period was late. Despite two positive results with home pregnancy test kits, Janet couldn't believe they'd actually been successful.

"I was sure she'd read the instructions wrong. After eight years and a turkey baster, it couldn't be this easy." A visit to the doctor's office confirmed that yes, it could. Janet remembers, "When Julie called me, I kept saying, 'You'll never have to buy us another present as long as you live.

Not a birthday. Not an anniversary. Never.'"

One thing these sisters are very clear about is who the baby belongs to. "I've always thought of the baby as Janet and Mark's," Julie says firmly. "It will be my little niece or nephew."

"I feel Julie isn't just giving us a baby, she's giving a person a life," Janet says. "We're all very lucky."

Which reminds them of the wishbone story. Once when Janet was trying to conceive, she and Mark followed a special diet that required them to eat lots of poultry. Every weekend when Julie came to visit, Janet would roast a turkey and save the wishbone. Mark refused to wish with her because he wasn't superstitious. So week after week, she and Julie would hold the wishbone, close their eyes, and make a wish.

"This is so silly," Julie finally said one night. "It doesn't matter who wins because we're both wishing for the same thing."

"Really," said Janet. "What's your wish?"

"I'm wishing that you and Mark get pregnant."

"That's funny," Janet said, laughing. "I always wish for a million dollars."

"And that is why," she says, "Julie got pregnant instead of me."

John Franklin Wittle was born weighing in at seven pounds, twelve ounces. Both mothers and child are doing fine. . . .

If John Franklin Wittle's

conception was, shall we say, a bit eccentric, the aftermath has been as ordinary as meatloaf and mashed potatoes. A husky ten year old, gifted at violin and passionate about computers, he loves his Aunt Julie and doesn't much care about the specifics of his birth—which is exactly what Janet and Julie hoped would happen.

"We figured the best thing would be to let him know from the get-go that Mommy couldn't have a baby so Aunt Julie had one for her and make like it was no big deal," Julie explains. "So it wasn't."

When he was three, a neighbor got pregnant, and John asked Janet the typical toddler question: "Was I in your tummy?" Janet replied, "No. You were in Julie's. Some of

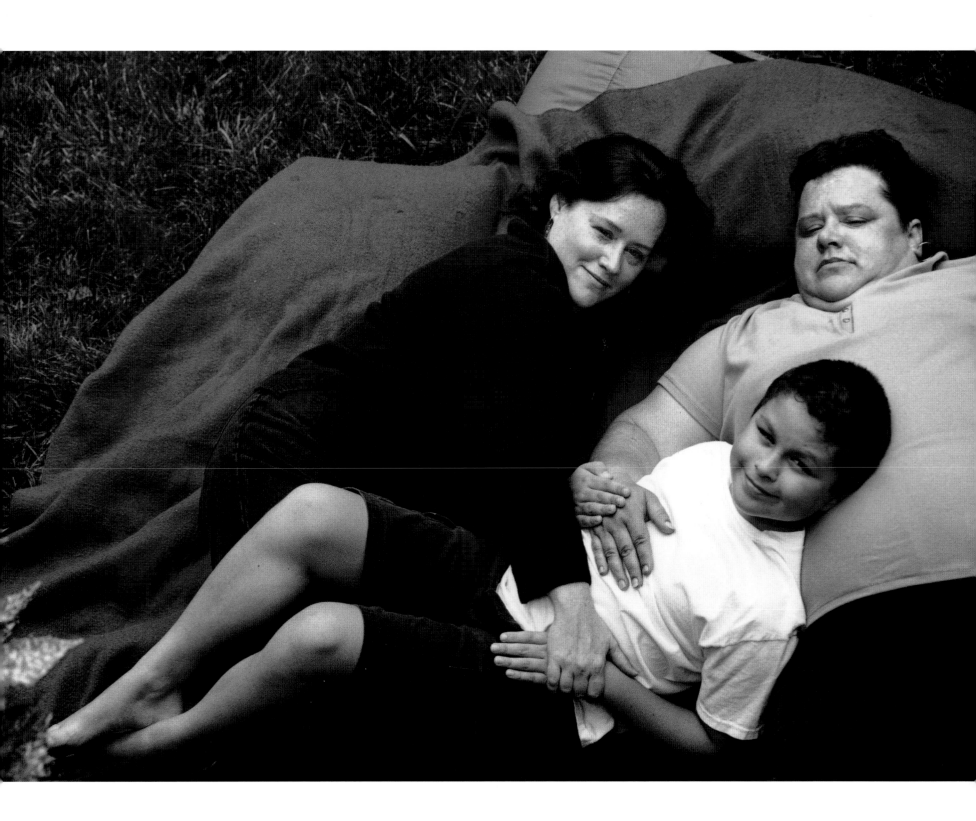

my parts didn't work, so she had you for me." He said fine and went out to play. When he was nine, an older friend who'd had sex education in school revealed to John some of the finer points on how sperm meets egg, leading him to inquire how daddy's sperm found its way into Aunt Julie.

"I told him we used a turkey baster," Janet continues. "He's a little techno kid and found that very interesting. Because it made perfect sense, he was fine with it. He did ask me once what should he call Julie. I explained that she was his biological mother and I adopted him, so I'm his legal mother, and he said, 'Oh, then you are my mother-in-law,' which he thought was terribly funny."

John's arrival had very little impact on the bond between his mothers. Just as she had anticipated, Julie registered zero interest in parenting and easily detached herself from their nuclear family. "I can remember babysitting one evening shortly after John was born," she vividly recalls. "I was holding him and trying to get that maternal feeling, thinking that he could be my son. But I couldn't get any kind of emotional reaction. It just wasn't there. He wasn't *my son*. He was Janet's. My reward was the fringe benefits of experiencing pregnancy and seeing what my DNA could do. I kind of got my cake and got to eat it, too, without having to wake up for two AM feedings."

While she's not the least bit proprietary about John—"Janet is the big influence in his life and she's doing a great job."—Julie does admit to a pitter-patter of pride when she sees parts of herself in her sister's child—like the way he recites entire scenes from comedy movies just as she once did. "He's messy like I am, too," she says sheepishly.

Because of their unique shared interest in John, Julie's granted Janet unlimited bragging rights about their progeny.

And she takes advantage of them. "I know Julie values the same things in John that I do," she says. "She wouldn't want to hear as much that he got an A on a test as that he helped a little girl stave off a bully in the class."

Julie sees her "nephew" only two or three times a year, although they write and e-mail all the time. Since retiring from the army, marrying and moving to Atlanta, she now lives several hours from the Wittle's North Carolina home. Yet she and Janet are more attached than ever, because she is working as a writer and editor in her sister's burgeoning educational consulting company. They talk every day, both for business and friendship. While John has added another dimension to their lives by contributing something that matters deeply to both of them, he has only a minimal effect on their lifelong unwavering connection.

"Our relationship goes way back to an instinct we two always shared of knowing how to keep the peace and when not to rock the boat," Julie points out.

"Or how to right it when someone else rocks it," Janet adds. "Growing up with four girls in the family, we recognized that we were the ones with a similar perspective on what was going on around us. Having a special sister who understands your point of view and what you get out of experiences becomes increasingly meaningful as time goes on. Even when Julie doesn't share my opinion, she knows why I have it. The older you get, the more you appreciate how rare that is."

"I've always loved Janet," Julie says. "My carrying John for her would never have happened in the first place if we weren't very close."

The turkey baster, by the way, remains tucked away in a box in Janet's upstairs closet. ■

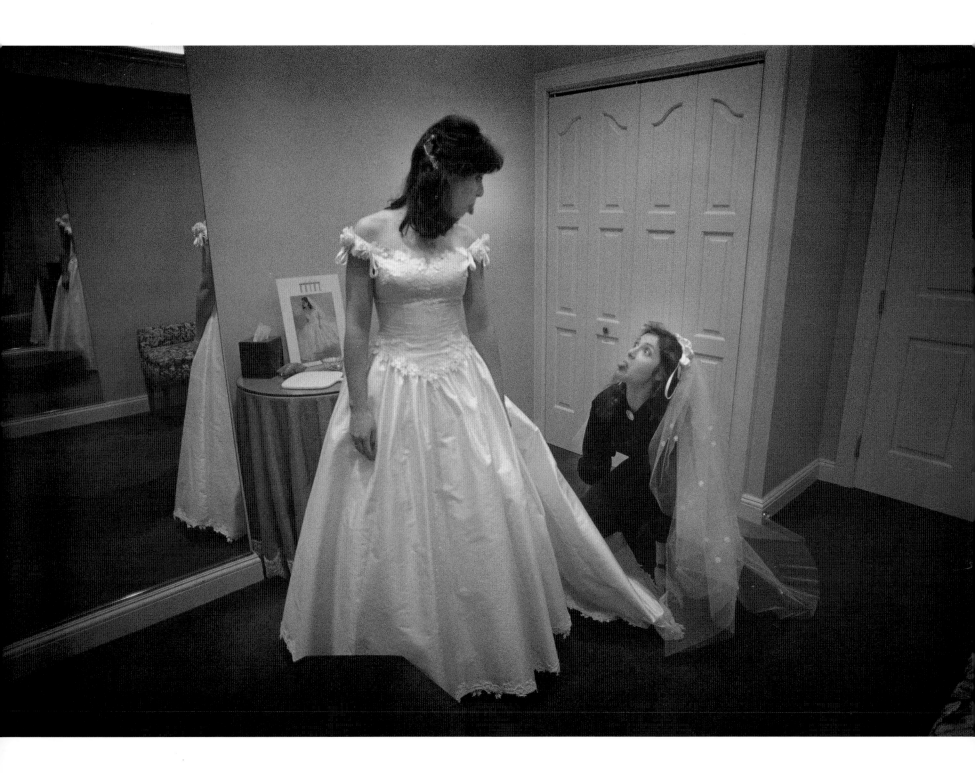

Linda and Susan:

The Karlin Sisters

"Do you like it?" Linda twirls in front of her sister, showing off her bridal gown.

"It's gorgeous," Susan gushes. "Wow, you even have cleavage."

"Were you excited when you first saw me? Was it scary?"

"Why? You're the one who's getting married. Actually, it is kind of overwhelming. My little sister a bride! My god, I guess this means that one of us is really a grown-up person now."

"You could borrow this, you know."

"We should all be alive that long."

"I want you to know that I don't believe you can replace a sister with a husband. I'm not a person who takes away people in my life. I'm adding Peter on, and I expect you two will love each other because I love you both."

"I don't feel like Peter is invading my territory. It's more like I'm gaining a new friend. But I guess this means we won't sleep together anymore when we come home for Thanksgiving."

When, as youngsters, Susan and Linda were moved into their own perfectly-furnished bedrooms, they continued to sneak into each other's beds because being separated felt like punishment.

The only time they had a major competitive clash was in high school. Susan, a senior, and Linda, a sophomore, were up for the same role in the school play. "I wanted that part

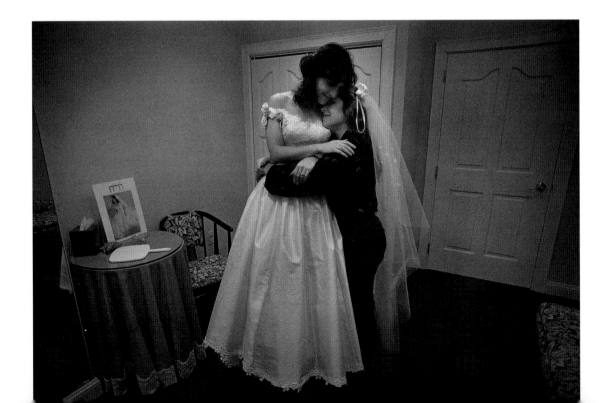

65

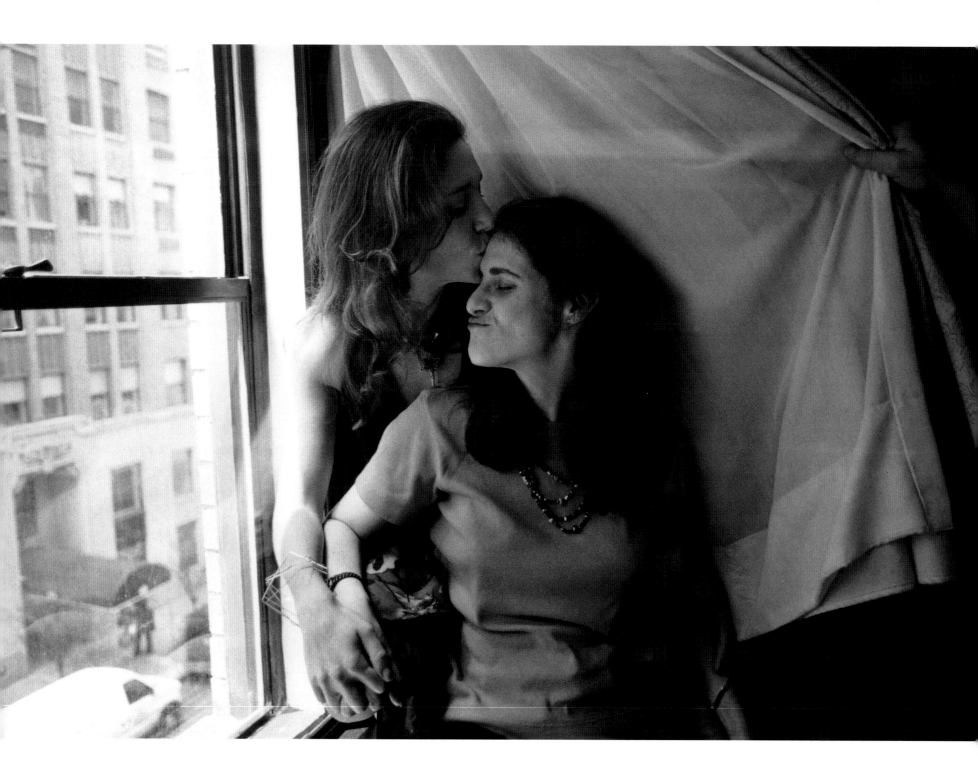

and tried like mad to undermine Linda's confidence because I saw her as serious competition," Susan remembers, still obviously feeling guilty. "One night at the dinner table she started to cry. 'Susan, we're sisters. What are you doing? We're not supposed to undercut each other. We're supposed to support each other.' I looked at her and it was devastating. She was right and I felt terrible. I apologized and said, 'Go knock 'em dead in your audition.' Linda got the part and I was disappointed, but I was also excited for her. She was my second choice."

Today it's often Linda who basks in Susan's achievements. "When Susan has an article published in the *New York Times*," she says, "I gain by that because she's a part of me. And it's exciting when she calls and tells me she's going off to the Cannes Film Festival or she was just at a party with some TV star and they hit it off because they both came from New Jersey. Other people don't get that from their sisters. All they do is call each other and swap recipes."

Their mother has a simple theory for why her daughters developed respect for each other instead of jealousy: "Unconsciously they staked out territories that each one could excel in. They sort of made their own spaces, their own places." Susan became a writer, an actress and a stand-up comic on the West Coast; Linda, a marketing and meeting planner on the other side of the country. But emotionally, they will always be next-door neighbors.

"You bring a constant sense of fun and craziness into my life," Linda tells Susan. "A gym teacher in high school once asked me what it's like living with you. I said it was a continuous vaudeville show. If you weren't my sister, I'd have missed the show."

"And you give me a solid foundation and a sense of when I stray too far from the norm," Susan replies. "I know I have a best friend for my entire life who is never going to go away.

"Maybe we could still sleep together when we come home for holidays. We'll just ask Peter to come join us." . . .

Linda's wedding dress is hanging in her closet pristinely packed, still waiting to be borrowed by her sister. She has followed the grand plan: happy marriage to Peter; an adorable son and daughter; house with a yard; part-time job managing customer newsletters for a computer company. "My life is traditional," she says. "When I'm not at work, I'm usually on the floor with my children pushing trucks around."

Susan, the designated free spirit, has even become more anchored. After dabbling on and off as a stand-up comic in Los Angeles, she's settled into a career as a freelance journalist and sometime actress. While not officially married, she might as well be. For the last four years she's lived with Gordy Clapp, an actor on the television series *NYPD Blue*. "Gordy and I treat each other like an old married couple," Susan deadpans. "I talk, and he sits quietly in the corner and watches golf on TV." Like Peter, Gordy has been

seamlessly integrated into the family. The couples, do not, however, share a bedroom on Thanksgiving.

"My sister is practical, efficient and normal," Susan says.

"I guess I'd describe Susan as effervescent," Linda replies.

"Does that imply I give people gas?" Susan asks.

Ba-da-boom. They're still good-naturedly tossing one-liners back and forth, still the nearest and dearest in each other's hearts. If, god forbid, something happened to Linda, Susan, the devoted aunt, would raise her children. In return, she has promised to leave Linda the care of her cats. Susan imagines playing out her golden years as a racy old lady who embarrasses everyone at the dinner table; Linda expects to be the one cooking dinner.

If they are serious about anything, it's their relationship, which has not suffered even a minor dent from the three thousand miles between them. Although their lifestyles have nothing in common, they feel enriched by the disparity.

On rare occasions they'll have an intense blowup that leaves both of them almost physically ill, but the bad feelings never last more than twenty-four hours. "You cannot *not* be with your sister," Linda explains. "Walking away is not an option. With sisters there's no end to trying. We are together for life."

That means when things are good and also when they're bad. Like the time Susan moved to London and her romance with an Englishman imploded. "After we got engaged, he left me for his mother," she jokes now. But it wasn't funny then. "Susan was a wreck," Linda recalls. "As soon as I found out what was happening, I called her and said, 'Don't go back to L.A. yet. Come to me. I picked her up at the airport. We hugged. We cried. We talked for a week, and she got from the point of being in crisis to being able to move on."

"It was something I knew I'd get through," Susan says, dropping the humor, "and Linda was the best person to do it with. She was my oasis. I certainly could have gone back to a friend in L.A., but Linda has far more of a vested interest in me than any friend could ever have. We've set the bar so high, a friend couldn't come close."

"I think a girl without a sister might find a best friend as a substitute, but I can't imagine it would be as deep," Linda says. "You know how your sister thinks, how she reacts, what makes her mad, what makes her laugh. We remember the wallpaper in our house, how grandma behaved. We shared the same clothing. Our lives tumbled together."

"What I've realized as I've gotten older," Susan goes on, "is how precious Linda is to me. Friendships come and go, but Linda is the one constant in my life, this rock I can depend on. She's always going to be there, and we'll always work things out."

"I think we take each other less for granted today," Linda says. "We feel very fortunate. We're acutely conscious of how important our relationship is and how we have to work to keep it that way."

"Like talking about grout?" Susan kids her.

Linda grins. "Susan was complaining once that she tells me all about her life, which is pretty glamorous compared to mine, but I never tell her anything. Well, we were remodeling our bathroom so I wrote her a very long, explicit e-mail about grout and tiles, and how grout came in different colors and textures, and the problems of picking it out."

They poke each other and chuckle. "But what we learned," Linda continues, "is that you have to make sure you talk to each other, not just about big things but about the little events that don't seem significant. What goes on day-to-day really does matter. Relationships are in the details."

"Especially," Susan says with mock seriousness, "when it's about grout!" ■

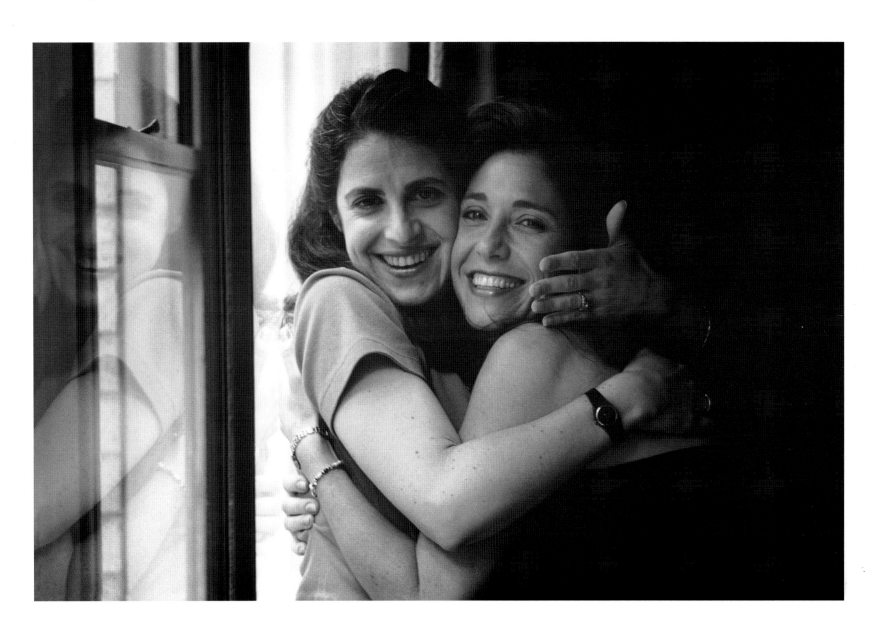

The Luong Sisters

Saan Luong had a dream. For 13 difficult years, this dream was her only relief from the harsh reality of her life. Then one day, her dream came true—and she discovered that what she'd been nurturing was more of a nightmare.

In 1979, Saan was a skinny 10-year-old living in Vietnam, the youngest in a desperately poor family of five older sisters and one brother. At that time, the Communist rulers decreed that upon reaching 15, a child could be taken away to work for the country. Some children were never seen by their families again. Saan's brother had already been arrested by the Communists for carrying forged papers, and had escaped to China. Saan's parents decided to try to save their littlest girl by pirating her out of Vietnam before the government came to look for her.

"My mother told me we were going to visit my grandmother in the country," Saan begins. "But the way we went was different, and she said we were going to stop at a another place first.

"Just before we leave, everybody is unusually nice to me. My sisters buy me things, get me clothes, and I'm thinking, 'wow, this is a big change.' Usually they're too busy to pay any attention to me. They even take me out to a restaurant, and we were so poor we could never afford to go out to eat. They know I'm going away. I don't.

"We got to this place and my mother left me with her friend and said she'd be back soon. But the boat had to take off before she came, or else the Communists would catch us. My uncle was supposed to be with me, but he got arrested. He yelled at me to run to the boat. I didn't know what was happening or where I was going. I just did what he told me. There were a hundred and fifty of us on a seventeen-foot boat. All I can see are strange people and I don't understand anything."

Four other boats, fleeing at the same time, capsized. Their survivors were loaded onto Saan's boat and the food supply thrown overboard to accommodate the added weight. "I am terrified," Saan remembers. "You can't move. You sit with your knees up to your chin. You go to the bathroom right there in your clothes because if you get up you lose your seat. I'm the only one that doesn't have my family, and I am thinking, I'm the youngest one, why me? Why not my sisters? They must not like me."

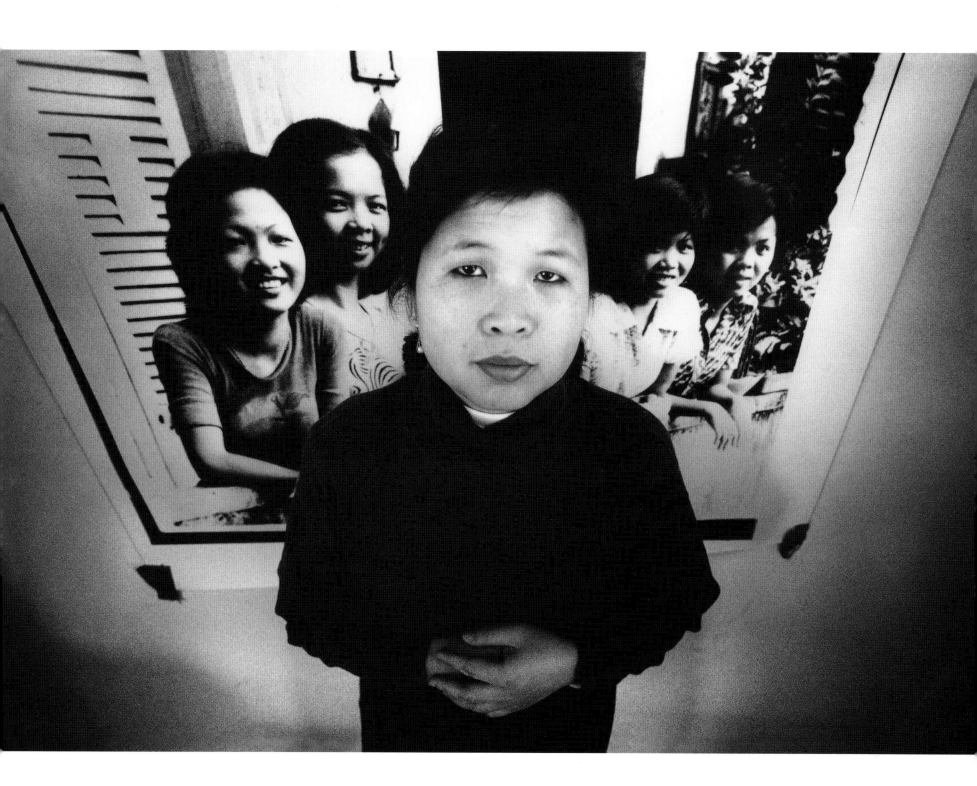

The refugee camp on the Malaysian border where Saan was eventually interred housed seven thousand people. She was squeezed into a tiny hut with 24 others—including her mother's friend, whom she finally found.

"There was stink and worms. But we were lucky; it was far from the smelly bathrooms. I cried a lot."

After several months she managed to get a letter to her parents, who thought she had drowned. In their reply, she learned why they'd sent her away and how they hoped she'd have a better life. Frightened and isolated in a crowded, filthy camp filled with strangers, their way of "saving" her seemed like a cruel joke.

After a year and a half in the refugee center, Saan was relocated to Hawaii, where the daughter of her mother's friend lived. It was there she discovered that her brother had made his way to Philadelphia.

"It was, oh my god, so great! I will see my brother. He can take care of me. All that stuff. But when I move in with him, it's not like that. He's about 20 years older than me. He gambles a lot and he doesn't care about me at all."

When she reached 14 and could lie about her age, she got a job in a Chinese restaurant and moved in with a friend.

"Every day I go to school until two and I go to work until nine PM. And I think how different my life would be if I had my sisters with me. I watch my friends with sisters close to them, and it breaks my heart. Always I think if my sisters were here it would change everything because sisters always know what we want.

"I pray for my sisters to come here so they could help me and do the things older sisters are supposed to do for younger ones. I write them how I wish they were here so we can do things together and talk like American sisters do. They write back and say the same. So all the years go by, and I have these hopes and dreams that one day they'll come and we'll be so happy."

It didn't seem like such an impossible dream. Her brother had applied for visas, but then had let the paperwork lapse.

"I found a teacher who would co-sign so we could get the family out fast, but my brother wouldn't give me the information I needed. 'What do you know? You're the youngest and I'm the oldest. I know everything.' One year passed. Another year. Another year. Finally I just start writing to everybody." Saan wrote to the embassy in Thailand, to her senator, to the U.S. State department, to one congressman after the other. Finally, in the fluorescent glare of an airport lounge, she was reunited with her parents and three of her five sisters—14 years after their separation. When she'd left them, she was a frail, sheltered Vietnamese

child. Now she was a 24-year-old American woman with a son and a daughter of her own.

"I was so happy and excited. I had my children draw the welcome signs in Chinese and Vietnamese. But once I see them in the airport, it's like they just see me yesterday. I cry, but there are no hugs or kisses. Not like a normal family. I think deep down inside they must be happy, too. But they don't show it. My dad and mom look glad to see me, but not my sisters. They don't seem to want to know anything about my life without them all these years.

"Then the next day, they tell me they want to go home. Later I learn they had been writing to my brother that they don't want to come, but they write me different letters because they don't want to get me upset. It costs five thousand dollars to bring them here. I don't have money to send them back.

"They're always complaining. In Vietnam, they were spoiled. They never work a day. My mother took care of them. Here they have to work in a sewing factory. They say it's tough and boring and cold. Oh my god, this is not what I expected! I think my sisters will listen to what I have to say. They'll help me take care of my children so I can go back and get my high school degree. But nobody even wants to stay with me. I understand my parents are old, and old people always want to stay with a son. My brother doesn't treat them nice, though. But why don't my sisters stay with me? My husband and I have a basement in our house that we fixed up so nice as a bedroom for them, but they won't come.

"Every time we see each other, we can laugh and talk, but once we go down to something personal or deep, the party's over. It's doesn't matter how much older they are— one is 35, one is 34, and one is 38—or how young I am. We're supposed to talk to each other and take care of each other. But my connection with them has a line. We go so far and that's it.

"Part of me is in pain; they don't know anything I'm feeling. It hurts to see the three of them very close and good friends. They know everything about what the other wants and likes, but they say I can never be a part of them because I'm too American.

"Maybe it would be better if they hadn't come at all, and I just had my dream of what it would be like if we are all here, sisters together. Inside of me I love them. I try to think they love me too, even though they'd don't act like they do. I have to accept that I can't change them. I can't force them to be what I want. I can't make them love me. That was just a dream." ■

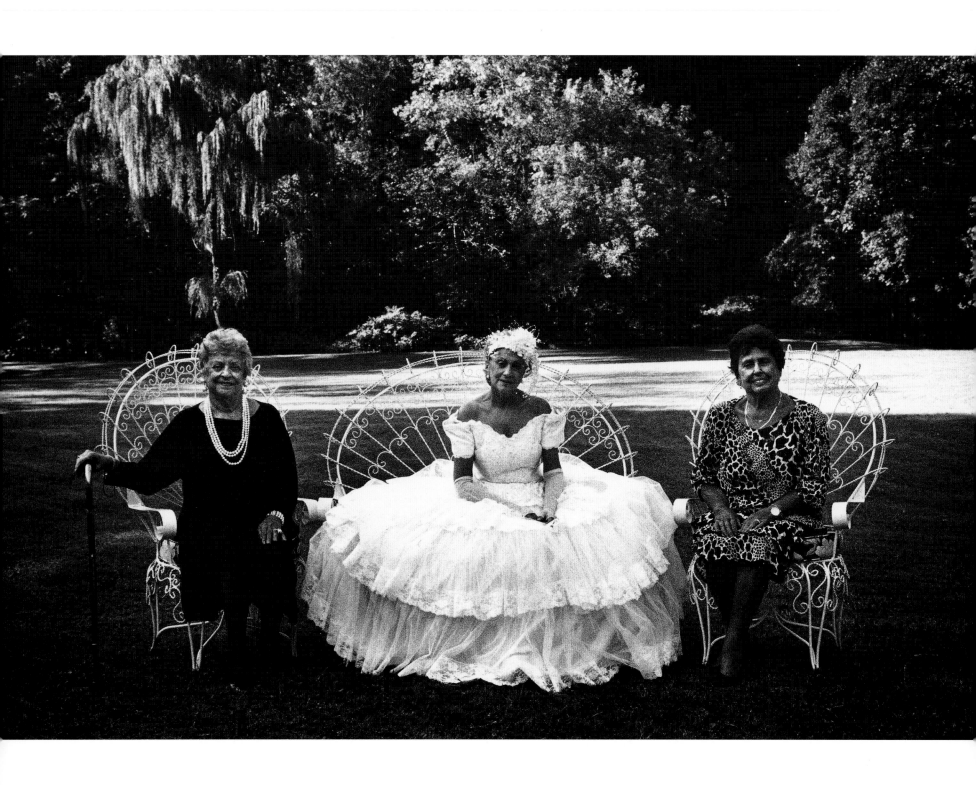

Millie, Gerry, and Anne:

The Adelman Sisters

Dearest Sisters,

So sorry I had to fib to you. I'll explain later. Harold and I were married this afternoon at 12:29 in the Jewish temple. The ceremony certainly was beautiful. I wore my blue pinafore dress, freshly laundered, of course. My bouquet—a beautiful white gardenia—was in my hair, and my ring is a gorgeous gold band from Kress: ten cents and a penny tax. You see, instead of getting any old thing, Harold and I decided to wait until we come home. Isn't Gerry Sills a darling name? Well, that's the last of the Adelmans. What a crew!

. . . Now for some important instructions. I have no clothes down here. Please send the following immediately (kinda ironic to be the owner of a lingerie shop and have no trousseau). I need: a. alligator bag. b. blouses—good condition ones only. c. grey flannel suit with bag to match. d. Chinese P.J.s and also my yellow midriff.

. . . Anne dear, you owe me three bucks. Well, kindly reimburse. . . .

Now Millie, dear, here's where you come in. I'm asking you to take over for me for about two weeks at the shop until Harold gets a furlough. Naturally the salary of twelve dollars per week is very little but perhaps I can arrange to send you about five more. . . .

So things are quite wonderful. . . .

Much love,
Sister

Fifty years after Gerry Adelman eloped with Harold Sills, she marked her golden anniversary by staging the wedding she'd never had. In an armory decorated with World War II memorabilia, she served an officer's mess that included mashed potatoes, succotash, and jello to two hundred guests instructed to come in clothes they would have worn circa 1942. As her own private joke, she dressed in a ruffly Southern confection that might have come straight from Scarlet O'Hara's closet—her teenage fantasy of how she had wanted to look as a bride.

Anne's reaction to Gerry's bash was, "That's my sister! She's nuts."

Millie, the emotional one of the trio, got weepy when she read the invitation. "I'm finally going to see her married. How lucky." So she packed her bags in California as Anne did in Florida, and they flew to Philadelphia for their sister's belated wedding. Before the ceremony, they sat down and reminisced. As often happens, their remembrances of things past didn't quite jibe.

Their mother died during kidney surgery when Millie was eight, Anne, six, and Gerry, just a year old. "We were staying with grandmother while mother was in the hospital," Millie recalls, "and we never left." Father was only an occasional presence. "When he was around," Millie says, "he was the best father he could be."

"That's interesting," says Anne. "He was the worst father I could imagine."

"He took us to dinner or the movies every Saturday night," Millie answers.

"That's not my recollection at all," Gerry says.

"You didn't go," Millie explains. "You were too young and Grandma wouldn't part with you. You were always greenish-looking and skinny, and she worried neighbors would think you weren't being taken care of."

"My memory," says Gerry, "is that Anne was the conservative of the family, Millie was the fast one, and I was just the baby."

"Millie wore too much lipstick and I didn't approve," Anne defends herself. "So I let her know."

"You still do," Millie says with a sly smile.

"I was more practical," Anne goes on, "and always the best-looking one."

"But I was the Miss America, the fancy one," Gerry interrupts. "Harold says they must have taken the wrong children from the hospital because we're all so different. Anne is into golf and bridge. I'm much more aggressive and worked in the fashion business all my life."

"We don't share common interests," Anne says. "Probably we wouldn't be friends if we weren't sisters. But I can't imagine going to anybody else when I'm in trouble."

"That's because it never mattered to us who had what," Millie says. "Whoever needed, got."

"It's still like that," Gerry says. "I remember when I was 15, Millie had an outfit she'd never worn. I can still picture it. And she let me wear it first. I never forgot that. Now we share problems. Though I've been married 50 years, I think my sisters know me as well as my husband, maybe even more, because they remember me as a child. It's a very close relationship."

"We're all totally devoted to each other," Millie pipes up.

So devoted that when their grandmother died, 17-year-old Millie, who was then making 20 dollars a week selling cosmetics, rented an apartment, moved her young sisters in with her, and assumed the role of caretaker. "Because I was the oldest, and my grandmother brought us up saying, 'One for all and all for one.' That's exactly it."

"I have no recollection of that," Gerry muses.

"You were seven years younger," Millie says. "I remember lots of things you don't. I bought a budget envelope, put five dollars away for rent every week. We got two cents spending money every night and a nickel for ice cream cones on weekends."

Gerry stops her. "That reminds me of a story that has always stayed with me because it foretold what we'd become. It was in the '30s. Times were very bad. I was 10 maybe?"

Millie cuts in. "You gonna tell about the green shoes?"

"No. No. What I recall is that Anne and I had a dime. I wanted to spend it and she wanted to save it. Doesn't that

describe our personalities? But the dime rolled into a grate and that ended the discussion. I think about that incident a great deal."

"Oh," says Millie. "I thought you were going to tell how you bought those green high heels for school."

"Gerry didn't buy those shoes for school," Anne corrects her. "She had a date and bought them to match an outfit she borrowed from me."

"Well, at least we've never had a fight so serious we stopped speaking," Gerry says.

"Never. Never. Never," comes from Millie. "But we don't disagree as sweetly as you make it seem."

"And now Millie has this new line," Anne complains. "She says, 'I'm 80 years old and no one can tell me what to do.'"

"She's been saying that since she was 60," Gerry teases. "The truth is we've never had any sibling rivalry between us since we each have something: Anne has all the money. I have all the glamour, and Millie has all our love."

"That makes me the richest," crows Millie. "I love my sisters far before anybody or anything. Always did. And even more so now." Then, still the emotional one, she pulls a tissue out of her pocket to wipe her teary eyes. ■

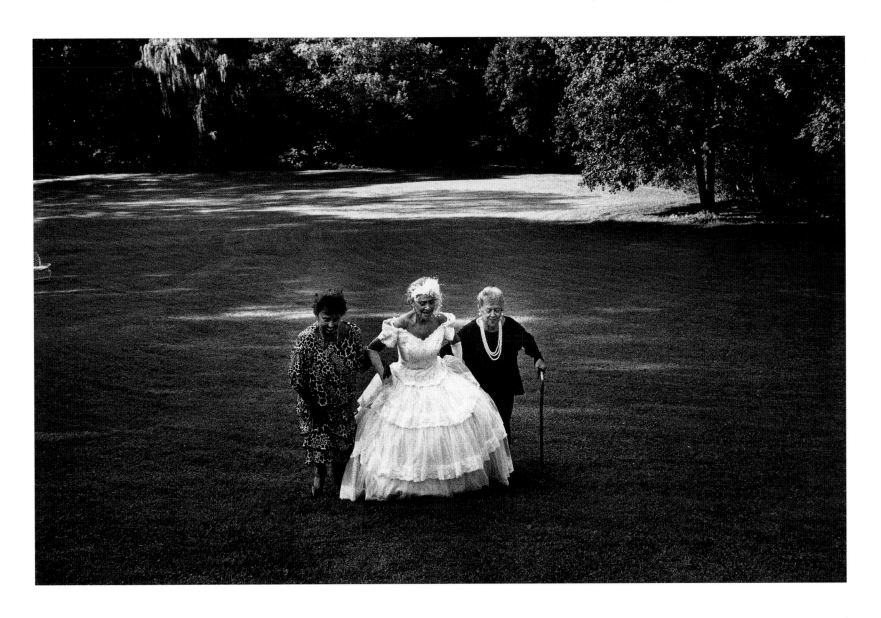

Nancy and Rhea:

The Lemmerman Sisters

"There was a polio epidemic—it was August, 1954, a year before the Salk vaccine came out—and the municipal hospital needed nurses," Rhea begins. "I'd just graduated from nursing school and agreed to work there for just six weeks until my position in a private hospital started. On September 21, six weeks to the day, I woke up feeling sick. The doctor said I had a deep-seated flu. My neck hurt. My thighs hurt. My back hurt. Everything hurt. I was quivering all over, but I had no fever, and I knew something wasn't right. You don't quiver with the flu. The following morning my fiancée came to see me, and I told him to let me brush my teeth and wash my face before he came up. I took about four steps and that was the end. I was totally, completely paralyzed. I couldn't close my eyes, couldn't breathe, couldn't unbend my arm."

By the time the polio ran its course, Rhea was left paralyzed from the waist down, unable to walk. The disease would reshape every aspect of her life. And in ways she could never have imagined, it would affect her relationship with her sister, Nancy.

Rhea's sister, younger by six years, remembers that initially, she felt inconvenienced by her sister's polio. "When you're 16," Nancy recalls, "you're so wrapped up in your own world. I knew Rhea was in a wheelchair and would never walk, but I had no idea what that implied for the rest of our lives." And because this wasn't a family that talked about feelings, neither of the sisters knew how to express their raging emotions. "There were so many undercurrents then," Nancy says, "and no way to vent them."

"I was bitter, miserable, frustrated, and angry," Rhea says. "I wanted to die, to kill, to maim."

"She'd never been easy," Nancy says. "Her place in the family had always been as the demanding one. Now she'd sit like a queen in this Barcalounger my parents bought her, expecting people to come to visit and choosing to see this one, but not that one. She wasn't the benevolent person she is today. Everybody kind of tiptoed around her because she was rotten. And understandably so. I remember in high school I'd be washing the dinner dishes and thinking, 'Goddammit, why can't she do this, just because she's in a wheelchair?'"

"I took advantage of my condition," Rhea acknowledges.

"And I'm sure I resented you," Nancy admits. "Remember when I had to go to a fancy birthday party and I didn't have a formal dress? Mom was never terrific on getting us clothes, and she said I could borrow that strapless blue gown you'd worn someplace when you were engaged. You got so furious when I put it on. I can hear you screaming in your chair, 'I don't want to see you in that dress.' But I wore it anyway because I had to."

"I was so jealous of you. And so depressed. I wanted to be married and have an apartment and go shopping at the A&P and push a baby carriage like all the girls in my crowd were doing. But my engagement had been broken off and because everyone I knew was where I wanted to be, I couldn't tolerate seeing anyone."

By that time Nancy had gone away to college. "Mother would call and say, 'Nancy, Rhea won't see a soul. She won't go out. You're her only friend. You're the only one she wants to be with, so you have to spend time with her.'"

"That's when my sister became my lifesaver," Rhea says, squeezing Nancy's hand. "All during college, she gave me one weekend a month. I'd learned to drive a specially-equipped car and I'd go to Douglas [then the women's college of Rutgers University in North Jersey], pick her up, and we'd be off to New York for the weekend. We saw every show, went every place for dinner, rolled and strolled

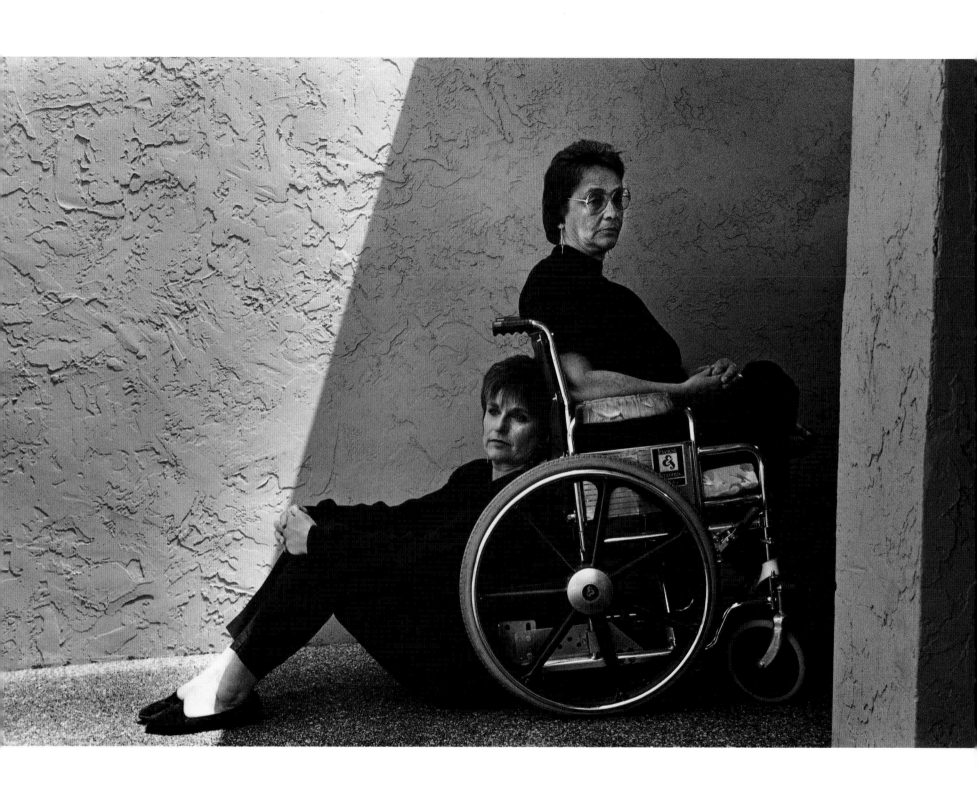

up and down Broadway and the Village. And once a year we'd take a major trip. We drove to Florida twice and one time flew to California."

"That last summer we went away I was starting to be serious with my boyfriend and was very reluctant to go," Nancy admits. "But Mom said I had to, so I did."

"That tells you about the character of my sister," Rhea points out. "I never knew that hesitation or felt it, and believe me, in my situation your antennae are out all the time. One of the reasons I love being with Nancy so much—and that goes for now as well as thirty years ago—is that she's totally non-judgmental. She just accepted me. Nothing was ever a big deal. Like a few years ago when I wanted to go to Europe. I knew it would be difficult, and someone in my physical situation can't put that on a friend. So I asked my sister."

"Of course I said yes. You paid for it!" Nancy quips.

"But that's not even the issue. I couldn't have gone if you didn't go. There were plenty of physical obstacles on that trip, but you made everything easy."

Rhea made it easier for Nancy, too, by evolving into a strong, financially independent woman. "It finally got to the point where I couldn't stand it at home anymore," she says. "I was dying. I had to get out. I took 500 dollars, my car, and two pieces of clothing and moved to Florida to get my college degree. I even stole Nancy's bathing suit top because I didn't own a strapless bra. It didn't bother me, then, that I stole it. I just figured I needed it. But when I think about that now, I could vomit. To steal from her when I loved her so much. I've lived with that for years."

"The fact that it still bothers her tells you about the character of my sister," says Nancy.

Rhea remained in Florida and created a productive life for herself. Today she heads a prestigious program at a rehabilitation hospital. Nancy is married, has three children, and lives in New Jersey. Both sisters have master's degrees in educational counseling.

The key to their successful adult relationship is balance. Nancy has never felt she gives more to Rhea than she gets in return.

"Growing up, I was always treated very much like the baby in the family," she says. "On some level, I still am. And I kind of like that role. Rhea was and always will be my older sister. Despite what happened, our roles were never reversed. She takes complete responsibility for herself, and I feel like she also looks out for me. I'm very well taken care of."

Rhea begins to weep softly. "Nancy knows how much I adore and respect her. I worry about her. She had a mastectomy and, and. . . ." She is unable to complete her sentence.

Nancy picks up the thread of Rhea's thought. "Rhea knows I feel exactly the same way about her. It really alters the relationship when one of the siblings no longer mirrors your life. I doubt we'd have had this intensity if Rhea didn't have polio. It also helps that we have the same attitudes."

"After what we've lived through, her cancer, my polio, we just don't take everything so damn seriously," Rhea says. "I think we're able to cope with what's happened to both of us because we don't sit around and kvetch."

"Even though we find most things really funny, we're very realistic," Nancy says. "We just know what we have to do, and we do it." . . .

In the year after Rhea retired from nursing, she began to suffer post-polio syndrome, which led to a gradual loss of strength in the working muscles she'd used to compensate for her paralysis. As the weakness increased, complicated by severe emphysema brought about by a life-time of smoking, she was robbed of her precious independence and needed a full-time companion. On a February morning in 2002, Nancy was awakened at five am by a call from that caretaker. Rhea had been rushed to the hospital. By the time Nancy flew to Florida, Rhea was under an

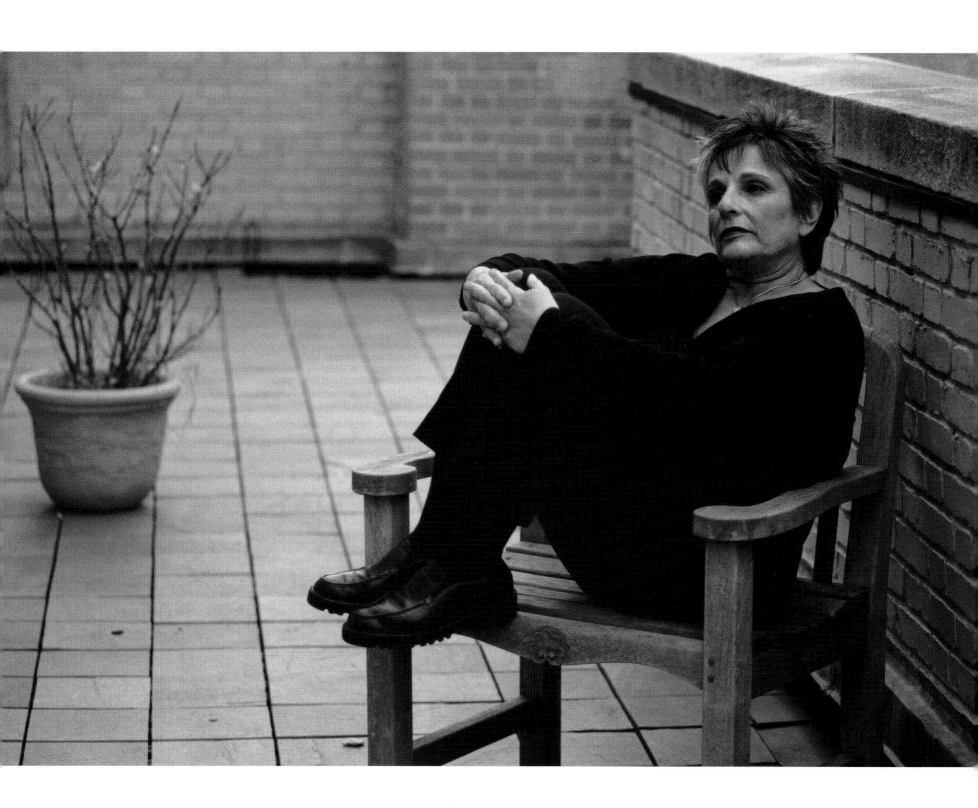

oxygen tent in the intensive care unit with a breathing tube in her windpipe, unable to speak.

"Over the next few weeks, she just went from bad to worse," Nancy relates. "They kept doping her up with drugs, because she was so restless and couldn't breathe. Finally, the hospital couldn't keep her any longer and insisted she be moved to a nursing home. Rhea knew exactly what was going on and would never have survived in one of those places. She looked at the oxygen tank and gestured to me with her hand to pull the plug. 'Are you serious?' I asked her. She nodded. I called the doctor and he repeated the question: 'You realize what's going to happen don't you?' She nodded again. If she hadn't asked to end her life, I think I would have told the doctor to let her go. I felt she gave me a present by my not having to make that decision."

Nancy could never have predicted her reaction to Rhea's death. Concurrent with her expected sense of loss, she experienced a strange sense of buoyancy, as if a great weight that she'd borne for so many years had suddenly been lifted. "Ever since my sister got sick," she explains, "every decision I made had been informed by her handicap. A huge amount of my life from 16 to 63 was devoted to her feelings and her reactions to whatever I was doing. My role was always to be upbeat for her— and I hated it. The physical responsibility was fine. I never minded *that*. It was the emotional responsibility that impinged on my private life. Because she lived so much through me, I could never be too happy or too sad. When your sibling has nothing and you have a wonderful family life with a husband and children and grandchildren, there's no balance. Whatever I

did, I always worried—how will this affect Rhea? Now that she's gone, I can devote my time one hundred percent to my family and do whatever I want. I don't have to think of my life in terms of my sister—and that is very liberating."

At the same time, Rhea's death left Nancy with an unspeakable emptiness. "I think of her every day," she says, "I think about her crappy, disappointing life. I think of how she made me laugh, of how she was my history, of how she made me strong by her example because she never once asked, 'Why me?' If I have a pain on a bad day, how could I complain when Rhea never did? Her activity kept me from being a lazy slug.

"Every so often I hear myself say something, or I look at my hands and I think of my sister. It isn't so much conscious, more like I just feel her. I want to call to tell her my daughter is living with a guy in New York—a Jewish guy yet! Most of all I miss that unconditional love she gave me—even though it was sometimes a burden, because she didn't think I could do anything wrong. And I wish I could have told her more often that I loved her."

Rhea left instructions to be cremated and asked Nancy to scatter her ashes at the camp in the Pocono Mountains where they'd shared such joyous times as kids. Though it's been more than a year since she died, Nancy still hasn't fulfilled the request because that would mean accepting the finality of Rhea's passing. "I just can't get rid of the ashes. They're in a canister in my bedroom," she says tearfully. "I still haven't written any thank-you notes to people either. It's too much of a closure for me, and I'm not ready to let her go. I still want her with me. Sooner or later I'll go to camp and do it. But I'll keep some of the ashes. I know my daughter will want her Aunt Rhea at her wedding." ■

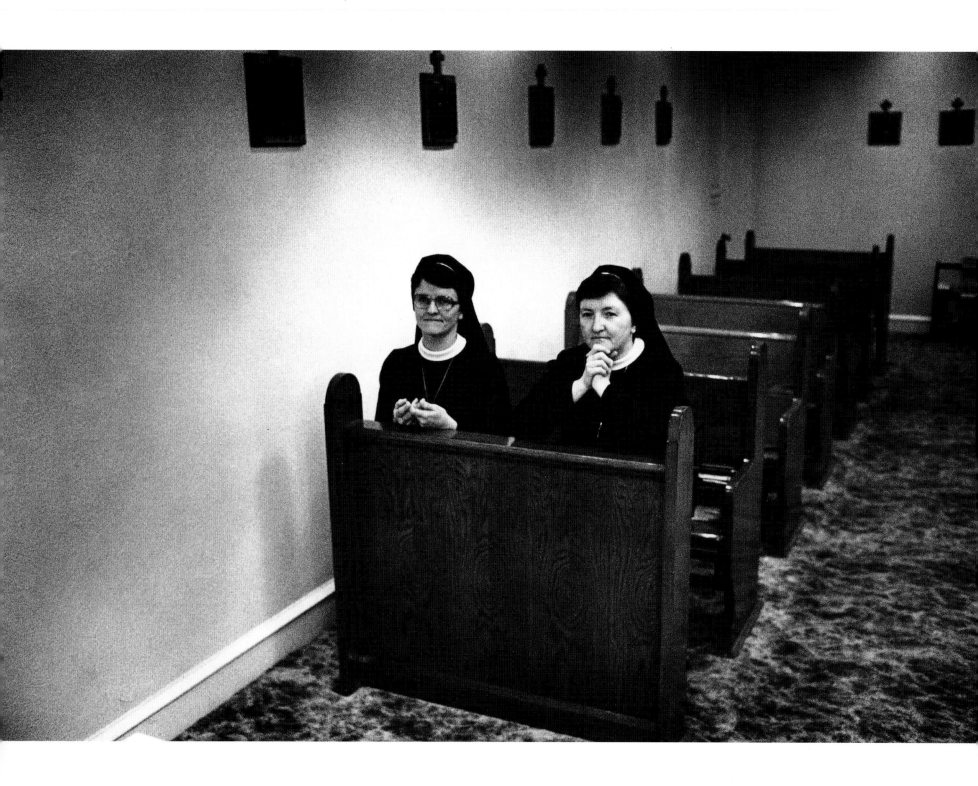

Sister Catherine and Sister Mary:

The Glackin Sisters

"I was a few months from taking my vows when Mary knocked me off my feet and said she was joining the order, too. Of course I was so happy, but I can't say I thought much about what it would mean to our relationship as sisters." For Catherine and Mary, both Sister Servants of the Immaculate Heart of Mary, becoming Sisters did not create the sisterly love they have for each other. That existed long before they went into the convent.

"In certain ways, this has brought us closer together," Mary says. "We're both teachers, so we have that common interest, too. Because we live the same lifestyle, Catherine is more understanding of some conflicts I may have. And there are secrets, especially of the community, that you can tell your sister because she's a Sister and she's *your* sister."

"Mary doesn't hesitate to do something I'd only think about," Catherine adds. "She acts on my thoughts. Like when Mom was so sick, I was thinking it would be nice to pray aloud with her—and Mary just started doing it. Prayer is a very spiritual thing and because we share a bond that might be a little deeper than you'd have with anyone else, our prayers can be deeper, too."

Their spiritual connection remains secondary to their family connection. While they have lived for more than 20 years in a community of devoted women, it's to each other they turn first when they need support.

"More important than anything is having your sister with you when there is family suffering," Catherine says. "It divides the pain and trouble in half when you carry the burden together. We don't live in the same convent and sometimes we wouldn't see each other, except when we were at home taking care of our parents. There was never any question but we'd both show up in a crisis and that made things much easier. That's where our closeness comes from."

Mary agrees. "You ask me if I feel lucky that my sister is also a nun? No, I feel lucky my sister is my sister. That is what matters to me. That we both are nuns is only an added blessing." ■

Donna, Debbie, and Shirley:

The Masiejczyk Sisters

When Shirley looks at her sisters, she sees reflections of herself. It's not just that they all have fair skin, blonde hair, and the same green eyes rimmed in blue. Or that they pierced each others' ears in elementary school. Or that when they shop separately for birthday cards, they often buy the same ones. And it's not even that the three of them wear the uniform of police officers. It's something much deeper.

"You know those television commercials where somebody stands in front of the mirror and the mirror talks back? That's what a sister is," Shirley says. "A part of yourself that responds to you. You can see it and feel it. This person you grew up with and shared everything with, who has your genes and your blood and is so much like you, yet also different. I draw great strength from that. You can't get the same thing from friends."

"Friends are friends, but there's always a line you don't cross," Donna explains. "With us there's never any line. We did plenty of fighting growing up, and we probably tell each other off every day. We're very critical, but it doesn't mean anything. Being sisters gives us lots of freedom to air our opinions, but there's an understood obligation to be careful not to hurt."

Debbie adds, "Friends support you in a different way. When I was going through my divorce, my friends felt sorry for me and wanted to take me out drinking and stuff, but my sisters were there for me night and day. Whatever happened to my marriage, I knew my sisters would always be my sisters. They weren't going anywhere."

"I tried to get my husband to understand that when we were picking godparents for our daughter," Shirley says. "I wanted to choose Donna, who was single at the time. My husband got this idea that godparents should be married. We went back and forth and finally he picked his sister and her husband. A few years later they were divorced. I never let him live that down. He should have let me pick Debbie because she'll be around forever. You can depend on that."

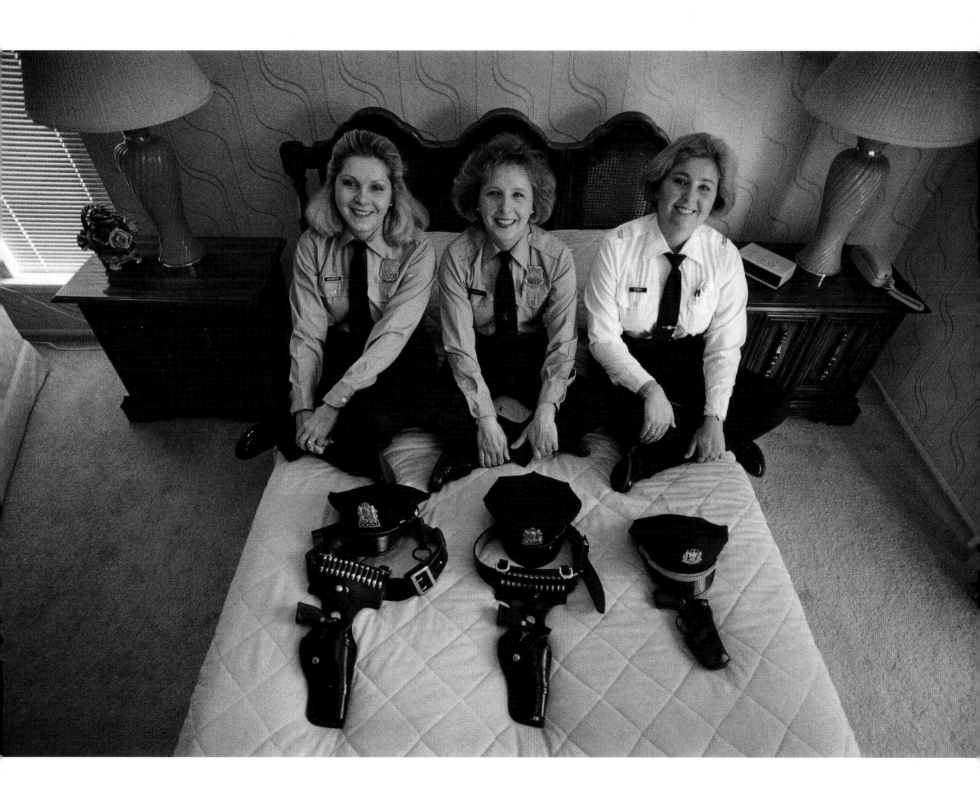

Joining the police force was Shirley's idea, which isn't all that surprising considering she's the eldest and the one who's always told the younger sisters what to do and how best to do it. "You know how it is with the big sister," she says. "You're like the mother and you can't help doing a lot of what they'd call meddling."

Debbie was still a senior in high school when Shirley, who'd already been out in the work world for six years, dragged her along to take the entrance exam for the police academy.

"I didn't want my sister to make the same mistakes I did, like not going to college or getting stuck is some dull,

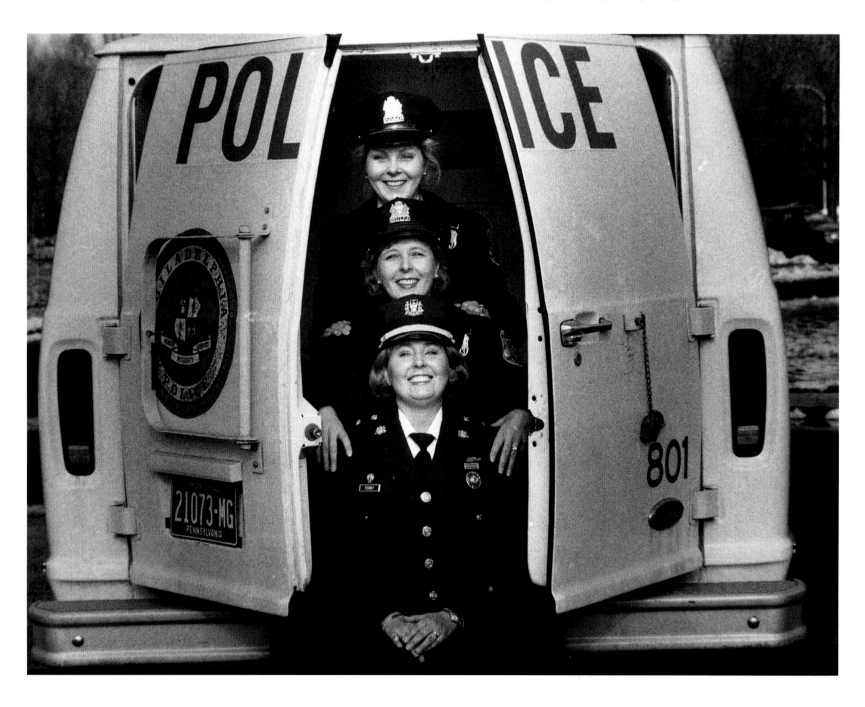

dead-end secretarial position," Shirley remembers. Debbie agreed to go along, "just to keep Shirley quiet." Four years later, Donna left her clerical job and joined them. "I didn't like feeling left out."

Sharing the same career gives these sisters more to talk about—"We always seem to end up discussing work," Shirley says—and more to fight about. Shirley is a supervisor, which tends to slant her perspective. "Our differences on the job can cause friction away from work," Debbie says. "We're always telling Shirley at home, 'Remember, you don't have your lieutenant bars on here.'"

Being policewomen definitely gives them more to worry about. "I remember, I'd been on the force about four years when Donna came into the department," says Debbie. "I knew there was danger out there, and she could get hurt. I'd had my face slashed by a hostile mental patient, and I'd had to shoot an angry husband who attacked me on a domestic violence call. When Debbie got assigned to a busy district without many officers, I found myself monitoring her all the time on the police radio. Once, she called for help, and my partner and I raced there from our district. A cop who arrived right after us said he had never seen anybody take six or seven stairs at a time like me—that's how fast I went up the steps. When it's your sister at risk, you worry. You really worry." Since then, they've made it a point to specialize in different areas.

If, on the one hand, these sisters are a source of concern to one another, they also provide a unique emotional safety net.

"I can't imagine what it would be like not to have a sister to support me, to tell me the truth, to be there for me whatever it was I needed," Donna says. "When we were kids, we took it for granted that there was always a sister on the other end of the teeter-totter. Now I realize what that really means. How do people get through life if they have to go to a playground by themselves?" ■

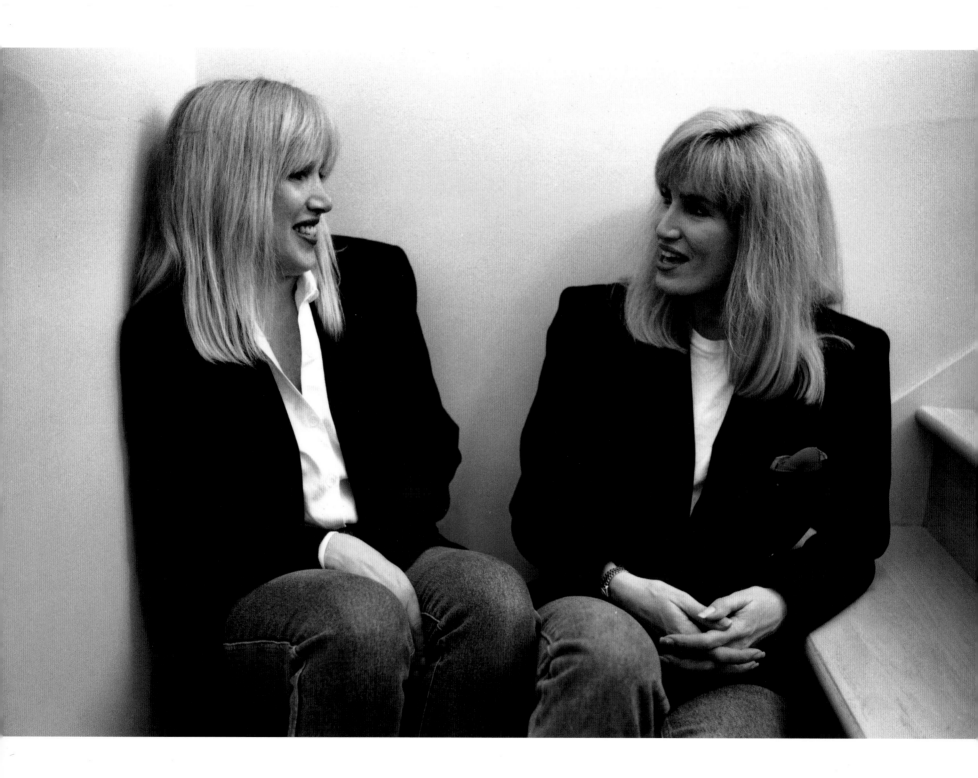

Sheryl and Nancy:

The Glass Sisters

So tell us true, Sheryl. Aren't you just a teensy, weensy bit jealous that your sister Nancy Glass hosts a nationally syndicated television show and gets all the attention?

"Absolutely not," Sheryl insists. "Being on the stage and doing plays was always what Nancy liked. I never had that desire. She's happy doing her thing, but I have *my* thing and where I live in Boston, I'm known for being me. I remember when Nancy started in television, I was working in the management program at Ann Taylor. This woman walked into the store and insisted she'd seen me on TV, on *Evening Magazine*. 'Listen,' I kept telling her, 'if I were on *Evening Magazine*, would I be here waiting on you?'"

"My parents never made a big deal out of what I do for a living," Nancy dives in. "They care more about what kind of wife and mother I am—and if I keep a nice house. They're very hard to impress. A few years ago I hosted a show that aired in some markets at midnight. My father asked me, 'Why are you on at midnight?' I told him, 'Dad, we're number one in the market.' He gives me this deadpan look. 'Honey, they're using you for a night light.'"

Nancy and Sheryl may live very different lives, but they look alike, sound alike, and even dress alike without planning. "Our tastes are so similar," says Nancy, "that if I like a movie or book and she doesn't, I think, 'Now wait a minute. Did I *really* like this?' I'm a very strong person and make important decisions every day, but if my older sister doubts a decision of mine, then I tend to doubt it, too. She's my barometer."

Sheryl screws up her face in one of those you've-got-to-be-kidding looks. "Puh*leeze*."

"Well, it's true. You were the star in the family, Sheryl. There are hundreds of pictures of you in the family album and only one of me."

"Right, Nancy, and you've been making up for it ever since."

They play off one another like a comedy team, giggling at inside material. There is no space in this relationship for anything as petty as envy.

"You have to understand that Sheryl's the big sister and I always looked up to her," says Nancy. "As kids we did everything together—only she did it better. I always thought she was prettier. More stylish. More graceful. She was this petite and perfect person when I was a 12-year-old with size nine shoes. So she got to wear Weejuns and my mother made me wear white bucks."

"That's why I didn't want to share your clothes."

"You didn't like to share anything. Remember when we had those dogs and Mom said, 'Sheryl, you must *share* the dogs with Nancy.' So you said, 'All right. She can have the back halves.'" They fall apart laughing.

"Nancy was such a tomboy, a real magnet for trouble. Always getting hurt. When she was four she already knew the way to the doctor's office. Our father used to call her Captain Klutz."

"Because I could fall off a carpet."

One memory triggers another and suddenly Nancy says, "This is exactly what sisters are about. We've shared our lives for over thirty years. That is *something*. You can tell your sister things you can't say to anybody else. I can say the dumbest thing to Sheryl or ask her which fork to use without embarrassing myself. When my husband has been with me as long as my sister, maybe then I'll tell him some of the things I tell her."

"With a sister you never have to censor your words," Sheryl says. "We talk about everything and nothing, from lipstick colors to serious things like politics and war."

"We're on the same wavelength," Nancy says. "I could shop for her, and she buys me the best presents. We even

have this nutty thing about food. In our family we always eat before we go to a party or restaurant, just in case we don't like the food when we get there. I mean, who wants to end up eating the bread? My husband cannot understand why I do this, but Sheryl thinks it's perfectly natural because she does the same thing."

"If I stop to wonder why we're so close," Sheryl says, "I think it's because of our parents' expectations."

"My mother was an only child," Nancy continues, "and she'd go on and on, all the time, about how 'Someday I won't be here; you'll only have your sister. So you have to be friends and love each other.'"

"Yeah," Sheryl says, "and remember how we'd roll our eyes and scream, 'Get her away from me!'"

But if you hear the same message long enough, eventually it sticks. "By college we started to understand," Nancy continues.

"Once we were no longer living on top of each other and had established our own identities, Mom's words took on another meaning, and we realized exactly what she meant. So I figure we'll end up in the nursing home together. Sheryl will still be telling the story of when I was 13, and the counselors at summer camp thought I was smoking cigarettes, which was forbidden, and they sent me home. After that, wherever we went, Sheryl would say, 'This is my sister, Nancy; she got kicked out of camp,' and I'd burst into tears. I was so humiliated."

"Oh Nancy, I can't believe that still bothers you."

And they dissolve into a fit of laughter at another family memory that only the two of them understand. . . .

They were the golden girls. They had it all, those Glass sisters. Then, *wham!* Breast cancer. Ovarian cancer. Divorce. Ordeals that can break the strongest of women. Yet Nancy and Sheryl describe themselves today as lucky. Lucky, because as sisters cling to each other through their blackest times, they find comforts and delights in

their relationship that might never have surfaced had they not been tested.

"I'm especially lucky that I discovered my cancers very early," Sheryl says smiling. "When you have cancer and you don't find it early like I did, you're dead."

Nancy, who recently shed her husband but didn't lose

her sister, glows with her good fortune. "What makes my life so wonderful now is that Sheryl is much more a part of it. And more of her means better. I can't wait to see her. I don't want to spend another holiday without her. Our relationship is more fantastic than ever."

Sheryl found the lump in her breast when the tumor was quite small. Nevertheless, after its removal, she needed both chemotherapy and radiation. "My god, you hear the word chemo and you think it's good-bye," she says, "that it's all over. Then comes the hair loss, adding insult to injury. I wore a wig and people would say, 'Oh, I love your hair color.' I'd grab my wig and tell them, 'Here, do you want it?'"

"She was so unbelievable," Nancy marvels. "She'd go for radiation and in the waiting room all these women would be complaining. All they wanted to talk about was their cancer. And Sheryl would say to them, 'I am not my disease.'"

Because there was a family history of cancer, the sisters decided to be tested for the BRACA gene, a marker for inherited breast cancer. Not surprisingly, Sheryl came up positive; Nancy was negative. She should have been elated; instead, she was distraught. "I wished it had been me who had it," Nancy explains. "Why should Sheryl have to deal with this? It wasn't fair. I felt I could handle anything. But she proved stronger than I ever could have been."

Based on the genetic test, and knowing that breast cancer can often metastasize to the ovaries, Sheryl courageously chose to have a prophylactic hysterectomy. The routine biopsy after her surgery showed yet another cancer. "You want to know how brave my sister is," Nancy raves. "She wakes up from the operation, hears this awful news that she has ovarian cancer and will need another round of chemotherapy and she says, 'Look how lucky I am. I saved my life by deciding to remove my ovaries.' No feeling sorry for herself. No woe is me. All she could think of was how she did the right thing. She is amazing."

But that wasn't the end of it. The surgery caused a blood clot in Sheryl's lung. She developed an allergy to the oral blood thinner required to treat it and had to inject herself

twice daily with a substitute drug. "I was at my lowest," she admits. "I told the doctor, 'I can't do this. I can't.' He said, 'You can and you will.' And I did." When she dropped to 90 pounds and was in no mood to celebrate anything, let alone her 45th birthday, Nancy flew to Boston and dragged her to the Four Seasons for dinner. They giggled and gossiped and had a great time. "We love to laugh. Finding humor is something we've always had in common," Nancy says. "When we're together, we usually go to a funny movie. Neither one of us thinks about the negative."

Throughout the three years of Sheryl's treatment, Nancy, who lives three hundred miles away, worried that even with all her cards, little gifts, calls, and visits, she wasn't helpful enough. Sheryl pooh-poohs that. "She was my biggest support. Always there. Leaving her business whenever I needed her." Then the tables turned, and the lifeline began to tug from the opposite direction. Nancy's marriage came to a bitter end, and now she needed to lean on Sheryl.

"The divorce was extremely difficult and unpleasant, and I was determined to get through it with as little drama as possible," Nancy says. "Sheryl was the only one who knew what was going on. I needed somebody to talk to, and she was it. She'd been there through the whole 20 years. She understood everything."

That intrinsic, irreplaceable, total knowledge of past and present is the fiber that attaches sisters. "Sheryl is my whole history. My life. No one else shares what we share," Nancy declares. "Before all this happened, our sister dynamic had a bit of a wisecracking quality where we could get snappish over silly things. That's gone. I don't even care that she won't let me eat or put on makeup in her car."

"As you grow older and mature, you value your sister more," Sheryl says, growing serious. "You realize in so many ways that you only have each other. Stuff comes out of the blue, and she is your support. Be grateful for her. Your sister is the only person who knows what you know, who's been through what you've been through, who is most capable of loving and understanding you. Take advantage of that. It will make you a richer person." ■

Janice and Elizabeth:
The Coffey Sisters

For the first 11 years of her life, Janice Coffey's sole siblings were all brothers—a fraternal twin and three older boys. She was especially close to the brother who was 15 years her senior—the one who bought her the most wonderful little outfits, read her stories, and played dolls with her. Then, when she was four years old, he suddenly vanished, like a drawing on her Magic Slate. For the next seven years, their only contact was a monthly telephone call.

"My mother used to make me go through this ritual," Janice remembers. "She'd say, 'Your brother's on the phone and you can speak to him if you promise not to cry.' I cried a lot because I missed him. Nobody would say where he'd gone. There was this cloud of shame, like he had cancer or a terminal disease that nobody dared talk about."

One day, without warning, her mother revealed the family secret. "We were in the kitchen," Janice recalls. "My father left the room, and, as tactfully as she could, Mother told us that our brother was no longer our brother; he was now our sister, Elizabeth. Mom tried to explain the sex-change process and how she'd supported Elizabeth through it. Dad hadn't wanted us to be with her—maybe he was afraid it would rub off or something.

"My immediate reaction was a little resentful—*that's* the dumb reason you've been keeping us apart all these years! All of us kids pressed for getting together right away. I was especially excited, because I'd never had a sister."

The reunion was scheduled for a big party that Elizabeth was giving to celebrate her 26th birthday. Except for the new bumps on her chest, Janice didn't think that Elizabeth looked all that different.

"We rebonded instantly," Janice says. "To me the whole thing, honestly, was no more than a name change. I was so happy to have this person back in my life, it never really fazed me. Gender wasn't the issue; the person was the issue."

"Who I was—and my relationship with Janice—held far more importance than what I was called," Elizabeth says. "Though I was born genetically male, I've always been who I am now, which is female. When little boys reach their teen years they're supposed to go through some sort of physical metamorphosis that turns them into little men. Well, it didn't work out that way for me. By the time I was 19, the only way I could relate to myself in a sensible manner was to have all the pieces fit. So I became, for lack of a better term, one of the original Johns Hopkins kids."

Twentysome years later, whatever angst Elizabeth suffered at the time of her sex-change surgery has faded. She married, and even her father has come to accept her as fully as her siblings have. But clearly, the easiest part involved changing from Janice's brother to Janice's sister.

"Quite frankly," Elizabeth says, "I think we always related as sisters. I came back into Janice's life at a time when I was able to enrich her and myself through our relationship. If Janice were not my sister, she'd be my friend. We have so much in common. Both of us care

about music, painting, reading. And then there were all the sister things we shared."

"You bought me my first junior prom dress," Janice reminds her, "and taught me how to wear make-up. We did all those arts and crafts things—ceramics, jewelry-making, needlepoint. Everything you were interested in, I had to know about. I don't think I'd be as politically or socially astute if it wasn't for your liberal, feminist views. It helped immensely to make me a more well-rounded person."

Couldn't Elizabeth have brought most of those qualities to Janice if she'd remained her brother?

"I don't think so," Janice says. "I have a wonderful friendship with my brothers, especially my twin, but it's not the closeness that sisters share. No one knows me like Elizabeth does. You can just totally open up to a sister. When I was little, I had great fun playing football and stuff with my brothers. I even joined the Boy Scouts. But when my big sister came back in my life, I finally had someone to talk to about girl things. I couldn't tell my brothers, 'I think this guy is cute' or ask, 'Does this dress look okay?' or, 'What color stockings should I wear with this outfit?' Elizabeth was what I needed."

Elizabeth also feels "enormously close" to her brothers.

"Quantitatively, we probably share as much with the boys as we do with each other," she says, "but what we share is different. I feel safe with Janice. When she says, 'How are you?' I know that I don't have to say, 'I'm fine.' Our conversations are emotionally-based rather than fact-based. We can be more intimate."

"She's constantly in the back of my mind," Janice says. "I'll see something, and if it's got Elizabeth written all over it, I have to get it for her."

"That reminds me of the bracelet story," Elizabeth says. "You must have been 12 when I came home one weekend from New York and pulled out of my suitcase a diamond and jade Victorian bracelet that had been given to me by a guy I was dating. 'Oooh, are they diamonds?' you gasped. I put the bracelet on you and it hung way down on your little wrist. You were fascinated by it, and, without hesitating, I gave it to you and told you to put it away because someday you'd grow into it.

"It's so obvious to me that when your sister loves something, you give it to her because she's your sister. I know that explanation sounds trite and sappy. But for me, that's just the only reason I ever need." ■

Bloomie, Dotty, and Minnie:
The Green Sisters

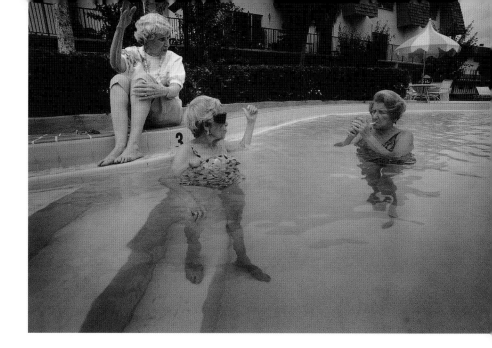

"The greatest tribute I can pay my mother and her two sisters is that from witnessing what they have, I feel a keen sense of loss that I never had a sister of my own. If I'd been that lucky, I'd have known exactly how to do it, because Minnie, Dotty, and my mother, Bloomie, were the best pattern-makers in the world. Too bad I never got to make the dress!"

Those eloquent words from Bloomie's daughter, Linda, describe three women who formed an exclusive mini-unit within a family of seven sisters. They've never dwelled more than ten minutes apart, and in 1970, when Dotty's husband wanted to retire to Florida, she refused to move until her sisters promised to follow her. Ironically, these three intensely devoted sisters had only one child each, but that meant, according to Linda, "All of us had three mothers." That vantage point gave Linda a unique opportunity to observe this remarkable four-score-and-still-flourishing relationship.

"Not until I became a young mother and a lonely adult living in a city away from home," Linda begins, "could I understand this wonderful connective tissue among them. How totally they share their lives. They told all, heard all. Enjoyed each other immensely. Had an incredible amount of companionability and a no-holds-barred commitment to intimacy. Never go to bed angry. Never bear a grudge. God forbid an unspoken anger or an unexpressed resentment should grow like a fungi into some poisonous plant. When they did argue they were outspoken about their disagreement, but it was carefully controlled. Nobody ever hung up a telephone. The most threatening thing in the world to them would be the loss of each other.

"What probably served as an escape valve was gossip. If one of them had a tremendous problem with the other, the way to deal with it and get rid of the pressure was to tell the third who went back and told the first. By the time the whole process went around, the tension was defused. The message got through and any ugliness was blurred.

"They came from a rollicking, bursting-at-the seams household full of women. There were two pianos, laundresses, boiling pots of starch, ruffles, curling irons, you name it. Apparently my grandmother managed to make each one of these kids feel like an individual. They never fell into a collective soup. They all felt special. Each has whispered to me at different times, 'I was grandpa's favorite,' or 'I was grandma's favorite.' That, I think, is what has enabled them to remain so totally accessible to each other. These sisters are like an immutable law of the universe that nothing could destroy. Nothing. Frankly, I think their marriages helped too. If they had married men who were emotionally demanding, I don't know if they'd have had as much energy left for each other. Sisterhood was much more rewarding, intimate, and sensual than marriage.

"Behaviorally they were quite different. My mother, Bloomie, was always like Rosalind Russell in *The Front Page*: Snappy patter, fast-moving, fast-thinking, enormously productive. A hard-boiled, hard-bitten dame. A terrific broad.

"Dotty, the clubwoman, had some kind of mythic vision of herself as a Southern belle.

"Minnie was a live wire, very bright, very compassionate. Soft where my mother was hard. Creative where my mother was linear.

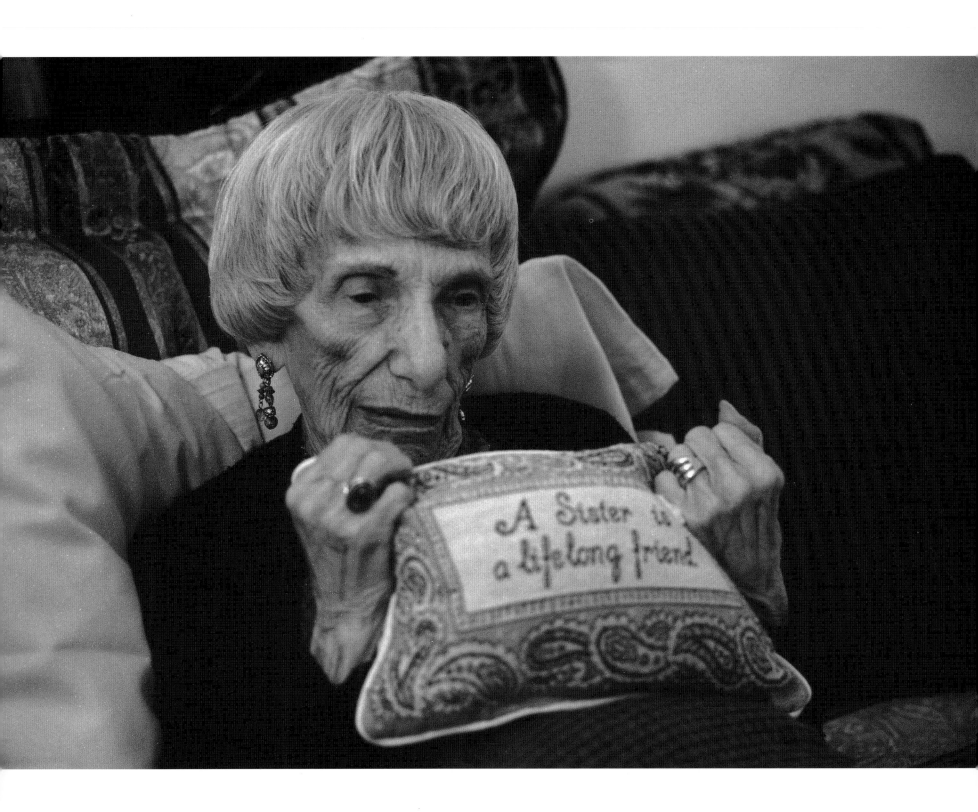

"Certainly there have always been things about one another that have driven them crazy. To this day Minnie and my mother still complain about how long Dotty takes to make a decision, how unbearable it is to shop with her, because she's so fussy. Then my mother and Dotty complain how Minnie can be so obstreperous. And Minnie and Dotty complain about my mother's tongue when what they want to say is that she is a mean S.O.B. Then they feel guilty, so they'll say she has a heart of gold—it's not *what* she says but how she says it. You see, loyalty is the leitmotif of their lives.

"And gratitude. They are enormously grateful for what they have. They know it and say it. And they are incredibly courteous to each other. Growing up in our houses it was classic to check in every day. I can still see my mother home from work, making dinner. Phone starts to ring. Dotty checking in. Minnie checking in. Even today, my mother and Minnie live in the same apartment complex in Miami, see each other every day, and still they kiss walking in and out of a room. For a number of years, we lived next door to Minnie. She'd call my mother from her office to say, 'I'm going to stop at the bakery before I come home. Do you need anything?' My mother would say—I can hear her now—'Pick me up a rye bread. Sliced, without seeds.' Okay. Minnie arrives with the rye bread and my mother is instantly in her purse. 'Fifty-nine cents. Here it is.' That's just one example of how they were very careful with one another. Meticulous. Debts were recorded and paid but never thrown in anybody's face. Never. Never. Never.

"They need each other like light and air, but at the same time they're very independent, very proud, very cognizant of boundaries. When one of the children suggests that it might make sense if they got together and shared an apartment, they throw up their hands in horror—nothing mock about it—and all say, 'God forbid. Can't think of anything worse.' Yet they're also interdependent. My mother is the last driver and primarily the doer. She complains, feels anxious about her capacity to keep doing, feels exploited. But I tell you she'd shrivel up without being needed by her sisters.

"My god, what an incalculable relief it is for the children that they are there to take care of each other. Dotty was mugged a few years ago and as a result of injuries she sustained had to move to a retirement community nearby. My mother put in untold hours of paperwork dealing with her insurance, paying her bills, et cetera. Do you think her son—who is chairman of the psychiatry department of UCLA—would have gone to Florida for eight weeks to do her checkbook?

"I carry two pictures of them in my mind. One is at my cousin's bar mitzvah. My mother is at the piano. My Aunt Minnie's got the maracas and my Aunt Dotty has a drum or something. They've got wastebaskets on their heads. Their stockings are rolled down, skirts pulled up, and they are having one helluva time. Then, sometimes, I picture them lined up and they're all old. All gray. All weathered and wrinkled, but above all, together. Together. That's the word. The only word. Together in body and soul.

"Just look at them. The panorama of what they've shared. They've had an ally, a best friend, a gal pal, a cheerleader in their corner, a helpmate, a caretaker throughout the entire course of their lives. Who am I going to have when I'm 82? My then 60ish daughter will be busy with her own life issues. Without a sister, who will I have to check in with? The desk in the lobby?" . . .

Dotty, Minnie and Bloomie thought they'd end their days living happily ever after as neighbors, true to their father's nickname: the three sisketeers. Dotty was the first to break the chain, transported into oblivion by the steely clutch of Alzheimer's disease. Bloomie went to see her once at her nursing home in Connecticut where, on the rare occasions that Dotty emerged from her wasteland, she'd talk to her son about how she used to have two sisters.

Bloomie stood still as Dotty, shrunken to a tiny old lady, shuffled down the corridor. Her eyes brightened like a light bulb when she saw her sister. They fell into each other's arms until Dotty broke the embrace and asked blankly, "Who are you?" Bloomie was heartsick. "In my mind," she says sadly, "my sister Dotty is already dead."

Soon after, Bloomie and Minnie separated. In 1998, Bloomie moved to Philadelphia to be close to her daughter, leaving Minnie behind at the Florida retirement home where they'd had apartments across the hall. The first year Bloomie came north, she was busy adjusting to her new life. "I never liked being in that retirement home," she says, "even though it was gorgeous and swanky. When I walked out, what did I see? Heads like mine, all gray. And never any little kids. Here in the city, I'm happy to walk outside. I see people going to work. I see white and black and brown, and children, too."

But the novelty of her new surroundings wore off and despite the proximity of her beloved daughter and grand-daughter, she began missing the company of her sister. "I can't fill that void of sisters who have a shared lifetime," Bloomie's daughter, Linda, says. "They bring her a sense of herself that I can't supply. It's very primal. With us, there is a role she plays—mother and grandmother. And this role has boundaries. With her sisters, she is herself in a way she can't be with anyone else."

Bloomie's sadness was compounded by the fact that the frequent visits the sisters had anticipated never materialized. After two or three times, Bloomie's worsening emphysema and asthma made it impossible for her to fly, while Minnie's body and mind began to fail. For a while, despite Minnie's rapidly progressing hearing loss, the sisters maintained their regular phone calls. Every single week Minnie would call Bloomie and scream into the handpiece without compre-

hending a word Bloomie said. While there was not much that could be described as communication, at least there was a connection. Then Minnie became completely deaf, and all they could do was write. "I still go to the phone and forget I can't call her," Bloomie complains. "We used to talk four or five times a day. We told each other everything."

For the last five years they've exchanged the same birthday card sent between their birthdays, which are a week apart in December. Bloomie initiated the tradition by mailing a fancy white card festooned with bluebirds and flowers bearing the inscription: "To my sister, my friend, who understands the inner me, accepts me at my worst yet helps me be the best I can."

"Send this to me next year," she instructed—and sure enough, Minnie did, back and forth until Bloomie's 92nd birthday in 2003, when the card never came. Minnie, slipping in and out of dementia, totally forgot. By then,

she'd been transferred to a nursing facility. In a lucid moment while packing her belongings, most of which she gave to her daughter, she chose only one memento to take with her. It hangs on the wall of her sparsely furnished room—a framed page torn from *People* with a photograph of the three Green sisters, hands intertwined, reprinted from this original book.

Now Bloomie fills her loneliness with memories. During her long insomniac nights, she clutches a pillow that Minnie gave her on their last visit, embroidered with the words, *A Sister Is a Lifelong Friend*. She thinks of what a great life they shared and how dull it is without them, surrounded by the silence of old age. "I'm almost sorry I'm not dead," she whispers. "I cannot believe I will never see again these sisters who were the best part of my life. The doctor says my heart has a weakened valve—but actually it is broken." ■

Tangra, Karen, Claudia, Linda, and Aulana:

The Pharis Sisters

Put the five Pharis sisters alone in a room and you've partially solved the energy crisis. The electricity they generate when they get together could easily satisfy the power needs of a small planet. Aulana Peters was the first black lawyer appointed to the Securities and Exchange Commission, Linda Munich is public affairs director for WPVI-TV in Philadelphia, Claudia Pharis is a policy analyst with a Harvard MBA, Tangra Allen is a community activist and grant writer, and Karen Owens works as a direct mail account executive.

These sisters live in different parts of the country and don't see each other as often as they'd like. But there's constant phone contact and conference calls whenever one of them has great news to tell. When they do get together, they invariably recall the family stories that form the tight warp of their lives: The time Aulana whipped Tangra for playing with matches, but protected her by not squealing to Daddy. When Claudia got mad at Linda and destroyed her very best favorite most wonderful peasant blouse. How Aulana refused to apologize for kicking apart a jigsaw puzzle Karen had just about finished. The time Linda applied for a camp job and was told there were no other black counselors: "That's okay," she said, "I'm not prejudiced." That particular story still breaks them up.

These sisters lend resonance to the phrase *separate but equal*. "I am from a family of five sisters," says Aulana, "and we all act like we're only children, which says worlds about how our parents nurtured us to be sole and unique."

"That's for sure," says Claudia. "I got a beating every day and Aulana never did."

"Because she didn't deserve it." Linda pipes up, and they burst out laughing again. "We are a tremendously competitive family but I can't say we were ever jealous. At least not in the traditional sense."

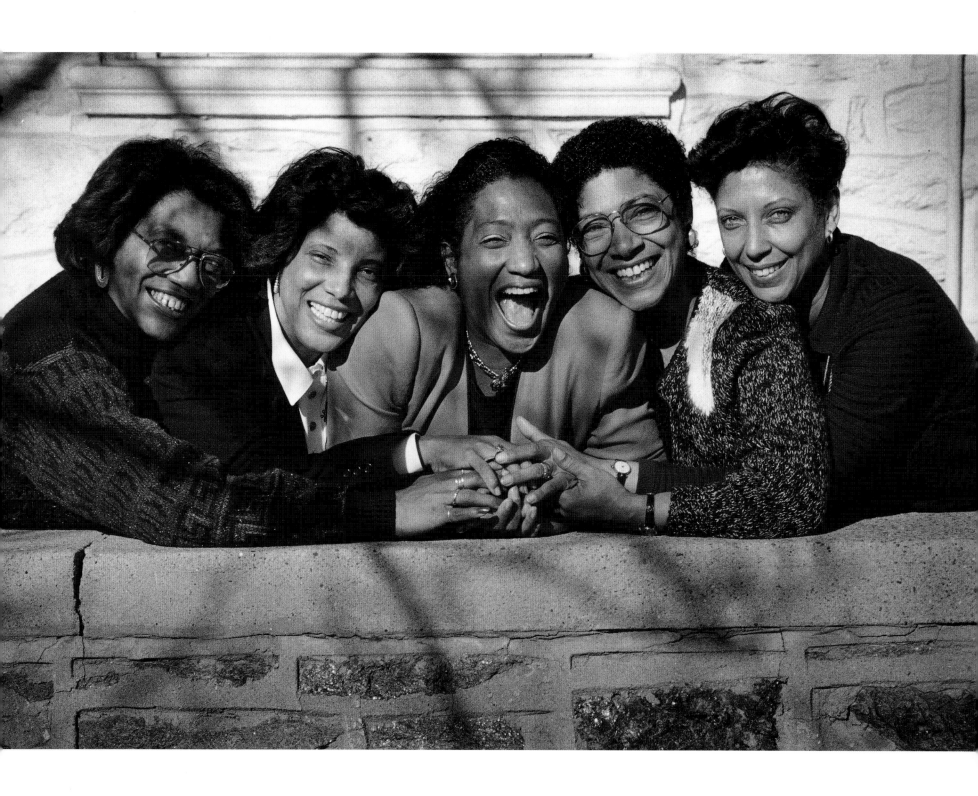

"Well, of course, growing up, my sisters each had something I wanted for myself," Aulana admits. "When I was a gawky, gangly teenager I would look at Linda and envy her beauty. When I struggled to get a B+ and wanted an A in calculus, I wished I had Claudia's enormous brainpower. Karen has this amazing capacity for love and patience. And Tangra is the most artistic. We all dabbled in dance, music, and painting, but I coveted Tangra's talent."

Somehow, what could easily have been petty jealousy emerges as tremendous admiration. Claudia appreciates Aulana's graciousness. "She was mommy number two to all of us and handled that role with such ambassadorial aplomb."

Aulana nods. "I never resented taking care of my sisters while my mother was working, but I think they're the reason I have no children. When the time came to have babies, I'd already raised my sisters, so I simply had no

curiosity what it was all about."

"I think we all see each other pretty much the same," Tangra says. "Karen has this personal sense of order—I swear she was born with clean, straightened drawers—and, as an administrator, I could use some of that. Frankly I was so different, such a nonconformist, I sometimes thought I was adopted. Finally my mother sat me down one day and said, 'Why in the world would I adopt another daughter when I already had three girls?'"

When asked to describe their roles in the family, they all have the same answers. It's agreed that, in birth order, Aulana is the group adviser; Linda, the nurturer; Claudia, the energy force, the most playful, and the favorite of the nieces and nephews. Tangra, the one who marched in Selma, is their conscience. And Karen is the glue, the one who calls everybody and remembers the birthdays.

Rather than feeling stifled by sibling rivalry, these sisters revel in it. Karen says, "Except for being the baby and having to wear hand-me-downs—remember those blue coats with the lace collars that wouldn't wear out?—this all-female group has always been tremendously reinforcing. You know how there are times in life when you need someone in your corner. Well, with five sisters you get to pick and choose because some are better in a particular corner than others."

Beyond that, these sisters hold up mirrors to each other for what it means to be female, and the reflections aren't clouded by the tensions of a mother-daughter relationship. "No matter how disparate we are," says Karen, "having four sisters gives you role models to learn how to become a woman."

Their one complaint about growing up in a houseful of women? "We had only one bathroom and Daddy always got first dibs." Their parents ran an orderly, traditional home where dissent was permitted only within a framework of understood obligations: Always show up for dinner, exhibit proper table manners, and talk during the meal. They were required to say "Good morning" every morning, "Good night" every evening, and to greet people when they walked into a room. But above everything loomed the unspoken rule, "Thou shalt love thy sister as thyself."

"We always thought," says Claudia, "that being the Pharis girls was the greatest blessing on this earth. There is nothing I could do, no disagreement I could have that would make my sisters not love me. We belong to each other and that is inviolate. We each contribute to the solidity of our bond by being there when we're needed. By carrying our own weight. You don't mess with that kind of stuff. You invest in it." ∎

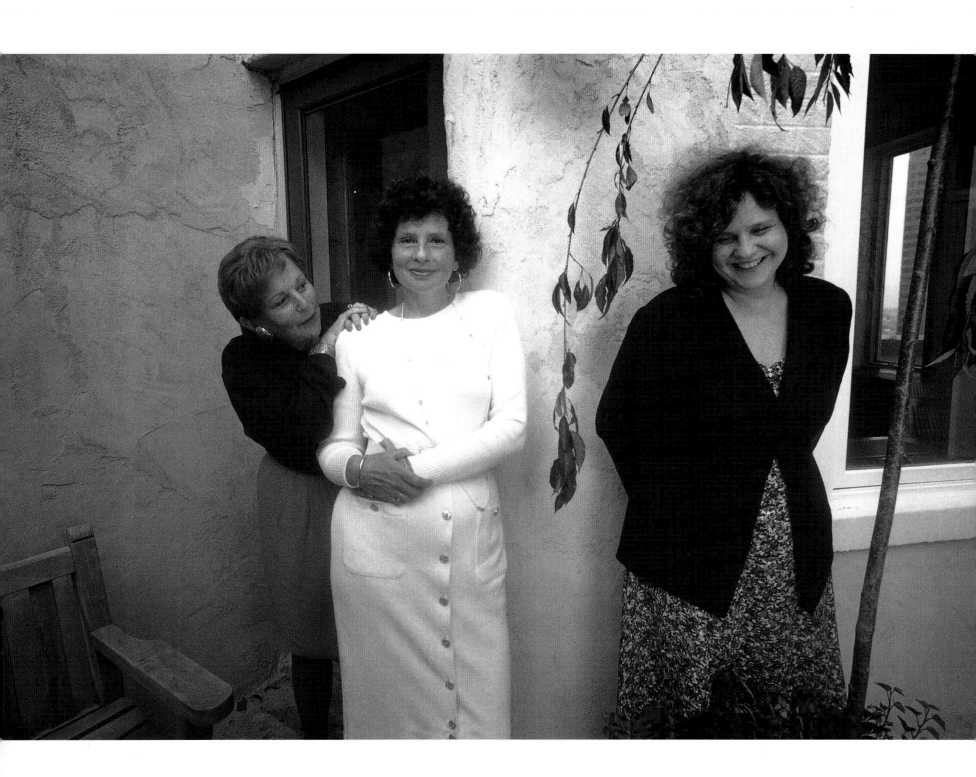

Sandra, Georgette, and Wendy:

The Wasserstein Sisters

Sandra, Georgette, and Wendy: The Wasserstein Sisters

"How are we alike? Hmmm, let's see," muses Wendy, the playwright, on the subject of the sisters Wasserstein.

"How about we have beautiful rosy skin, thick blonde hair, and no hips?"

"We have narrow cheekbones?" Georgette, an innkeeper, suggests.

"And thin arms," says Sandra, a high-powered banker and business consultant. "You and I are very proud of our thin arms."

"And we don't like scary things," Georgette continues. "When the music gets scary on a TV show we all leave the room."

"Do you like amusement parks?" Wendy asks.

"No, I hate them," her sister replies.

"And I think we all hate beets," Georgette says.

"I certainly don't like beets," Sandra agrees. "Do you like beets, Wendy?"

"I'm so amenable that I would eat them if I were forced to. But they're not as bad as those drinking eggs Mother gave us for breakfast." She turns to Sandy. "Speaking of food, remember when you came back from living in England? I was at the June Taylor School of Dance and also studying at The Yeshiva. I was pretty much a believer then. Anyway, mother gave you money to take me to Howard Johnson's and Radio City."

"Wait a minute," Sandra interrupts. "It was *my* idea to take you out. Mother may have given me money afterwards."

"But you were supposed to take me to Howard Johnson's."

"No, I just said I was taking you to dinner and a movie."

"Well, you took me to The House of Chan and we saw this movie called Expresso Bongo with a dancing scene where the girls were wearing little plaid kilts and had no tops on. Then we had coffee in the movie lobby. I found this totally startling."

"Probably because at dinner I ordered shrimp in lobster sauce and spareribs, which certainly weren't Kosher."

Retelling tales from their book of memories is something all sisters love—and the Wassersteins are no exception. Theirs was a rollicking, boisterous household (three daughters and one son), governed by the dictum that success comes from high achievement. When the kids weren't excelling in school, they were performing original shows in the living room.

"When we took car trips," Sandy remembers, "instead of listening to the radio, we sang camp songs and show tunes." And, as if on cue, they launch into a lusty rendition of "A Cannibal King with a Big Nose Ring," complete with hand motions.

"There were such large personalities in our family," Wendy says, "that I think I got along by being funny and sweet enough so that everybody would leave me alone. You had to stake out your own territory. My feeling has always been, 'If everybody's in Louisiana, then get yourself on a horse and go west. Why would you even bother with Louisiana at all?'" Her role was beloved baby of the family.

"Wendy and I shared a room, and she would jump into my arms every day when I came home from school," recalls Georgette, who is six years older.

"You didn't think I was so cute when I spilled ink on your college application," Wendy reminds her. "And to punish me you locked me outside to get bitten by the squirrels and die from rabies."

Georgette, given the nickname "Gorgeous" by their father, embodied for her sisters what it meant to be feminine. "At eight, she was already elegant. *And* she had a clean neck," Sandra says with mock exasperation. "Mother always threw that up to me."

"And mother would say to me," adds Wendy with a giggle, "Look at Audrey Hepburn. Doesn't she look like Georgette?' I'd say, 'Yes.' In my mind, Georgette was very glamorous. And Sandy was the sophisticated big sister."

"I'm very conscious of being the big sister," says Sandra, 13 years Wendy's senior. "In fact, my managerial style is

modeled on having been the big sister. It's made me a very good coach, a mentor to younger people coming up."

Wendy credits her sisters with being her models for the myriad possibilities open to women. "They've shown me that women can have their dignity and do so many different things. They can own inns, or be executives. I always loved going to Sandy's office because in television or movies you never saw women in big offices like hers. And when I was in college at Mt. Holyoke, I would visit Georgette, and there'd be all this warmth with her home and kids. So I instinctively knew that women were valuable in all kinds of ways, because I grew up with it."

"I think my sisters have shown me how to live," Georgette says.

"Yes, of course," Wendy nods. "It has to do with that awful word, *values*. I think about sitting in your room when I was young, asking you if so-and-so was a nice person and sharing thoughts about what it meant to be a nice person, a good friend. That is something very basic I got from my sisters. And what I'd like to have from you now, Georgette, is that outfit you're wearing."

"Oh you can't," Georgette exclaims. "It's my gorgeous outfit."

"Well," says Sandy, "I might like to have Wendy's talent."

"Not me," Georgette answers. "I'm happy for Wendy to have the talent and to be related to it. I'm sincerely proud of both of my sisters."

"I feel blessed," Sandy says, "to have two people in my life who have to take me as I am, whereas the world doesn't. Back in the touchy-feelie era of the '60s, I was pressed by my company into attending a week-long, mostly male, executive self-awareness seminar. It was all about bonding and being supported by your T-group. By the end of the week, these men were talking about this having been the major experience of their lives. I mean major! I couldn't understand how could this be so profound for them. They were rich, successful, famous, married. Then I realized why it hadn't been so

powerful for me. I'd been walking around with my own permanent T-group for years. Me and my sisters. With the exception of my children, I prefer their company to anybody else's. I feel very attached to them. Very big sisterly. Very. . . ." and she is too choked up to finish.

Wendy, in a soft voice, fills the silence. "I am very grateful to my sisters for teaching me what I know about people. For showing me different ways to grow. For never having to worry whether they'll show up for me. I'll never forget the opening night of *The Sisters Rosensweig*. This was a play I'd written about sisters, and here were my sisters with me. Sandy was sort of organizing people, saying 'Mother will sit here, and so-and-so will sit there.' Georgette was being charming and lively. And I was hiding. I thought, well, there you go. That's us. We're being just who we are. It was wonderful."

The three of them sit quietly for about thirty seconds. Then they break into smiles and begin to sing, "A Cannibal King with a Big. . . ." ∎

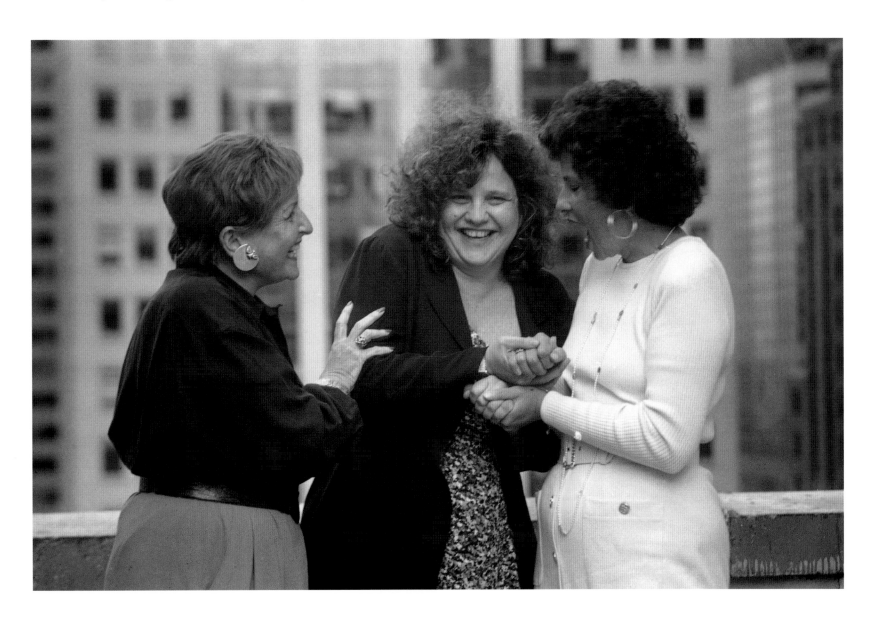

Katie, Charlene, and Julie:

The Cunningham Sisters

The moment frozen in this photograph will always evoke a treasured memory for Charlene, Julie, and Katie. They've just returned from a perfect vacation, one they could not afford financially, but could not afford to pass up emotionally. They'd recently heard the news they'd most feared: Charlene's breast cancer had begun to spread, and the prognosis was not good. Without hesitation, they borrowed the limit on their credit cards and fled for a week to a rented villa in the Caribbean to be alone together, as sisters, one more time before Charlene's health started to decline.

Unexpectedly, the trip helped Charlene plan her funeral. "The idea came to me after we went snorkeling one afternoon," she said. "I was floating and looking at the spectacular sea life around me and I just wanted the current to take me away. I felt I was home. That's when I decided I wanted to be cremated and have my ashes spread out in the ocean. I don't want to be buried in a casket, because I don't want a place for my family to come and cry."

As children only 14 months apart, Katie, Julie, and Charlene had been raised like triplets. (There is another sister, ten years older, but they've never been close.) "Three peas in a pod," their mother called them. They were given their first bikes on the same day, and, together, were allowed to stay up past nine o'clock for the first time.

"We lived in the country," Charlene explains. "If we wanted to go out and play, we didn't have anybody else, so we relied on each other for entertainment. We had to get along. We biked and hiked and rode horses. Even though we fought, we knew we'd always be there for each other."

As is the case with many sisters, the ride got bumpy in their teen years. There were fierce fights, especially over clothes—shared by the sisters, who were all the same size. Often Charlene and Julie would gang up on Katie, provoking new arguments. By their college years, feeling suffocated by their intense closeness, they drifted apart, but kept up with each others' lives through reports from their mother.

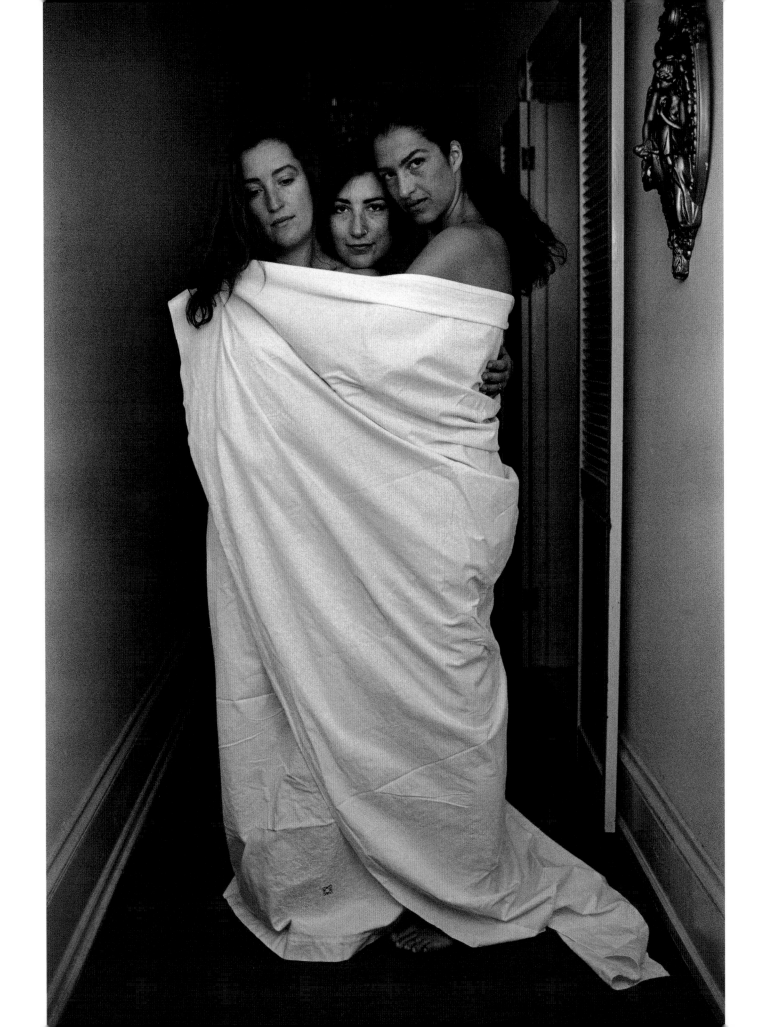

"I can't quite say how we came back together," Katie muses. "All of a sudden I identified that something was missing in my life: my sisters. I guess we just needed a little space to get rid of those adolescent resentments. When I look at other sisters who have terrible relationships, I think it's because they couldn't get past those petty little things that happen growing up. Now at least ten times a day something reminds me of my sisters and reminds them of me."

"We also learned what was out of bounds," Charlene says, "and how to make up afterwards. Just blow off the fight and never hold a grudge."

When they finally held a post-college reunion at the Jersey shore, they fell right back in love. Katie remembers, "I looked around and thought, 'My god, we're all adults now. This is our first adult woman vacation.' It was very significant. We had our own money and our own jobs and were really close again. I thought it was so great to be together. I imagined that we'd be doing things like this the rest of our lives. Then, six months later, Charlene got diagnosed."

Breast cancer often runs in families, but it doesn't usually show up initially in a youngest daughter. Charlene was 25 when she first felt the lump. She went to the hospital right away. A needle aspiration and an ultrasound yielded little information, so a biopsy was scheduled. Julie, who works as a radiation technologist in the hospital, got the report first. "It's about Charlene," the doctors said when they called her in, and she thought, "Oh shit. It's bad. Real bad." It fell to her to tell her sister that she needed a mastectomy.

Julie knew Charlene was scheduled for a perm and she intercepted her at the beauty shop. "On my way over I thought about using a gentle approach, but then I thought, 'This is going to be an ordeal. Hard. There's no way I can lie to her, so from here on in I'm going to tell her absolutely everything. I have to be tough.' But when I saw her coming down the street, I went numb and I wasn't sure I'd be able to get the words out."

They walked to a park nearby. "You're not sick. You are fine," Julie told Charlene. "There's nothing wrong except this lump and they have to take it out." Charlene heard the words like a death sentence. They both started to cry.

The next victim was their mother. Her tumor was not as large nor as aggressive as Charlene's, and required only a lumpectomy. But that was when Julie and Katie, a registered nurse, began to panic, and on the advice of physicians

decided to have their breasts removed as a preventive measure. The sisters, with their marvelous sense of humor, kept each other smiling with boob jokes.

"We talked about getting our boobs knocked off," Charlene recalls. "It's good to be able to take things lightly because they are just boobs, you know, and there's more to life than body and boobs."

For several months they focused on their mutual surgeries to divert attention from Charlene's condition. "I was reassured by seeing Julie's," Katie says. "We communicated every step of the way. What do they look like? How do they feel? We'd always talked about everything. Sex. Our husbands. We had no secrets." In the meantime, Charlene moved in with Julie (who was coordinating her treatment) and her husband and started chemotherapy. Everybody feigned optimism until the cancer recurred and there was little left to hope for.

Julie began to feel overburdened. "Help me, Katie," she wept. "I can't be as strong as I have to be." Katie got on a plane from California and came to Philadelphia to stay with her.

These sisters, who have always talked about everything, are now talking openly about death. Charlene tells her sisters how grateful she is to them for giving her an outlet to share her pain and fear. "There's nobody I can be more comfortable with, just be myself."

Katie asks Julie, "What the hell are we going to do without her? It'll be so boring. We'll be incomplete. We balance each other so well."

Julie fights despair. "She's our adventurous spirit. Who's gonna get us to try new things, loosen us up?"

Recently, Charlene told Katie she's going to leave her an expensive diamond ring from her canceled engagement. "I want you to have it," she said. "Will you wear it for me?" Katie could barely answer. "I just don't know. I don't know if I can."

Charlene believes she has lived before and will live again. "I'm most sad about leaving the ones I love because I know how much they'll miss me." When Katie heard about a medium who channels spirits of the dead, they chose a special word for Charlene to use from the beyond to establish contact. And, true to form, it was something raunchy.

Should Charlene manage to get a message through, her sisters already know what they want to hear. "That she's happy. That she knows we love her. That there is still a connection between us." ∎

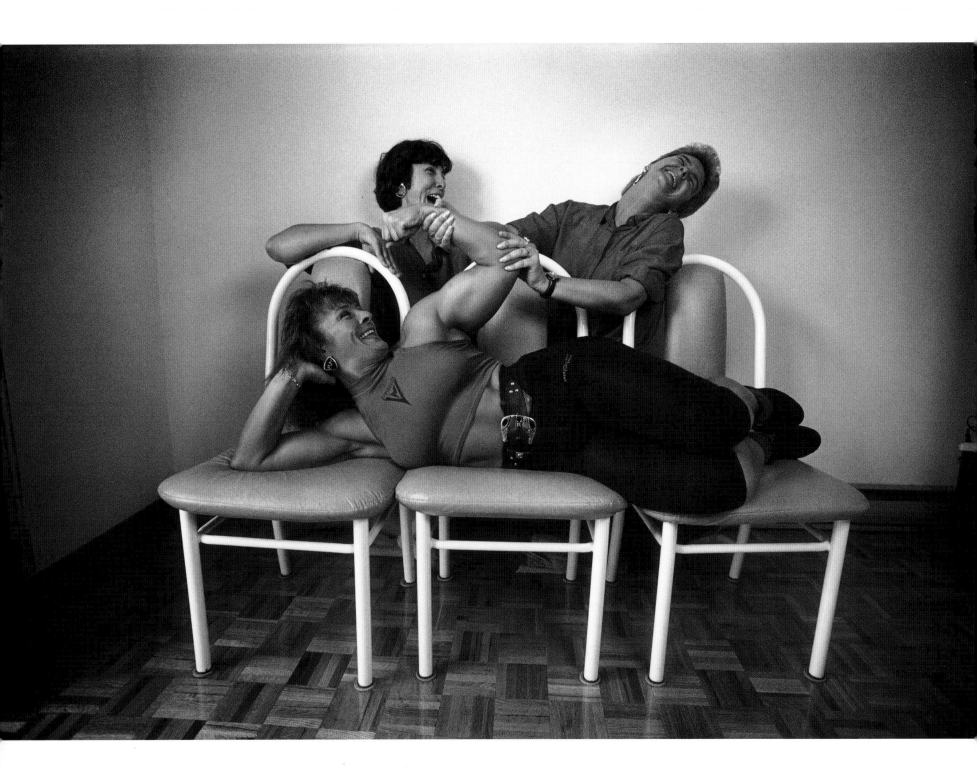

Kim, Sandra, and Sheryl:

The Blackie Sisters

Dozens of impediments could have prevented the Blackies from being friends—different interests, personalities, lifestyles, and even different countries. Two live in Canada, one in California, but they rarely write or talk on the phone. Family news tends to get circulated indirectly through calls to their mother. But the shared history of their youth is enough to make all their differences unimportant.

"We're sisters," Sheryl states quietly, knowing that those words obviate the need for further explanation.

Still, Sandra, who lives three thousand miles away, embellishes her sister's thought. "No matter how old, how young, how good, how bad—no matter what—your sisters are there," she says. "We have no choice, because we will always be related."

Kim, the youngest of the three, concurs. "Well, anybody can see that: we all have fat ankles."

These sisters have plenty of good memories—camping, fishing, riding, sharing clothes, sneaking beers and cigarettes—and plenty of bad ones, too. "Our stuff is there all right," Kim acknowledges, "but we act like it's way in the past. Water under the bridge. We talk about what's current and focus on the present. Even if we fight, the next time we see each other, we act like it never happened."

Even the old resentments, especially between Sandra and Sheryl, burn less intensely now that the sisters have reached their thirties. "We were only two years apart," Sandra says, "and my parents dressed us the same way. People thought we were twins, and it was awful. I wanted to be me. I wanted people to like me alone, and I hated that my mother was always pushing us together, making me take Sheryl everywhere."

"We always ended up fighting," Sheryl says, "because I could talk to Mom—I was her favorite—and the minute Sandra tried to talk to her, they'd be yelling and screaming. That caused lots of friction between us. And Sandra was a terror. She caused a lot of trouble."

Sandra was wild: drinking and drugs, running with a fast crowd, minor clashes with the law. "I was always a rebel. For a lot of my life—but no more—I've been involved in pretty hard-core addictions."

Sheryl hated Sandra for tearing the family apart. "She was older; I couldn't tell her anything. It was so difficult to sit there and watch what was happening. If I did say something, she basically told me to go to hell. Teenagers are like that. But now," she says strongly, "I'm very proud of her."

"You are?" Sandra asks with surprise.

"Yes. I've seen you hit bottom and get back to where you are today. Totally clean. A champion body builder. Healthy. You've got direction in your life. That's quite a change."

Sandra sighs and shakes her head in wonder. "Out of everybody in the family, I'm always most nervous about seeing you, Sheryl. Kim and I have always had our athletic interests in common, but I thought you didn't care about my lifestyle, which is the thing that's most important to me.

You didn't seem to have any interest in my bodybuilding. It never dawned on me that maybe the distance between us came from my old addictive behavior."

As the sisters talk about the past and present, it becomes evident that they still crave each other's approval. Kim admits that before seeing Sandra, she was worried about getting into shape. "Yeah," Sheryl says, "when we get around each other I start thinking Kim's thinner and Sandra's this health nut. Me, I just come home from work, sit on my butt, have coffee, smoke cigarettes, and try to relax my brain."

"I don't think we want to be *like* each other," Sandra suggests. "It's more the feeling that if your sisters don't accept you as you are, who will? I'm sorry sometimes that we don't go out of our way to be in contact more. Funny, isn't it, that it doesn't really make much difference where we are or what we do. We're still bound together. Still connected.

"If one of you committed murder or won a million dollars or landed on skid row, it wouldn't change one thing." ■

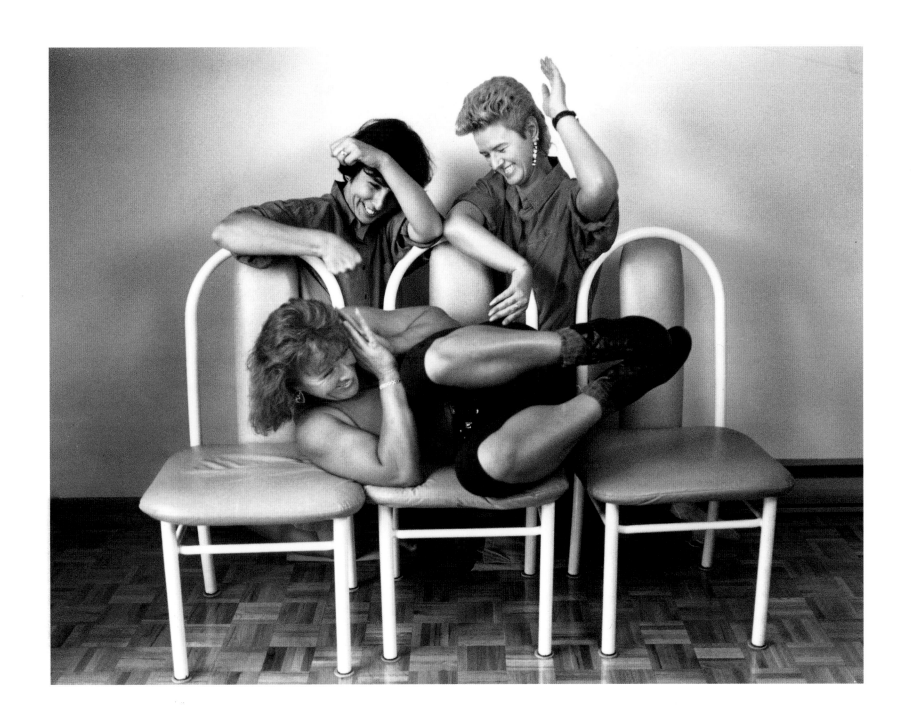

Clare, Chris, and Jeanne:

The Evert Sisters

Chris Evert—the number-one world-ranked tennis player for seven years—has beaten just about everybody she's ever played.

But her roughest matches may have been against her younger sister, Jeanne.

"There was a time when I was 17 and she was almost 15—we're two years and nine months apart—that we were pretty close in ability. We'd both been tops in our age groups. We spent every day on the tennis courts and traveled the junior circuit together. The tough moments came when we started on the pro tour. It got pretty strained. Tennis was my security, the one area I wanted to be superior in, not only with her but with everybody. We played against each other three times in tournaments, and that was the sickest I ever felt in my life. On the one hand, she was my sister, and if I was beating her badly I felt sorry for her. On the other hand, if, all of a sudden, she started winning a few games from me, I felt threatened. It was the worst feeling ever."

Fortunately, their competition ended before the attachment between them frayed. "It's easier to have one big win than it is to stay winning," Jeanne explains. "There are a lot of elements that go into making a champion, and I might have had one, but I didn't have all of them like Chrissy. She's just a lot more competitive, and I came to accept that. My dad used to ask me, 'What are your goals?' and I would answer, 'To be happy, to get married, and to have a family.' I reached a point where tennis wasn't giving me that happiness."

By then, a third sister had joined them. Clare was born when Chris was 13 and Jeanne, 10. "She was not so much our sister as she was like a daughter," says Chris. Despite the differences in their ages, the girls grew up to become best friends.

Clare and Jeanne developed a close rapport when Clare reached high school and Jeanne, newly married, returned to Fort Lauderdale from Canada. Jeanne took a position coaching Clare's high-school tennis team and drove her baby sister to tournaments while their parents were away watching Chris play in matches such as Wimbledon.

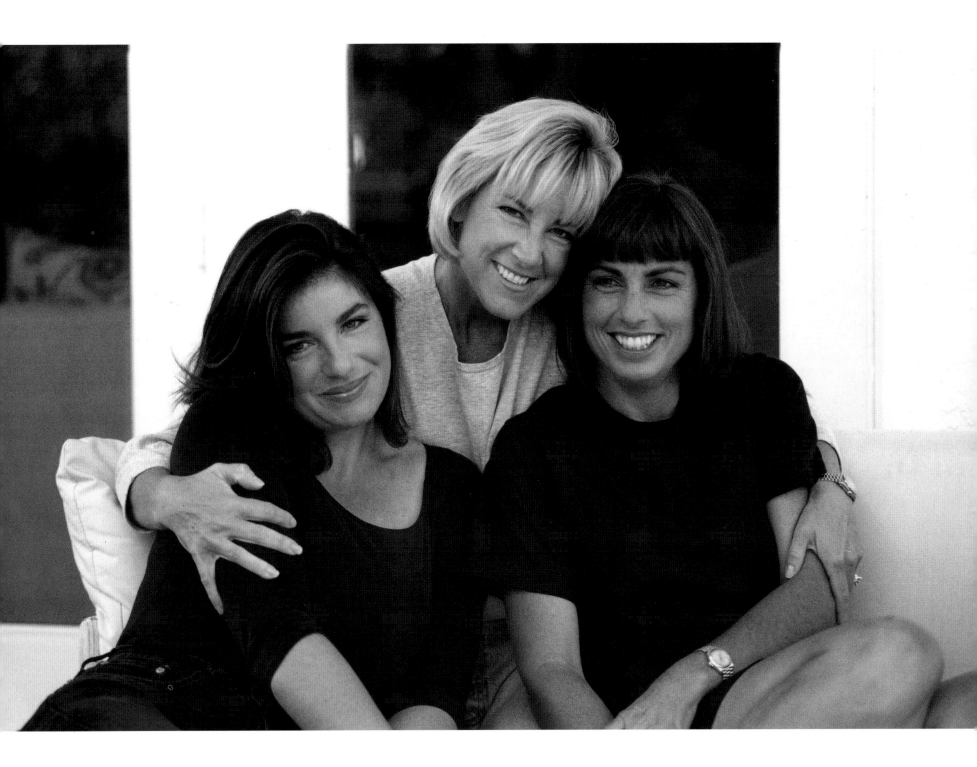

Clare and Chris bridged their 13-year age gap after Clare graduated from college and began working as a tennis pro at a club in Aspen, where Chris owns a home and spends much of her time. (Her other house is in Boca Raton, not far from Jeanne.)

Today the sisters' relationships form an equilateral triangle where the connection between any two points is as important as the connection among the three. The lessons they teach each other as adult sisters are far different from their old court secrets.

"Maybe growing up, I was the leader," Chris says. "But now I think the roles are reversed. I look up to Jeanne because she's always been the perfectionist in the family. Whatever she did, she did really well. Whatever I did, I did okay but never as well as she did. Except for tennis. Because I travel so much, I haven't been much of an expert on domestic issues. I see the way she is with her kids, her patience, and how she spends time with them. She is Miss Chef—makes these beautiful dinners—and always has her house immaculately cleaned."

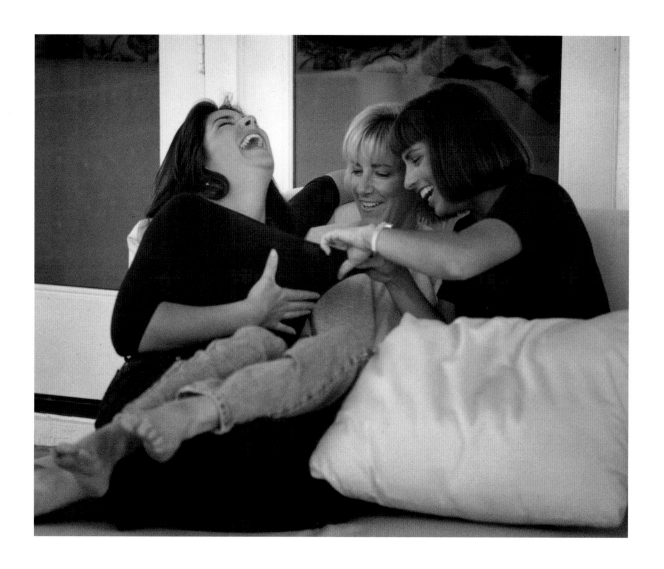

"This year I just couldn't do Christmas dinner like I always do," Jeanne interjects. "The family got so big, up to thirty people, and my house is one-third the size of Chris's so I asked if she'd mind having it. She said, 'Okay, I'll just call the caterer.'"

They all laugh, and Chris continues, "Both of my sisters are doing things I never did. Clare graduated from college, has a place of her own at 25. I lived with my parents until I was married; one regret I have is that I never lived alone. She deals with her bills which I had an accountant do. So it's like I'm the young one. Clare is really a people-person, which I'm not naturally, so she's taught me to relax, enjoy life, and not get so intense about everything."

"We've all learned from each other," Clare says. "Being a people-person isn't the greatest thing in the world unless you've also got some of what Chrissy has. When I go out to play a match I can do it physically, but I can't focus or concentrate like she can. Nobody can think like Chrissy. One in a million has that talent she has. So you come to respect your sister for her strengths. And one of the things that's great about growing up with somebody so famous is that you get to see people for who they really are."

Chris nods her head and smiles. "So Mel Gibson walks into the tennis club and Clare is like, 'Yeah, Mel Gibson is playing here. No big deal.' Nothing fazes her."

"Right," Jeanne adds. "Clare is our free spirit. Chris and I are more traditional and conservative."

But there was nothing conservative about the way Chris chose to have her son, Alex. In 1988, she married sports commentator Andy Mill. When she became pregnant two

and half years later, she decided she wanted her sisters right there with her in the delivery room.

"She told us in no uncertain terms, 'You're going to be there,'" Jeanne says.

"I flew down from Aspen and waited about ten days for her to deliver. Almost got fired."

"Jeanne's kids were adopted, and I thought she would like to see a baby being born, have that experience with me," Chris says. "Since I was also the first girl in the family to give birth, I thought my sisters should be there to support me. I wanted them with me—and my mom, too. I had a 24-hour labor so it was pretty awful. They were all there with blankets trying to get some sleep. That experience brought us closer."

Almost as difficult as Alex's birth was choosing which of her sisters would be her son's godmother. "I tossed and turned for three months," Chris remembers, "worrying over whose feelings I was going to hurt. Maybe I wouldn't have another child. I didn't want to choose Jeanne just because she's the eldest. That would be unfair to Clare. She's an adult now, and I love them both the same. I wanted them both involved." Her solution perfectly reflected their relationship: she asked them to share the role and be co-godmothers.

As these sisters have matured from girls to women, the sport that was so central to their interaction has moved to the periphery. "Early on, tennis was our common bond," Jeanne says. "But it doesn't even enter into it anymore. Now it's marriage, children, home, religion, spirituality, so many things." ■

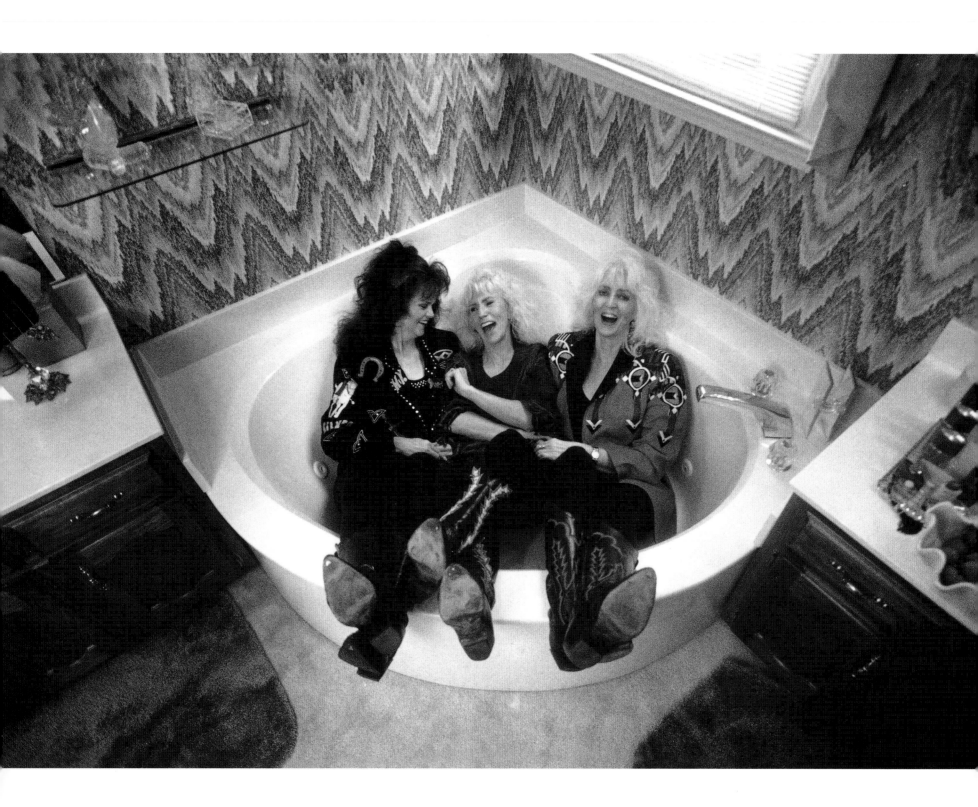

Kay, Loretta, and Loudilla:

The Johnson Sisters

Now y'all listen to this here story 'bout the Johnson girls and how they came from a farm in a windy corner of Colorado and done got themselves famous enough to be photographed by Avedon, written about in Time Magazine and booked for a guest appearance on "Hee-Haw." They can't sing a lick nor play no music neither, but they're best pals with Loretta Lynn and they chum around with all them Country Western stars. Even look like stars themselves with their big hair and cowboy boots.

What they do is run fan clubs. That's big stuff in these parts. They kinda stumbled onto it back in 1960. Loretta Johnson—she's the zaniest of the three, writes novels and says jest what she thinks—anyway, she up and wrote a fan letter to Loretta Lynn back when she was just an unknown playing clubs for fifteen bucks a night. Well, this was the very first fan letter she ever got and the gals started hanging out and helping out. One thing led to another and they hitched their wagons together.

As Loretta Lynn climbed the charts and became a major star, her fan club increased to more than five thousand members. Other fan clubs, noting the great job the Johnsons did for Loretta, sought out their advice. No sense giving it away, they thought. So they became consultants to the industry and founded the International Fan Club Organization, which has grown into a booming business with 320 members and a wildly popular annual dinner show just for Country Western fans. Along the way, the Johnson sisters have become something of a legend themselves, and today these queens of fan clubdom have darn near as many fans as the singers they promote.

Their business partnership is just a small part of why the Johnson sisters are as tight as three hens sitting on a single nest. In the fifty-odd years they've lived together, they've never been apart longer than thirty days, and that was when Loretta went to visit her Momma and lost weight pining for her sisters.

The girls were largely raised by their daddy, a powerful, beloved figure who passed on in 1987 as a result of injuries sustained in a head-on auto collision. The sisters mention him at least once every five minutes. "When we lost our Dad, a lot of people thought, 'Well, those girls are going to fold up,'" Loudilla says. "They misinterpreted what we were about. We were Daddy's pride and joy, but he made us stand on our own two feet. In our family we all take care of each other."

Daddy Mack Johnson farmed wheat on a seven-thousand-acre spread. Picking up the mail was a fifteen-mile ride; a quart of milk, a forty-two-mile round trip. By necessity the three sisters and their three brothers formed their own little community. By the time Loudilla was eight years old, Momma was gone, leaving her in charge. She cooked; the others split the chores of laundry and cleaning. They had a perfectly wonderful, though isolated, childhood and never felt they'd been cheated of anything. When Loudilla, the sharpest of the lot, graduated high school, she won two scholarships but used neither.

"It was like this," Loudilla says. "Loretta hated school. I knew she'd quit if I left home. So I stayed, and she

finished. That's how the fan club got started. We'd met Loretta Lynn, and I wanted a hobby, something to occupy my time."

After Daddy died, the farm became too much for the girls to handle, so they moved themselves and their business to a four-thousand-square-foot, decorated-to-the-rafters home in a suburb of Nashville. Barring marriage, which seems unlikely to them, they expect to live together happily ever after.

"I don't think any of us ever made a conscious decision that 'My sisters are more important than any man, so I'm not going to marry,'" Loudilla explains. "But men do seem intimidated by our closeness."

Could they imagine being separated? Just barely! Except for the fact that the younger sisters "lean on Lou more than we should," they go together like chicken and biscuits. Kay, the quiet one with a whispery voice as gentle as her personality, says, "It's so convenient and logical to live together. We enjoy it. It's other people that find us strange. Okay, strange in their world, but not in mine."

"To me," Loudilla says, "weird is sisters who haven't spoken in fifteen years. Or sisters who were good friends

until their mother died and have fought ever since because one got the china and the other took the silver. Oh, lots of times I can hear those two saying, 'Keep away from Lou today cause she's bitchy and got her tail over her back.' But when we're mad, we talk about it."

"Daddy taught us," Loretta says, "if you've got something to say to somebody, you need to say it. If you don't, the problem festers inside and becomes bigger than it deserves to be."

"He was smart man, our Daddy," is Kay's contribution.

One time Daddy woke up 'round about midnight hearing all kinds of laughin' and chatterin' downstairs. He put on his clothes and tiptoed into the living room, carryin' his shoes in his hands. There, settin' on the sofa, were the three girls gigglin' and carryin' on fit to beat the band.

"Why, Daddy, what are you doing awake?" one of them asked, surprised to see him.

"I heard all this partyin' and I jest assumed we wuz havin' company," he said.

"Nope, Daddy. It's jest the three of us having fun all by ourselves." In all these years, nothin's changed. ■

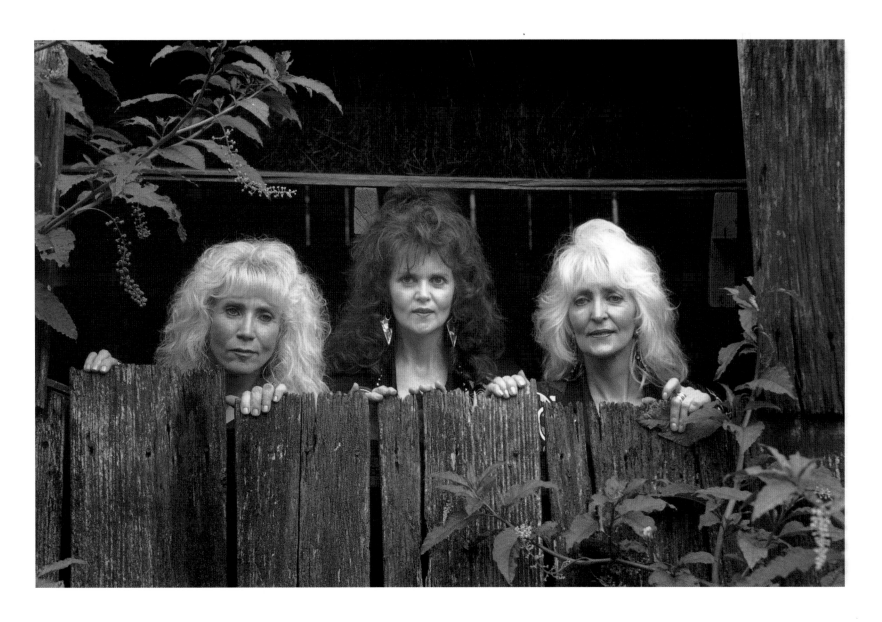

Kristin and Laura:

The Beck Sisters

"Is there anything I like about my sister? I don't think so," says 16-year-old Laura Beck. "We're just not connected. Our personalities don't click. She's not the type of person I would hang out with. It's better if I stay away from her and don't get involved because I know we're going to have a fistfight or an argument that will lead nowhere. It would take a lot of work to build this relationship, and right now it's just not worth it to me."

The Becks are typical of many sisters who battle their way through their teens and can't imagine that they might ever become friends.

"I'm kinda jealous when I see other families where sisters sit and talk and the little sister looks up to the big sister as an example," Kristin, 14, says wistfully. "It hurts when your older sister doesn't like you and beats you up. You feel like you have no friends."

"It's not that I'm being a bitch," Laura defends herself. "But everything she does annoys me. She does stuff because she knows it will drive me nuts. She enjoys aggravating me."

"When you go and tell Mom I'm annoying you, I do it again on purpose," Kristin admits.

"Like the time you were sick and you kept asking Mom, 'When do I take my medicine?' I told you, 'You take it three times a day. It says it right here on the bottle: Once in the morning, once in the afternoon, and once at night. It's not that difficult.' But every ten minutes, it was, 'Mom, do I have to take my medicine yet?' Over and over. And you kept it up because you knew it pissed me off, didn't you?"

"Yeah," Kristin says. "Because you call me hunkachunk and tell me I'm fat. I know I'm fat, I don't need to hear it from you because you're skinny."

"I only do it for your own benefit," Laura retorts. "You eat constantly, every bit of junk we have in the house. And I wish you'd grow up and learn some manners. She's so gross."

"You can yell at me; I don't care. I can always get even by going to Mom and tattling on you and then you get yelled at by Dad."

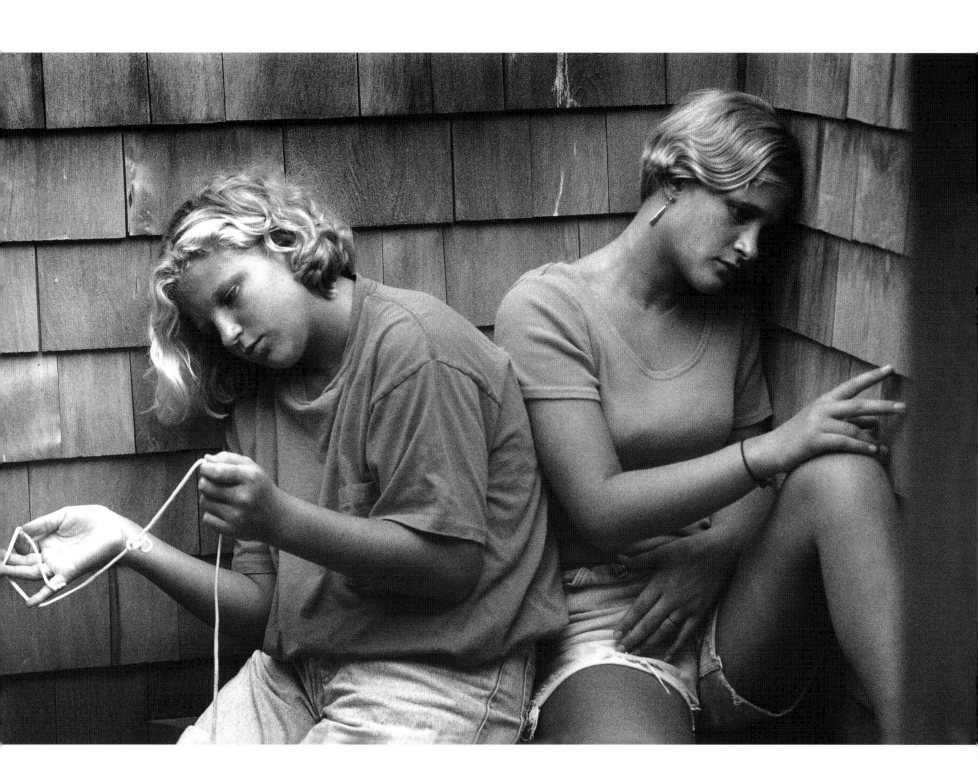

Bicker. Bicker. Bicker. It never stops.

When the girls were younger they shared a room, and their mother had to separate them for fear they'd injure each other.

"It wasn't little fights," Laura says. "Every night we really beat each other up. We fought over any little thing. Basically, I'm fanatic about neatness and she's messy. Her stuff could pile up for years and she wouldn't care. Finally, I drew a line down the middle of the room and told her, here's your side. I'm not vacuuming it anymore."

Forget anything as sisterly as shopping together. "I couldn't shop with her," Kristin says. "She usually gets Mom to buy her the thing I would want, and if I pick something out for myself, she just goes, 'Yuch.'"

Laura rolls her eyes in exasperation. "We have totally different tastes."

Laura and Kristin have developed warmer relationships with other siblings, but those don't substitute for their failure to get along with each other. They're painfully aware of how sisters are "supposed" to behave and will admit a deep sadness over not matching the ideal.

"I feel bad that I'm not the big sister Kristin wants," Laura says quietly. "I don't give her much credit for things, like working hard when she does well in sports. I should be more protective. A big sister should show her younger sister

how to act, what not to do, who not to hang out with. But I can't pretend to be that kind of sister for her, because I'm not a fake. And I know it hurts my parents. It would mean so much to them to see us get along. They feel they did something wrong bringing us up, but it's not their fault. I know everybody tells us, 'Someday you guys will be best friends.' It's awfully hard to believe."

In her own way, Laura misses having a sister she can depend upon as much as Kristin does. "Out of all the people in the world, sisters are the ones you are supposed to be able to totally trust and confide everything," she says. "But Kristin is such a different person from me, she wouldn't understand where I'm coming from. She's such a goody-two-shoes."

"How come you can tell your friends things you can't tell me?" Kristin asks plaintively.

"Because I don't care how other people look at me. But I do care how my own sister judges me. I don't want you to know my inner secrets, because I don't want you to see me as I really am. I just want to graduate high school, go away to college, and get on with my life."

"I'll be happy then," Kristin says. "Once you're gone, it will be my turn to be the oldest sister in the house. I hope that if we stay far apart for awhile, maybe there is a slight chance someday we could get close." . . .

Kristin and Laura's development

is a lot like the life cycle of a good red wine that needs a few years to mature and fulfill its potential. When Laura was sixteen she couldn't find anything likable about her sister. Now, at twenty-six she describes their relationship as "comfortable, easy, and connected." Their personalities are still very different but those imbalances are no longer a point of contention. Sure, Kristin still annoys her sometimes, and their teasing and banter might drive their other siblings crazy. What's gone, though, is the mean edge to

their interactions. They've come to really value what they have as sisters.

Things began to shift after Laura left for college, just as Kristin predicted they might when she mused, "I hope if we stay apart for a while, there's a chance someday we'll get closer." When Laura was in her junior year pursuing a degree in culinary arts and food-service management in Providence, Rhode Island, Kristin enrolled in a university in Boston. "I started having roommate problems," she explains, "and I began spending my weekends with Laura.

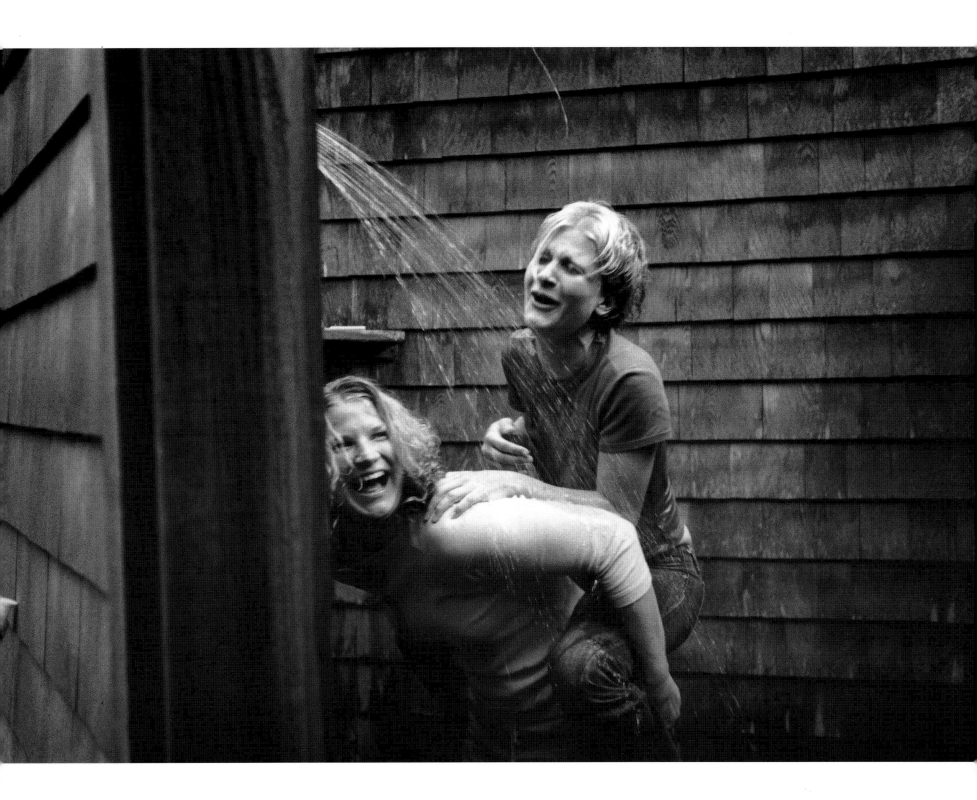

It was only an hour away by train." Laura got her sister a job catering, and soon she was coming down a night or two during the week as well.

"It wasn't the same as when we lived at home," Laura says. Kristin adds, "Yeah, there was nobody else interfering."

After Laura graduated and moved away, they really missed each other. Time and space apart have a funny way of creating an appreciation that proximity often smothers. Laura trotted about the world chasing her dreams. She did an internship with the Marriot in Amsterdam, worked for a resort in Hawaii, spent time at a restaurant in South Carolina, and moved to California, where she helped open a major golf resort in San Diego. Kristin studied in Australia and returned to Boston to earn her doctorate in physical

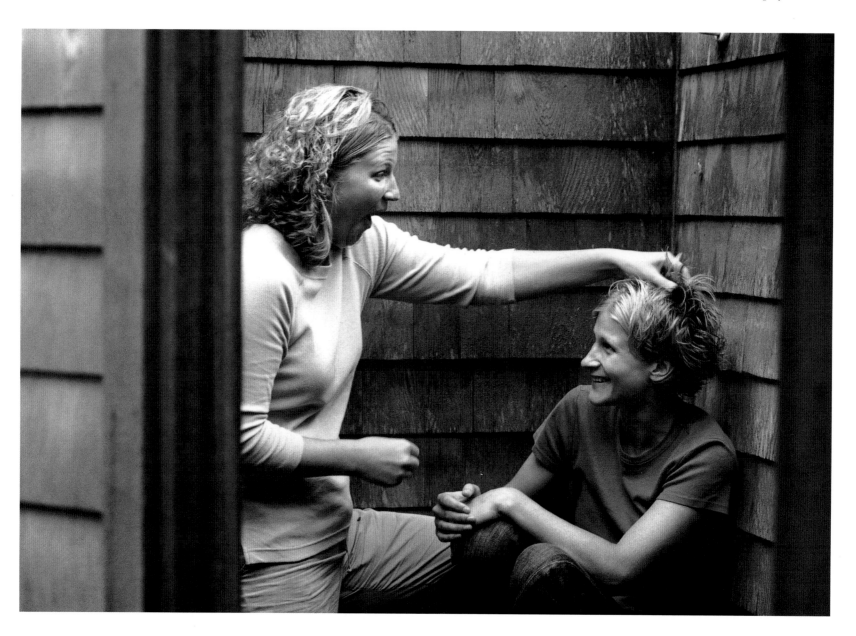

therapy. During the year or more they didn't see each other, without their noticing, they outgrew the issues that once divided them.

"Part of being a teenager is that you're all emotional and cranky-pants," Kristin says. "All you care about is who your friends are. You're so superficial, and appearances are everything. I see it with our two younger sisters who are at the stage we were then. They fight over stupid stuff."

"Then you get older," Laura says, "and you learn that your family and your sister are all you really have."

"With friends, so much depends on what your connection is at a particular time—where you live and what you're doing," Kristin elaborates.

"But regardless of what part of your life you're in, you can always hang out with your sister," Laura goes on. " I have acquaintances, but I'm not going to call them and tell them the things I'd tell Kristin."

So they rack up long-distance phone bills, complaining about the pressures they share, leaning on each other for moral support, and bolstering the one whose spirits are sagging. When Kristin has a bad day, she calls Laura—and

Laura is finally ready to listen. "I wanna know how she's doing." Laura says. "I wanna give her helpful advice. Before, I didn't care about what she was interested in. Now I care even if it doesn't interest me, because it's important to her."

Back in high school, Laura's life revolved around her group of pals. Today, she and Kristin agree that while friends come and go, sisters are a guaranteed constant. "Back then I was too busy with my friends to make time for my sister, to be there for her," Laura says thoughtfully. "There were more important things I thought I needed to do. Now those friends are gone. I never see them, and my sister is a critical part of my life. She's become to me like all the friends I had then. I can go to her if I need anything, and in return I want to be there for whatever she needs. It's not important that we're not the same kind of people. What matters is that we have each other, and we have this connection no matter what. You make an extra effort with your sister. She's not going anywhere."

"We may not be all huggy and kissy," Kristin says. "But we know we're blood. My sister is my sister and my good friend. She'll always be here." ∎

Bernetta and Margaret:
The Crommarty Sisters

"We never separated too much," Margaret reckons. "We's always been side by side. You know how it is when you got a younger sister and your father tells you to be together and love one another. In them days you did what you was told, so we never got too far apart. Never fought much either. What we gonna fight for? We was raised not to fight. Came up in the church and never knew much else."

Once upon a time, these eighty-something sisters did everything and went everywhere together. Now they go nowhere and feel blessed simply to still be together. Their parents are long gone; of the eleven children in the family—Margaret was the eighth and Bernetta the youngest—their only remaining sibling is a 95-year-old brother in a nursing home. Their husbands, divorced, are forgotten. "If they weren't right, I didn't stay with them," Bernetta declares. Neither has children. What they do have is a deep faith and an unconditional commitment to one another that makes it pointless to paraphrase the biblical question and ask, *Am I my sister's keeper?*

Margaret and Bernetta own one of four dilapidated houses that remain on what was once a stately block in a neighborhood of Philadelphia that has decayed beyond hope. The sisters' entire existence has been confined to the 10-by-30-foot front parlor since 1984, when Bernetta lost two toes to diabetes and with them, the ability to walk. "We eat here. We sleeps here and we doo-doo here." There is a commode behind a screen and a television set in the corner. A few pieces of faded furniture are draped with brightly-colored coverlets that Margaret crocheted in the days before her arthritis, when her fingers could still work the hook.

At 86, Margaret is five years older than Bernetta and, by comparison, relatively healthy. "I got bronchial asthma and lately my blood pressure's been jumping up on me, but I don't worry. The good Lord takes care of me, so I can take care of Bernetta."

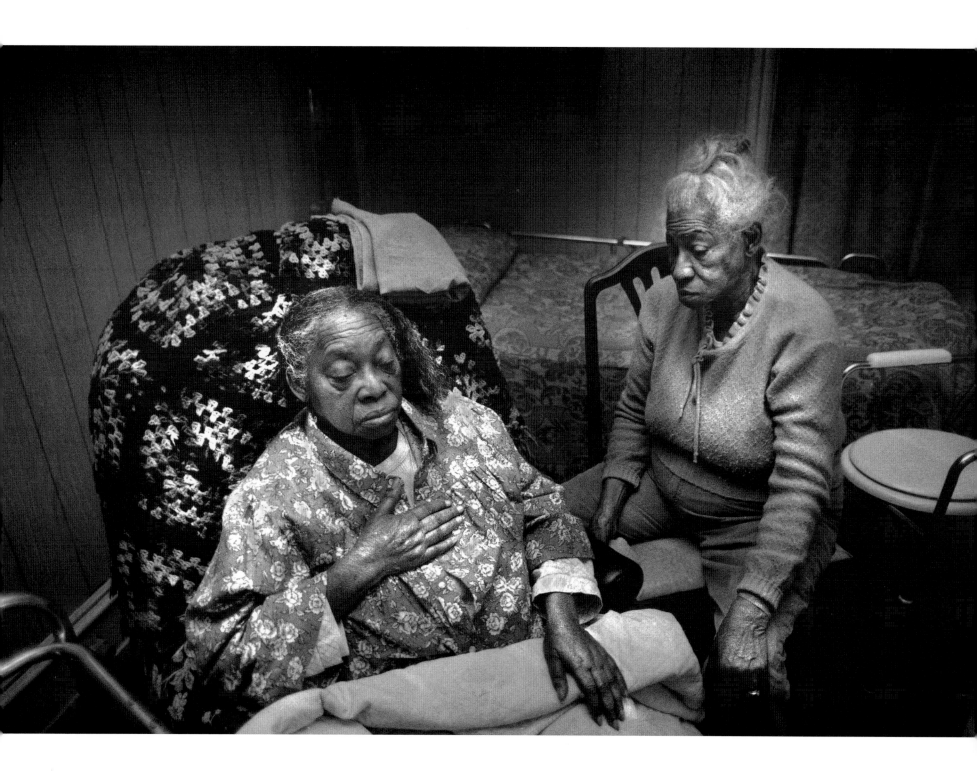

"I'm gonna tell you, Margaret does *everything* for me." Bernetta says with a tired wave of her hand. "I sit in this chair. I can't go get nothing. She gives me something to eat. Helps me wash myself. I don't know what to do but love her."

Their daily routine rarely varies. Margaret rises each day around seven AM, folds up the roll-away bed she sleeps on and wheels it into the front hall, where it remains until she pushes it back into the living room every night so her sister won't be alone. Then she prepares their breakfast from food a nephew brings once or twice a week.

"Bernetta don't like cereal, so I make potatoes and eggs, or hash and eggs. Maybe toast. Before we eat, I bring her teeth and some water to wash her mouth. I has to give her all her medications—three pills before she eats, for her sugar and something else, and four more after she eats. I clean up from breakfast, dusts a little, makes her bed. Then Bernetta needs to be washed. I can't get her to the bathroom. I bring in a pan of water, wash her down, and put on a clean nightgown and robe. I wash up the same way. Can't get in the tub myself 'cause I can't get out. Besides, if I went upstairs to shower and fell, who would hear me? I is supposed to soak

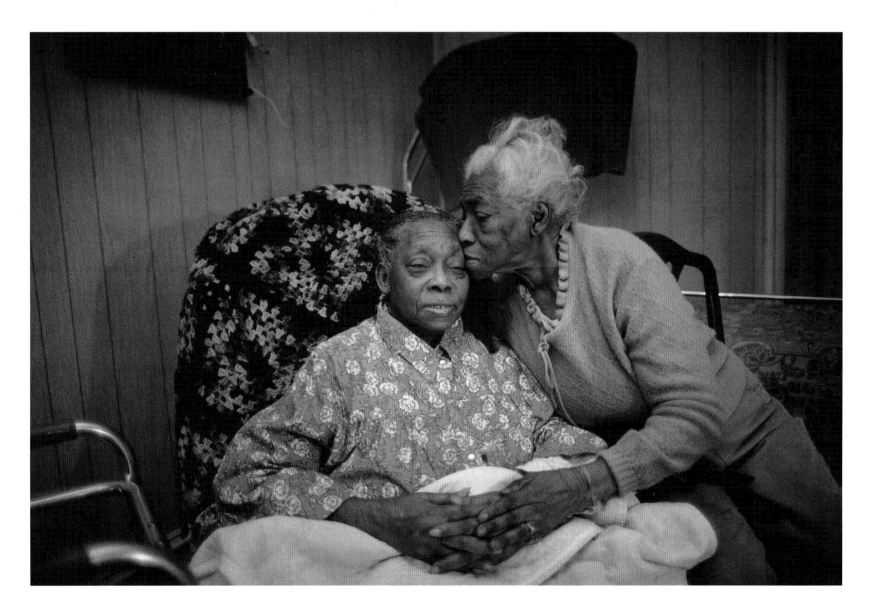

her foot every morning in warm water and she should be greased all over 'cause she's so dry but I can't do more than her foot. Comes the evening, I read my Bible and pray."

"I'm always telling her sit down and rest. Seems there's nothing Margaret hates doing for me."

"Sometimes I say I ain't gonna do so and so, but I get right up and does it anyway. If I weren't here, I don't know where she'd be or who'd look after her."

Lately Bernetta's mind has begun to wander, making her dependent on Margaret not just for her medications but also for her memories.

"Did I used to sing in the choir, Margaret?"

"Yes, you surely did, honey."

"What did we sing?"

"We sang 'Jesus loves me.'"

And in reedy, off-key voices, they hold hands and sing, "Jesus loves me. Yes, Jesus loves me, for the Bible tells me so. Oh yes, God is real. He's real in my so . . . oo . . . ul."

Though the memories are foggy, Margaret and Bernetta love to talk about the past and sometimes even about the present. But they rarely talk about the future.

"Lots of sisters don't look after each other like we do, Bernetta."

"I didn't know that. Why not?"

"Because they wasn't raised like we was to stick together. We're blood."

"Yes, that's true. But we is *old* blood. And you wouldn't leave me nohow 'cause we always been close. Very close." Bernetta raises her index and middle fingers and squeezes them together. "This close," she says. And they both grin. ∎

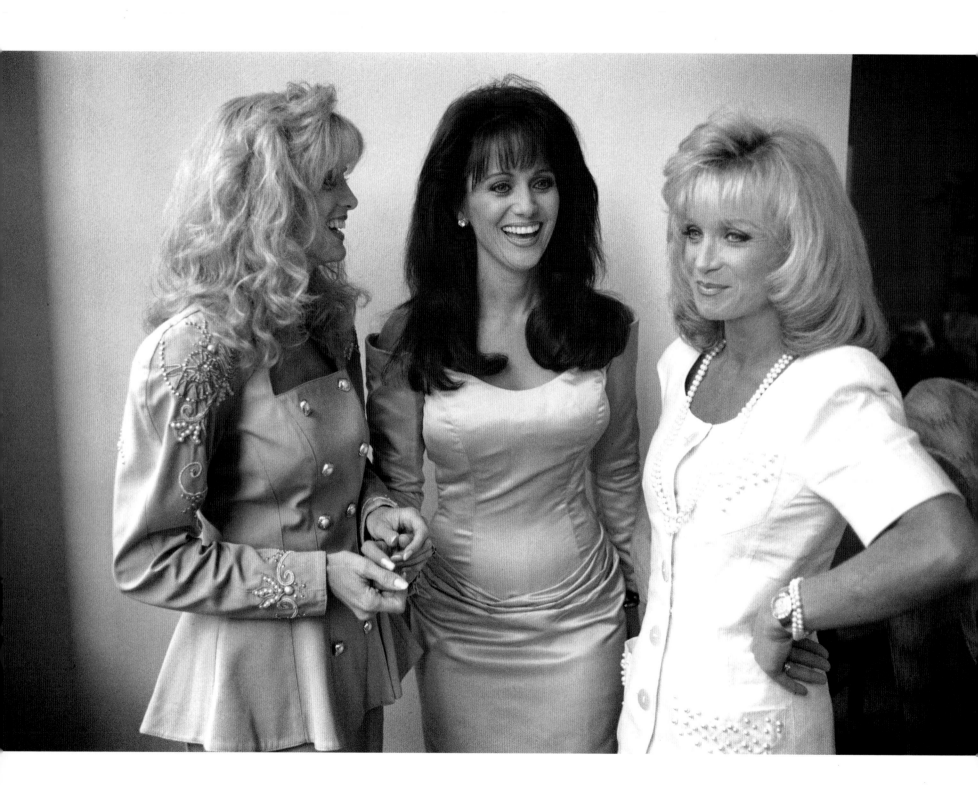

Irlene, Louise, and Barbara:
The Mandrell Sisters

Barbara Mandrell was a five-year-old "only child" when her sister Louise was born, and she made it clear to her parents that she had no interest in sharing the spotlight. Her father, Irby, decided to try a little of homespun psychology.

"Louise had dark hair when she was born," Irby says, "and Barbara was blonde. When we brought Louise home I told Barbara, 'They must have given us the wrong kid. We don't have any black-haired children. This can't be your sister. I'll just flush her down the toilet.' I walked into the bathroom, closed the door, laid Louise in the bathtub and pulled the shower curtain.

"Barbara was screaming and crying outside, and as soon as I walked out, she found Louise, picked her up from the tub, and announced, 'It's okay. I want to keep her. I'll take care of her myself.' By the time Irlene came along eighteen months later, Barbara was so used to having a sister, she just took her in, too."

The Mandrell sisters have been lovingly caring for each other ever since. "We all feel special," says Louise. "I believe with all my heart that I'm the favorite in the family. I know Irlene feels the same way, and so does Barbara.

"We're all very comfortable with our roles. Irlene loves being the baby. She's really the family comedian and the best entertainer, on and off stage. I've always been Aunty Louise, the one the kids love and who takes them everywhere—the Girl Scout leader.

"Barbara was always the bossy big sister. 'Stand here, smile, do this.' She's in the center of things, very much in charge. At family events she drives us crazy with her camera. She takes all the pictures and we can relax, because we know the prints will come in the mail. She also happens to be very knowledgeable, and we listen to her because she knows what she's talking about."

During her long recovery from a nearly fatal car accident in 1984, however, Barbara assumed a different role in the family. In unexpected ways, that experience brought the Mandrell sisters to a new level of appreciation. "I was in Barbara's hospital room," Louise recalls. "She didn't know who I was and it was obvious already that she had a bad head injury. I held her down while the doctor set her leg, and that day changed our relationship.

"All of a sudden there was no one telling us what to do. I became the big sister for a long time. I was the one who organized the family. That was so hard for me because I never knew how important those things were or how well Barbara did them.

"For a long time I lost the sister I knew. She stayed in her house with the curtains drawn and wouldn't go out. Her personality changed. Then when she came back to herself and took over again, we went through another transition. I had to make room for her to be herself and she had to allow space for me. Strangely enough, through all of this, we became closer."

Without the active encouragement of her sisters, Barbara might not have returned to the stage. "After the accident, I thought I would never perform again," she says. "But my sisters were right there, urging me to listen to my father's advice. He said, 'Just get up there one more time and then decide.' They all supported me not to let the accident dictate my life."

Barbara says her sisters are unfailingly sensitive to her needs in all kinds of ways. "Louise and Irlene always say or do just the right things to make me feel better," she says. "When we were doing our TV show together, it was a very building time in our relationship. They were always worrying about my health, seeing that I ate enough. I'll never forget when a reporter came to interview us and asked about how we handled sibling rivalry. Well, we'd heard of it, but had no idea what it was."

"And you were afraid," Louise reminds her, "that people would think something was wrong with us because we don't argue. So you told that reporter we fight over normal sister things. And me, Ms. blunt Louise, said, 'No, we don't,' and right there we had our first argument—over whether or not we argue."

"Well," Barbara says, "I was thinking about arguments like 'Oh no, I shouldn't have this, you take it. It looks better on you.'"

"Like the mink coat?" Irlene asks. "This nice Italian man wanted to make Barbara a mink coat but she already had one. So she gave him my measurements instead of hers, and when the coat was ready, she gave it to me. Later when the man found out, he thought that was so nice he made another one for her."

As tight as the sisters are as a threesome—"When we're together as two, we're always worrying about the third," Louise says—they also make a point of carving out time

for one-on-ones. Every January, Louise takes Irlene on a trip for her birthday. And sometimes, when Irlene is too busy for an outing, Barbara (her neighbor) will drop in, grab a dust rag and help her clean house.

"Once, I was living in California, studying acting," Irlene says. "My birthday came and I was feeling really lonesome for my family. My husband told me he was taking me to a restaurant that had a special room just for us. When we got there, two people were sitting at a table with menus in front of their faces, and I was annoyed because I thought we were supposed to be alone. Then they lowered the menus and it was Barbara and her husband, Ken. They'd come to surprise me. I started to cry. Both my sisters are big-hearted and generous in a million ways. They are truly my best friends."

While the Mandrells admit to being strongly competitive with each other in games and sports such as softball, golf, and target shooting, there is no competition in their careers. "It's not because we're so nice," Louise says. "It's because we had smart parents. When Barbara started out in show business she could not afford a band, and would not have had one, had it not been for Irlene and me."

"Barbara had married Ken," Irlene explains, "and decided to retire from show business and be a Navy wife. Louise said to me, 'Watch. She won't retire forever. We have to keep practicing our instruments so when she goes back, we don't get left out again.'

"One night we all went to the Opry and Barbara couldn't stand sitting in the audience. Pretty soon she was back on the stage. When she put together her band, Louise and I were as good as anybody—all that practicing paid off—so she made us her original *Do-Rites*. We toured all over with her."

Louise completes the story. "Later on, Irlene and I became successful because of the Barbara Mandrell TV show. We got her started, and she got us started. When someone is successful and you help them get there, you can't but celebrate your part in it. Our work gives us something extra to share.

"I've always been a little bit leery about explaining my love for my sisters in public because I don't want us to sound crazy, but there is a bond between us that goes beyond normal sisters. I think it comes from our love of God, from our parents teaching us to love each other unconditionally, and from sharing a business where we've helped each other and been there for each other."

If there is one complaint these sisters have, it's that their busy careers don't leave them enough time together.

"We decided to set aside once a year where we would go away, just the three girls," Barbara says. "No children. No husbands. We planned to go to Atlanta and thought it would be grand. Room service. Just us talking. Well, the three of us were asked to co-host an award show and the script needed our attention, so we used the time we'd set aside for each other to rewrite it.

"We're still trying find our three days together." ■

Clementine and Melba:

The Moorman Sisters

Nine-year-old Melba Smith and ten-year-old Clementine Moorman became sisters when Melba's mother, a nightclub singer, married her accompanist, Clem's widowed father. The concept of "stepsisters" never even entered their family. "It would never occur to me to tell people we were stepsisters," Clem says today, and Melba agrees. "We just don't relate that way."

Clem remembers being thrilled with the news that she was gaining a sister. "I had just lost my mother and was looking for something to fill up that nice feeling again. The fact that Melba was almost the same age was nice, too. But when she arrived, well, we had to go through an adjustment. I was looking for somebody who wanted to go shopping and play dolls with me. Melba was a tomboy. Much rougher."

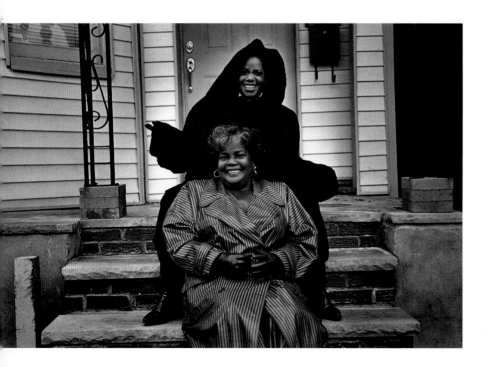

Melba nods, remembering the unhappy spirit she brought to their home in Newark, New Jersey, pictured here. "I'd been slapped around and beaten up a lot. I was bright but I'd been brought up to think I was stupid. I couldn't express myself. I'd never been allowed to. It was, 'Sit down and shut up, girl.' So I was very quiet and sullen. And here was Clemmie with this gift for speaking. She was so articulate, always reading books. Didn't like to be dirty and she couldn't fight for nothin'. But she could tear you to shreds with her ladylike attitude."

Clem's gentleness was exactly what Melba needed. "I would probably have been dead by now if this new family hadn't come along. I was already so convoluted, so bitter that I couldn't talk. A lot of my learning how to live came from watching and observing Clemmie. Her sweetness eventually healed me. She gave me the gift of her loving heart. To me, it was the difference between life and death."

"You couldn't dislike her," Clem says, smiling at the memory. "She was so bewildered, such a little prankster. There was nothing else to do but make her my little sister and love her."

"I think we really came together when we started being conspirators, the kids-against-the-adults thing," says Melba. "Because our parents were entertainers, they were away and left us alone a lot. When they did come home, it got to be a confrontation. Here we'd been taking care of ourselves just fine, and it was like, now you can't come back and tell us what to do. That really bonded us."

And bond they did. They went to their proms together. Sang spirituals around the piano. Fought over boyfriends. They made 1-2-3 cakes of flour, sugar, and water. "There

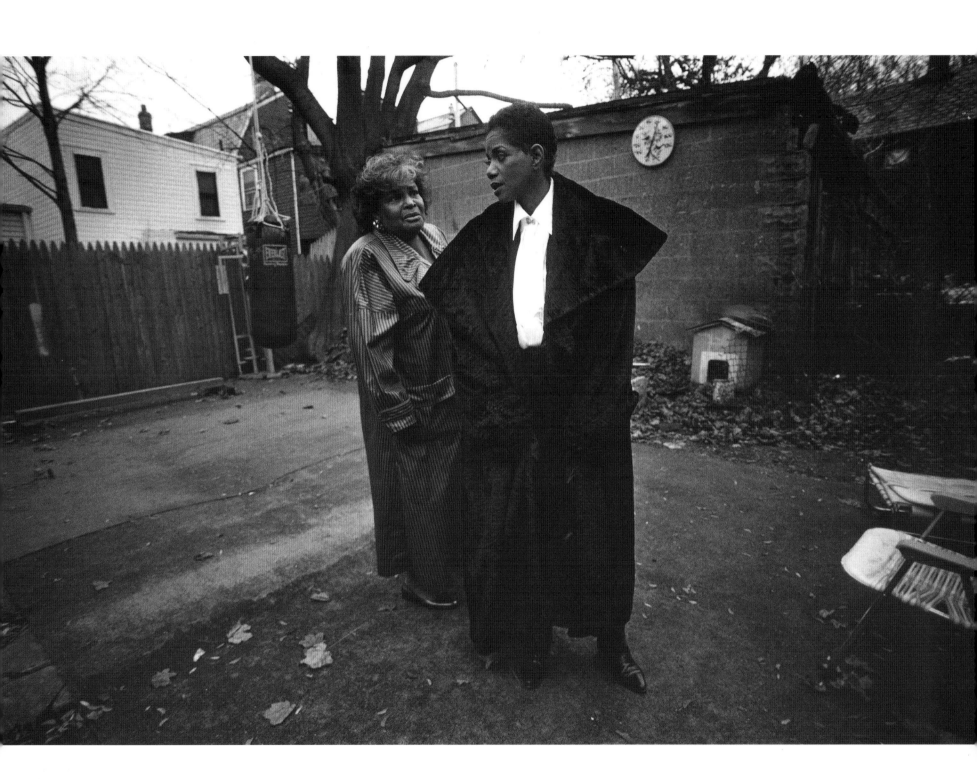

was so much of each ingredient you died from cholesterol. Remember, Clemmie? And how we used to dress up alike and go to supermarkets and guess how many people would ask us if we were twins."

They were absolutely, positively, best friends, which may be why Clem took such pride in Melba's emerging talent: "She is not just an actress and a singer. Melba is a gifted, extraordinary musician. As a teenager she was totally absorbed in music. Practiced for hours and hours. She would willingly give up her social life to learn something on the piano. You could tell early on she wasn't going to lead a nine-to-five life."

So it was no real surprise to the family that though both girls became teachers, only Clem remained in the education field. Melba Moore moved up to Broadway, jumping from the chorus of Hair to the lead role. Then it was on to a Tony for her performance in Purlie—and a career as a recording artist and television star.

As the sisters' worlds diverged, their relationship suffered. Melba's dedication to her craft and her determination to succeed built a barrier between them. "Looking back," Clem says, "Melba's early days on Broadway were the best time of our lives. She was where I could lay my hands on her. I'd drive from Philadelphia to New York to be at all her openings. She wanted to share her good times and her good fortune. Seems like I saw her more then. But lately we just haven't been as close."

"My lifestyle has been so different from Clem's," says Melba. "Besides that, our living in different towns has made it difficult to be together."

"I don't think it's just about Melba being famous," Clem says sadly. "It just seems she doesn't need me anymore. Doesn't want to be with me, and that hurts. But that doesn't dispel the fact that Melba is my sister, and if she ever calls and says she wants me or needs me, I'm gonna be there."

"Would you only be there if I needed you? Is that the only way you'd be comfortable?"

"No," Clem answers. "What I'd really like is for you to think of me as someone who you just wanna be with when you have free moments."

"I hear you," Melba says. "I understand. If we're going to be tight like we used to be, I have to make more of a special effort. Call you. Have lunch with you. Make you a part of my routine and my life. I forget to do that."

"I'm making an effort, too," Clem tells her. "I'm planning to move back to New York so these things can happen. I can't think of anything that's more important to me. You know what I'm going through, my depression and all that, and I know what you're going through with your separation. That understanding is very deeply rooted between us."

"In the old days, Clemmie, you were the strong one," Melba says, slipping her arm around her sister. "You came from a whole family and weren't crippled like I was. There was nothing for you to overcome. Me, I had to learn how to be strong. That's hard right now. I'm dealing with a crisis in my life and trying to redirect my career. So you're right; I'm feeling wounded. But there's no reason you can't be part of my reconstruction and I can also be a part of yours.

"This is the perfect time for us to help each other. We can do that. We're sisters." . . .

It would be lovely to report that after Clem moved to New York, Melba cleared a space for her in the maelstrom that is her life, and they reconnected as the inseparable duo they'd been as children. That didn't happen. There's no question these two love each other intensely. When they can manage to be together, they click instantly, sliding into girl talk about makeup, skin care, and jewelry, and singing harmony like they did as kids around the piano. But time is their enemy. "As sisters, we are very close," Melba says. "But we're not physically together enough. Now and then, we will realize that we need to be in touch more, and that priority moves to the foreground.

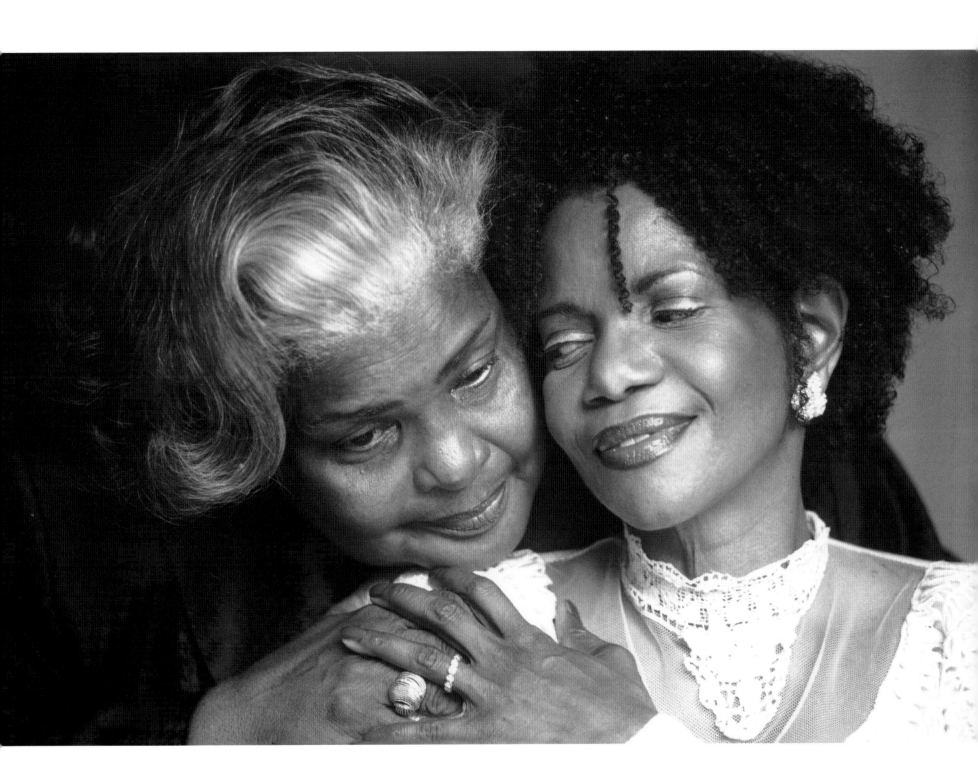

Then we get caught up with the issues of the moment, and our relationship slips again into the background."

In fairness to Melba, her issues during this past decade have been monumental. An ugly divorce left her emotionally and financially destitute. Evicted from her apartment, she took refuge with friends, declared bankruptcy, and applied for welfare. Her precious daughter cut off all contact. (They have since reconciled.) Once a star on Broadway and television, Melba was now touring in gospel musicals and singing in Florida retirement homes while she battled her way back into mainstream entertainment.

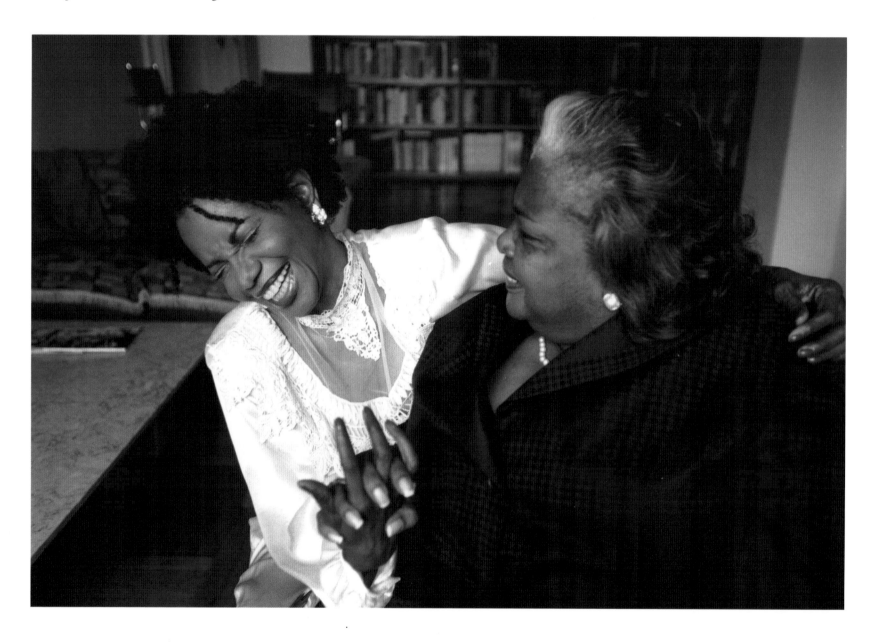

Her companion for much of that journey was her powerful born-again Christian faith. Clem attempted to help her sister, but there were periods when she didn't even know where Melba was. "I couldn't afford the luxury of intimate sisterly love then, " Melba says. "I didn't need someone to talk to. I needed answers and strategies from people in my industry, and Clem's background as a teacher is so different that she couldn't understand what was happening to me."

Ten years ago, words like that would have wounded Clem. Not anymore. "I realize now that Melba's career is the thing that drives her. So I have to step aside until she has time to get back to the relationship."

They can't create the routine of sisters who lunch and play tennis weekly. "I don't call to chit chat," Melba admits.

But she'll drop everything for a family crisis, like the death of their brother last year, when they leaned heavily on each other to ease their grief. And if Melba can sneak away from work to relax, Clem's is the number she dials. "Last spring, she called me and came to Brooklyn and stayed for a while," Clem happily relates. "We laughed. We went to dinner. We spent some real good time together. Everybody loves Melba. She's so quiet. She's such a center of peace. You could say we have these droughts of nothingness and then a holiday pops up. It's always a holiday when we're together."

"We love each other very much," Melba affirms. "We just have a totally different lifestyle."

"We'll never fight," Clem points out. "And I'm going to share her pain—and her joy—whenever I can." ■

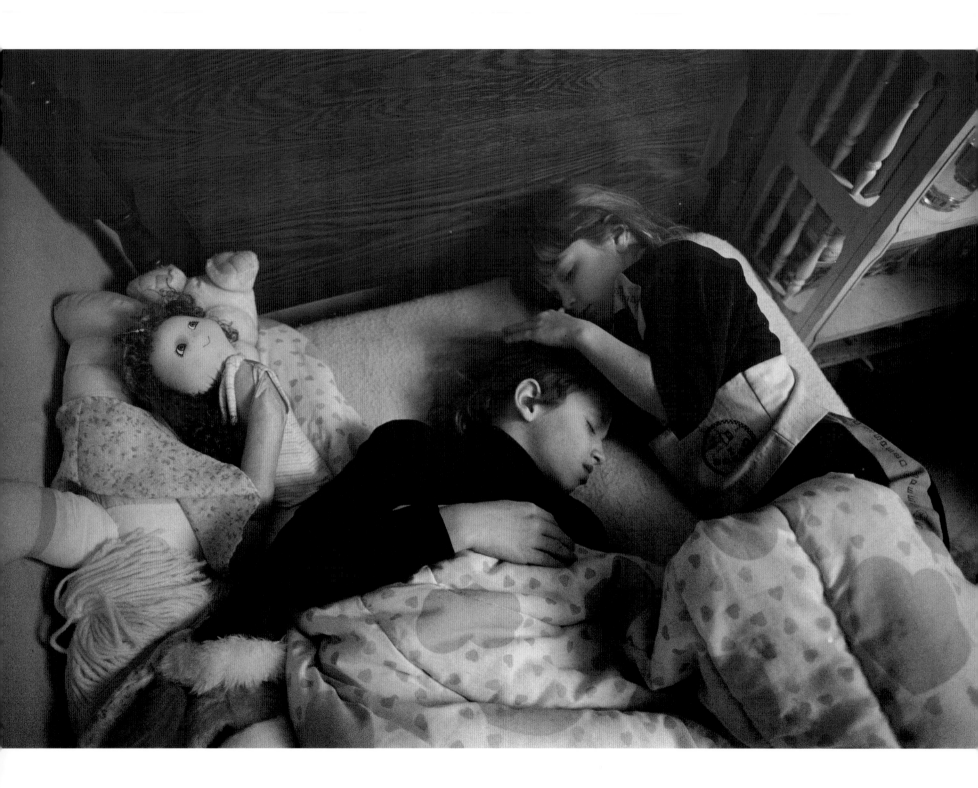

Whitney and Becky:

The Williams Sisters

On a bitter cold day in January, Whitney Williams celebrated her 11th birthday at a lively party held in an indoor amusement park near her home in suburban Chicago. Between coughing bouts that wracked her thin body, she and her girlfriends rode the Ferris wheel and the roller coaster, shrieking as the rickety cars careened up and down the noisy little track. When it came time for her to blow out the candles and eat the cake, Whitney closed her eyes, clasped her hands, and asked God to find a cure for AIDS.

Whitney wasn't merely making a sensitive birthday wish. She was pleading for her life. There are approximately two thousand children in the United States suffering from AIDS, and Whitney is one of eighty-five particularly baffling cases: Doctors have no idea how she became infected with the AIDS virus. Her parents are both HIV-negative. She's never received a blood transfusion or been sexually abused.

When Whitney discusses her illness with adults, she speaks like a wise old woman. "I'm not afraid of dying," she says coolly and calmly. "It's stupid to be scared. I have strength inside my heart. I don't think God will take me this early."

But in an unguarded moment, lying in bed next to her seven-year-old sister Becky, she awakens from a bad dream and forgets to put on her mask of maturity. "Becky," she sobs. "I had this nightmare that I was dying. I was lying in my casket and Mommy was standing there crying because she couldn't help me."

Becky wipes her sister's tears. "That's why I like to sleep with you. So I can cuddle with you and protect you from nightmaries."

"It's nightmares, not nightmaries, and, to tell you the truth, cuddling doesn't help much with nightmares. You have to remember what I told you."

"You mean about guardian angels? You told me that when we sleep a guardian angel watches over us. And when you go to heaven, you'll be my guardian angel sister. Only when I wake up in the morning you won't go away. You'll stay with me all the time and you'll give me hugs. Only I won't be able to hug you back because my arms will go right through you." . . .

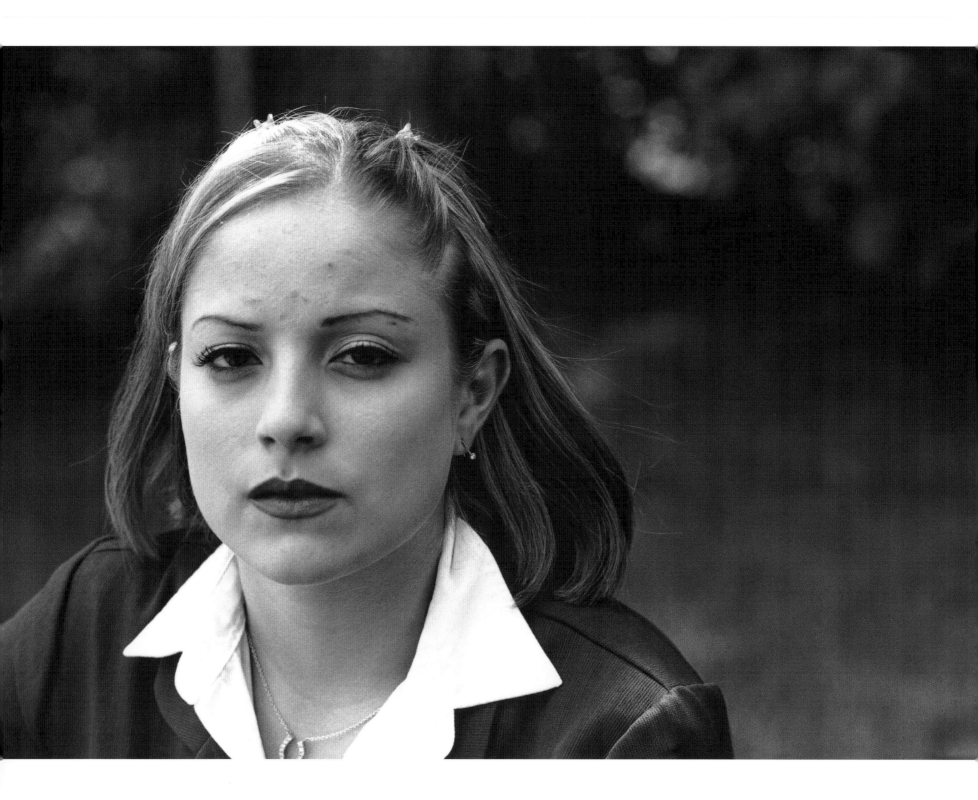

A few minutes after five PM on the Tuesday before Mother's Day, 1997, Whitney Williams died from complications related to AIDS. She was 15 years old.

That particular spring day was warm enough for her sister Becky to wear shorts to school for the first time. When the call came from the principal's office summoning her to the hospital, she started to shiver and couldn't stop. Later she borrowed a sweater from her grandmother that she never remembered to return.

"I knew right away something was going to happen," she says, speaking very slowly and fighting not to cry. "On the way over I tried to prepare myself. 'What do I say? How do I deal with this?' Whitney looked so sick when we got there, like it wasn't even her. The nurse by her bed said, 'You can tell when someone dies from their last breath.' Then Whitney took the deepest breath ever. The nurse grabbed her hand and said, 'She's gone.' And I was like, 'Oh my God. What do you mean? You have to bring her back.' I was stunned. My hero wasn't here anymore. I walked out of the room and just kind of melted."

At the huge funeral, Becky was one of many speakers. Through great gulping sobs, she talked about the brave, optimistic, amazing person Whitney had been and of all the things the sisters liked to do together—color, cook, chatter away hours swinging on the tire in the park. How Whitney helped her with school work, especially creative writing. How they laughed and cried at exactly the same scenes in movies. How Whitney would light up a room. The way people listened to her and respected her opinion. She was so strong. So strong.

When you are 12 years old and your sister dies, you can't imagine what your life will be like without her. By the time you reach 18, the emptiness has rooted in your bones and you know what it means to live with sorrow.

"I never disown Whitney. If somebody asks me whether I have a sister, I always say that I do, but she's not physically here with me. Sure we fought about stupid things like all sisters do, but we made up. I get jealous when I see sisters together. It really upsets me if they're fighting and yelling things like, 'I hate you.' *Hate her!* Don't say that. You don't know how it feels not to have her.

"There's so much I miss about Whitney. I miss not having her here to hold me and say everything will be okay, like she always did when my parents fought. I miss her honesty. People lie so much to make you feel better; she was honest even when you didn't want to hear it. I'd love to turn to her now as a sister and ask her advice about boys and college. I'm trying to make so many decisions on my own, and I can't really go to my parents. If my sister were here, she could help me.

"On my 16th birthday I broke down, because Whitney didn't have her 16th or her 18th or her 21st. There was so much she deserved that she didn't get. Why should I? It isn't fair. I think a lot about those things she never had. What college would she have gone to? What kind of car would she drive? Would she be married? We used to plan our weddings. We both wanted big white dresses with long veils and flowers down the back. Whitney didn't want any kind of red roses—she hated them—so we said we'd have pink roses and sunflowers. I wrote it all down, and when I have my wedding, I want her to live it through me."

Whitney had promised Becky that one day she'd be her guardian angel, and Becky believes she's kept her vow. "Sometimes when I get sad or feel really down I wonder, 'Where are you, Whitney? You said you'd always be here.' Then I feel her positive vibes and, weird as it sounds, I'll talk to her. I'll tell myself, 'Think like Whitney. You can fix this.' She's the angel in my head, reminding me that she saw so much potential in me. She always said that I could do whatever I wanted—as long as it didn't have a deadline. I'm not good at deadlines. I know if she were here, she'd push me to be successful. And I really want to make her proud of me.

"My biggest regret is that as close as we were, I never really expressed how I felt. I should have said 'I love you' more. I could have done a better job. I always told her 'You're awesome' or 'You're cool,' but I never said the words, 'I love you.' And now I can't." ∎

Tamara and Deborah:

The Hadley Sisters

"One of the most interesting things about our careers is that neither one of us set out with any dreams of ever being ballerinas," says Deborah Hadley, principal dancer with the Seattle-based Pacific Northwest Ballet. Tamara Hadley, her younger sister, a principal dancer with Philadelphia's Pennsylvania Ballet company, nods. "We danced because it was fun, but I tried to quit every summer. I hated getting sunburned and having to wear those scratchy leotards. Mommy would say, 'Just hang in there,' but I dreaded it. Then in winter it would be all right again. But, no, I never longed to be a ballerina. I liked my classes but I never liked the competition. Neither of us were ever bun heads. We didn't eat, drink, think ballet, and get like little toothpicks."

Like it or not, they would ultimately have to deal with competition. But while they could not control the rivalry among other dancers, they found a way to prevent it from destroying their own close relationship. Once they became professional ballerinas, "dancing together just wasn't ever discussed," Debbie says. "We always knew it was healthier for our careers to be totally separate."

The establishment of their careers was choreographed in a rocky point-counterpoint rhythm. Deborah hit stardom early when, at age 15, she was plucked out of her hometown San Diego company by the Jeoffrey Ballet in New York. A negative experience in the Big Apple soon soured her on the dance world, and she quit, got married, and had children. But she always remained peripherally involved in ballet, taking classes and appearing occasionally on the local stage.

Meanwhile, in high school, Tamara packed away her toe shoes to be a cheerleader and gymnast instead. Five years later when she returned to ballet, she had a very different attitude. "You can't do ballet half-assed," she says. "I buckled down, lost ten pounds, got serious, and realized I loved to dance." Now it was her turn for success. She was signed by the Pennsylvania Ballet and moved to Philadelphia, leaving her sister behind in San Diego.

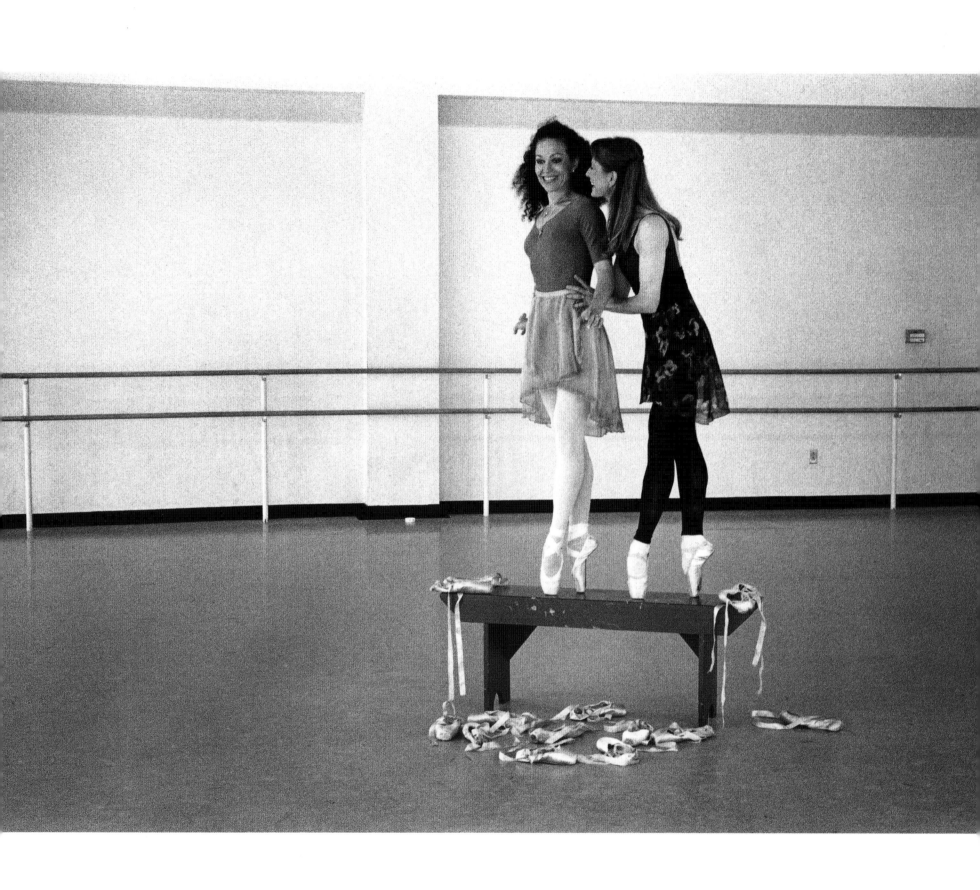

Six years passed. Deborah, at what she calls the lowest point in her life, living on food stamps, coping with a failed marriage, and raising two children, came to visit Tammy in Philadelphia and was persuaded to take a company class. In no time she was hooked all over again. "It was like, oh my God, I can't believe how much I missed this. But who would hire a divorced 27-year-old with two kids who hasn't danced in five years?" How about a friend of her sister's who'd just started a new ballet company in Seattle? Debbie pawned her inheritance—her grandmother's ring—to pay for the airfare to attend an audition and was hired on the spot.

That is how these two sisters wound up dancing on opposite coasts. Ironically, they both perform in Balanchine-oriented companies with similar repertoires, where they typically dance the same roles.

"It's so great," says Tammy, "to pick up the phone, ask 'What are you doing this season?' and have this common ground of sympathy for the demands of the role. Oh, you've got to do that grueling variation. That's too bad. Or, oh you'll get to do blah, blah. That's fun. We give each other the inside scoop on choreographers, too. We have this base that we feel and work from, and

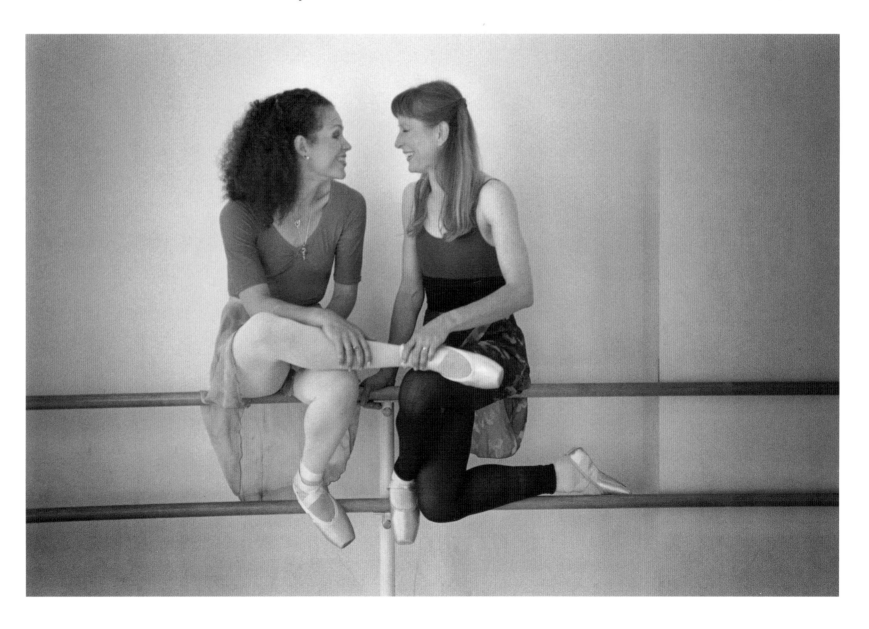

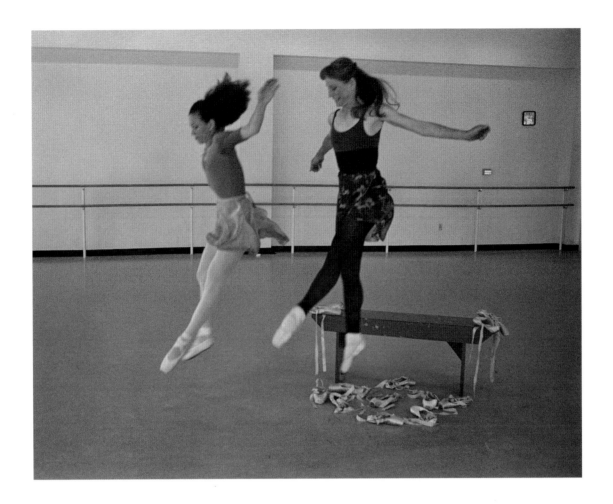

it has nothing to do with how often we talk or see each other."

"It's fabulous to be able to have that really sympathetic ear where you know the other one really, really knows," says Debbie. "It's given us a mutual respect for what the other has done because we've both done it and know how hard it is."

Throughout their careers, the sisters have danced on the same program only once, at a festival, and that was by choice rather than by accident.

"It's not because we're competitive or jealous. We've never been," Tammy explains. "Mother did not pit us against each other. It was always praise, praise, praise. It's that the dance world is such a closed circle. So gossipy. If we danced together somebody would say, 'Her feet are

better than yours.' Or 'She does this better than you.' Why set yourself up for that? We thought it would be smarter to be in very distant companies so that we wouldn't ever be compared to each other."

"People have tried all along the way to compare us," Debbie says, "and we just never buy into it. They want to see us perform together on the same stage, and we say, 'Are you kidding? Just forget it.'"

"Besides," says Tammy, "I think she's better than I am and she thinks I'm better than she is."

"Our relationship has never been in jeopardy," Debbie says. "We are as close as two people could be. No matter how far away we are, there is this base that we feel and work from. The only reason we've stayed separate is to protect our careers." ■

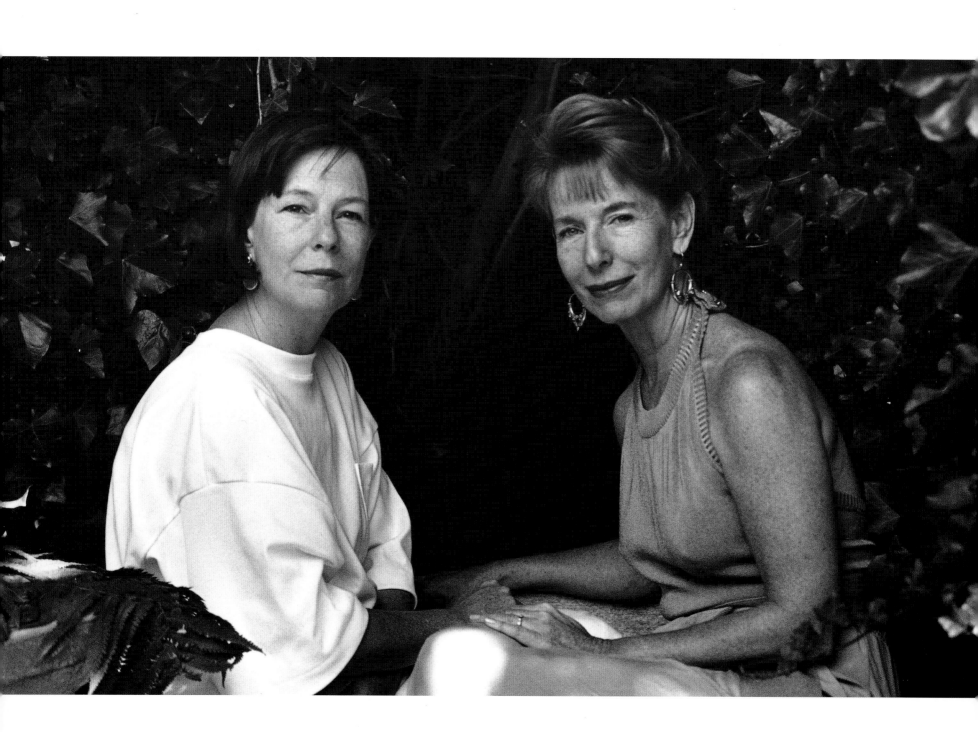

Pat and Gail:

The Henion Sisters

"I remember I'd come back early from a Saturday playtime and walked in on my parents making love," says writer Gail Sheehy, becoming for a moment a precocious eight-year-old with a wicked secret.

"It was quite shocking, and they had to immediately come up with some kind of cockamamie story as a cover. They said they were trying to make me the sister I wanted. That was great, because now they had to deliver the goods or I wouldn't have believed them. I giggled to myself all day long. This was really neat. They were finally going to do what I'd been asking them to do for years." Just about nine months later, Pat was born. "It was amazing," Gail says with a tender smile. "Here was this live baby. Someone to play with and love. Just a delightful addition."

The nine-year age gap between the two sisters eliminated the potential for competition, and also defined their roles in the family. Gail easily played the part of the older, wiser, grown-up. Trish, as Gail calls her, acted out the adorable child. But for these sisters the beauty in their relationship turned out to be its changing nature.

"Once you move out of the family household," Gail says, "you don't have to be the good-deed sister or the obedient sister any more. There's no specific role one must play with one's sister. With husbands you have a love contract and matters that need negotiating. With children you have all the complications that come with resenting advice and direction. But with your sister, there is no ulterior motive. Nothing done out of obligation. How you are depends on where you are and what you need from each other. For Trish and me, our adult phase started when we went to Paris together.

"I was 29, already slightly bruised, in turmoil from the end of my first marriage and raising a daughter alone. Trish was 20, a kid kind of sprouting, coming to visit me in New York for two weeks on her way to Boston. Then I got an assignment from *Cosmopolitan* to fly to Paris, go out with three sexy Frenchmen, and find out why they're the world's best dates. I arranged to get Trish ticketed as my researcher and took her along. It was a gas! I'd only been to Europe a couple of times; she'd never been outside

the country. It was so delicious to show this to someone you love. We had a marvelous hotel and stayed in a room with big shutters that opened onto a courtyard. I still remember the sun streaming in every morning. It was this great new world and we were experiencing it together.

"Later, we went to Ireland and as we were driving along, one of us said, 'We're like those sisters who wrote *The Joy of Cooking!*' They were two women who'd never married, and they realized they were going to spend their lives together, but neither one knew how to cook. So they learned together and wrote this cookbook and just enjoyed life with each other. This will be Trish and me, I thought. We'll always play together, have adventures, find ways to have fun. I very clearly recognized that something had happened, a whole new possibility in life. We didn't have to be big and little sister anymore. We could be friends. We could be pals."

Pat has been listening thoughtfully, and laughs softly. "Well, I was like the man who came to dinner. I still haven't left New York. That trip did set up the shape of our relationship. The second thing that molded it was taking care of Mom over a period of years when she was ill."

"That's one of life's tasks you don't learn in school," Gail says. "We did it well, really did it well. Somehow we learned to pass the baton between us."

"There was definitely a give-and-take," Pat says. "I might get a phone call, a distress signal, and I'd call Gail to tell her about it and what I was doing. She'd make suggestions, sometimes prop me up. Her efforts would keep me going."

"Once we went down and found Mom in a desolate state," Gail says. "All huddled up and turned in on herself. We began opening her up by massaging her, rubbing her feet, taking her into the shower, washing her hair, getting her into the sun. It was one of the most loving interactions I can ever remember because there weren't any words between us."

"Just physical things," Pat continues. "Later we'd say how happy we were to have each other there. Can you imagine going through this alone? We didn't have to elaborate. We both knew exactly what we meant. I think that experience took our relationship to another level. Made us more conscious that as we get older we might need that kind of care and one of us might be giving it to the other."

"We actually had some belly-splitting laughs outside that hospital room," Gail says. "It's so easy to be jovial around my sister because she knows how to make me laugh—and laugh at myself. She offers me laughter and forgetting. Takes me out of my head. That gives me the extra boost of energy to do the next mile and the next."

"When it comes down to who's going to empty Mom's bedpan, you have to have a sense of humor," Pat says. "Gail supports me, too. It's very important to both of us to keep things on an equal footing. She gives me intellectual stimulation. Sometimes financial help. She's encouraged me to go on with my education—I'm getting a Masters in English at Hunter College. Lately I've been concerned about what I call the wild-woman side of Gail, the part that loves physical challenges. She doesn't do enough of that because she spends

so much time writing at the word processor. So I told her I'm taking over her physical activity, making arrangements to go kayaking and things like that. Maybe we'll do an Outward Bound together."

Pat and Gail's relationship works because they work hard at nurturing and protecting it. "Sometimes the boundaries are getting uncomfortable or we're falling into a funny pattern," Gail explains. "And even though we live close by, one of us will write a long letter and the other will always respond with a long answer. We get it all out before a misunderstanding creeps underneath, like a vine that's all twisted. We write each other thank-you notes, too.

"Ever since our trip to Paris, we haven't taken our relationship for granted. I always remember what I felt then. My marriage was ending and I said to myself, 'Husbands come and go; children come and eventually they go. Friends grow up and move away. But the one thing that's never lost is your sister.'" ∎

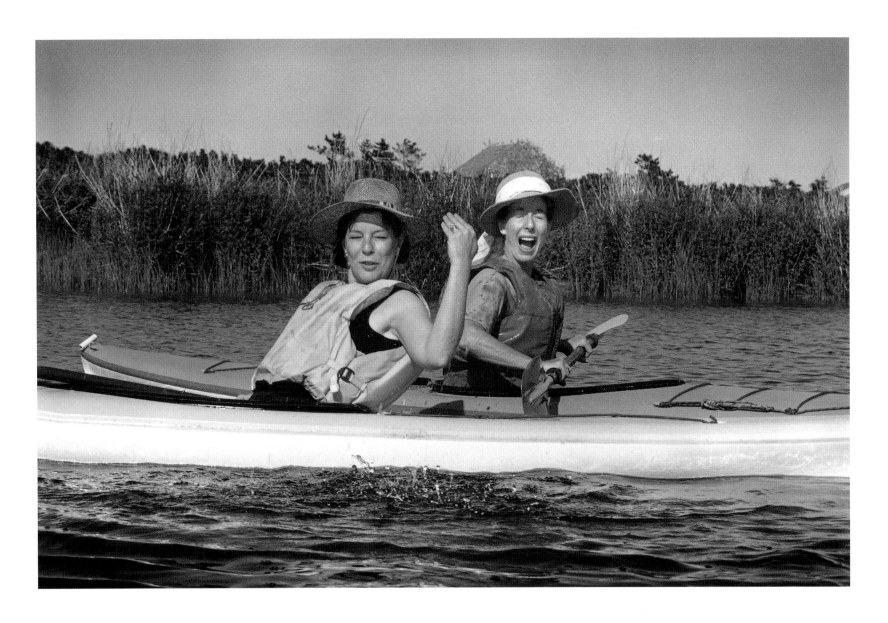

Hope and Mary Binney:

The Montgomery Sisters

"We are three years, one month, one week and two days apart, and Hope is older," Binney announces.

"That's why I'm so protective," Hope retorts. "I always used to beat up anybody who bothered her, and I still protect her. Two years ago Binney broke her hip in India—she was there taking pictures for her lectures—and I got her out by calling our dear friend, Walter Annenberg, in California.

"It was New Year's Eve and I told him, 'My sister is stuck at Heathrow Airport with a broken hip and no way to get out for four days.' Well, it was awfully lucky that Walter happened to be with Richard Nixon and the British Ambassador. They called British Airways and bumped four people because she had to be out flat. You see, we always help each other."

Binney nods in agreement. "She helped me, all right. She got Walter and made it happen. She has this will to get things done."

Hope and Mary Binney have been standing up for each other since they were little girls, even though they chose different paths. Hope became an athlete; Binney, an artist.

"I knew so little about fine art that I thought Goya was a gigolo I met in Paris," Hope says. "I can't tell you why we have this tight bond. Our lives today are totally different, except for how we give parties. Mother trained us how to set a table, to entertain, and be charming. But we never did anything together, so there was never any rivalry."

"I respect my sister very much because I feel she's honest," Binney offers.

"But dear, you're honest, too," Hope counters.

"I know that when Hopey was sent away to boarding school, I missed her terribly and thought it would be wonderful if I went, too. But mother said no."

"I wanted her to come. She was part of my life."

"We never had any secrets from each other. Hope told me never to keep secrets."

"I told her all the things I learned and I always had the greatest respect for my sister because she was so artistic," Hope says. "We had a dancing class in the house and Bin was the star. She moved beautifully. Even did toe dancing. I could never do that."

"Not so," Binney says. "You were very good."

"I was terrible. One time I did this Russian dance and I was stiff as a ramrod."

"It was Hungarian to the Rhapsody by Brahms, and no, you weren't."

"Do you remember when father leased that sailing boat and we spent the winter on the Nile?"

"You were 17 and I was 14 and we decided to fall in love with one of the sailors. Of course, we never spoke to them. We just spent our time waiting for them to climb the mast so we could look at them. I remember I'd just turned 14 and I was so excited, because I thought now everyone would come calling on me as they did on Hope. She said I shouldn't count on it, and she was right. Hope always had more beaus than I did. The night she decided to marry Edgar she had five other proposals that very evening."

These memories are still vivid, part of the sisters' connection, forged long ago in the bedroom they shared from childhood to adolescence.

"We lived in a huge house, but mother put us together because it was more convenient," Hope recalls. "Every night we had this unbreakable ritual. We'd kneel down together and say our prayers. Then we'd kiss each other and get in bed. That was our time to talk. There was always so much to talk about. After we talked, we'd say this little rhyme we'd made up, alternating the parts until we got it all out. 'Good night . . . Sleep tight . . . No dreams . . . I hope you don't wake up . . . Stay tucked in bed . . . Go right to sleep . . . No more talking.' And we'd touch hands with each other. We never went to bed without touching hands."

162

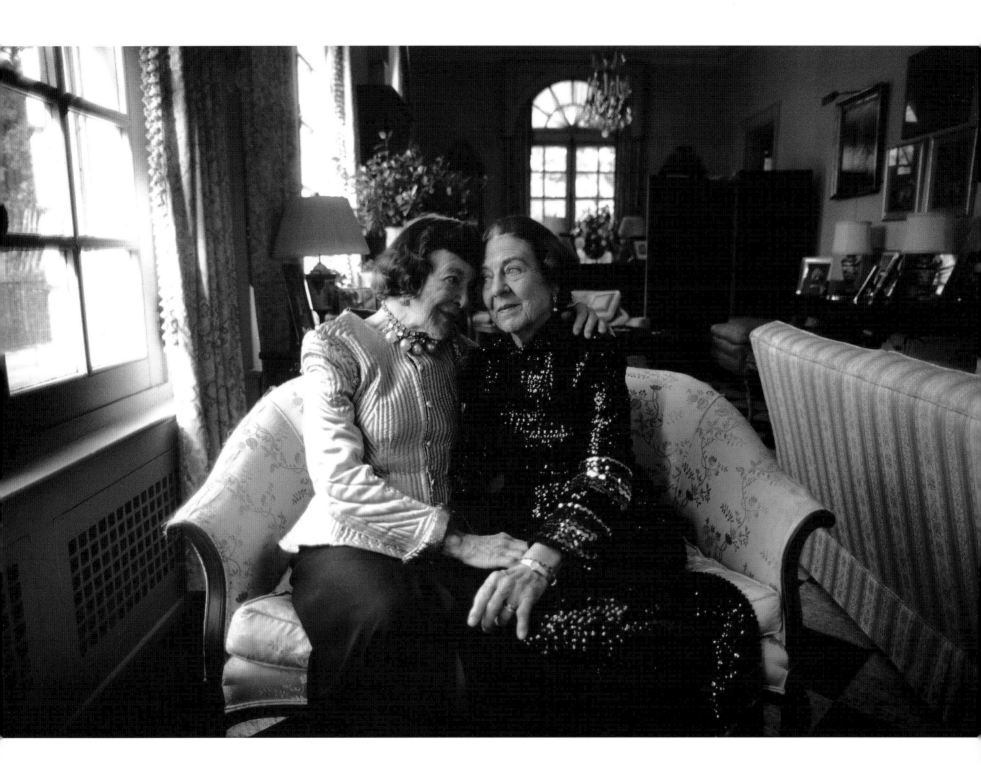

These two girls, growing up like princesses on a 750-acre estate with thirteen servants, sharing a tutor, a governess, a playroom, and a bedroom followed very different paths. Hope became a nationally-known championship horse-woman, one of the first to ride in Madison Square Garden, and today manages a large working dairy farm. Her willful, madcap personality was the inspiration for the heroine in *The Philadelphia Story*, written by Phillip Barry, a family friend. "It was really about Hope's attitude, not her life," Binney says. "She's been married for 68 years. And my sister is much prettier than Katharine Hepburn."

Hope graciously deflects the compliment. "I did want to do everything and know everybody. I loved people and parties." Indeed, she succeeded—from sharing deck chairs with Winston Churchill on the Onassis yacht to meeting every American president since Roosevelt.

Binney, by contrast, pursued a life in the arts. She was a fine enough pianist to play once with the Philadelphia Orchestra, but, put off by stage fright, she turned to dance, and founded and ran a ballet company for ten years. She ultimately became a published photographer. And, in her own way, she, too, was an iconoclast. Tired of waiting for the man of her dreams, in 1940 she adopted two children.

"I was determined to have a family even if I didn't have a husband. Then, one night I went to a dinner party and there was a beautiful man sitting next to me. I played the piano after dinner as well as I could to attract his attention, and afterwards we danced on the carpet." Within four months, they were married. Eighteen years later he died, and she never remarried.

Two remarkable women. Two highly individual lives. Yet they've remained as close as they were seventy-some years ago when every night they reached out and touched hands before they closed their eyes.

"You see, it doesn't matter whether or not we had similar interests or lifestyles," Binney says. "We learned to love each other as children, and we never stopped." . . .

On an unusually mild January day in

1995, Hope was leading her three donkeys in from the paddock when one of them bumped into her, causing her to fall and hit her head. With characteristic moxie, she ignored the blow, walked into the house, and kept an appointment with a beautician who'd come by to cut her hair. Later that day, her son Robert returned home and, as was his habit, stopped to check on his mother in her bedroom where she normally took her afternoon nap. The bed was empty. Then he spied Hope's slender legs sticking out from the bathroom doorway where she'd fallen a second time, felled by a cerebral hemorrhage. She tenderly reached for his hand, kissed it, and fell into a coma. As the emergency squad carried Hope's inert body into a Medivac helicopter parked on the lawn, her 96-year-old husband, slumped in an armchair, momentarily emerged from his forgetfulness to mutter a poignant good-bye: "There goes my darling." Hope died the next day, a few months shy of her 91st birthday.

Hope's death devastated her sister Binney, who'd spoken to her on the phone nearly every day of their lives. Binney ruefully confided to her daughter, "Well, at 88, I finally got to be the oldest of my siblings—and I don't like it one little bit." She survived Hope by only four months, her life ending just as the April crocuses began to poke their shoots through the thawing spring soil. Binney had just finished delivering one of her slide lectures on travel in India to a group of matrons gathered in her elegant living room. After the guests had departed, she invited her projectionist to join her for a drink. He heard a thud, turned around, and Binney was dead on the floor.

Befitting the grand dames they'd been in life, Hope and Binney took their leave with their dignity intact. No prolonged suffering. No bedpans. No pain. Feisty and vigorous to the final moment. Loving and devoted sisters to the end. ■

The Editor

GÖRAN CEDERBERG is an enthusiastic, experienced flyfisherman and contributes regularly to Scandinavian sportfishing publications. He was the editor of Nordbok's "Complete Book of Sportfishing", and has been the project leader of the present volume on flyfishing – responsible for editing, the choice and arrangement of illustrations, and adaptation to the international public. Göran Cederberg has written Chapters 1 and 3.

The Authors

STEEN ULNITZ is a fishing journalist whose specialty is flyfishing. He contributes to a number of European fishing magazines and has written several books on fish biology, flyfishing and flytying. His experience with flyfishing covers almost all corners of the world. Steen Ulnitz has written Chapters 2, 5 and 8.

BENGT ÖSTE has contributed for many years to Scandinavian sportfishing publications and was previously editor of the journal "Flugfiske i Norden" (Flyfishing in Scandinavia). His books, TV programs and articles have been a main force in the development of flyfishing in still waters, notably in Sweden. Bengt Öste has written Chapter 4.

ARTHUR OGLESBY is without doubt one of the "grand old men" of English salmon flyfishing. He is a well-known casting instructor, with the Spey as his home water, and has written both books and a large number of magazine articles. In addition, he is a staff member of "Field and Stream". Arthur Oglesby has written Chapter 6.

LEFTY KREH is one of the world's authorities on saltwater flyfishing and an able commentator on the scene in North America. He has written several books and a wide range of articles on coastal and sea fishing with flies, for tarpon and bonefish as well as other big sea game. Lefty Kreh has written Chapter 7.

The Illustrators

GUNNAR JOHNSON has created most of the illustrations in this book. He is well-known as an artist when it comes to fish, animals and nature – and as an illustrator of books and magazines both in Scandinavia and elsewhere. Also editor of "Flugfiske i Norden" (Flyfishing in Scandinavia), he has written several books about flyfishing.

TOMMY GUSTAVSSON is a graphic designer, illustrator and nature-painter. Being a devoted flyfisherman as well, he has contributed beautiful water-colours to this book. For many years he has published articles and illustrations in the sportfishing press, mainly in Scandinavia, and he has illustrated several other books.

Contents

CHAPTER 1

The evolution of modern flyfishing

GÖRAN CEDERBERG

Flyfishing's early history
The sport and its literature
The great pioneers
How methods and equipment have developed
PAGE 4

CHAPTER 2

The fish, the insects and the fly

STEEN ULNITZ

The flyfisherman's prey
Where, when and how fish eat
Insects – the natural prototypes
Flies – our deceptive imitations
PAGE 20

CHAPTER 3

Equipment and casting techniques

GÖRAN CEDERBERG

Rods, reels, lines, leaders and flies
Casting with a single-handed rod
Casting with a double-handed rod
PAGE 68

CHAPTER 4

Flyfishing in still waters

BENGT ÖSTE

How to read the water
Tactics and techniques
Choosing equipment
Flies for still water
PAGE 90

CHAPTER 5

Flyfishing in streams

STEEN ULNITZ

Holding places and types of rise
Essential equipment and its proper use
Methods and how to vary them
Catch and release
PAGE 126

CHAPTER 6

Fishing for salmon and sea trout

ARTHUR OGLESBY

Selecting equipment and flies
Casting and presentation
Where, when, and how salmon take
Practical methods of flyfishing
PAGE 168

CHAPTER 7

Saltwater flyfishing

LEFTY KREH

Fishing in shallow and deep waters
Locating the fish
How to present the fly
Types of saltwater flies
The tide's influence on fish
PAGE 206

CHAPTER 8

Flyfishing dream waters

STEEN ULNITZ

Scandinavia's best waters
Eldorados in North America
Sprinters on the "flats"
The European classics
PAGE 220

Index

PAGE 234

For the confirmed flyfisherman, the great adventure beckons from all waterways. Every ripple becomes an attraction, and each shadow on the bottom is a challenge. With a devotion which seems obsessive to outsiders, we can devote days and weeks, indeed months and years, to our attempts at catching fish with our ingeniously tied decoys. Yet only in happy, and often all too brief, moments do these monumental efforts yield the desired returns.

The long time which generations of more or less successful flyfishermen have spent on different fishing waters around the world – in studying insects, observing the behaviour patterns and eating habits of fish, choosing flies, and casting at real or imagined quarry, as well as contemplating the always fascinating diversity and unpredictability of nature – has naturally resulted in an amazing store of knowledge about the conditions and requirements of flyfishing.

To give a coherent picture of where modern flyfishing stands today is a difficult task, though not a hopeless one. No other type of fishing has so many common denominators and so few national peculiarities as flyfishing.

The flyfisherman's prey, consisting primarily of salmonoids, are generally the same everywhere, as are our equipment and the types of water in which we choose to try our flies. To be sure, insect fauna, and therefore their elegant – if also inadequate – imitations, vary from region to region. Yet the fact remains that the principles for tying, selecting and presenting a seductive imitation to an often highly fastidious fish are, on the whole, quite similar.

Göran Cederberg

The evolution of modern flyfishing

*Flyfishing is
undeniably more a way of life than
a mere hobby or an everyday sport. Being a
flyfisherman frequently means a special
attitude towards the nuances
of nature on and under the water surface.
Qualities such as watchfulness, good
observational ability, patience, imagination,
and reaction speed are often ascribed to a
clever flyfisherman. To this can
be added an almost scientific accuracy in
studying what the fish eats, as well as
where, when and how it
consumes its food.*

It should be emphasized, to begin with, that flyfishing is an extraordinarily effective method of fishing – on many occasions superior to any other technique – and that successful fishing with more or less close imitations of the fish's natural prey is essentially the result of experience.

Flyfishing is by tradition associated mainly with fresh waters, in particular flowing waters. Trout and salmon are the classic quarry, perhaps due to their strength and willingness to bite. But during recent years other species have also become interesting, such as grayling, char, pike, perch and bass. Besides, many of us have discovered the terrific excitement of using a fly rod to challenge saltwater species which are undoubtedly magnificent opponents, despite their lack of an adipose fin.

In fact a dramatic evolution of flyfishing has occurred during the twentieth century alone. From the English chalk streams, where only small and exact imitations of insects could be used, to flyfishing with large, hairy saltwater flies for tarpon and other great fighting fish on the flats in North America, is a very long step. An important link in the sport's development has also been the early spread of English flyfishing to colonial lands, such as Australia, New Zealand and parts of Africa. Flyfishing in the United States was originally also based in large part on the English flyfishing tradition, as are many classic fly patterns which are now well known: March Brown, Greenwell's Glory, Butcher, Red Tag, Teal and Red, and Zulu are a few random examples.

The history of flyfishing is, of course, relatively brief. This is eloquently illustrated by the fact that several of the flyfishermen who have had great, even decisive significance for the sport have lived into the middle of our century. It is also noteworthy that rapid changes have often been due to

Greenwell's Glory, one of the classic English wet flies which are still popular among many flyfishermen.

provincial ideas which won new enthusiasts, who in turn have refined and passed on innovations from the viewpoint of their own special conditions.

It is admittedly impossible to present a true picture of flyfishing history without granting a leading role to England and its many forward-looking flyfishermen. After all, the cradle of the sport once stood in that country. Still, we may thus be underemphasizing developments which have occurred elsewhere in the world and which have played a momentous part in the growth of modern flyfishing over the last half-century. Developments not least in the United States and Scandinavia have been extremely rapid. In addition, new ideas are spread like the wind today through the mass media and tend to sow revolutionary findings.

Which, then, are the principal ingredients in the mixture of achievements which we shall use to weave our delightful tale? The development of flyfishing in literature, and the authors who have been and still are active? The evolution of equipment from natural materials to the high-technology products of the space age? The progress of the art of flytying and the advent of new, more practical materials? Or is it simply the case that the history of flyfishing can be told on the basis of careful observations which attentive flyfishermen have made in order to learn more about the behaviour of fish and their food on diverse waters?

Well, the truth is probably that in such a historical drama, neither discoveries due to exact observations while fishing, nor the seemingly inexorable march of progress toward the high-tech society, should be excluded. It must also be kept in mind that a number of leading personalities continue to have a great influence on the development of the flyfishing which we call modern.

The beginnings of flyfishing

Archaeologists believe that the fishing hook was discovered sometime around 30,000 years ago in southern Europe. The hooks, which were eventually provided with barbs, were first manufactured of bone and probably also of different wooden materials. But just when man first found that feather-covered hooks could be very effective fishing equipment is shrouded in the mists of time.

The first literary description of flyfishing comes from about the year AD 200. In his book *On the Nature of Animals*, the author Claudius Aelianus described how people fished with a fly in the river Astraeus in Macedonia. The prey is presumed to have been trout, since it had a "spotted exterior". To judge from this description, the Macedonians fished with hooks which had been covered with red wool and wax-coated cock feathers. These feather creations presumably were more reminiscent of today's jigs than of flies, but we have no reason to doubt their fishing ability.

Although these true pioneers of flyfishing probably fished mainly for their daily food, that naturally does not mean that the Macedonians found no pleasure in fishing with a rod, top-knotted line and flies.

It was not until the end of the fifteenth century – to be exact, the year 1496 – that we find the first certain proof that people fished with flies for the sake of the sport. In her *Book of St. Albains*, Dame Juliana Berner described fishing methods of the time in an article entitled "A Treatyse of Fysshynge Wyth an Angle". This shows that feather-clad hooks were also used as prey.

Dane Juliana Berner is believed to have been the abbess of a Benedictine nunnery in Sopwell. Her article, written in 1425 and subsequently hand-copied by monks until it was printed seventy years later, is absolutely decisive for the early development not only of flyfishing but of sportfishing in general. Here too is described, in detail and for the first time, how fishing for trout and salmon was conducted with artificial flies. She had discovered, among other things, a seasonal regularity in the insects which she observed on her fishing waters. Her conclusion was that the fish's choice of diet depended largely on the supply of swarming insects. With her observations of insect life as a starting point, she developed twelve different fly patterns – one for each month – which are so well described that a flytier today can tie them without much trouble.

Dame Juliana's "Treatyse" had a considerable impact on sportfishermen's attitude to their sport for a long time afterward. The "proper" fisherman had to be an idealist, a philosopher and a nature-worshiper, and had to master the sport down to the smallest details. The perfection of the sport, flyfishing, meant for example that the fisherman should build his own rods, twine his lines and tie his flies. He should on the whole possess the qualities of the true sportsman. The greatest pleasure was indubitably provided by the fish which was hardest to overcome.

In this connection it should obviously be pointed out that the entire *Book of St. Albains* was devoted to the greatest arts of the age, such as heraldry and hunting, and that it was written for nobles and gentlemen. Thus to the great arts was now added fishing with a rod, line and hook for the sake of pleasure and as a source of recreation. At the same time Dame Juliana devoted her work to all virtuous, well-meaning and freeborn individuals – in other words, not only the upper class. With that, the basis for a long tradition was laid.

Fishing equipment in those days was described as consisting of relatively simple tied flies, long rods of ash, hazel and willow, and lines braided with horsehair. The rods, which are assumed to have been about 15 feet (4.5 metres) long, were made of two parts joined by iron or tin links. We may imagine that it could be problematic to play large fish with this primitive gear.

The next milestone in the development of sportfishing was *The Compleat Angler*, which appeared in 1653 and was written by Isaak Walton, then aged 60. In 1676 it was expanded with a section on flyfishing by Charles Cotton. By now the book has seen almost 400 editions and been translated into many languages. With time it has become one of the real classics in fishing literature.

Charles Cotton's flyfishing section has been widely regarded as very significant for the progress and orientation of flyfishing until the beginning of the nineteenth century. He can therefore be called something like the founding father of modern flyfishing.

Through the book's dialogue between Mr Piscator and Mr Venator, we get a good view of how fishing with a rod and hook was done at the time. The tradition from Dame Juliana Berner is clear: fishing was done for enjoyment and was in large part a means for the romantic adventurer to experience nature. We follow the writer to remote brooks and rivers where he is forced to use all his knowledge in order to vanquish the elusive fish, accompanied by the babbling of waters and the song of birds.

Izaak Walton was no devoted flyfisherman, but he undoubtedly became one of the great founding fathers of sportfishing. In the inset picture below, we see his fishing basket, now kept at the Flyfisher's Club in London.

The Compleat Angler may also be called the first true handbook of sportfishing. In lyric phrases it describes not only the eating habits of fish and their resting places, but also how to go about luring them onto the hook with all manner of baits, as well as how to serve up the catch.

Fishing equipment during the seventeenth century was simple and not very different from that employed in Berner's time. The rods were often made of jointed wood, long and – by our standards – colossally clumsy. The lines were made of twined horsehair and, since no reels were available, they were top-knotted.

The breakthrough of split-cane rods

Progress in improving fishing equipment was quite slow. In the mid-1660s, however, hooks began to be made more durable by hardening them. Plagues and fires forced needlemakers, among others, to move out of London. Redditch soon become a center of hookmaking, and the old handicraft of smithing was transformed into a large-scale operation. Industrialization also brought with it improvements in the quality of hooks: they became thinner and lighter, though still thick and unwieldy compared with those of today.

Even if both Berner and Walton/Cotton showed great interest in the insects taken by fish, it was first in 1747 that the initial book on flytying first appeared, *The Art of Angling* by Richard Bowlker. This is widely regarded as the first handbook on the subject and something of a trendmaker. He not only presented a list of his own flies, indicating some knowledge of entomology, but gave direct instructions for special types of fishing, such as upstream fishing.

The rods which were used during the eighteenth century were primarily for the purpose of taking up the fish's strike. On the whole, flyfishing in those days bore little resemblance to that of today. The line and fly were not cast, but swung out to the presumed holding spot of the fish. Only at the end of the century did small primitive reels began to be manufactured, with room for storing a small amount of line. At about the same time, it had been discovered that the lines could be tapered by twining in more horsehairs at the middle than at the end.

By the outset of the nineteenth century, the rod's length had been considerably shortened from 16-18 to 11-12 feet (around 5 to 3.5 metres). There were frequent experiments

with different kinds of rod materials such as greenheart, hickory and bamboo. In the mid-1840s, an American violin-maker managed to construct the first split-cane rod by gluing bamboo ribs together. This was a real breakthrough, as a perfect rod material had now been found along with a superior method of construction in order to build really strong, practical rods.

Split-cane rods, compared with earlier types, were light and pliable. In addition, they cast significantly better than their predecessors. However, they were still heavy and hard to handle as casting tools. Despite their overall advantage, it was to be some years before their production could be effectivized to make mass manufacture profitable. Two not entirely unknown names figure in this connection: the Americans Charles Orvis and Hiram Leonard. After about another decade, an Englishman named Hardy began his production of quality rods in the British Isles.

It was not only the development of the fly rod which started things moving in the mid-nineteenth century. Lines were also greatly improved. Thanks to the introduction of oiled silk lines, the casting length could be as much as tripled. More or less simultaneously, the horsehair was replaced by silk gut. Today's modern flyfishing had thus begun to take shape.

Flyfishing as a whole underwent extensive changes during the nineteenth century. The development of equipment, the interest in entomology, the creation of new fly patterns and techniques are all indications of this. A further factor, to be sure, was that flyfishing began to be popular in the true sense of the word. But with the popularization of flyfishing, the distance widened between it and other kinds of sportfishing. It became snobbish, ceremonial, and regarded as a fine art. There were echoes from the days of Berner: such a noble sport should be conducted and perfected by gentlemen.

Flyfishermen during the nineteenth century were evidently very conservative. Flyfishing was, and remained, a way of fishing surrounded by a certain mysticism – an attitude which has indeed persisted far into our own century.

Entomology and flytying, though, became ever more interesting, and the fly was what most captured the attention of flyfishermen. A number of books on this very subject appeared during the nineteenth century, some of the best known being *Fly Fisher's Legacy* by Scotcher (ca. 1810), *Fly Fisher's Guide* (1816), *Fly Fisher's Entomology* by Alfred Ronald (1836), and *Floating Flies and How to Dress Them* by Frederic M. Halford (1886).

Flyfishing tended ever more to become a science. Alfred Ronald was the first author to point out the relevance of insect breeding. His book of 1836 was, in fact, the first entomological description of insects in nature and their imaginary equivalents. Ronald's book inevitably increased the interest in insect studies. It suddenly became a matter of great concern to tie exact insect imitations by carefully observing all sorts of flying creatures at the water and recreating these faithfully for the fish.

During the second half of the nineteenth century, a lively debate blossomed about how the fly should be laid out. Upstream casting, downstream casting, and casting more or less across the stream were important questions. It was W. C. Stewart who made himself the champion of the upstream cast in his book *Practical Angling* (1857) which presented the technique and its advantages: by approaching the fish from the rear it is easier to imitate the insects' natural route downstream, and playing can occur without disturbing the fish upstream (that is, in as yet unfished water). Stewart was also of the opinion that it was more important to show the insect's size, form and appearance than to tie exact imitations.

Early attempts were made to tie flies that imitated the natural food of fish. Shown here are some flies from the late seventeenth century, together with their real prototypes.

The reign of the dry fly

Around 1860, dry-fly fishing began to take off in southern England. This new technique gathered ever more enthusiasts, and it did not take many decades before dry flies became ubiquitous, not least in English chalk streams. In the wake of this innovation, there followed a total devaluation of all that wet flies and wet-fly fishing stood for. It was regarded as unsporting and virtually immoral to fish with any kind of wet fly.

It had long been noticed that fish gladly took a wet fly just when it had landed on the water surface or had broken through. The new technique started by trying to get wet flies to fish dry. The fly was dried by means of a number of air casts, then landed on the water and floated until it eventually got soaked and sank under its own weight. Although dry-fly fishing is generally thought to have been "discovered" in England during the mid-nineteenth century, there is proof that the technique was used in Spain already during the seventeenth century, according to the *Manuscrito de Astorga* (1624).

In any case, the basis of today's dry-fly fishing was developed in the south English chalk streams, for example at Itchen where there were plenty of hungry – although sometimes quite selective – trout and loads of insects. As the fish "learned" to see the difference between real and imitation prey, the wet flies which were dried out by air casting fished less well. The "true and proper" dry fly therefore came as a fresh start, not only because it was a new fashion in itself, but because it fished more effectively.

As for who was actually the first to introduce the dry fly is, as with so much else, a controversial question. Some maintain that it was Pullman in his *Vade Mecum of Fly Fishing for Trout* (1851), while others claim that it was a professional flytier, James Ogden, who made the innovation. At all events, it was an article in *The Field* during 1857 written by Francis Francis which spread the principles of dry-fly fishing beyond a rather small circle of fishermen.

What then of Frederic M. Halford, widely considered the indisputable father of dry-fly fishing? The fact is that he, according to reliable sources, did not attempt dry-fly fishing until 1868 – that is, several years after the "discovery" of dry flies. Yet what Halford did do was to perfect the technique with floating dun hooks.

The last decades of the nineteenth century brought a strong upsurge in flyfishing, not least due to Halford and the group of outwardly passionate flyfishermen who sur-

(Above) The fly reel certainly created new opportunities and made the old fishing with a top-knotted line obsolete. These beautiful old reels are made of brass.

(Below) Interest in dry-fly fishing surged at the end of the nineteenth century. Here we see six of Halford's original flies, which he himself tied.

in a systematic way all the phases of dry-fly fishing. This is a virtually comprehensive work on fishing with dry flies in the English chalk streams. On certain waters, such as slow-flowing streams with selective trout, it is still of great value.

We can say without exaggeration that Halford released an avalanche: interest in dry-fly fishing grew at a raging pace. It became modern to collect insects and make naturally faithful copies with Halford's theories of imitation and his flytying technique as a basis. However, the other side of the coin became a fanatical attitude that only dry-fly fishing was the correct way to seek contact with the fish. True believers would never have picked up a wet fly with a pair of pincers.

For this tragic development, Halford bears great responsibility, since in his later days he became quite intolerant of divergent opinions. The "father of dry-fly fishing" was unimpressed by wet flies and nymphs. Rather he tried to combat them as if they were a dangerous nuisance in the fly box. Fishing with dry flies for standing fish was the only proper method for him, while downstream fishing with a wet fly was not only ineffective but also a destructive and immoral form of flyfishing.

The challenging nymph

Along with the strong expansion and popularization of fly-fishing, equipment was improved as well. Rods became easier to handle and the lines smoother to cast. Not least the Americans contributed much to these developments. When this fishing tackle came to England around 1900, nymph fishing slowly began to arise.

A central figure in nymph fishing was George Edward Mackenzie Skues, the technique's inventor and chief theoretician. Born in 1858, he died in 1949, a full 91 years old – and it may be surmised that his success at fishing was one reason for his long life.

Like dry-fly fishing, nymph fishing was developed in the English chalk streams. This is because such streams are fine to experiment in, with their clear water, abundant insect life, and selective fish which have become familiar with hooks due to the active flyfishing.

Skues fished mainly at Itchen and is said to have been a clever dry-fly fisherman, although not a narrow-minded or fanatical one, in contrast to Halford. Despite, or perhaps because of, the predominance of dry-fly fishing in the chalk streams of the late 1800s, Skues began to experiment. He

rounded him. Enormous pains were taken to develop both equipment and techniques. The oiled silk lines were improved, body materials were tested which did not draw water, and new techniques were sought for tying more durable flies. Halford became a dry-fly fisherman by profession. At the age of 45 he retired in order to devote all his time to the sport. This unbelievable commitment, of course, yielded returns. Together with his fishing friends he developed a standard in regard to rods, lines and flies which maintained its relevance long into our century.

His passionate activity also resulted in a couple of books which are regarded today as established works for flyfishermen. His first and best-known, *Floating Flies and How to Dress Them* (1886), presented, after years of intensive insect studies in the chalk stream district of Hampshire, nearly 100 duns and spinners. Three years later came his *Dry Fly Fishing in Theory and Practice* (1889): here Halford described

asked himself: why fish with dry flies when the quarry take food in or just under the water surface?

The idea of fishing with a wet fly when the quarry did not take insects on the water surface was, at the time, heretical to many flyfishermen in conservative England. But this did not prevent Skues from pursuing his research: he developed methods and patterns on the theory that fish were occasionally more interested in the hatching insects than in the already hatched ones. Thus soft-hackled, unweighted flies became the alternative to dry flies.

In 1910 came Skues' first book, *Minor Tactics of the Chalk Stream*. It meant a revolution for the chalk streams, in view of the overwhelming adherence to dry-fly fishing. His concepts were widely regarded as logical, well thought out, and in some respects obvious. Yet the most doctrinaire dry-fly fishermen choked on their whiskey at the mere mention of Skues.

It should be noted that these attitudes existed only in the chalk stream area. People in northern England for centuries had fished upstream with wet flies, this being sometimes necessary to make the fish take at all – and Skues received a ready audience there. What has been magnified by some histories of flyfishing into a life-and-death battle between the two methods was, in other words, actually limited to a small though significant district. Indeed many sportfishermen, particularly outside England, regarded the debate as a storm in a teacup. Still, the events in England were important due to the country's leading role, during much of our century, in the theoretical and practical development of fly-fishing, as well as in generating new ideas and in publishing much of the best literature on the subject.

Skues' nymph fishing was refined further, in the face of long opposition from England's numerous old-fashioned fly-fishermen. Frank Sawyer and Major Oliver Kite, also acute observers of nymph behaviour in the water, were main proponents of the method in the mid-1900s. Skues had concentrated on fish that took hatching nymphs near the water surface, calling for a vigil – whereas Sawyer and Kite focused on fishing with imitations of swimming and drifting nymphs in deeper water. The weighted Pheasant Tail is the fly most closely associated with Sawyer's name. Kite, one of Sawyer's own disciples, was soon fascinated by nymph fishing and wrote *Nymph Fishing in Practice* (1963), which is still considered the most complete treatment of the Netheravon school of fishing.

The embroiled controversy about dry versus wet flies must have accelerated the development of nymph fishing in England. Things went more slowly elsewhere in the world. Classic wet flies were long the obvious alternative when the fish did not rise, creating no great need for nymphs. In Scandinavia, for example, nymph fishing did not see a breakthrough until the 1960s, and it was primarily done with Frank Sawyer's method. The faster development of nymph fishing in England was, indeed, the only positive effect of the dogmatic attitude among dry-fly fishermen towards all sorts of wet-fly fishing.

Salmon fishing stimulates progress

By and large, salmon fishing runs parallel to the emergence of flyfishing as a whole. But salmon fishermen have probably been the driving force in regard to reels, obviously because the rushing of salmon demanded an ability to store a reasonable quantity of loose line as easily windable as possible.

Even though Isaak Walton described some sort of prototype fly reel for salmon fishing already during the seventeenth century, it was not until well into the eighteenth that the development of equipment began to get under way. Yet the rods were still heavy and clumsy, while the few existing reels were very simply constructed and were quite small in comparison to the rods. The rotating spool lacked a brake and actually had only one function – to store the line on.

Salmon flies are commonly associated with the large, colourful, feathered creations which seem more attractive to the flyfisherman than to the salmon. A typical example is Jock Scott, which reputedly first saw the light of day in 1845 on a boat between England and Norway, and which in its original form probably contained 42 different parts. Its opposite is the American hairwing fly – tied simply, often with only a few ingredients, but no less effective for that.

It is believed that salmon flies until the mid-eighteenth century consisted primarily of the same fly patterns as those for trout, except that they were tied on larger and stronger hooks. But during the nineteenth century, interest in salmon fishing grew explosively, bringing with it a powerful development in flies and equipment. Rods became more flexible, and more purposeful reels began to be used. With the need of greater casting lengths and possibilities of playing the fish, reels were made which not only served as a

Fully dressed classic salmon flies.

line-winder between fishing tours, but also fulfilled their function during the fishing itself. They still had overdimensioned spools and were simply built, but the salmon fisherman no longer needed to leave all the loose line on the ground while casting and playing.

Yet it was not until the end of the nineteenth century that fly reels were more or less fully developed. Soon afterward, the equipment firm of Hardy began to produce "The Perfect", which became one of the world's most desirable fly reels.

Many now well-known classic salmon-fly patterns can be traced back to that time. Just like Jock Scott, the first classic salmon flies were colourful and elaborately dressed. The connection between overdimensioned salmon flies and the Victorian era in English history is not hard to see. Ladies' interest in showy clothes and feathered hats made the importation of exotic feathers a profitable business. Salmon-fishing gentlemen did their part to expand the area of use. Patterns such as Thunder and Lightning, Black Dose,

Silver Doctor, Black Doctor, and other fully dressed salmon flies derive from the same period, when overdimensioning was in fashion.

Some literary milestones of that period are George M. Kelson's *The Salmon Fly: How to Dress it and How to Use It* (1895) and Pryce-Tannatt's *How to Dress Salmon Flies* (1914). But the pendulum soon swung back, and fishermen began to undress the "Victorian" salmon flies, in particular making the wings much simpler. Ernest Crossfield was the man who led this new orientation. He appreciated simplicity and practicality in flies – the qualities which he thought were responsible for their fishing ability. Flies like Jimmie, Silver Blue and Blue Charm are good representatives of this school.

It was not only in England that new winds were blowing. In the USA around the turn of the century, fishermen began to experiment with new patterns and flytying materials. Hairs from bear, fox, mink, beaver, hare, squirrel and other animals became the "new" stuff of salmon fly wings. Today

George M Kelson.

the American hairwing type is more common than traditional featherwing flies on salmon rivers all over the world. American influence in fly material has even pushed out deeply rooted English traditions. Nowadays even classic British flies in simplified variants are tied with hairwings. Also artificial materials such as fluorescent ones have recently become ever more common in salmon flies.

The change which has occurred in salmon fly materials is profound and the trend is quite clear. Hairwing materials have come to stay among flytiers. The reason is plainly that it is easier to tie hairwing flies and they fish at least as well as the classic salmon flies.

Scandinavian flyfishing

Today, flyfishing in Scandinavia is mainly inspired by the Americans, even though England lies geographically closer and the first impulses came from there. Although we have proof that the Lapps in the Swedish mountains fished with streamer-like flies already in the mid-eighteenth century, it was undoubtedly Englishmen who initiated the sport here during the nineteenth century.

Scandinavia, primarily Sweden and Norway, received many visits by a long series of adept British flyfishermen. Undisturbed salmon rivers and virgin trout streams were the two main sources of their interest. Thus one of the first Swedish flyfishing handbooks, *Om Flugfiskeriet* (1844), was written by an Englishman, Robert Dalton Hutchinson.

In general, the English flyfishing guests played a prominent role in the development of Scandinavian flyfishing. The seemingly inexhaustible fishing resources made Norway and Sweden especially attractive travel goals for the adventurous Britons, and it was naturally the fantastic salmon fishing which drew them most.

One of the pioneers was the great fisherman and bear-hunter Arthur Llewellyn Lloyd. Among his better-known books is *Field Sports in the North of Europe* (1830), which can be characterized as a bold travel journal more than a handbook. Still, it came to inspire Britons for generations afterward. It became the highest fashion to sail over the North Sea to the Scandinavian peninsula in order to challenge big trout, grayling and salmon.

The English began to travel to Norway in the 1820s, bringing with them a knowledge of salmon fishing with flies to, for example, the Norwegian rivers Nidelva, Namsen and Gaula. Hutchinson, already mentioned, travelled around Norway in the 1830s, and came out with the first Norwegian flyfishing book, *Fluefiskeriets Anvendelse i Norge* (1839).

The English "salmon lords", or visiting fishermen, were almost always lords, barons, landowners, officers or very high-ranking civil servants. They dominated Norwegian salmon fishing and flyfishing throughout the nineteenth century and well into the twentieth. This period is usually termed "the Englishmen's era" and is marked not only by a great development of salmon fishing in Norway, but also by a widespread collision between English upper-class habits and the west Norwegian farming culture.

Incredible quantities of salmon were caught in rivers during the entire period. If fishing luck was good, the catch was best counted in wagonloads – daily catches of up to 50

*A classic salmon fly may contain up to fifty differ-
ent components in the original pattern. The fly
shown below at right, of Jock Scott type, is taken
from George M. Kelson's book "The Salmon Fly:
How to Dress It and How to Use It".*

An afternoon's catch of about ten big salmon was, once upon a time, nothing unusual on the Norwegian salmon rivers.

salmon occurred – rather than in the number of fish. A clever rower and guide, however, was often a prerequisite for normal fishing. These gillies came mostly from the fishing district in question, and knew exactly how the river ought to be fished. In return, they learned how effective flyfishing should be conducted. Not seldom, they acquired rods, reels, lines and flies from their guests. Many Norwegians also learned how to tie flies and, with time, became clever flyfishermen.

Thus Norwegians first gained the knowhow of salmon fishing from Englishmen. This period laid the basis for the widespread sportfishing after World War II in Norwegian rivers, which are probably the world's best waters for salmon in terms of both number and size. Salmon of 12-15 kg are nothing unusual there.

Flyfishing in the United States

The English colonists who reached the North American continent during the eighteenth and nineteenth centuries naturally brought with them a knowledge of, and interest in, flyfishing to their new land. The sport had taken root by the end of the eighteenth century, and it is even thought that special shops then existed for flyfishing materials and equipment.

Serious fishing with a fly began in the United States around 1850. At this time the Wild West was still living up to its name. It was therefore mainly in the eastern parts of the country that people diverted themselves by fishing with

Salmon fishing from a boat on a Norwegian salmon river in the mid-nineteenth century (illustrated by Lloyd's "Scandinavian Adventures", Volume 1, in 1853).

a rod, line and hook. In the more civilized Eastern states, people also began to realize that flyfishing was an unusually rewarding form of sportfishing.

In 1887 the book *Fly-Fishing and Fly-Making* by John H. Keene came out. Its main interest is that it shows that people in the USA had come farther in the development of flyfishing than we have tended to believe. The book not only describes how to tie dry flies, for example, but also displays a degree of innovative thinking which was long thought to have been reserved for greater luminaries such as Theodore Gordon.

Despite the country's late entry into flyfishing history in relation to England, the refinement of rods, spools, reels and lines was steadily driven forth. As mentioned previously, it was an American violin-maker who, in the mid-1840s, made the first split-cane rods. After about 25 years, they began to be mass-produced and the rods were improved in features like casting ability and weight – so much that the English began to import them around the turn of the century. English rods at the time were long, heavy and stiff; thus gradually the English took over the American type of rod, which many have seen as a prerequisite for the development of nymph fishing.

The American equivalent of the chalk streams in Hampshire became the Catskill rivers in the state of New York. Rivers such as the Neversink and the Beaverkill are today classic waters in the history of American flyfishing.

In Europe and England, the brown trout was the target for the hardily casting flyfisherman. This species, however, did not originally exist in the USA. There, people fished instead for brook trout in the eastern states, and for steelhead or cutthroat in the west.

With the growing popularity of fishing, the supply of brook trout in particular decreased drastically. During the 1880s, trout consequently began to be imported from Europe. The first fish were taken from Germany and the species is thus called the "German trout".

As brown trout, and later rainbow trout, were implanted in rivers, the waters became harder to fish. The traditional downstream wet-fly fishing proved ineffective. These trout were simply not as easy to fool as the brook trout, and flyfishermen were slowly but surely forced to reconsider.

One of those who perhaps came to mean most for the development of American flyfishing was Theodore Gordon. He was something of a loner who, in 1905, settled on the Neversink in order to be able to tie flies and do his fishing in peace and quiet. His literary production was primarily a number of articles in the journals *Forest and Stream* (USA) and *Fishing Gazette* (England). He also corresponded fluently with Halford and Skues. Through this lofty correspondence with two of the great men of flyfishing, he acquired a fine insight into the development of English flyfishing.

At the end of the nineteenth century, Gordon obtained some 50 dry flies from Halford. However, these were tied according to English conditions and were therefore poor imitations of the insects which existed in Gordon's home waters. As a flytier, though, Gordon began to tie his own dry flies with Halford's technique, but modelled on local insects. He created many original patterns, the best known being Gordon Quill, and he also developed the so-called "bumble-puppies" in the Neversink. These flies were the predecessors of the bucktail patterns, subsequently so much used.

Gordon laid the foundations for the Catskill School, which came to have a huge impact on American flytying. The fanaticism which marked English dry-fly fishing never reached the USA and there were thus larger possibilities of experimenting. The results were significantly more sparingly dressed flies than the typical dry flies from the Halford epoch in England.

Another American who has acquired a leading place in the history of flyfishing is George LaBranche. In 1914 his first book came out: *The Dry Fly and Fast Waters*. He is regarded for this and other reasons as the man who made American dry-fly fishing really popular. In the book was presented a technique for effective dry-fly fishing even in relatively rapid waterways. It differed in various respects from Halford's theories, which were primarily suited to the English chalk streams.

LaBranche's fishing technique was distinctive in many ways from the Catskill school, one essential difference being the size and bushy appearance of the flies, which made them float high and remain easily visible to the fish. LaBranche also belongs to those who developed the technique of fishing salmon with dry flies.

In general a different style of flyfishing and flytying arose in the USA as compared with England. An example is the special type of wet flies called bucktails and streamers. They grew up in America during the 1920s and are refinements of the classic wet fly. Observant flyfishermen had discovered that wet flies with silver or gold bodies could be identified as fry by the fish. Gradually there arose a whole lot of different patterns of bucktails (hairwing flies) and of streamers (featherwing flies) which, in one way or another, imitated fish fry in different species and stages.

In addition to those authors already named, Edward R. Hewitt had a great influence on this progress. He was a contemporary of LaBranche, and was one of the great flyfishing authors between the two World Wars. Today he is perhaps best known for his division of flyfishing development into three phases: (1) as many fish as possible, (2) as big fish as possible, (3) as difficult fish as possible to catch. Hewitt also advanced the view that the presentation of the fly was extremely important: the main thing according to him was not to have as great a range of flies as possible, but to have a smaller number and be able to present them correctly.

In the same way as Gordon, through correspondence with Halford, became something of a pioneer in American dry-fly fishing, Hewitt continually corresponded with Skues and thereby gained impetus for trying nymph fishing in the USA. But it was, of course, essential to adjust the English nymphs to suit American conditions. Much of this work took place in the Neversink River itself.

Yet another pioneer in American flyfishing was James (Big Jim) Leisenring, who also corresponded with Skues. In the middle of the war, he published *The Art of Tying the Wet Fly* (1941). Although in many ways it had a more up-to-date attitude towards wet-fly and nymph fishing than did earlier authors, Big Jim's book received no wide recognition until much later. The flymph (something in between a dry fly and a nymph), which tries to copy the insect in the transition between nymph and flying insect (actual hatching), was among other things a result of Leisenring's intensive observations on the water.

The Catskill rivers continued long into the twentieth century to be a principal centre for the development of flyfishing. Besides the Catskill school's typical lightly dressed flies, the American imitation doctrine also got its nourishment from that area. Lewis Rhead, Preston Jennings, Art Flick and several other devoted flyfishermen collected insects in the Catskills for a long time, resulting in two standard works on trout flies and the natural prototypes which they imitate: *American Trout Stream Insects* by Lewis Rhead (1916), Preston Jennings' *A Book of Trout Flies* (1935) and *Streamside Guide to Naturals and Their Imitations* by Art Flick (1947).

The basis of the American imitation school was now laid, and the outcome was an improvement of the traditional patterns and a reduction in the number of necessary imitations to about ten patterns.

Lake flyfishing presents new possibilities

During the twentieth century, Americans have increasingly dominated the development of flyfishing in running waters. As English fishing in such waters has declined due to factors like pollution, however, there have been attempts to expand flyfishing into other types of waters. Lake flyfishing for trout, and for the rainbow trout implanted from the USA, has thus acquired great significance. Actually, lake flyfishing has a long tradition in Great Britain, primarily from the Scottish and Irish lochs – but naturally the fish in inland lakes, ponds and reservoirs have quite different behaviour patterns and eating habits than those in running waters. It was only in the mid-twentieth century that flyfishermen began consciously to study these differences.

In 1952 the first book on lake flyfishing came out: *Still Water Fishing* by Tom Ivens. The English continued to refine this special type of fishing. Their exact observations on the water gave rise to new patterns and improved methods, so that a fresh generation of flyfishermen founded yet one more English tradition. C. F. Walker, Geoffrey Bucknall and John Goddard are now well-known authors and good proponents of this sport. Among the flies which have become popular for lake fishing are imitations of midges and snails.

Flyfishing is a passion for many people – and for some, a real addiction – which often lasts a lifetime and can seldom be completely cured...

The fish, the insects, and the fly

*A skilful flyfisherman is
something of a universal genius. He
knows about fish and their biology, studies
insect life in and around fishing
waters, has sound
insight into the chemistry and physics
of water, and pays close attention to the
weather, wind and water level. Although
well-informed and conscious
of the environment, he
never stops learning. There are
always new things to discover and fresh
experiences to gather. This is what makes
flyfishing a lifelong passion for many —
and for some of us, almost
a religion.*

*T*oday we are flyfishing for innumerable species in a wide variety of places. The sport has developed so far that it ranges from stream- to still-water fishing, from fresh to salt water, and from the Arctic to the tropics. But the dominant quarry around the world are salmonoids, which were the original inspiration of modern flyfishing. In the following pages we shall therefore concentrate chiefly on salmon, trout and grayling.

Our prey

All fish are cold-blooded, which means that their metabolism – and consequently their activeness – depend directly on the water temperature. Very few flyfishermen, however, realize how much this relationship influences the fish, or what it implies for the choice of equipment, flies, and fishing methods.

Every species has a range of temperatures in which it can survive. If their surroundings become too hot or too cold, the fish simply die. By the same token, there is a certain temperature at which they feel best: then they are extremely active, hunt eagerly and grow rapidly. On the warmer or cooler side of this optimum temperature, their energy and appetite decrease, so a flyfisherman cannot get them to bite as easily, and the striking periods are not as long or remarkable.

Temperature affects the fish's behaviour and vigour in further ways. Salmon are typical as regards their love of cold water and their need of oxygen. Since cold water usually holds more oxygen than warm water, rising temperature lowers the water's oxygen content. Thus, salmonoids can reach a point where their increasing activity is suffocated by a deficiency of oxygen.

In such situations the fish are forced to seek waters that are cooler, richer in oxygen, or both. Those in streams soon find their way to rough rapids, which enable more oxygen to dissolve – and those in still waters sink to deeper levels with low temperature. A good flyfisherman is aware of this phenomenon and pursues the prey accordingly, without wasting time at places poor in fish!

Most fish also follow a certain daily rhythm in their activity, due to both the water temperature and the light conditions. Early in the year, when the waters are cold and the

The activity and appetites of fish depend on the species' favourite temperature. In turn, they influence the fish's urge to take our flies. When the water is warmer or colder than this optimum temperature, the striking periods become less long and energetic. Typical flyfishing prey – notably salmon and trout – prefer relatively cold water as it contains more oxygen than warm water. Above, we see how fish in flowing water, for example on sunny days when the water is warm, head for rapids and channels where the water is rough and oxygen-rich.

When the water temperature sinks below the fish's optimum, it swims into deeper water, which is colder and holds more oxygen. As seen in the lower picture, fish tend to avoid the chilly surface layer during the coldest season and stay on the bottom, where the temperature suits them best.

During the warm season, with strong sunlight and high temperatures, fish are often very shy in the daytime. They prefer to hide in deep, shadowy and even overgrown places that offer good protection.

fish sluggish, midday is normally the best time to catch them, as the sun shines most brightly and the water is warmest. Even fractions of a degree's rise in temperature can start the prey swarming. By the same token, in summer the ideal hours are early morning and late evening, when the temperature becomes more favourable. Sunshine combined with low, clear, warm water makes the fish shy and reserved; they are often active only in the cool darkness of night. Feeling secure, they can then leave their hideouts to hunt in the shallows near land. Many of the animals they feed upon obey a similar daily rhythm.

In sum, how active fish are, and how willing they are to bite, is determined by several factors which are well worth knowing. Moreover, a number of biological circumstances shape the behaviour of fish in relation to the fishing hook. What is it that drives a fish to devour our flies?

Hunger and aggression are, generally speaking, the main motives for a strike. But another reason may be the plain curiosity of a fish when it sees something new – the fly. Simply because it has no hands, the only way in which it can investigate more closely is to take the fly with its mouth. Before going into details about such behaviour, though, we must distinguish between salmonoid fish that are hunting for food and those which are travelling to their spawning grounds or defending their territory.

Hunger

All salmonoids are territorial, from the moment when they leave the protective gravel of the river bed until the day they die. Ever since the fry stage, and during their last – perhaps only – spawning period, they will have fought over shelters in streaming water. Some species, however, are more territorial than others. Among the most aggressive is the brown trout *(Salmo trutta)*. If introduced to a waterway which is already populated by rainbow trout *(Salmo gairdneri)* or brook trout *(Salvelinus fontinalis)*, it will outcompete them and become the dominant species. At the other end of the spectrum we find grayling *(Thymallus thymallus)*, which gladly swim in small schools and belong to the least aggressive salmonoids.

Competition between salmonoids is hard in general, when it comes to the limited numbers of resting places and the equally restricted amounts of food in fresh waters. A waterway's permanent residents, such as brown trout, fight each other for the best holding or resting places and feeding sites – in other words, those spots which offer protection from the current as well as good and stable access to food. Usually the resting place is a deep calm one, and certainly brook trout prefer a shadowy abode with a roof over their heads. But the feeding site, not far away, is more open and

But in the evening, as the light fades and the temperature sinks, the fish become more active. Under the cover of darkness they leave their hideouts and hunt in shallow waters near land.

exposed, so the fish risk their safety in the resting place when they have to go out and eat. Many salmonoids, notably members of *Salmo trutta*, are therefore active at night and stay hidden by day. Yet all salmonoids are extremely active at dusk, which makes it a good time for fishing. At that hour, everything in nature wakes up!

As the amount of food in a waterway is limited, several salmonoids have developed subspecies which migrate into lakes or seas for a crack at their far richer food supply. Large lakes and the open ocean offer a virtually infinite diet for salmonoids, and enable them to grow many times faster there than in the tributaries.

Salmonoids are true freshwater fish in that they require fresh water in order to breed and survive as species. A number of their species can tolerate the very saltiest sea water, but not immediately. First the fish must go through a process known as smolting: the little salmon or trout changes in appearance from a round, dark one to a slim, silvery "smolt". This shiny exterior provides excellent camouflage in free waters, at the same time as the fish acquires an ability to tolerate salt water. Whereas it stays near the dark bottom in a waterway, it has to hunt small fish near the surface when in the sea.

Size, not age, is what determines the point at which a young salmon, trout, steelhead or seagoing char becomes mature for smolting. For example, an Atlantic salmon may do so already as a one-year-old in a warm, nutritious Spanish river. By contrast, the Atlantic salmon in Greenland have only a couple of short summer months to grow in, and may take up to five years before reaching a sufficient size of 10-15 cm (4-6 in).

The ability to tolerate sea water depends on its temperature, not just on the fish's size. If too cold, it lowers the fish's metabolism so much that there is no surplus energy to regulate the internal salt balance. Likewise, the migration of smolt from fresh to salty water begins during the springtime, when the water temperature is high enough. On the other hand, we may observe a migration of, for example, trout into relatively fresh – or less salty – waters during the cold winter months. Hard winters can force them all the way up into tributaries or make them overwinter in brackish coves. Here they can naturally be fished with a fly rod, but the fishing has to be done slowly and deeply in such cold water.

In the sea, fish devote themselves wholeheartedly to eating. There is plenty of food and consequently, with their open surroundings and shiny hunting coats, fish no longer need to be territorial. Instead, their decisive trait is a so-called striking reflex. When the fish sees something edible, such as a smaller fish or crustacean, its striking reflex is acti-

vated automatically. The hungrier it is, the more easily this reflex operates. Conversely, a fish full of food is difficult to attract with a fishing fly: it simply stands digesting its meal, apparently uninterested in anything else. Nor will it swim after the fly, which therefore has to be served right in front of its nose, and perhaps more than once before the fish will strike. Hungry, hunting fish are eager to swim quite a distance for a fly, and are generally easy to deal with, having few scruples about the fly's nature or presentation.

We often encounter fish which follow the fly all the way up to the rod end without striking. They may have recently satisfied their appetite for everything except curiosity. Or else the fly may not be quite right in its size, form, colour or movements. A fish that follows a fly out of sheer interest, however, collects impressions. If it collects enough of them, its striking reflex is triggered – as if you were pressing a button. After all, fish are simple creatures with elementary behaviour. Rather than thinking about objects, they react to external influences. And similarly, if they do not collect enough impressions, they turn round and abandon the enterprise. Then you have to try a different fly or technique until you find the right one.

Aggression

The above remarks apply to fish that are eating, by actively hunting at sea or in lakes and streams. But the situation is different with fish that are defending their territories, whether they be stationary species (such as brown trout) or are migrating in order to breed (such as salmon or sea trout).

Fish in the sea frequently undertake long migrations in search of food. One of the best-known examples is the European Atlantic salmon *(Salmo salar)*, which roams up to the Davis Strait between Canada and Greenland for a meal from its rich supplies. At some time, though, the fish become sexually mature – perhaps as young males after only one summer at sea, or after as many as four summers – and then they turn homeward.

On the way back to their childhood rivers, guided exactly by their sense of smell, they gradually lose their appetites. By the same token, their striking reflex diminishes. Fish which have been migrating for a long time will have entirely stopped eating when they reach home. They have begun to live on the fat reserves which they built up during months at sea. As their body fat is used up, they also lose

the red colour of flesh which is the hallmark of salmon. This is because the red colour comes from pigments in crustaceans that are eaten. Fish that need not travel so far to reach home will, to some extent, retain their fine red flesh as well as the striking reflex which is so important to us fly-fishermen.

Most migratory fish – whether salmon, sea trout, steelhead or seagoing char – still possess a degree of striking reflex when they have just swum up from the sea. These fish are, as a result, usually easiest to catch if other conditions are right, particularly the water level and temperature. But the striking reflex diminishes with every day spent in fresh water, and eventually it disappears. Moreover, during this transitional period, great hormonal changes occur inside the fish. Its production of sexual substances is in full swing, taking a further toll of its fat reserves, so that the fish becomes quite worthless as a food animal at the end of the season. Its value is far higher if it is allowed to spawn!

Along with these hormonal changes, the fish reverts in a way to its childhood nature. It repeats the habits and behaviour patterns which characterized its youth before going to sea. Thus it begins again to defend territory, a trait that becomes ever more marked as the fish approaches spawning.

Corresponding changes are seen in the fish's appearance. The reflective hunting garb which it wore at sea is gradually transformed into a darker, more colourful breeding costume. Its skin turns thick and the silver hue vanishes. Loose scales, typical of the shiny fish while at sea, now become attached and absorbed into the skin. Its outer coating of mucus is also strengthened.

Whereas the fish in the sea thought only of eating, in the rivers they think only of reproducing. Increasingly aggressive, and looking ever more scary, they ultimately boast the bright colours of breeding, and the males can display impressively long jaws with powerful hooks.

Although the old striking reflex has faded into memory, the fish can still be caught. However, it now bites only due to aggressiveness or plain irritability. Flies that come too close are immediately chased out of its territory, either with a swat of its tail or with a direct bite. The shiny summer fish was happy to rise up to the surface for a tiny black fly, but the well-dressed breeding fish has to be tempted with big flies in brilliant colours.

In conclusion, we must consider two different kinds of fish – the glistening mariner and the gaudy marrier. They belong to the same species, yet each has its own personality.

The eyes of fish have spherical lenses that provide a very wide field of vision. They can also be moved independently of each other. Yet the field in which a fish can focus an object with both eyes is very narrow.

How fish view the fly and fisherman

For us flyfishermen, the fish seem to enjoy an obscure existence under the water surface. They have a better chance of watching us than we have of glimpsing them. Nevertheless, we can penetrate their cover with a little science.

Air and water do not have the same density. Water is much more dense than air, and this fact not only enables us to see farther on land than underwater, but also causes light to refract when passing between air and water. How much, then, can a fish see?

To begin with, the common idea that fish are nearsighted is not entirely true. A fish hardly needs to see very far, since the water itself sets limits – so a fish's eye is mostly focused at short distances. But its eyes, unlike those of us mammals, has a spheroidal lens which gives it an enormous field of vision. In addition, its eyes project and can move independently of each other. On this basis alone, we should not be surprised that fish are easy to frighten!

Fish were also long thought to be colour-blind, yet they can see colours very well. Just like humans, they have special colour-sensitive cells in their eyes. Still, everything looks grey in the dark to them as well, because colour vision requires a minimum amount of light, and too little light leaves only black and white impressions. This is why black flies are best for night fishing, since these create the clearest silhouette against the dimly lit sky. A fly's colour can be effective only in daylight.

In front and overhead, the fish has a fairly narrow field of vision where it can focus objects with both eyes at once. There alone, it is able to judge distances – an ability which is crucial for its willingness to rise and take an insect at the surface. Obviously, an absolute requirement for the dry-fly fisherman is to present his fly inside this field.

Above the fish is its "window" to the outer world, a circular field in which it can see through the surface and, if it wishes, up onto the land. Beyond the window's edges, the water surface resembles a vast mirror to the fish, simply reflecting light from underwater. The window is sharply outlined in calm weather, but becomes less transparent when the surface is disturbed by wind and waves.

A fish can "see round the corner" of its window's edges, due to the refraction of light at the surface between air and water. Thus, a fisherman who stands on land and may think

In order to judge the distance to an insect – or to your fly – the fish must be able to focus on it. Fish can see up through the water surface through their "window" field, a cone with an angle of about 97.5°, which becomes larger as the fish goes deeper. Thus, fish that hunt near the surface and have a small "window" may be very hard to catch – not because they are too selective, but because they can only notice a fly which is presented quite accurately.

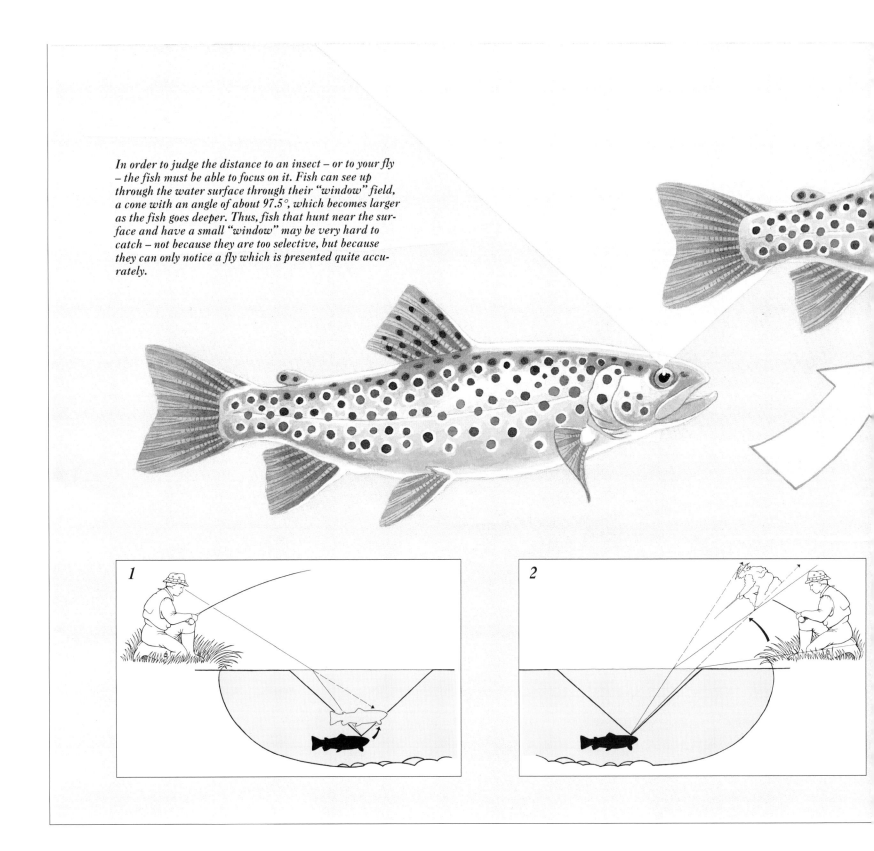

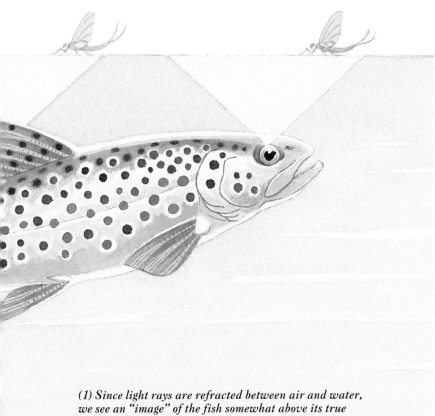

(1) Since light rays are refracted between air and water, we see an "image" of the fish somewhat above its true position in the water. (2) The same factor influences a fish's view of the surroundings above the water surface. For instance, the fish sees a fisherman as if he were compressed and hanging in the air. This also means that the fish can see him even if he is squatting or trying to hide. (3) Due to these optical phenomena, fish notice an insect on the water surface even before it enters their "window" field. They first see the upper part of its wings, then ever more of it until the whole insect is inside the "window".

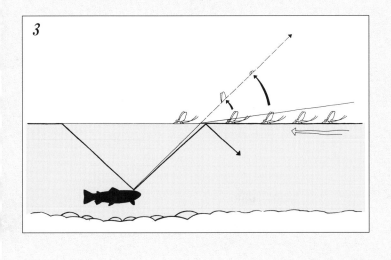

3

himself hidden by shore vegetation is often visible to his quarry. The same phenomenon makes it easier for us to notice a fish hidden in deep water. However, refraction also shows the fish to be shallower and farther away than it really is. This illusion must be taken into account, especially by nymph fishermen when presenting a weighted nymph.

The fish's picture of the world above the surface through its window is compressed, and ever more so as it looks toward the edges. So a fisherman sitting on land will seem abnormally low and broad to a fish, as though viewed in a "funny" mirror. For the same reason, when an insect approaches on the water surface, the first thing that a fish sees is the insect's "footprint" where it has made an impression on the surface. If it is a mayfly, the next to be seen are its high wings, which are actually the first to enter the window field. Only when the insect is entirely inside the window does the fish see it clearly.

On the other hand, if an insect comes drifting or swimming under the water surface, and if the surface is smooth in calm weather, a fish will see two insects instead of one – that is, both the insect and its reflection from the surface. Yet the reflection disappears when the insect enters the underwater part of the fish's window field.

A fish carries its window with it everywhere, into the depths and up to the shallows, swimming and resting alike. The window merely becomes larger when the fish sinks, and smaller as it rises toward the surface. This explains, for instance, why fish that are specialized to eat very small insects can be hard to catch. They lurk just beneath the surface and have an extremely narrow field of vision. So a fly must be cast with great precision if they are to see it at all. Their attention is directed only toward this window and, if the fly does not pass through it, they can hardly react. Often we think that a fish is highly selective, whereas in reality we are simply poor casters!

A general rule is that fish should be approached from behind, supposedly in order to make use of their "blind angle". But the supposition is wrong. The location of a fish's eyes, already mentioned, would easily enable it to see a fisherman who tries to sneak up on it from behind. What makes the fish vulnerable is that its attention is directed forward – up the stream which brings food to it. Naturally this can be exploited by approaching from the rear direction that it watches least.

Food and environment

The food supply largely determines where fish are to be found. It is therefore essential to know the kinds, appearance and behaviour of the animals on which the fish feed. A flyfisherman must be able to recognize these different insects, crustaceans and other prey, if he or she is to have any hope of success. Such awareness makes it possible to decide upon the right fly and to be in the right place at the right time.

Flyfishing is an intimate interplay between the sportsman, his quarry, and the fish's food. The fish hunts for food and is hunted in turn by the fisherman. The fisherman, who enters into the fish's ecosystem, should know not only about its biology and the food it eats, but also about the entire watery environment – streams, lakes or the sea in which he is fishing. And the feeding habits of fish are a good clue to the environment. Which animals or insects occur, and which are caught by the fish, reveal much about the water's quality and its special properties for fishing, one reason being that certain creatures tolerate more pollution or acidification of the water than do others.

Even if a number of particular environments contain the same kind of fish, they may differ radically. Trout, for instance, can be found in fresh or salt water, running or still water, nutritious or depleted water. The ability of trout to adapt themselves is impressive, and goes far beyond what their feeding habits alone indicate.

The food supplies in such environments may vary in great detail. Several of the kinds of animals eaten by trout are the same everywhere, yet their subgroups or species depend on the surroundings. Most insects and crustaceans are adapted to life in either running or still water, but not in both. If mayflies dominate in streams, midges are often the main insects in lakes and ponds. No insects at all exist in the sea, where small fish and crustaceans are predominant. Thus, our choice of fly and fishing technique must be varied accordingly.

The majority of insects and crustaceans on a fish's menu are consumers of plants and of algae which grow atop the sediment. They graze on algae or gobble up the dead, partly decomposed, plant material known as detritus. Evidently the fish's prey are themselves dependent on having enough food and an abundant supply of microscopic algae.

These conditions, however, apply only to relatively clean and clear water, which can transmit light most easily. The light is what activates the process of photosynthesis, creating algae at a basic stage in the food chain. With the energy of sunlight and the building materials of water, carbon dioxide and salts, the algae can produce their organic components. While carbon becomes part of the algae, oxygen is released into the water. As a result, plants in the water do more than provide nourishment for insects and crustaceans. They also generate much of the oxygen needed by both a fish and the animals it eats.

If the water quality is ruined by run-off from a source such as nutrient-rich sewage, which uses up the water's oxygen when decomposing, the fish in the water will naturally disappear fast. A similar but indirect effect can occur in a larger lake or enclosed sea bay. Nutritious run-off water will overfertilize the environment, causing "eutrophication", and the free-swimming planktonic algae will experience a population explosion due to the abundance of nutrient salts. When the water becomes murky with algae, no light can reach the bottom where other algae and plants are rooted, so these die out for lack of energy. This leads to a decline in production of the insects and crustaceans eaten by fish – which are the very foundation of our flyfishing!

Although water environments are harmed by an excess of nutrient salts, the world has numerous excellent fishing waters that are rich in nutrients and provide fish with a huge range of diverse prey. Good examples are the classic chalk streams, which come from sources in land with plenty of limestone and calcium. Their water dissolves the salts from the earth and becomes alkaline – with a high pH value – forming the best possible conditions for animal and plant life.

Quite the opposite are waterways that receive run-off from rain and melting snow in the countryside. Such water is virtually sterile, containing almost no dissolved salts, and its low pH value tends to make streams unproductive. The consequent poverty of food limits the growth of fish and keeps them hungry. Whereas the water level and temperature in a chalk stream are more or less constant all year round, the variations are great in a "freestone stream" of the nutrient-poor kind. It takes in masses of ice-cold water during the spring when most snow is melting; afterwards its level sinks, and its temperature rises with the warmth of summer. Sudden rain on nearby land will cause the water

Dense swarms of insects usually attract fish to the surface. They may rise enthusiastically, but often become very selective and hard to catch.

level to rise again, and perhaps even to flood over – as is indicated by the term "spate river".

Waterways and lakes with a low pH value are, moreover, extremely sensitive to acidification and its effects. Acid rain lowers the pH value rapidly to a critical point, where only a few plants and animals can survive. The animals eaten by fish are the first to perish in such bitter surroundings.

The insects
Mayflies
(Ephemeroptera)

Mayflies have always had a special significance for modern flyfishing. A main reason is that the cradle of dry-fly fishing lay in the English chalk streams, where mayflies were overwhelmingly predominant. Anyone could see that the trout took mayflies up at the surface. Until then, fishing had been done only with sinking flies, but the development of fishing equipment and the production of dry-fly oil made it possible to get densely hackled flies to float. With that, modern flyfishing became a reality. Thus the mayfly has played an important role in the progress of flyfishing.

A mayfly undergoes three stages in its life cycle, and all are of interest to the flyfisherman and flytier. First, the nymph stage is spent in the water, and makes up most of the mayfly's life. As a nymph it feeds on algae and rotting vegetation, moulting its skin several times while it grows. Its colour is dark before moulting, and lighter again afterwards.

There are various forms of mayfly nymphs, but they can be divided into four chief groups, each with its own appearance and way of life. These are the burrowing, the creeping, the crawling, and – last but not least – the swimming kind. Almost all are characterized by three tail antennae.

Among the burrowing nymphs are the large "drake" *(Ephemera danica)* and the "dark mackerel" *(Ephemera vulgata)*. The former lives in running water, the latter in lakes and ponds. Both stay buried most of the time, but must come up to moult their skins, and may then become a fine meal for fish. The drake is declining in many places, as it demands a lot from the environment.

The creeping mayfly nymphs include common species such as the "may duns" *(Heptagenia)*. Creeping nymphs have a flat body which facilitates their grip on slippery stones in fast waters. Many of them are by nature demanding in regard to the water quality, and therefore have widely died out.

Better able to survive are the crawling nymphs, which show less sensitivity to the water quality. They vaguely resemble the creeping nymphs in body form, but are not quite as flat, since they prefer slower waterways. Living on bottoms or water plants, the well-camouflaged nymphs pursue a rather inconspicuous career. Their camouflage may consist of algae or clay particles stuck to the body. The most widespread crawling species include the Blue Winged Olive Dun *(Ephemerella ignita)* and the small but prominent "white midges" *(Caenis)*.

Swimming nymphs are the commonest of all mayflies. Slim and active insects, they can move very fast in water. When swimming, they draw their legs in toward the body, becoming streamlined in shape. We find these fast swimmers in both flowing and still waters. The classic "olives" *(Baetis)* dominate in running water, while lakes and ponds favour their relatives which, aptly enough, are called "pond olives" *(Cloeon, Procloeon)*. The species living in waterways have fixed gills, but those in lakes have movable gills – and need them, since there is no current in a lake to move fresh water over the gills. In contrast to the burrowing nymphs at places with sand or soft bottoms, and the creeping nymphs on stony bottoms in streams, the swimming nymphs stay close to water plants. Here they swim about and become easy prey for trout. Hence they are among the most important water insects for us flyfishermen.

Mayflies are peculiar in many ways. For one thing, they exhibit what is called incomplete metamorphosis, lacking a pupal stage. Nymphs, the insect larvae, instead gradually resemble the adult insects ever more closely. In other words, they never undergo any rapid change to define a pupal stage.

After a year as nymphs, most mayflies are ready to hatch, turning into adult winged insects. Some species, however, produce two generations annually, while others – such as the drake – produce only one generation every second year. Consequently, drakes need two years to reach their impressive size. After numerous moultings, the wings are fully developed and the nymphs find their way up to the surface. Some species crawl up onto stones or plants; others ascend passively or swim busily upward. During their journey to the surface, they face a considerable risk of ending as food for fish.

Mayflies have always been quite important for flyfishing. Their many species look much alike. Winged mayflies are characterized by upright wings and three tail antennae. Shown here are a typical mayfly nymph (at left) and an adult winged mayfly (above and at far right).

Once on the surface, the skin cracks between the wings, and what emerges from the water is a winged mayfly in the "dun" stage. This hatching takes a longer time during the early and late months of the year than during summer, because the temperature determines the rate of hatching.

A dun mayfly has dull colours with opaque wings and relatively short tail antennae. It is a fairly clumsy flier and can have trouble in lifting from the water. If the water is cold, it sits for a long time on the surface before taking off. On warmer water, its wings speedily harden and it can fly away almost immediately. It then heads inland to find a hiding-place.

There the dun moults again and turns into the third, last stage of the mayfly, a "spinner". The time between these two moultings can vary from several days in cold and windy weather, to a few hours or even minutes in warm weather. A spinner has clear colours, transparent wings, long tail antennae and excellent flying ability. But it cannot consume any nourishment, so it does not live long.

Towards afternoon, and especially in the evening, mayflies form swarms if the weather is suitable. The males swarm thickly above the trees and bushes where the females are hiding. Soon the females fly up, and mating occurs while they are airborne. Then the males immediately die, but the females follow the current upstream and lay their eggs on a suitable stretch of water.

The eggs can be laid in different ways. Large drakes sit on the surface and lay several batches of eggs, which the fish are not slow to observe! Others lay their eggs in a single clump. Some *Baetis* species, quite common in flowing waters, crawl down on stones or plants beneath the surface to lay eggs. Afterwards, the females too die: they drift downstream as "spent spinners", offering the fish an easy and concentrated meal. Such an occurrence of dead or dying females is termed a "spinner fall". Thus, the females are far more significant as food than the males, which seldom end up in the water.

The descent of *Baetis* species into water for egg-laying is very important to flyfishermen. In some cases there is no spinner fall of spent females on the water. Instead, after laying eggs, the females rise to the surface, where the fish can see them clearly and eat them with no difficulty. However, they are almost invisible to us, unless we know exactly what to look for. One must bend right down to the surface in order to see them thronging just beneath it.

Places full of mayflies are rich feeding areas for trout and grayling. The fish take them deep down near the water

Mayflies undergo an incomplete metamorphosis – as do stoneflies. This means they have no pupal stage. The nymph keeps growing and increasingly resembles the adult insect. After about a year, it rises to the water surface, its skin cracks between the wings, and the winged insect hatches. In this dun stage, the wings are dull and opaque, and the tail antennae relatively short. Soon the dun flies away inland to moult its skin again, thus becoming a spinner. In this final stage, the insects swarm and the females lay eggs, then die as spent spinners.

plants, or when they climb toward the surface to hatch, or when hanging dead at the surface while hatching; or again, when the bold fliers with their big wings are blown down in hard wind, or when they have laid their eggs and fall lifeless into the stream.

Caddis flies
(Trichoptera)

The mayfly has been in the limelight ever since we invented the dry fly. But things are different with the caddis fly, which has long been neglected. Its status has nonetheless grown greatly in recent years, partly since caddis flies tolerate more pollution than do mayflies. Relatively robust, they get along better with the poor water qualities of the late twentieth century, although many species still require excellent water quality.

All caddis flies, unlike the mayflies, undergo a complete metamorphosis: their larvae pass through a pupal stage before becoming winged adults. The caddis fly is interesting to flyfishermen in both its larval and pupal stages as well as when an adult.

Caddis flies are divided into three main groups: the free-living, the net-spinning, and the case-building. Best known among the free-living larvae are the *Rhyacophila* species. These large greenish predators stay on the stony bottoms of clean waters, and are therefore becoming scarce in many places. The larvae live freely all the time, and only when about to pupate do they build a little flat house on a stone.

More common are the net-spinners, a frequent example being the larvae of *Hydropsyche* species. They are easily recognized by three conspicuous back-plates just behind the head and on the light rear body. This is a specialized creature which spins small hunting-nets between stones. The net opens upstream, and the larva sits on the bottom waiting for the catch – namely algae and bacteria which come along with the current. At some sites, *Hydropsyche* larvae are plentiful and provide much of the food for fish. Such conditions often occur at the outlets of lakes whose water contains a lot of planktonic algae that the larvae can catch and eat.

The last and most perplexing group are case-builders. They include the big *Phryganea* species, which are very hard to mistake in view of their sheer size. Most of us are familiar with the larvae, which are seldom abundant in rapid waters and prefer calm places in waterways or lakes. The larvae are elaborately camouflaged with cut-out plant parts or mosaics of small pebbles. They are usually not seen until they move. Each of the numerous species builds a characteristic kind of "house". The *Phryganea* erect spiral abodes with bit-off vegetation, whereas larvae of the family *Leptoceridae* construct slightly curved cones with glued-together grains of sand. Many other larvae are much harder to identify, some building in intricate patterns, and some taking pride in what look like ruined tenements.

When a caddis fly becomes fully grown, it pupates. The "house" is anchored and the opening closed. Pupation is one of the most mysterious processes in the insect world: a total change occurs in the larva's body and, after a few weeks, the developed pupa gnaws its way out. Not seldom, a mature pupa is considerably smaller than the larva was at the beginning of the process.

As with mayflies, there are great differences in how the caddis-fly pupae rise to the surface. Some species creep up onto land, while others swim up through free water. Some hatch right on the surface, but others fight upward and swim to land. Certain species hatch even before they reach the surface.

A typical caddis-fly pupa is surrounded by a thin, more or less transparent membrane, and has a pair of powerful legs in the middle. The membrane can be filled with air, which provides a lifting force to the insect on its way up. The central legs have swimming brushes on their ends, to be used skilfully during the ascent.

Adult winged caddis flies have a hairy coat and, usually, long antennae. Whereas the wings of mayflies are a large front pair and a tiny rear pair, the caddis fly has four equally large wings and is thus easy to recognize in the air, resembling a flapping moth. When it rests, the wings are laid roof-like across the rear body.

Caddis flies are clumsy fliers and often get wet, both while drinking and while laying eggs. Since the adults differ from mayflies in being able to drink, they can live comparatively long on land and in the air. Mating normally occurs in the air and, as with mayflies, the species differ in regard to egg-laying. For example, the large *Phryganea* crawl down into the water and lay eggs there. Some others drop eggs into the water, or fasten them to reeds and branches that hang over the water.

After mating and laying eggs, the caddis fly has finished its work and dies – doing so on land, in contrast to mayflies.

Caddis flies have become ever more important for flyfishing, since they are relatively tolerant of water pollution. They undergo complete metamorphosis before turning into winged insects, so they also have a pupal stage. All three stages appeal to fish – the larva, pupa and flying insect. Shown at top is a winged caddis fly, typified by its hairy body and long antennae. Below this are the larva, the pupa, and (at bottom) a "case worm" larva (Hydropsyche).

So there is no "spinner fall" in this instance. Yet caddis flies are the flyfisherman's dream insects, because all three of their stages provide food for fish and are, in addition, easy to imitate when tying a fly and fishing with it.

Stoneflies (Plecoptera)

The stonefly is an age-old, exceedingly primitive insect. Like mayflies, it undergoes incomplete metamorphosis. The nymphs are readily identified by their long antennae and, in particular, the two on their tail, where a mayfly normally has three. Further characteristics are the stonefly's flat body and its powerful legs, which enable it to hold firmly on stony bottoms in strong currents, similar to the creeping mayflies.

Many stoneflies hatch during early spring, when no other insects are about. One can often see them sitting inconspicuously with a grip on poles and tree stumps while an icy wind rushes along their surging stream. Not without reason, some of these winter bathers are known as "February Reds".

Stonefly nymphs, instead of climbing to the surface and hatching there, crawl up on land to undergo metamorphosis. During extensive hatchings, fish are attracted and hunt eagerly along the bottom for wandering nymphs. Once on dry land, the nymph cracks its skin and an adult stonefly crawls out. Like caddis flies, it has two almost equally large pairs of wings – but when resting, the wings are laid flat over the back, which makes them easy to distinguish from caddis flies. Besides, the latter are hairier than stoneflies.

A winged stonefly has little talent for flying, and prefers to stay on land among reeds and grass. No doubt it realizes its limitations in the air. For it also mates on land – often preceded by a kind of foreplay, in which the females call the males by drumming on a tree trunk. Sophistication indeed!

Like caddis flies, the adult stonefly can drink and is able to live for some time on land. After mating, the male dies and the female flies upstream to find a stretch of suitable water. There she lays eggs by dipping her rear body in the water. At that time, she naturally faces a great danger of being gobbled by a fish.

Stoneflies are bound to flowing waters, and many of them are very demanding about the water quality. As a rule they are good indicators of clean water, although some robust species can survive in mediocre waters. On the whole, stoneflies are most important in waterways with stony bottoms as well as pure, cold water. Here they also constitute a key food for trout and grayling, which enjoy both the nymphs and adults.

Most prominent of all are the stoneflies in northwestern America. A couple of very large species, belonging to the family *Pteronarcidae*, provide the local basis for exciting and productive flyfishing – partly when the nymphs, several centimetres long, approach land in order to hatch, and partly when the big females return to lay eggs. Since the adults have pale orange bodies, these giants are known in the region as "salmon flies".

Stoneflies are primitive insects which undergo incomplete metamorphosis. They need relatively high water quality in order to thrive, and are definitely of interest to both fish and fishermen in waterways thet are not too polluted. Shown at right are the nymph – with its typical flat body, two tail antennae and long feelers – and the winged insect, which characteristically lays its wings flat on the back.

Damsel- and dragonflies (Odonata)

The insects to be discussed here are large and, like mayflies, have an ancient and primitive origin. Dragonflies are among the biggest insects that ever flew – prehistoric giants with a wingspan of from 30 to 40 cm (12-16 inches)!

Today's dragonflies are not huge, but they still resemble their ancestors in appearance. Their significance is greatest for fish in lakes and ponds, even if several species also occur in or near running waters. They are greedy predators and all can fly well. Like a helicopter, they may stand motionless in midair and then be gone. Thus, they are difficult to catch, being most vulnerable during the early morning hours when it is still cold and the insects are somewhat lazy.

The dragonfly undergoes an incomplete metamorphosis, going through no pupal stage. After up to three years in the water, the nymph crawls up on land in order to become a winged insect. As a nymph, it moves quietly and calmly in the mud and between plants, where it is hard to observe. It is a greedy, rather clumsily built predator, which moves slowly but can go very fast when necessary. It then uses the "jet" principle, ejecting water with great force from its rear body.

The adult dragonfly is unimportant as fish food, being an all too skilful flier. Its nymph is therefore the target of fish. This is also generally true of the damselflies, which are less well known than dragonflies. They are often mistaken for small dragonflies, but the difference is clear. Adult damselflies are distinctive in laying their wings back along the body when resting, whereas dragonflies hold their wings straight out from the body at rest.

Dragonfly nymphs are short and thick in shape, while damselflies are slim and elegant. Since damselfly nymphs pursue an active life, they are very often found on the menu of fish, and are important insects for the flyfisherman and flytier. They have long, thin legs and the rear body is provided with three gill leaves, which function like sculling oars.

Just like dragonfly nymphs, the damselfly nymphs go up on land to become adult insects. However, the latter are poorer fliers and often land in the water, or in a fish's stomach. On the whole, these nymphs are an important source of food in lakes and ponds – much more significant than dragonflies.

(Above) Damselflies and dragonflies are enjoyed as food by fish in many waters. They have no pupal stage, undergoing incomplete metamorphosis. As the middle picture shows, the nymph is slender with three "gill leaves" on its tail. Beneath it is an imitation nymph.

(Below) Dragonflies, too, undergo incomplete metamorphosis. The short, thick nymphs are an important food for fish in lakes and ponds, where they live in the mud and among plants.

Two-winged insects (Diptera)

This group includes such different insects as crane-flies, houseflies, mosquitoes and dung-flies. Here, though, we shall discuss only the two-winged water insects of the families *Simulidae* and *Chironomidae*, namely the buffalo gnats and the midges. Both are very important for fish. Buffalo gnats live in running water, while midges are most prominent in lakes and ponds.

The buffalo gnat undergoes a complete metamorphosis, with a pupal stage between its larval and winged stages. The larvae are very easy to recognize, having an elongated shape with a flat rear body and, usually, a greenish colour. In waters polluted by organic sewage, such as streams where fish ponds cause pollution, buffalo gnats occur in vast quantities. They sit in thousands upon water plants, and function as a sort of biological purification apparatus. This is because the larvae nourish themselves by filtering bacteria out of the flowing water. In clear, cold water farther north, however, quite different species dominate, placing great demands on clean water.

After several moultings, the buffalo gnat larva pupates. Its case is fastened to a stone or a water plant, resembling a paper cone with the opening turned upstream. When a couple of weeks have passed inside the case, air is formed under the pupa's skin, which eventually bursts. The winged, developed gnat rises on a tiny air bubble to the surface, where it takes off and flies inland. Thus, the buffalo gnat is hatched, not on the surface like other water insects, but already inside its pupal case in the water. The mature buffalo gnat has a characteristically humped back, which explains its name.

The winged female buffalo gnat must suck blood before mating and laying eggs, a fact which causes great trouble for grazing horses and cows. Mating usually occurs in midair, followed by laying of the eggs on or in water. Particularly during the month of May, the water surface can be almost covered with egg-laying females, and the fish feast on them!

Midges, too, undergo complete metamorphosis with a larval, a pupal, and a winged stage. There are innumerable chironomids, as they are also called, but fortunately they can be grouped according to appearance and way of life.

The midge larva is notably important as food for fish in lakes, ponds and bogs. It lives on or in the bottom, where it eats rotting vegetation. The larvae may be green, brown or red, depending on their locality. Green larvae are naturally bound to plants, while brown ones stay on muddy bottoms. The red larvae, which are probably the best known, remain in the depths on the bottom, often in oxygen-poor water. Their red colour is due to haemoglobin, which enables them to survive even under very oxygen-poor conditions. All midge larvae resemble worms with a cylindrical body.

When the larva has become big enough – the largest are up to 3 cm (1.2 in) long – it pupates. The pupa has a characteristic appearance: its rear body is long, slim, and clearly jointed with small, light appendages farthest back. Its breast is much thicker and has marked, dark wing vestiges. On its head are conspicuous bushy, white gills.

The pupal stage seldom lasts longer than two or three days. As the time for hatching approaches, the pupa becomes ever more active. It swims around near the bottom, where it is often caught by fish. When the conditions are right for the pupa, as they normally are during calm evenings and mornings, it swims up to the surface where it may stay hanging for a surprisingly long time. This is obviously the most critical point in the midge's life. The pupa actually hangs with its breast on the surface and its rear body underwater.

In calm weather the water surface is difficult to break through. This is certainly why the midge pupae stay hanging for so long at the surface before they hatch. On the other hand, not very many of them drown during hatching and remain hanging in the water surface film. Suddenly, the adult midge crawls out and flies away inland.

The fully grown midge has a cylindrical rear body with short, slim wings. Males are thinner than females and have large, bushy antennae. Midges create enormous swarms of dancing insects, but – unlike buffalo gnats and ordinary mosquitoes – they do not suck blood. Instead, their wings purr cheerfully, giving rise to the nickname "buzzers". After mating, the fertilized females fly out over the water, often with a thick, bent rear body, to lay eggs.

Midge larvae are extremely important for fish in still waters, and this is true of trout as well as carp and eel. Yet the larval stage has little significance for flyfishing, which profits from the active pupal stage. Trout usually take the pupae when rising calmly for nymphs, with both their back and tail fins showing over the water surface. However, the egg-laying midge females can also be of value to fish and fishermen. When the heavy females find their way down to the water and lay eggs, they become easy prey for fish.

Midges are by far the most important insects in lakes and ponds. They undergo complete metamorphosis, and thus have both a larval and a pupal stage before acquiring wings. The elongated larva (above left) varies in colour depending on where it lives, and can grow up to 3 cm (1.2 inches) long. When large enough, it pupates (above right). After two or three days, the pupa swims up to the water surface and hangs there until it hatches. The pupae are extremely important for flyfishing, since the fish at times feast on them just when they are hanging in the surface film.

What often occurs is a hectic attack on the buzzing insects in almost total darkness.

It can be frustrating when midges hatch and swarm, frequently in incredible numbers at the same time. In spite of that, midges are probably the insects of greatest importance to trout fishermen in most lakes – followed closely by the damselflies.

Water boatmen (Corixa)

The last of the water-living insects to be mentioned here are the water boatmen. Unlike "back swimmers", which have light backs and dark bellies, the water boatman stays on the right keel and, similar to other animals, has a light belly and darker back.

For some reason, back swimmers are seldom found in the stomach contents of inland fish. But water boatmen are apparently quite popular to fish. Moreover, they are exciting insects in themselves. A water boatman can fly as well as live in water – an ability which it shares with very few other insects. Its spoon-shaped front legs are used for eating, its claw-shaped middle legs for holding on, and its powerful oar-like rear legs for swimming. Water boatmen are very good swimmers and rise quickly to the surface, where they take in air and may then return to the bottom, on which they spend most of their time.

When a water boatman needs oxygen, it swims up to the surface and surrounds itself with an air bubble – which it holds tightly with small, water-repellent hairs. As the oxygen in this balloon is used up, more oxygen is pressed in from the surrounding water. So the air membrane operates as a kind of external gill for the water boatman, which can therefore hold itself down in the water for long periods at a time.

Although they live in water, most water boatmen are superb fliers. When they return to the water and dive in again, they make an ample splash! These are heavy insects and can grow to 1.0-1.5 cm (0.4-0.6 in).

Trout is one of the flyfisherman's most common and popular quarries.

Water boatmen can live in water as well as in air. Because of this remarkable combination, they must regularly rise to the surface, so the fish soon notice them. But thanks to their long and powerful rear legs, they can swim surprisingly fast.

Terrestrials

Formerly, flyfishermen and flytiers spent little time on land-based insects, which occasionally fall into the water and become food for fish. There were enough water insects for all purposes, especially the classic mayflies.

Today things have changed, and many insects – not least the mayflies and stoneflies – have faded from our trout waters because of pollution and other damage due to man. Massive hatchings of such insects are thus only a memory. Interest has therefore naturally concentrated upon "terrestrials", and not only since they occur at periods when no water insects are hatching. One can also often tempt fish with imitations of terrestrials when there are no insects at all on the water. The fish know by experience that a tasty insect may tumble down at any time on the water surface, so they are always prepared!

There are thousands of different land insects able to fall into water. As flyfishermen, however, we can content ourselves with noticing four groups: the ants, beetles, crane-flies and grasshoppers.

Since long ago, flyfishermen and flytiers have been pre-occupied with the so-called "flying ants", a term that is often misunderstood. In fact, only a tiny proportion of all the ants ever acquire wings. Ants are community-building insects in the same way as, for example, bees. An ant community consists of a queen and a large number of workers. The queen normally lays unfertilized eggs which turn into workers. When a new community is to be founded for any reason, the queen begins to lay fertilized eggs. These will become males, whose sole purpose in life is to fertilize the queen. Only the queen and the few males have wings – the working ants never have them.

Once they have come that far, the males and queen leave their old community, and the queen mates with one of the males. The ants are then said to be swarming. After mating, all the males die, while the queen begins to found the new community. If any males fall into the water, the fish go crazy. This usually happens a few times each season, and it is obvious that such "ant falls" can seldom occur. Nonetheless, imitations of ants are frequently good as bait. The reason is that worker ants are diligent, active insects, which commonly fall into the water. The fish thus see and eat both the winged and wingless ants.

Beetles are an important insect group for flyfishermen. On the one hand, they are extremely widespread. On the other, they are clumsy fliers and often need to land on the water surface. When things go wrong, these heavy creatures come down with a splash, which always arouses attention in the water. Imitations of beetles, therefore, are always worth having in your fly box!

Although crane-flies are only occasionally caught by fish, they are interesting insects for both the flytier and flyfishermen. Fish indisputably adore eating them, as can be experienced every year on the great inland lakes in Ireland. There, during late summer, a literal "crane-fly season" occurs, when many of these big insects blow out across the water. They flutter helplessly about, a pattern of behaviour which appeals enormously to the hunting instinct of fish.

American flyfishermen have had great success with grasshoppers, and not surprisingly. Hardly any other insects can get trout to take as easily as do grasshoppers. They are large and nutritious, representing almost pure "energy food", and fish gladly swim several metres to take them. The strike is therefore violent and the fishing quite exciting. This type of fishing is most popular in the American Midwest, where grasshoppers are abundant on the wide prairies.

(Left) A number of land insects are exposed to the hunger of fish at times when other food is scarce. The fish are then quick to take an insect that happens to fall in the water. Examples of such popular terrestrials are shown here: ants, the crane-fly and the grasshopper.

Crustaceans

Crustaceans are among the most important of all fish food. Often plentiful, they are what gives the flesh of trout its beautiful red colour. In fresh waters, we are referring to the groups *Gammarus* and *Asellus*.

Gammarids are recognizable by their high, compressed body with downward-pointing legs. They occur in both still and flowing waters, but need rather clean water in order to flourish. In waterways, they live freely between and on the water plants, at the margins of the current. Their colour is usually greenish with grey and brown markings.

By contrast, the members of *Asellus*, which are broad and flat with outward-pointing legs, tolerate quite a lot of organic pollution and acidification in the water, so they can exist in lakes where not much else survives. Staying in quiet muddy places, they are dark brown with light spots – a fine camouflage on muddy bottoms with rotting vegetation.

Only a few species of these groups exist in fresh waters. Yet both groups are particularly abundant in salt water, where *Gammarus* includes about 200 species and Asellus around 100. There too, they are very important as food for trout and other fish. Other crustaceans live in the sea, not least the large shrimps. These stay buried in sandy bottoms, or circulate near water plants. Most abundant is the group *Crangon*, but more exciting are the *Palaemon* shrimp which undertake regular migrations from shallow to deep waters and back again. At such times, the fish stuff themselves with shrimp!

Finally we have the small but numerous mysids – almost transparent "opossum shrimps" which are not bound to the bottoms, but float freely with the currents. Large quantities of mysids in the water can make it murky. We may not be able to see individual mysids, yet the fish do so with ease and they place high value on this source of food.

Drift

Drifting is a well-known habit at least in the United States, where many flyfishermen drift with the current in boats along the fine trout rivers of the Midwest. This, however, has nothing to do with the "drift" which occurs underwater. The latter phenomenon was discovered rather recently and is very important for both the flyfisherman, the fish, and the animals eaten by them. Such drift is a downstream transfer of insects and crustaceans, often in huge numbers.

There are several forms and causes of drift. At regular intervals, insects and crustaceans lose their grip on their usual habitations and are swept away by the current. This kind of drift happens all day round, and is normally not extensive. Sometimes it increases, as when violent changes occur in the environment, for example during the intensive meltings of ice in spring, or when other events take place that may be experienced as real natural catastrophes by the small animals in waterways. Drift can then be so great that most animals are literally washed away.

In these cases, of course, drift is involuntary. But in others, it occurs more or less by choice. This can happen when the activity of small animals is suddenly heightened: they may be seeking more open water with stronger current, and then the drift will naturally grow. Increasing drift may be due to the daily rhythm, to crowding, or to imminent hatching.

The daily rhythm is the main cause of drift. Nearly all animals exhibit some sort of daily rhythm, being more active at certain times of day or night than at others. Insects and crustaceans are no exception, and most of their species are distinctly nocturnal, making the drift greatest at night. Their drift increases sharply just after sunset and after sunrise. Generally speaking, drift is greatest after sundown when the darkness provides good cover for small animals – and for fish!

Some waters support so many insects that there is just not enough room for them all. Crowding occurs over the best living sites, and this involves a degree of emigration among the surplus insects. They drift downstream in hopes of finding places with more space.

At times immediately before hatching, insects tend to be very active. They regularly leave their residences among water plants and stones, and swim around in more open water until they climb or migrate to land. This means an increased drift, which the fish are quick to exploit.

If these different forms of drift were not somehow counteracted, all of the insects and crustaceans in a waterway would eventually end in the sea, with the final result that no more animals would exist in flowing waters. But obviously this does not happen, and the drift is actually opposed in two regions – the water and the air.

Many species work against the drift by actively travelling upstream. Their journeys occur on the bottom, and in places where migration is possible in spite of the curent – often along the shores in rapidly flowing waters. Crus-

Diverse crustaceans are abundant in both fresh
and salt waters. As a result they rank high among
fish foods. Illustrated at right is a Gammarus
shrimp, which occurs in flowing and calm waters
alike. Usually greenish in colour, it lives on or
between the plants in streams with relatively good
water quality.

taceans are not the last to oppose drift in this way, as it is the only method available to them.

The insects do likewise, but have a further alternative. They always fly upstream in order to lay eggs. Thus they compensate for the unavoidable drift downstream, to which they are subjected during their larval and nymph stages. Water insects never fly downstream to lay eggs – that would mean sheer suicide for the species.

All small animals in a waterway drift, but some are naturally more prone to drifting than others. The most active ones expose themselves to greatest risk, and the more active they are, the greater their chances of being taken by the current. Gammarids are nocturnal creatures and drift in large numbers. The same is true of the swimming mayfly nymphs and a few of their crawling relatives. The digging mayfly nymphs and the case-building caddis fly larvae, as might be expected, seldom drift. Yet the net-spinning caddis fly larvae often do so.

Natural drift is important in many respects. On the one hand, it provides a distribution of any surplus of animals over a large area. On the other hand, it means that empty areas can quickly be repopulated. The last fact has great significance in view of pollution, which kills the life in a waterway. Drift ensures that a rich variety of animals can re-establish itself in such places.

Finally, drift is also of clear value to the fish in a waterway. Much of their food consists of insects and crustaceans which come drifting down to them. Even if all fish profit by drift, it is most important for the smaller fish. Big fish are nourished to a greater extent by sizeable bottom animals, which rarely drift, and by smaller fish.

Drift is, nonetheless, so important for all fish that they generally choose to stay in places where the current concentrates the drift and, therefore, the food. A good example is the inlet of a fast current to a calm hole. The rapid flow brings many small animals which the fish can easily eat in the calm water. Studies have shown that more small animals drift into such a hole than out of it, and the difference must therefore have been eaten by the fish!

In conclusion, drift is of enormous value to both fish and fishermen. The fish seek places where the drift is greatest, and it is there that we can tempt them with our flies.

A stubborn trout has at last been outwitted. The choice and presentation of the fly were evidently correct.

Small fish

As mentioned earlier, there are no insects in the sea, so marine fish direct their hunger toward crustaceans and smaller fish. However, the latter are also an important part of fish food in fresh waters, especially for the biggest fish. It is therefore necessary for the flyfisherman to know a little about the small fish which are regularly on the menus of other fish.

Small fish are of less significance as fish food in running waters than in still waters. Our trout in running waters gladly eat minnows *(Phoxinus phoxinus)*, small colourful carpfish which need clear, oxygen-rich waters. Elsewhere it is often habitual bottom-fish that are eaten, for example the American sculpins *(Cottidae)* which, with their flat body form, are adjusted to life in flowing waters.

The relatively great importance of small fish in still waters is seen in both lakes and the sea. In both of these, one can distinguish between fish which are bound to the bottom or to water-plants near the shore, and typical school fish which travel pelagically in the free water masses.

To the first group belongs the stickleback, an abundant fish in both fresh and salt waters, which is important as food for trout among others. So are the year-old fry of perch and various non-predatory fish in lakes. The latter normally spawn in late spring, and the fry stay hidden during the summer in vegetation in very shallow waters. Towards summer, the smaller fish wander out to deeper water – as far as the underwater plants which, at that time, often reach up to the surface. Out there, the smaller fish are commonly attacked by larger predatory fish that drive schools of fry to the surface. The small fish leap for their lives, resembling a virtual rainstorm on the surface.

In coastal seas and coves, there are frequently large numbers of gobies. These small bottom-fish closely resemble the above-mentioned sculpins, having broad heads and breast fins. Farther out, one can meet the big sand lances, which are quite valuable to predators. The long, thin, silvery sand lance is easy to recognize. It spends much of its time buried in gravel and sand, but cannot feel secure even there. Sea trout, in particular, enjoy swimming around and sucking up the sand lances on sandy bottoms.

Other food

If we pass to greater depths in lakes and the sea, we find pelagic school fish which are a key source of food for big predators. Larger and deeper lakes with cold water are inhabited by smelt, a thin little salmonoid, almost transparent, which swims freely in sizeable schools. It loves cold water and, during the summer, moves out to deeper water – followed by inland lake trout and other predators. On the other hand, these typical cold-water fish are active until well into the autumn. In melt-water lakes, it is therefore not unusual to observe a "perch picnic" with diving gulls and leaping fish as late as November and December, when other small fish in lakes have long since gone out to over-winter in the depths.

The bleak is another important school fish in lakes but, unlike the smelt, it is a warm-water carpfish that breeds in shallow waters during June and July. This often occurs in large schools, which naturally attract the attention of predators.

In the sea, it is herring that dominate the diet of predators. The great herring is known for long migrations into and out of coastal waters, but the sprat – which is smaller – does not travel so far. Both of these fish live on animal plankton and fish fry, so they journey in free water. There they follow the planktonic organisms' daily rhythm, which is controlled by the sunlight: up towards the surface with waning light, and down into the depths with waxing light. Thus, the greatest chances of finding active herring-hunters are at the surface by dusk.

In addition to the insects, crustaceans and small fish discussed above, several other foods are eaten by fish. Actually most fish are opportunists, consuming whatever they can get. Only seldom are they so selective that they feed on a particular animal species.

In fresh waters, there are often small snails among the more mobile prey. This is something which the flyfisherman hardly needs to know, and bottom-dwelling snails are almost impossible to imitate anyway. However, some snails occasionally abandon their life on the bottom and rise to the surface, where fish gladly take them. Why snails behave in this manner is unclear, but it is certainly a faster means of getting about.

Leeches are frequently found in the stomachs of fish caught in fresh water. Obviously the fish enjoy these fleshy creatures, which swim by wiggling through the water. Leeches can become very large and are also liked by bigger fish. They are easy for both the flyfisherman and flytier to imitate.

In salt water, it is often ragworms that are found in fish stomachs. Notable are the large *Nereis* species, and particularly during early spring when these blue-green worms "swarm" in shallow coastal waters. They leave their holes in the bottom and swim up to the surface in order to mate. Numerous and commonly 10 cm (4 in) long, they offer the fish an easy meal which, in the still cold water, may well be the first one of the year.

There are many examples of fish food other than insects, such as the small fish in lakes and seas. At left are shown two species of importance to bigger fish: the sculpin in North America, and (beneath it) the minnow in Europe. The bottom-living leech (above) often occurs in fish stomachs. It can grow rather large and, just like small fish, is therefore quite popular to the bigger fish.

The flies – our deceptive imitations

There are many thousands of fly patterns around the world. Every day new materials and patterns appear. The range is so wide and difficult to survey that a newcomer may well feel confused when he or she is choosing flies for the first time.

However, flies and fly patterns are often two different things. Fly patterns are what you use as a model for tying; flies are what you fish with. All too many flyfishermen and flytiers overlook this distinction. They place excessive faith in the fly pattern itself, and think more seldom about how the finished fly works and whether it is suitable for fishing.

Among us flytiers are plenty of "pattern fanatics": flytiers for whom a fly is acceptable only if tied exactly according to the rulebook, and then only with the correct materials. Thus they become slaves to the pattern, and are unable to tie a particular type of fly if they lack any of the often exotic materials which are prescribed.

It ought not to be that way – at least from the viewpoint of a flyfisherman. The fish are indifferent to tiny details and conceits; they are far more interested in the actual presentation of the fly than in the pattern. What counts for a fish is the total impression, not the absence of a few fibres or a peculiar feather.

Imitations or fantasy flies

If you tie flies for the sake of flytying, you obviously have to stick to the correct patterns and materials. Then it becomes a hobby in itself. But fishing has for many years suffered from the fact that authors are often more inclined to flytying than to fishing. The available literature has therefore given, at least to beginners at flyfishing and flytying, the mistaken impression that fly patterns are something sacred and inviolate.

Fortunately a clear change in this situation has taken

place during recent years. New materials and tying methods have arrived, banishing the old classics into oblivion. These materials are easier to work with than the original ones, and are much more durable too.

Plastic tinsel does not break down like the old metal materials, even in the saltiest water. Stainless steel has shown the same advantage in regard to hooks. Polypropylene has revolutionized dry flies, for example, where it is lighter than water and, moreover, is water-repellent. On the

of fishing situations. Just think of the "muddler", which can be tied in all conceivable circumstances – from the smallest to the largest – and is fished both wet and dry. It is a good instance of a true classic: a fly type rather than a fly pattern.

Consequently, a fly pattern should be regarded mainly as a proposal, rather than as a prescription. It ought to be a starting point for individual interpretations. A pattern which has been thought out or developed in order to suit the discerning trout in a quiet English chalk stream cannot necessarily be transferred to other parts of the world. It must be adapted to the fish's size and the water's current speed, depth and clarity, to mention only a few local factors.

Lastly we should consider the way in which a particular fly pattern came into being. Often the fly's inventor has been in a situation where he or she was forced to get along with the materials at hand. Perhaps quite different materials would have been used if available at the time, and perhaps the finished fly would have been even better. So the flytier ought to have a relaxed attitude towards the pattern. Flies are primarily intended to be used for fishing and, if one does not happen to have the prescribed material, one replaces it with something similar – maybe even better than the original material – for one's own fishing water!

A fly pattern can be created from various points of view. It may be a pure fantasy fly, or an exact imitation. The fly can be imagined to imitate the fish's natural prey, or it can be designed as a provocation. Thousands of fantasy flies have been conceived through the years, but very few have stood the test of time. England's bright red Cardinal, for example, has survived precisely because of its beautiful appearance and classic name. The same is true of a fly such as Silver Doctor, which is equally popular for brown trout, sea trout and salmon. It is obvious that the pretty colours are what have kept these flies in the fly-box, even more than their ability to catch fish, which is no better or worse than that of many other flies.

Things are different with the imitation flies, many of which have lasted remarkably well. This is especially true of dry flies and nymphs from the age of Halford and Skues. Although first tied around the turn of the century, they have nevertheless managed to retain their status for decades. It was, in fact, first when Swisher and Rickards created the famous "no hackle" dry flies that Halford's original dry flies became obsolete. Among other innovations, that of synthetic polypropylene – then called "phentex" – set the development in motion. Until then, natural materials had enjoyed a monopoly.

A deceptive imitation and its prototype.

whole, synthetic materials have made life a lot happier for both the flytier and flyfisherman.

In spite of that, many classics are still in our fly-boxes. They are flies which have been around for longer than most of us can remember – flies so simple and ingenious that they still fish as well as on the day when they were first conceived. Often it is not a question of the actual pattern. These eternally young classics are types which be varied according to the conditions and can therefore cover a range

Good and bad imitations

On the whole, the classic English dry flies are incredibly poor imitations of real mayflies. Their dense hackle, which was needed to let them float at all, was enough to make them bad imitations. That they still could, and can, defeat shy and selective trout in the southern English chalk streams may tell us more about the fish than about the flies.

We usually say that dry flies float, but they very seldom do so. In order to float, a fly must be lighter than water, and this is far from true of ordinary dry flies. A conventionally hackled dry fly is heavier than water and cannot float. It does not sink simply because it is held up by the surface tension. It actually stands on the surface with its many hackle fibres, just as the real insect does with its legs. Both rest on an unbroken water surface and are so shaped that the surface tension supports them. As soon as the surface tension is broken, the fly or insect sinks.

Left: Many flyfishermen think that conventionally hackled dry flies float – in other words, that they are lighter than water. But the truth is that they rest on the water's surface tension.

The surface tension of water, however, varies a lot from place to place. The cleaner the water is, the stronger its surface tension, and therefore the greater its ability to support insects and dry flies. When the water is polluted in any way, the surface tension immediately decreases. Then dry flies have difficulty in staying afloat. But what is worse, the same applies to the real insects. Many of them become unable to complete their life cycle, since they are "caught" hanging in the water surface and remain hanging there while they hatch.

Flytiers should take account of this phenomenon. It means that dry flies must be hackled more densely for polluted than for clean water. Actually we may get along well enough without hackle, as the above-mentioned "no hackles" indicate. As their name implies, these flies have no hackle at all, but consist of a tail, a body, and a pair of conspicuous wings. They can still be made to rest superbly on the surface tension, although in an impregnated condition. At the same time, they are silhouetted to the fish, and this is far better than the hackle fibres' imitation of characteristic mayflies. Especially typical of these insects are their upright wings.

Dry flies can be tied in numerous ways. Here we see a traditional example (upper left), a "no hackle" dry fly (lower left), and (at right) the two steps needed to tie a parachute-hackled dry fly.

Sparsely tied flies are, as a rule, best for selective fish in clear, calm water. They imitate their natural prototypes better than do densely hackled flies, which merely give the fish a confused picture of something that might be edible. Even so, in many situations we are forced to depend on the latter kind of flies – for example in fast waters, where flies with little or no hackle sink instantly.

For such fishing, therefore, special dry flies have been developed, which can stay afloat even in a whirling current. Instances are Wulffs, Kolzer Fireflies, Goofus Bugs and various Irresistibles. These flies are all equipped with strong wings and tail, as well as dense and bushy hackle of the highest quality. This structure enables them to stand high on the water, and keeps them visible to both the fish and fisherman. In the case of Goofus Bugs and Irresistibles, a further step has been taken: they are provided with a sort of "life jacket", an air-filled body of deer hair, which gives them volume and floating force when it really counts.

These ample "floaters" seldom resemble anything in particular, but rather resemble a morsel which the fish are reluctant to pass up. In fast waters, it is nevertheless unnecessary to use the exact imitations which are required in clear, calm water. Fish in a rapid current do not have time to study the fly – they must react fast, or else it is gone again!

But densely hackled flies can also be needed in still waters, for example when fishing with imitations of caddis flies. This often involves large insects that cause commotion when they flutter about, especially during egg-laying. Such behaviour can be imitated by allowing a dry fly to drag on the surface, a technique which calls for densely hackled flies that do not sink immediately.

Today it has become ever more common to tie certain types of flies with foam rubber such as "polycelon". In this way the finished fly is made to literally float, in contrast to normal dry flies which simply rest on the surface tension. Such an ability is used for flies that have to float on the surface – typical hatching nymphs, or heavy land insects like beetles and grasshoppers. The latter can often be served up to notable advantage with a clear, loud splash that draws the fish's attention to the fly. And this is a technique that demands self-buoyant flies: those with a body of cork or foam rubber, which is easier to work with and also lasts longer. Here is still another proof that synthetic materials have revolutionized flytying and given us completely new opportunities.

Colour can trigger strikes

But what is it about our flies that gets fish to strike? An ethologist can provide some insight into this fascinating subject. Ethology is the science of animal behaviour, and conducts research on why animals act as they do.

In one of the most classic ethological experiments, it was investigated how the stickleback reacts to different stimuli. As is well known, the male becomes extremely aggressive during the spawning period. He defends his territory and nest against all intruders, especially competing males.

During spawning, the males are coloured bright red on their bellies, while the females have a large, distended stomach full of eggs. It was studied how the sticklebacks reacted to various decoys. Some of these were exact imitations of males and females, whereas others bore little or no resemblance to them.

The experiment yielded interesting insights into the fish's ways of reacting. Not unexpectedly, close-imitation decoys with bright red colours triggered a violent reaction in the males, which naturally thought that the decoys were competing males. Moreover, decoys with a distended belly attracted great interest as if they were real females.

Yet the truly fascinating result was that perfect imitations did not release stronger reactions than did the less close imitations. It was the colour which proved decisive for the males, and the shape for the females. Colour and shape were the so-called "key stimuli" which triggered reactions – the factors that determined whether there would be any reaction at all. As long as the decoy was red, and preferably bright red, the males showed violent reactions, ignoring all else. Even a red car which drove past outside the window was enough to excite the male; and a red car cannot be said to have much in common with a stickleback!

One might think that sticklebacks are more primitive than the salmonoids which we try to catch with flies, but such is not the case. From a purely evolutionary standpoint, salmonoids are more primitive, and the stickleback is among the most advanced fish. The experimental results with sticklebacks can thus very well be applied to salmon and trout.

When fishing in cold water, colourful flies are often the best choice.

What can we learn from this as flytiers and flyfishermen? Quite a lot. It is natural to attempt to imitate, as closely and detailed as possible, the animals which constitute fish food. The more a fly resembles its prototype, the better it fishes – for fish are not stupid, are they?

Well, fish are indeed stupid, at any rate by human standards. They cannot think in the sense of adding two and two. They learn from experience, but do not reason. They have no perspective on their situation and, instead of thinking, react to external influences. Whether we like it or not, a fish is a primitive machine, controlled by its environment. The frequent difficulty of catching it is due to various factors which we are seldom able to govern.

This logic serves simply to bring down to reality the controversial "imitation principle". Certainly it may be interesting to tie very exact imitations, but unfortunately the fish rarely set much store by them. From the experiment with sticklebacks, we saw that the colour is the decisive key stimulus. If we look at our own flies with the eyes of a fish, things become more complicated.

Fish can see colours – this is a fact. But in regard to dry flies, for example, colour is by no means as important as was once thought by flytiers and flyfishermen. The fish see a fly from below, outlined against the sky in backlight, so they can hardly distinguish beween different colour tones. In practice, it often turns out that we can do quite well with a small range of dry flies in a few colours.

Down at the water, of course, the fish can study our wet flies. Still, exact colour nuances are seldom decisive. This is because there are large individual differences between natural insects. For instance, nymphs which have to moult their skins are very dark, while those which have just done so are very light. Thus the fish see both dark and light insects at the same time, which means that they are not fastidious about exact colours. After all, they only want something to eat!

Colourful flies can be attractive

When we speak of colours and fish, we must remember that colours above the water surface are not the same thing as colours under the surface. The water absorbs some of the light which enters it. The murkier the water, the less light can get in, and the less significance a fly's colours have. We should also keep in mind that red is the colour which fades soonest, and blue is the colour that penetrates deepest. The red part of the visible spectrum is least energetic, and blue is most energetic. If you need a visible fly in deep water, it is thus a bad idea to choose a red one, which will look black to the fish and be hard to see. Instead, choose a fly with blue or green colours – ideally with plenty of tinsel, which can reflect the little available light.

Fluorescent colours have always been of great interest to flytiers. For many of us, fluorescent flies have seemed to be something magical, which now and then can save an otherwise fruitless day of fishing. But there is nothing magical about fluorescent colours. Fluorescence is due to energetic ultraviolet light, which is invisible to us. It is the same kind of light that gives a suntan or sunburn. When ultraviolet light, which is especially predominant on gray and cloudy days, hits a fluorescent material, this is activated by the light's energy and shines with unusual strength. Consequently, fluorescent colours are most clear on dark days, although they should not be confused with phosphorescent colours, which can emit light even in darkness. If there is no light, there is no fluorescence either!

In fly patterns for salmon, particularly the so-called "egg flies", fluorescent colours have made notable progress. Here they are quite superior, although of more doubtful value in smaller flies with quieter colours. Fluorescent colours seem to have the greatest effect when they are used in flies that provoke the fish to strike – in other words, flies meant for fish on spawning migrations. But they should not be forgotten if we are fishing in the cold months, when the water contains little food. Then the fish are hungry, and not especially discerning. In such situations, a fluorescent fly can attract great attention and curiosity, yielding surprisingly good results. Later in the year, when food is abundant, fluorescent colours often lose their ability to attract strikes.

A colourful fly like the classic, eternally young "Mickey Finn" is regarded as a natural attractor – that is, a fly which draws the notice of fish with its strong colours. But it is a fly which can also be very effective during the warm months, when there is plenty of food in less bright colours. Strong red-yellow hues are, perhaps, not so impressive after all. Considering the colours of a minnow or stickleback, one can see that almost every colour in the spectrum is represented. So who knows? Maybe the fish believe that a fly like "Mickey Finn" is an ordinary small fish.

Streamers may be very effective when the fishing is slow. They are easily visible and are frequently good imitations of small fish. Mickey Finn is undoubtedly a classic streamer that can lure fish to strike even when the water is relatively warm.

MICKEY FINN
Hook: streamer hook No. 6-12
Body: silver tinsel
Wing: three sections – yellow, red, and yellow – of hair from polar bear, calf tail, or goat

The fly as a caricature

The experiment with sticklebacks showed clearly that exact imitations are not necessarily the best. Other scientific studies indicate that it can even pay to exaggerate the key stimuli. A good imitation therefore need not be a fly which most resembles the prototype. It may instead be one that overemphasizes typical characteristics of the prototype. We have to think like a caricaturist who instantly hits upon the quirks of his "victim" and exaggerates them. Then there can be no doubt of whom the picture represents. It might be said that the caricature is more realistic than reality!

If the insect to be imitated is, for instance, a mayfly – which has big wings – the fly should have extra large wings. This is actually true of the so-called "no hackle" flies, already mentioned. Usually regarded as exact imitations, they are actually faithful caricatures. Their wings, which are not veiled by any hackle, tell the fish immediately that this is a mayfly.

The "no-hackle" introduced by Swisher and Rickards imitates the mayfly in its "sub-imago" stage, that is, the newly hatched insects. This very stage has caused the flytier much trouble through the years, and has given rise to a number of different proposals for the best way of shaping and tying flies. Already at an early date, flytiers began to provide their dry mayfly imitations with upright wings – which were difficult to tie on, were not very durable, and gave the fly the wrong balance. Besides, the wings became almost completely hidden by the dense hackle.

The classic dry fly is slowly disappearing from our flyboxes and being replaced by new, better and more durable imitations. Not least the parachute flies, whose hackle is wound around the wing root, have become popular. They are easy to tie and rest low on the water, just like the real insects. At the same time, their horizontal hackle adds extraordinary buoyancy. Moreover, the fly lands as light as a feather and always correctly on the water. This is certainly not true of normally hackled dry flies with upright wings, which readily topple over and lie down on their sides.

A mayfly's last winged stage, the spent spinner, is very easy to imitate. This again is due to the modern synthetic materials, which do not absorb water. With them, we can make the flies rest in the surface layer without using hackle. The "polywing spinners" are outstanding imitations with a particularly simple structure – a pair of long tail antennae, a polypropylene body, and a horizontal wing of poly yarn. They can hardly be simpler, and the fish love them!

All these imitations rest on the water, while the hook tip and the whole hook bend protrude down under the surface. Ultimately such a fly does not closely resemble its natural prototype. Insects do not break through the surface – they stand on it. Nevertheless, thousands of very selective fish have been tricked by our flies, despite the quite unnatural iron clump which hangs beneath the surface. This could be seen as another proof that exact imitations are not very significant for the fish's view of our flies.

There are flytiers who make complicated "upside down" flies, with hook points and bends that do not break through the water surface. But these have never been widespread, since they are too hard to tie. As we have seen, even the most selective fish are only seldom able to appreciate our exact imitations, which are primarily for the flyfisherman's own sake!

Function and movement

In the long history of flyfishing there are some examples of amazingly simple flies, so simple that it might be doubted whether they can be used for fishing at all. Frank Sawyer was showered with praise when he created his now classic Pheasant Tail, a fly that consists solely of pheasant cock tail fibres and copper wire. The latter serves partly as binding thread, and partly to weight the fly so that it can sink fast.

Sawyer had noticed that mayfly nymphs of the genus *Baetis* hold their legs close to the body when swimming. He therefore saw no reason to put hackle on their imitations. With sparse material he was able to contrive the right form and colour, while relying on the rod end to give the fly correct movements – an "induced take" which has since become famous.

Oliver Kite, one of Sawyer's disciples, further reduced the Pheasant Tail nymph. He went so far as to use only copper wire on a bare hook, and his Bare Hook Nymph caught plenty of fish. Most of his fishing for fastidious trout took place in the English chalk streams. So much for exact imitations!

Function is a key word when it comes to flies for practical fishing – and regardless of whether they are exact imitations or fantasy flies. The fly just has to work. Dry flies must float, being tied with water-repellent materials; wet flies must sink, absorbing water so as to break through the surface tension. The latter rule is crucial for non-weighted flies: light nymphs, spiders, or wet flies made to be fished high up in the water.

The current speed also influences our choice of material and flytying style. For instance, wet flies for use in still water must be tied with soft material that can look alive and move correctly. Such flies normally fish best when they are sparsely clad. Good illustrations are the classic spiders and soft hackles – their material pulsates at the slightest excuse. Superb in this respect are flies tied with marabou feathers.

The opposite rule holds if wet flies are to be used in fast currents. Here a fly tied with soft material would soon collapse and lose its originally intended shape, becoming just a dead lump of no interest to the fish. One should employ stronger material like cock hackle instead of hen hackle, bucktail rather than marabou, and so on.

If the fly must reach down to fish in fairly deep water, there are two alternatives: using a sinking line to pull the fly down, or weighting the fly and fishing it with a floating line and a long leader. Both methods have their pros and cons. With a sinking line you do not need to weight the fly, which thus behaves more lively in the water. But when fishing nymphs upstream with a floating line, there is only one solution: weighted flies. Then, of course, you must remember that heavy flies are dead flies with no essential life. In sum, clear limits exist to how much the fly can be weighted

Fish often let themselves be tricked into taking, even though the fly is really a rather clumsy imitation of natural food.

The Pheasant Tail Nymph created by Frank Sawyer is as simple as it is ingenious. Having no hackle, it is tied with only copper wire and pheasant cock tail feathers.

PHEASANT TAIL NYMPH
Hook: No. 12-16
Tail: three fibres from a pheasant cock's tail feather
Body: tied and weighted with red-brown copper wire, using pheasant cock tail feather fibres which are wound forward to the head, then bent back and forth to make an ample wing-case, and finally tied to the head

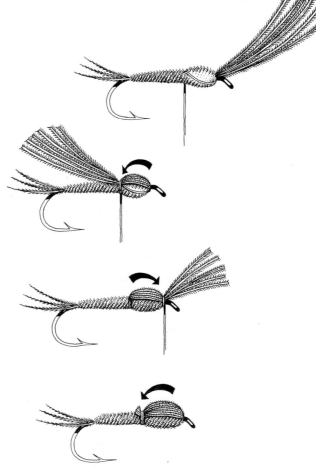

without hurting its ability to catch fish. The important thing is always to tie it with soft and vital material.

Recently we have acquired fast-sinking leaders, provided with built-in weights. They allow use of a floating line and non-weighted flies. The leader enables the fly to come down to the fish anyway, while also presenting it with a light and lively fly.

From the casting viewpoint, there are definite limits to how heavy a fly can be. Strong fly lines can carry heavy flies better than light flies, but every line obviously has its limitations. Big, densely hackled dry flies create a lot of air resistance and need relatively strong lines to be laid out against the wind. This is familiar to salmon fishermen who try their luck with big dry flies of the Wulff type. But light flies can also be very heavy. Good examples are the "zonkers" and "puppies" tied with thin strips of rabbit fur. The latter have an amazing ability to absorb water, and a wet rabbit is a very heavy rabbit in terms of casting!

The flyfisherman often needs flies which are really bigger and heavier than his equipment can handle. Such is the case with imitations of many medium-size small fish, and with giant flies for huge game like tarpon and sailfish. If these flies were tied in the conventional way, they would be unduly heavy and impossible to cast.

While tying streamers and bucktails on long-shafted hooks, we usually employ short and light hooks for really large flies. They are provided with a wing which is several times longer than the hook shaft, making a fly that is very large and yet does not weigh much. To prevent the long wing from winding itself round the hook bend, it is frequently tied to the rear of the hook shaft. This is done, for instance, on special "needlefish" flies – and characteristic tarpon flies, where the long hairwing is simply replaced by saddle hackle.

Nevertheless, it is also possible to tie a tiny fly on a comparatively large hook. Not seldom, we go after big fish that need strong hooks to be played on. But the flies must be small, since they imitate small insects. Such dry flies can be tied "double", with two flies on one hook. This offers a great advantage when the fish take midges of size 18-24. There is ample room for two flies on a hook of size 16, and then you can also use a stronger leader tippet which matches the fish's size better. Imitations of individual fish eggs – "Glo Bugs" – can likewise be made small on rather large hooks, and paradoxically at no cost to their fishing ability. Here is yet another proof that fish see flies with different eyes than we fishermen do.

Adaptation to practical fishing

Flyfishermen and flytiers are committed, creative people who work continually to keep their hobbies progressing. Originally flyfishing had a very restricted range. The cast was short and the flies could be fished only on or just under the surface. If the fish were not there at that moment, nothing could be done about it. But today's modern, well-equipped flyfishermen want to fish everywhere and under all conditions.

Thanks to developments in gear, we can now reach farther out and deeper down than our predecessors. With fly-lines that differ in sinking rate, we can scrape the bottom in virtually any kind of water. On the other hand, this has led to new requirements for the flies. We must be able to fish them all the way down to, and even on, the bottom without getting them stuck.

The latter problem has been solved in two distinct ways. Flies can be tied "upside down", or provided with a mono-filament eye that covers the hook tip. They may be tied on ordinary hooks – as is the popular "Crazy Charlie" type of fly, which is intended for fish on the bottom – or on so-called keel hooks. These can be bought ready-made, but you can use your own pliers to bend the front part of a hook upward. For instance, the well-known "Bend Back" flies are to be used for fishing near the bottom between weeds and stones.

When Don Gapen invented his Muddler Minnow, he hardly realized how much this fly would come to mean for flytying and fishing. It was a fly that, to great extent, could be used both wet and dry. The hollow deer hairs, of which its head is made, give it a characteristic shape as well as good floating ability and water resistance. Floating ability is a natural advantage when the fly must be fished dry or high up in the water. But when fishing deep, near the bottom as an imitation of a "sculpin", the floating force becomes a problem and must be compensated with some weighting.

As a result, we have recently invented flies with the same characteristic shape but tied with other materials. Widely used today are Wool Head Sculpins, where the air-filled deer hairs are replaced by water-absorbing wool, which is clipped down to the right form. Moreover, thick chenille is substituted for the typical "muddler head", giving the same shape but improving the function greatly. The water-absorbent materials enable the fly to sink more easily, so that

Muddler Minnow can be used as either a wet fly or a dry fly. Its head, of hollow deer hair, makes it both buoyant and water-repellent. The muddler's characteristic shape produces clear pressure waves as well as a conspicuous silhouette. It is thus very suitable for fishing at night, whether in shallow or in deep water.

MUDDLER MINNOW
Hook: streamer hook No. 8-12
Tying thread: black
Tail: a section of brown-speckled feather, for example from turkey
Body: gold or silver tinsel
Wing: squirrel hair covered by two sections of brown-speckled feather
Head: a pudgy shape made of a big bunch of deer hair, tied in just behind the eye, then bent backward, secured with tying thread and trimmed

much of the weighting can be avoided.

Besides giving the fly its shape, a "muddler head" has the effect of producing pressure waves in the water. These waves can be sensed by the fish and help them to locate the fly under adverse conditions. Thus, it is no accident that "muddler flies" are particularly suited to night fishing. They present a clear silhouette against the less dark sky, while also sending out plain pressure waves that enable the fish to make exact strikes!

Not seldom, "dragging" flies are also very good for night fishing. They pull up ripples in their wake on the surface, making them easily visible to fish. Notably good in this respect is the original Muddler Minnow with its air-filled deer hairs. Since the fish always see a "dragging" fly from below, its colour is rather unimportant. It is seen in back-light, even at night, so the colour black, being least transparent, gives the clearest silhouette.

Quite different are the "bass bugs" intended for surface fishing in full daylight. Here the colour can obviously be significant for the fishing results, and these flies are tied in all colours of the rainbow – perhaps for the sake of the fish, but in any case for the comfort of the fisherman, who can see the flies more easily on the water. Likewise, "bass bugs" are tied in all conceivable shapes. But they have in common a dependence on the buoyancy provided by their trimmed deer hairs. This keeps them floating on the surface where they can bubble and gurgle, so that even the laziest bass or pike go mad!

Bass can often be provoked by large flies that intrude on their territory, such as a big "bass bug" which is parked among the water-lilies where the fish lurk. Large flies also frequently draw a strike from salmon, at least those that are migrating to spawn. But the fly has to reach down to them – on the bottom, where they defend their territory. When the spawning time approaches, the males in particular acquire an impressive spawning dress, which shines with strong colours. Long jaws with razor-sharp teeth, and a grimly conspicuous jaw-hook, tell competitors to keep their distance. These traits can be exploited by the flyfisherman, if he serves up big flies in bright colours that may release the striking reflex in such aggressive fish. Small dark flies, which made the fish rise to the surface in summer, will have lost their effect in the cold water. Then only big flies can work – and preferably in colours which match those of the fish.

With that, the circle is closed. Flies can be tied as imitations or provocations, dry or wet, and in any sort of shape or colour. Yet the universal rule is that they must fulfil our basic functional needs. They have to be adapted to the fish and the fishing water – otherwise they are worthless for practical flyfishing.

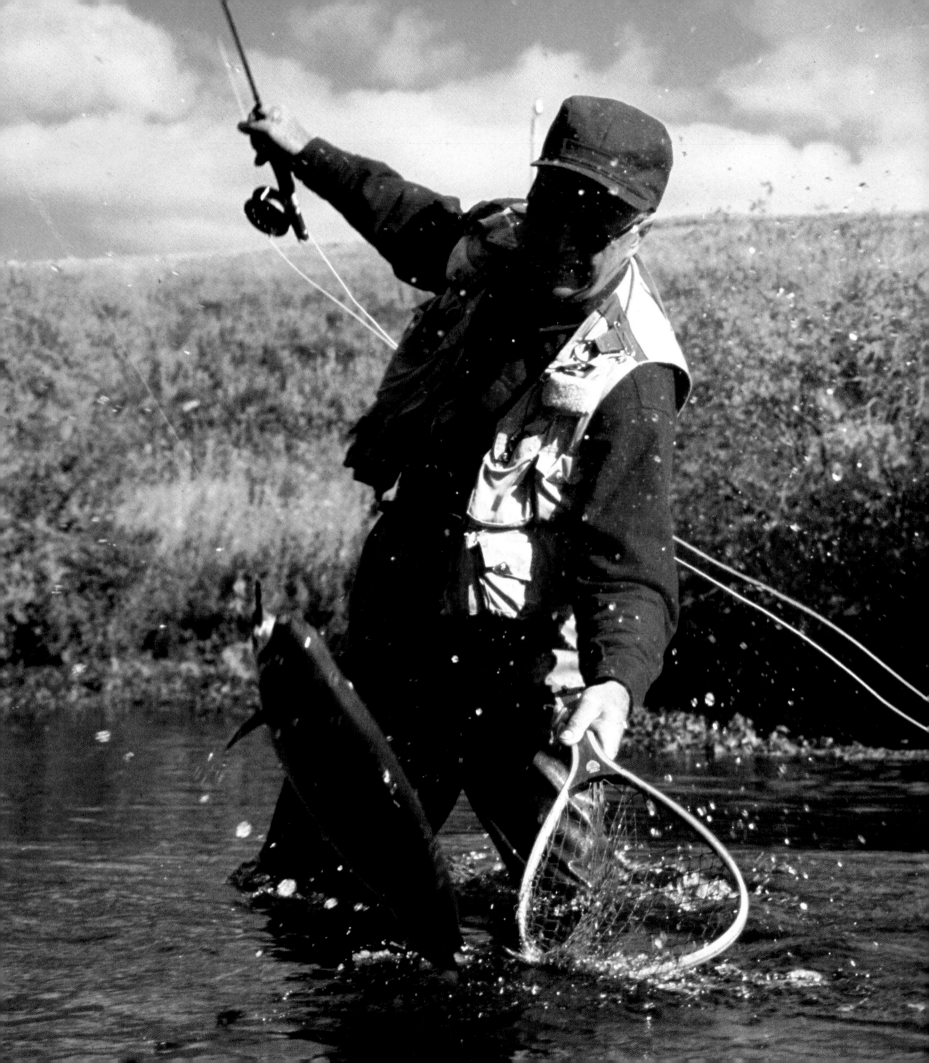

Equipment and Casting Techniques

*It is a fascinating
and beautiful sight to watch
flyfishermen as they present their flies to
the fish with well-timed, harmonious
casts. For the uninitiated,
flyfishing may seem to be a difficult,
exclusive and expensive sport. Yet the fact
is that a fly rod, line, reel and leader are
all you need for learning how
to cast a feather-light fly out
over the water.*

Equipment

The fly line is what determines the casting weight. So it is essential that the rod be balanced against the line's weight during the cast and presentation of the fly. To obtain this balance, lines and rods are classified by a system called AFTM (American Fishing Tackle Manufacturers' Association). Which class or classes you should choose depends on the water you are fishing in – its current, required casting distance, fish size, and other factors.

Rods

Until the 1950s, nearly all fly rods were made of six glued-together segments of bamboo, with triangular cross-section. This is known as the split-cane technique. The unavoidable disadvantages of such rods were their higher weight (much higher for salmon rods), their greater demands for care and carefulness, their relatively high price and shorter lifetime. The advent of synthetic fibre rods was greeted with joy by many flyfishermen, and these rods soon dominated the market.

Carbon fibre rods began to be produced in the late 1970s. Many of us think—perhaps rightly—that their high-tech construction, low weight, fast action, and superb casting ability have revolutionized flyfishing. But it should be remembered that such rods also have drawbacks. Besides being brittle and delicate, they are fine conductors of electricity, which is a serious danger if they come into contact with high-voltage cables. Tube-built glass-fibre rods, although heavier, are thus still on the market, since these are comparatively cheap and durable, as well as often having excellent casting properties.

For technical developments have made quite good tube-built glass-fibre rods available at a fairly low price. In sum, nothing shows that an expensive rod need be better than a cheaper one.

Apart from the AFTM classification, rods are grouped according to their action—that is, how they work. Normally we distinguish between fast action, medium action, and slow action. A rod with fast action has its elasticity mainly at the top. With slow action, the entire rod works during the cast and playing. Medium action is a popular combination of these types, used in many modern fly rods.

When choosing a rod, you must know what it will be used for. The action, line class, and length are determined by the type of water and the fish's species and presumed size. One-handed fly rods are used for fishing in brooks and streams, small rivers and lakes, ponds and coastal waters. Two-handed fly rods are almost exclusively for salmon fishing. Long two-handed rods make it easier to manage a lot of line in the air, but they are heavy and tiring to cast with. A short one-handed rod is convenient when the fishing water is surrounded by bushes and thickets.

The choice of rod depends on further things too. One must check that the handle, reel seat, windings and guides are of good quality and that the rod has enough spine. Generally you can control the line and fly more easily on the water, and achieve a more even casting rhythm, with a longer rod. Rods under 7 ft (2.1 m) cannot be recommended except under very special conditions. For those who need advice when choosing equipment, the following may serve as guidelines.

7.5-9.5 ft (2.2-2.9 m), AFTM class 4-6: fishing in brooks and small streams.

8-10 ft (2.4-3.0 m), AFTM class 6-8: fishing in large streams, lakes, small rivers, and for light coastal flyfishing.

10-13 ft (3.0-4.0 m), AFTM class 9-10: fishing at coasts, large lakes, and for light salmon fishing.

14-18 ft (4.3-5.5 m), AFTM class 10-12: heavy coastal and salmon fishing.

Lines

As the fly line has decisive importance for the cast and presentation of the fly, demands on lines are very high today. They must be supple, light-casting, durable, and easy to feed out through the guides.

Functionally, the fly line helps with its weight in carrying out the feather-light fly. Lines are therefore grouped in twelve standard classes, on the basis of the weight of the line's first 30 feet (9 metres) measured from the line tip. Higher class means greater line weight. Your line class, too,

In order to cast correctly and present the fly elegantly to the fish, there must be good balance between the rod and the line.

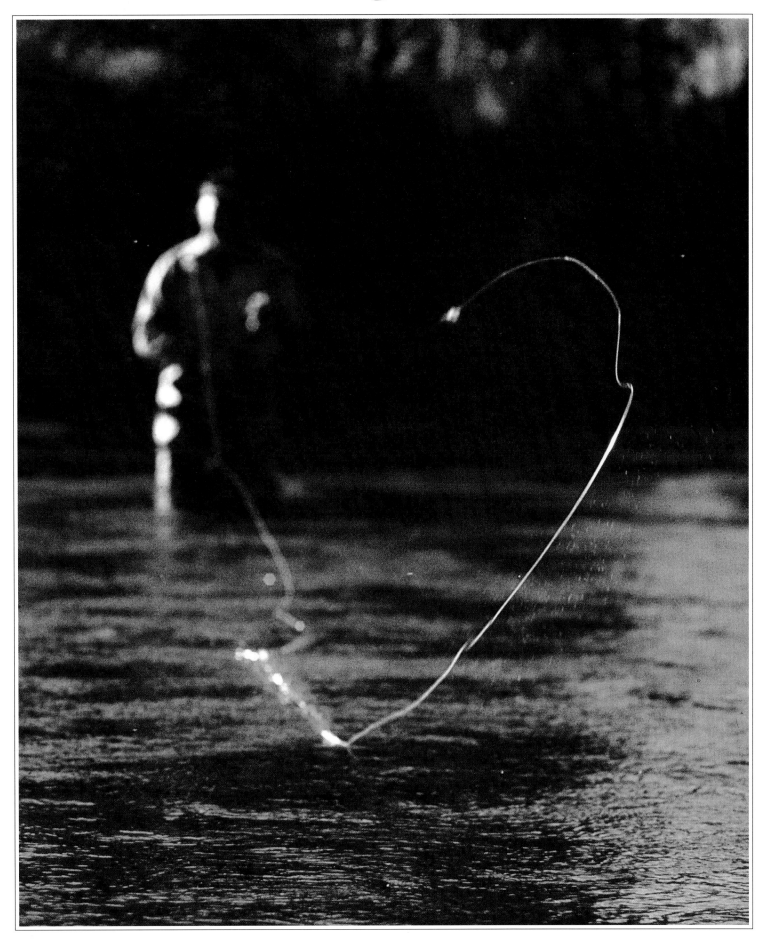

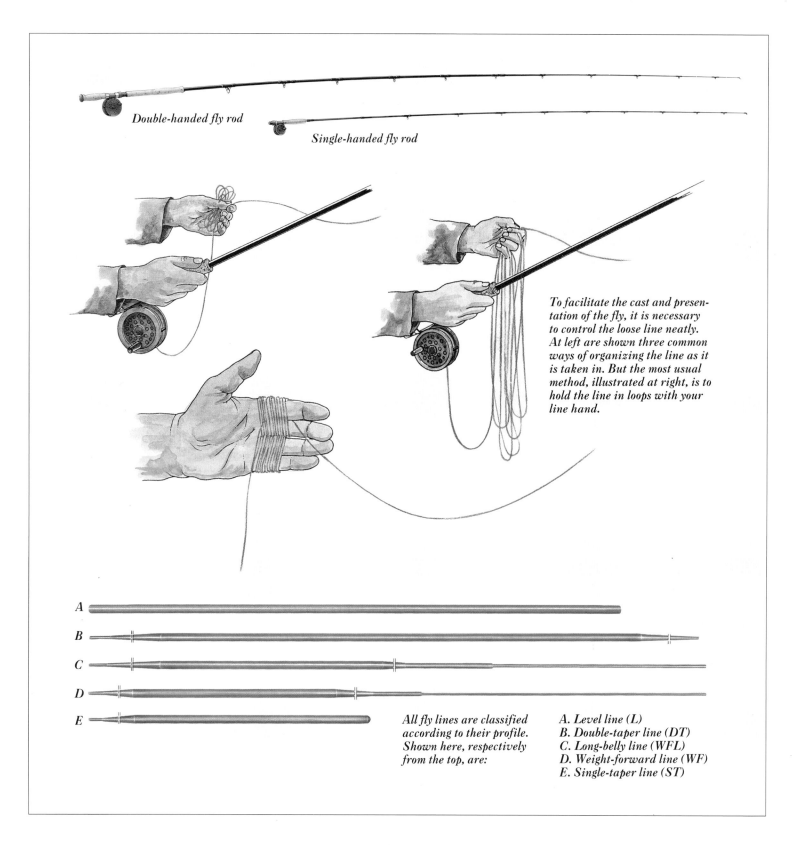

Double-handed fly rod

Single-handed fly rod

To facilitate the cast and presentation of the fly, it is necessary to control the loose line neatly. At left are shown three common ways of organizing the line as it is taken in. But the most usual method, illustrated at right, is to hold the line in loops with your line hand.

A

B

C

D

E

All fly lines are classified according to their profile. Shown here, respectively from the top, are:

A. Level line (L)
B. Double-taper line (DT)
C. Long-belly line (WFL)
D. Weight-forward line (WF)
E. Single-taper line (ST)

is determined by the fishing conditions at the water. Since a light line is harder to cast than a heavy one, only the lowest line classes should be chosen for small and windless waterways. The larger the water – that is, the longer the cast you need to reach out with the fly – and the heavier the fly, the higher the AFTM class which should be chosen. However, a line heavier than class 9 ought to be used only for salmon fishing and arduous coastal flyfishing.

To make the equipment suitable for different types of fish, we have not only the AFTM system but also variations in the tapering of fly lines. This refers to the line's profile, and two main groups exist. A double-tapered line (DT) is thickest in the middle and becomes gradually thinner toward both ends. A weight-forward line (WF), besides its tip, consists of a "belly" about 26 ft (8 m) long – where the weight is concentrated – and a long casting line.

The DT line is used most, because it allows soft and harmonious casts, which are essential for well-aimed and discreet layout of the fly. Its popularity is naturally increased by the fact that it can be turned round when one end has worn out.

The WF line is suitable primarily for situations that call for a longer cast. Depending on the kind of use, the belly length varies. Most marked and short is the belly on the "saltwater tapered" WF line, which serves especially for long casts with heavy flies in bass and saltwater fishing. The "long-belly" line (WFL) has an extremely long clump that makes it behave like a WF line in long casts, yet like a DT line in short casts. A third type of line is the "shooting taper" (ST), also called "single taper", which consists of a short clump attached in a thin casting line, and operates like a projectile when the fishing needs a really long cast.

There is also a distinction between floating and sinking lines. A floating line (F) is used in dry-fly fishing, and when fishing with nymphs or wet flies on the surface. Sinking lines (S) are required when the fish stay deep. Within these groups are also various classes. We speak mainly of slow-sinking (Intermediate), normal-sinking, fast-sinking, and extra-fast sinking lines. In addition, various sink-tip (F/S) types are on the market, and can be preferable to sinking lines – for they give full control over the floating section, and their sinking end can be adapted to the type of fishing at hand. Rapid currents obviously call for heavier (and thus more slowly sinking) line than do still waters, in reaching down to a given depth.

The line's colour is frequently less important than we tend to believe. Fish are hardly frightened by a fly line even if it is very colourful, provided that the leader is long enough. On the other hand, one must keep in mind that light-coloured lines are easier to see when the illumination is poor. Sinking lines, of course, do not suffer by being dark.

Fly lines should always be supplemented with a backing line, or reserve, in case a far-rushing fish takes the fly. A backing line also fills up the reel so that the fly line does not wind up in too tight turns. Such lines are made of monofilament nylon or braided dacron. The latter is usually most expensive, but pays off in the long run since it ages well, is more durable, and tangles less than monofilament line.

Reels

The fly reel is commonly the least emphasized part of our flyfishing equipment. A functional reel must fulfill two requirements: having enough room for backing and fly lines, as well as being able to play big fish effectively. For salmon fishing in particular, it must tolerate long and powerful runs without breaking down. Playing a hooked fish with a loose line lying on the ground is a cause of concern, with the inevitable tangle and lost fish. At least 100 metres (330 feet) of backing line, in addition to the fly line, have to fit on the reel. There must be an adjustable, dependable braking system. The reel should be easy to care for, and soundly constructed with no gap between the spool and housing where the line might get stuck and damaged. Moreover, it should have easily replaceable spools so that you need not carry a reel for each line.

The most usual type of reel is doubtless the traditional one, simply built with no finery. Its handle sits right on the spool, which rotates once each time the handle is turned as the line is wound on – and in the opposite direction as the line is pulled off. When the line is drawn out, the spool is braked by means of an adjustable screw, and you can use your index finger to brake more effectively. This type of reel operates superbly when playing small fish.

Big fighting fish are best chased with a reel whose braking system is more powerful and efficient, such as a slip (clutch) brake or disc brake. These finely adjustable mechanisms also provide soft braking, which can be necessary during powerful rushes so as not to snap the leader. There are also geared reels that wind up several turns of line each time the handle is pulled round.

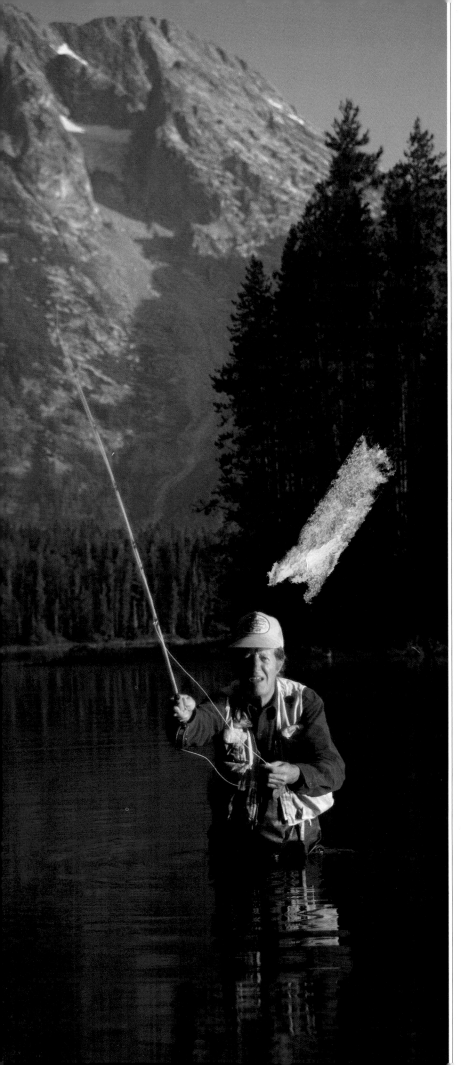

In general one should always choose high-quality reels. Besides making the fishing more enjoyable, they produce less wear on lines and have a more dependable braking system. It is also worth remembering that the reel should not be too small. It has to hold enough line and backing for the type of fishing you do. And finally, a reel for saltwater use must be corrosion-resistant.

Leaders

The leader's chief duty is to provide an even transition between the relatively thick fly line and the hook eye. A thin leader tip makes it easier to present the fly without alarming the fish, but is too readily broken off by a sizeable fish. Conversely, a thick leader tip can withstand big fish better, yet may be rather clumsy for elegant presentations.

To some extent, the leader's thickness must be adapted to the fly's size. For a thicker leader guides a big fly more accurately than an extremely thin leader tip does.

Leader tips thinner than 0.12 mm (0.005 in) should be totally avoided, and not less than 0.18 mm (0.007 in) ought to be used for medium-sized fish, while 0.30 mm (0.012 in) is a minimum for salmon and other true fighting fish. Large salmon that need big hooks can even call for up to 0.50 mm (0.02 in) at the tip.

The length and tapering of a leader are also important. A good rule is that it should be a little longer than the rod when fishing with dry flies and nymphs, but that 1.5-2.0 m (4.9-6.5 ft) suffices for wet-fly fishing. A leader is built up from its thicker upper end, via a more or less smoothly narrowing transitional section, to the thin tip. About 60% of its total length should consist of the strong upper part, followed by about 20% narrowing and then about 20% tip. The thickest part of the leader, which is tied or glued onto the fly line, must be around 0.5 m (1.6 ft) long with a diametre of 0.45-0.50 mm (0.02 in).

In addition, the leader has to be flexible, soft and easily cast, non-knotting, and able to keep itself stretched in and on the water. A coiled leader can really spoil your sport, not least when dry-fly fishing.

Besides the essential equipment, a clever flyfisherman also needs certain personal qualities, such as an ability to concentrate...

The knots are the weakest link between fly and fisherman, so they must be durable and reliable.

The spool knot (to tie the backing line on the reel spool)

The nail knot (to tie the leader and backing line on the fly line)

The blood knot (for tying together sections of monofil)

The clinch knot (for fastening the fly and leader)

Even if there are ready-tapered leaders on sale in stores, it is not hard to tie them yourself with pieces of monofilament nylon line. The pieces in the leader material should not differ in diametre by more than 0.05 mm (0.002 in), since otherwise the knots are not as dependable.

If you choose to buy leaders ready-made, there is a great range of different types to choose among. Best are ready-tapered, knotless monofilament nylon lines – and braided leaders. The latter, flexible and soft, do not curl as easily when they lie rolled up on the reel for a long period, and they give a generally good presentation of the fly.

Flies

We now come to the equipment which not only gave its name to our kind of fishing, but is the very foundation of this sport's existence – the fly. A symbol that unites the hundreds of thousands of flyfishermen all over the world, it is also a source of arguments. Some maintain that a wide choice of flies is necessary, whereas others are content with a few carefully selected flies. Many of us demand exact imi-

tations, but equally often we consider caricatures to be what attract the fish to strike.

Who is right or wrong in such disputes will not concern us here. Perhaps it is enough to note that our flies and fly patterns are infinitely diverse, and that flies are always a fascinating topic beside the fishing water as well as in the sportfishing stores and magazines.

Internationally, fly patterns are almost uncountable. A lot are pure fantasy flies, while many are precisely tied imitations of particular insects that may live in only one area. There is also a long list of patterns intermediate between imagination and reality. Despite this amazing variety, flies can be divided into main groups: dry flies, wet flies, nymphs, flymphs, streamers, bucktails, lures, salmon flies, and so on.

Hooks, too, enjoy a virtually limitless range of choice. We need only mention the essential differences from a practical viewpoint. Hooks with an upturned eye are generally used for dry-fly fishing; hooks with a downturned eye are for wet flies, nymphs, streamers and other flies that are fished underwater. However, salmon flies usually have an upturned eye although they are fished deep. The hook shaft differs between fly types. A short or medium-long shaft is

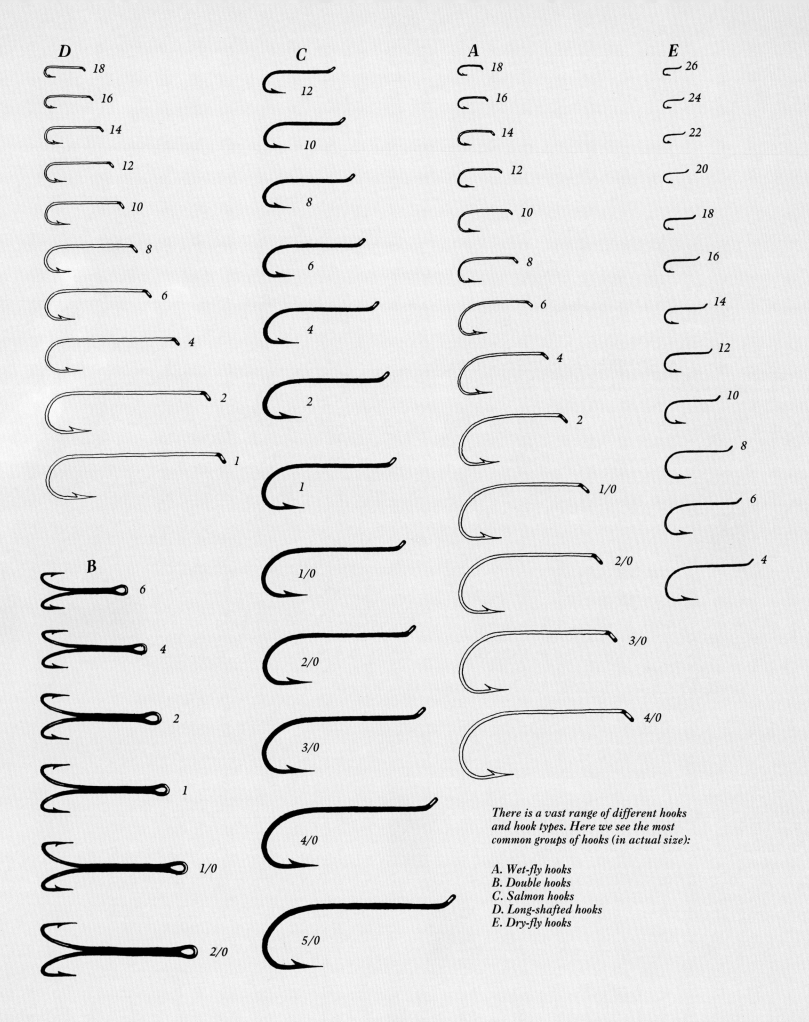

D
18
16
14
12
10
8
6
4
2
1

C
12
10
8
6
4
2
1
1/0
2/0
3/0
4/0
5/0

A
18
16
14
12
10
8
6
4
2
1/0
2/0
3/0
4/0

E
26
24
22
20
18
16
14
12
10
8
6
4

B
6
4
2
1
1/0
2/0

*There is a vast range of different hooks
and hook types. Here we see the most
common groups of hooks (in actual size):*

A. Wet-fly hooks
B. Double hooks
C. Salmon hooks
D. Long-shafted hooks
E. Dry-fly hooks

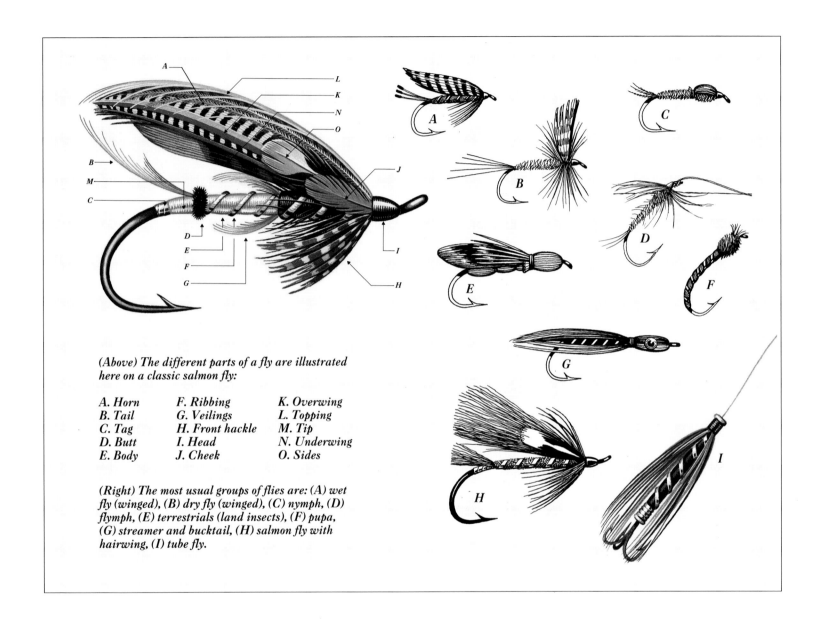

(Above) The different parts of a fly are illustrated here on a classic salmon fly:

A. Horn	F. Ribbing	K. Overwing
B. Tail	G. Veilings	L. Topping
C. Tag	H. Front hackle	M. Tip
D. Butt	I. Head	N. Underwing
E. Body	J. Cheek	O. Sides

(Right) The most usual groups of flies are: (A) wet fly (winged), (B) dry fly (winged), (C) nymph, (D) flymph, (E) terrestrials (land insects), (F) pupa, (G) streamer and bucktail, (H) salmon fly with hairwing, (I) tube fly.

used for dry flies and wet flies; streamers, lures and some nymphs are tied on long-shafted hooks.

If flies are to fish effectively, you should always be careful about their quality. This applies to the material as well as to how they are tied. Moreover, hooks should be sharp – and neither so soft that they can bend out during a hard fight, nor so hardened that they can break off. Besides being durable, they must hook the fish solidly. In addition, it is worth knowing that the long shaft of a streamer hook, while allowing very effective imitations of small fish, resembles a lever and gives the hooked fish an excellent

chance of prying itself loose during the play.

Naturally a pattern meant to imitate a certain insect has to portray its prototype in all basic respects. Yet this does not require it to be an exact copy in every detail. Only its similar characteristics need be made clear to the fish – in other words, the fly's proportions and the appearance of its body, hackle, wings, and tail must be right.

In any case, flies obviously have to fulfill their elementary functions. A wet fly should sink to the depth where fish are hunting at the time. A dry fly must be able to float high and lightly, in order to be presented as in nature. A flymph

ought to remain hanging just in the surface film, or only a few centimetres under it. The purpose of a salmon fly is to somehow provoke the aggressive spawning fish to strike. And so on...!

Accessories

The equipment described until now is an absolute pre-requisite for effective flyfishing. But there are quite a lot of items that can make your fishing easier and pleasanter, although not essential to its success.

Clothing should first and foremost be roomy, comfortable and rugged. It ought to give the fisherman proper camouflage, so as not to frighten the fish unnecessarily. Moreover, it should withstand rain and wind, as well as having plenty of pockets to help you organize your fishing adventures.

A fly vest is probably the most common piece of clothing. Its pockets must be practical and accessible. Before investing in a vest, though, you should check that the pockets will really hold fly boxes and are not so shallow that the contents fall out.

Fly boxes ought to float. A box is easily dropped and, if this happens over deep water, a sinking box can be lost forever. Besides, a good fly box should be clearly arranged and must provide maximum protection for the flies and hooks. Dry flies are best kept in boxes with separate compartments that can be opened and sealed simply, or else in spacious boxes where the flies are fastened in foam-rubber bands. Wet flies are less delicate and can thus do well in relatively flat boxes. The same is true of nymphs, streamers and salmon flies, where it is most important that hooks and barbs do not lose their sharpness. We should therefore be careful with metal clamps and similar fasteners – they must never be allowed to damage the hook point!

Leaders and their materials, too, must be stored so that they are not damaged. If you tie your own leaders, a dispenser is preferable to loose spools, but it must have room for at least five different sizes and the lines should be able to feed without tangling.

Your fly vest or equivalent apparel should also contain a sharp pair of scissors or nail-clippers for purposes such as cutting leader stubs and dressing knots or flies. A sharp knife is necessary for slaughtering and cleaning. Substances that increase the buoyancy of dry flies and floating lines are further examples of essential accessories. A small rotatable lamp which can easily be attached to a jacket or vest is indispensable for flyfishing at night if you want to have a fair chance of switching flies, tying leaders, and other work that needs some light. Scales and a measuring tape, flat-nosed pliers, a hook-sharpener, line grease, and a line basket can be added to complete the picture of a well-equipped flyfisherman.

Those who do not practise "catch and release" fishing, or land their fish by hand, often need a deep and preferably collapsible landing-net, or one with extension handle. And if you fish much from overgrown shores, a variant is a small collapsible landing-net that can be carried in a quiver. Short-shafted, wooden framed landing-nets are good when wading, while long-shafted landing-nets are more all-round and serve excellently for fishing from low or high shores as well as from boats. The inexperienced salmon fisherman who does not want to risk losing his "dream salmon" when grabbing it by the tail will need a tailer or gaff.

Basic accessories also include some sort of eye-protection. A gust of wind, or a wrong move of the rod, can easily send the fly on a dangerous course and, at worst, into your eye. Ordinary glasses or sunglasses are a cheap guard against permanent eye damage. A clear advantage of polaroid glasses is that they filter out the sunlight reflected from the water surface, and thus increase your chances of seeing what swims under it.

A fishing hat is not only symbolic of fishing success. It also helps to protect the face and eyes from flies that change course during the cast. Besides a broad brim or a screen, the hat should have a deep shape and cover as much as possible of your face, ears and neck.

Sooner or later, one finds that many fine fishing spots cannot be reached without a pair of thigh or body waders. Which of these you choose depends mainly on the water depth. Body waders can take you into relatively deep areas, but they are clumsy to wear in shallow water or on land, and uncomfortable condensation easily forms inside them. Thigh waders are lighter to walk and move in, but limit the depth of water you can enter.

Body waders made of neoprene have many advantages over the "old" rubber type. They are convenient to wade in, provide fine insulation against cold water, and can easily be repaired by the waterside. A drawback is still their expensiveness.

Whether you use thigh or body waders, and whatever the material, certain demands should be placed on their soles. These must primarily be non-slip. The bottoms should be

In addition to the basic equipment, a lot of useful accessories can make the fishing both easier and more fun.

covered with felt or matting, to prevent your slipping on stones and perhaps being taken by the current. Another advantage of silent materials like felt is that they do not scare shy fish as readily when you wade.

As an aid, some kind of wading staff should be used. You can easily make one from any stable length of wood. The important thing is that it does not bend even under heavy force. For this reason, be careful when buying a staff that can be disassembled, as it must be able to support a hard-leaning body. A good wading staff should also have an eye or other device where you can attach, for example, a rubber cord to keep the staff from drifting away with the current if you happen to let go of it. Ideally it ought to have a sound-muffling "shoe", for instance of rubber, as the fish are then not frightened so easily.

Another helpmate for fishing at some distance from shore is a float-ring (belly-boat). This is used almost exclusively in still or very slow waters. You then have every advantage of a boat, and it is a lot easier to transport and launch. But

obviously greater care is needed with sharp objects in a belly-boat. A puncture while far out in a lake can be disastrous. One should therefore always make sure that the belly-boat has a two-chamber system.

Such fishing may seem a bit odd to anyone who has never seen a belly-boat fisherman in action. But for those who regularly put on their body waders and flippers, jump down into the inflated ring, and "paddle" out to free water with a fly rod resting on its rubber cover, this is as natural and rewarding a method as any.

Casting with a single-handed rod

As mentioned earlier, the casting weight is determined by the fly line. In other words, the fly is transported out to the fish by means of the line. This undoubtedly looks much harder than it is in practice when the art has been learned. For a beginner, getting the fly and line out while avoiding nearby trees and bushes is almost impossible. Yet only a few hours of intensive training are usually required in order to grasp the basics so well that at least ten metres of line can be cast with no real trouble.

To achieve long casts and complete precise presentations, you often have to spend a long time on different fishing waters. But the fact is that fishing can be effective even with relatively short casts. Long casts are not at all necessary for catching fish, especially in small waterways. It is, however, quite essential to learn correct presentation of the fly, whether you are casting long or short.

Practice and more practice: this is the recipe for learning how to cast harmoniously. A skilful instructor is certainly worth having, but not a prerequisite – the best teacher of casting is the process of fishing itself.

Basic casting technique

When learning to cast flies, you should start in a place with room for the back cast. Many people begin to practise on a grass lawn, but the best location is a lakeside, since laying the line on the water is an essential part of many casts. For the line's friction against the water – which cannot be obtained on a lawn – helps to build up the action in the rod. Certain casts, such as the roll and switch cast, are just impossible to perform except on water.

It is simplest to begin with a single-handed rod of 8-9 ft (2.4-2.7 m). To protect the tip of the fly line, a piece of leader should always be tied farthest out. Moreover, tie on a fly with its barb nipped off. The fly helps to stretch the leader tip, giving better control over the final phase of the cast.

A good cast is based on harmony between the line, rod, and casting arm. One common beginner's mistake is to force the cast, particularly the forward cast. Many are also afraid that the line will hit the ground, and do not wait until the

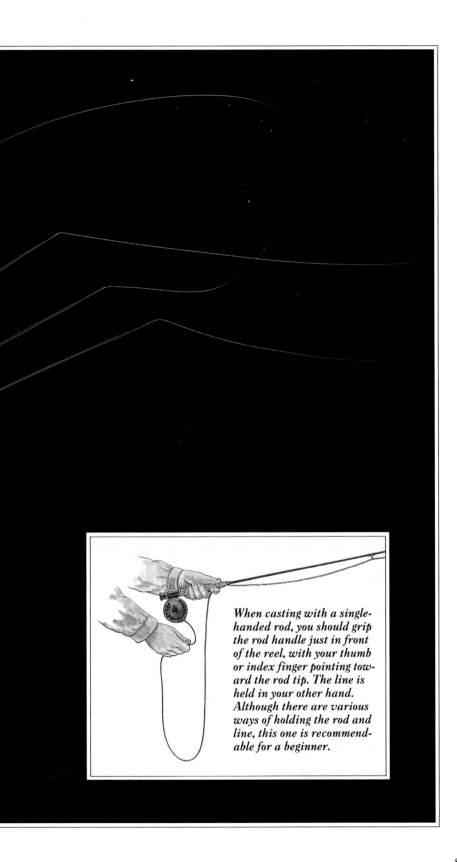

When casting with a single-
handed rod, you should grip
the rod handle just in front
of the reel, with your thumb
or index finger pointing tow-
ard the rod tip. The line is
held in your other hand.
Although there are various
ways of holding the rod and
line, this one is recommend-
able for a beginner.

back cast has really stretched out. As a result, the cast col-
lapses and the line falls in a heap. To avoid this and acquire
the right rhythm, you should turn your head during the
back cast, watching how the line moves and when it has
stretched out completely. Only then does the time come to
start the forward cast. Calm, smooth movements are the
essence of becoming a good caster.

Here we shall briefly describe the traditional casts and
their variants. But the continual progress of developments
in equipment makes it likely that opportunities will arise in
the future for learning new types of cast – tested and adap-
ted to suit modern rods, reels, lines and leaders.

The overhead cast

This is to be recommended as the basic cast. Before begin-
ning the cast itself, pull 6-8 m (20-26 ft) of line from the reel
and lay it out on the water. Hold the rod handle with your
casting hand just in front of the reel and your thumb poin-
ting toward the rod top. Take the line in your other hand,
held at waist height. Stand relaxed with the rod top poin-
ting slightly downward.

Lift the rod upward with a strong but smooth movement.
Once it is vertical, stop the back cast. Wait till the line is
lifted and stretched out backward. When you feel the out-
stretched line's weight in the rod top, it is time to start the
forward cast by moving the rod forward to a horizontal posi-
tion – smoothly but sharply. The line now rolls forward over
the rod tip and stretches out before you. Make sure that the
line hand always follows the rod's movements.

The next step is to try holding the line in the air, without
its collapsing on either the backward or forward cast. These
air-casts are made by stopping the rod, during the forward
cast, in a position pointing obliquely upward. When the line
has rolled forward over the rod tip and is nearly stretched
out, the rod is moved backward in a new back cast. The line
now flies back and stretches out, whereupon you start a new
forward cast. Once this can be done without letting the line
touching the ground, you have mastered the air-cast as well.

The overhead cast is the first cast that a beginner
should learn.

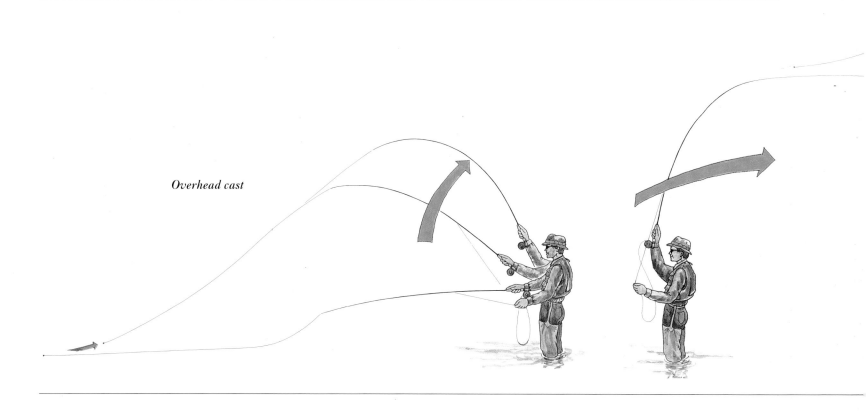

Overhead cast

Achieving perfect coordination requires some training and many failed attempts. But when you can keep 8-10 m (26-33 ft) in the air with no trouble, practical fishing can begin. At first, you should choose a shore area with space behind you, so that the back cast meets no obstacles. Despite this precaution, you can expect the fly to get caught occasionally on branches and bushes.

Having learned to cast 8-10 metres at the water, you can increase the amount of line in the air by a few metres each time. Hold the loose line in one hand and, when the accelerating backward-and-forward cast has added more energy, release the reserve line in a forward cast. Now the loose line shoots out through the guides to join the airborne line. This step, too, calls for exact coordination which is acquired only through much expert training. Eventually, you can thus lengthen the cast according to your ability, metre by metre.

Shooting out the line in this way is also useful when presenting the fly – not least in fishing with shoot-lines and certain other types of belly-lines, as well as in dry-fly fishing.

A variant of the overhead cast is the side cast. This horizontal, half-high movement follows the rule that a cast should be stretched out where there is enough space. It comes in handy when, for example, fishing on overgrown waterways with limited free space.

The double haul cast

Although on most waters we can manage with casting lengths of 10-15 m (33-50 ft), longer casts can be necessary in order to increase the chances of a catch, for instance when fishing in lakes. Even while wading, with the line almost nudging the water surface as you cast backward and forward, the technique of a double haul is very useful, since the cast easily collapses if the line touches the water.

A double haul means that you draw the fly line downward with your free line hand during both the backward and forward casts, thus increasing the line's speed and force. Begin with a strong downard haul at the very beginning of the back cast, then complete it as usual. Just when the forward cast is to begin, make a new haul with the line hand, then release the line when the casting weight is greatest. The loose line will shoot out in the last phase of the cast.

This variant can lengthen the cast by 3-5 m (10-16 ft), but it demands exact coordination between the rod hand and line hand. Since the cast must be calm and harmonious, you should be a relatively good caster before starting to practise it.

Once the double haul is mastered, you can easily feed out a rather long line with some air-casts and finally shoot out the line by 3-5 metres. The double haul's increased line speed can be essential when you are fishing in a powerful headwind and when you need to cast far.

With a double haul, the cast can be greatly lengthened, as when wading or in a headwind.

Serpentine cast

The serpentine cast

This cast is employed primarily in dry-fly fishing when the fly has to drift evenly without drag, even if the current is erratic. Your line hand must hold a certain amount of loose line that can be shot out in the forward cast. At the same time as the fly line shoots out, the rod top is moved rapidly forward and backward, parallel to the water surface. Thus the line lands in big curves on the water. The dry fly will gain a little extra time in order to float freely, before the fly line stretches out in the water and the fly begins to straggle. To lengthen the drift, you can also flick the rod top while releasing a little loose line, which glides out through the rod rings and adds to the line already lying on the water. This way of lengthening a cast can, of course, be used in combination with all casting variants, so that the fly will follow the current freely.

Roll cast

The roll cast

A roll (or switch) cast is used in fishing areas where a back cast is quite impossible to carry out. You can then certainly not cast as far, but with some training a fair length can be laid out.

About 5-6 m (16-20 ft) of line should lie stretched in front of the rod tip. Then the rod is lifted until vertical. Once the line hangs in a curve next to the fisherman, it is cast forward by means of an accelerating whip action – upward, forward and then downward. The line rolls out on the water and the fly lands. By pulling out more loose line and repeating the roll cast a few times, the casting length can be increased to more than 10 m (33 ft).

One can also combine the roll cast with other casts, such as the side cast, for effective results in many situations.

Parachute cast

The parachute cast

The difference between a serpentine cast and a parachute cast is that, in the latter, you stop the rod top during the forward cast when it is pointing obliquely upward. The line then shoots away in that direction and stretches out at the same height as the rod top. Then you lower the rod, and the fly jerks back a little before landing with the leader in curves. If the cast is done correctly, the fly, leader, and line end will land after the fly line's rear portion. And the fly can drift somewhat farther downstream without dragging.

Mending

Mending

The purpose of mending is to prevent flies from dragging or being hindered in their natural drift when the current takes the fly line and drags it along in big curves. You simply float the fly line some distance upstream by mending it, without affecting the leader tip or the fly. Mending is a cast-like movement parallel to the water surface in the current direction. If it is properly performed, the fly line will be laid in a gentle upstream curve. Thus you can considerably lengthen the natural drift – in principle, until the cast is completely fished out and the fly line ends straight downstream parallel to the shore. When fishing for salmon, it is sometimes necessary to mend downstream in order to increase the fly's speed.

Casting with a double-handed rod

Fishing is generally the same with a double-handed rod as with a single-handed rod, but it can be very arduous and energy-demanding because a double-handed rod is longer and heavier. Consequently, a couple of variant casts have been developed specially for this kind of fishing. Perhaps the best known is the Spey cast, which works well in nearly all situations if done right. This cast requires relatively little strength, is effective even in a wind, and does not need any space for a back cast. Moreover, it produces no knots on the leader – which are common in, for example, the traditional overhead cast.

The overhead cast

Casting with a double-handed rod differs in several respects from its single-handed counterpart. But the overhead cast is essentially built up in the same way. Obviously it also has

the same weaknesses: you need a lot of space for the back cast, the leader can easily become knotted, and you often have to do an excessive number of blind casts which can be tiresome with a heavy double-handed rod. The aim should be to do only one back cast and then lay out the fly.

The underhand cast

The hard work of fishing with long double-handed rods is made much more comfortable by modern, light rods of carbon fibre and/or boron. However, it is still important to learn energy-saving methods of casting.

An underhand cast is not only elegant, but also offers the opportunity of fishing for a long interval without getting tired. In addition, this restful cast is quite effective. Using a back cast, the line is brought under the rod in front of you. When the rod is pointing obliquely backward, the movement stops and the forward cast begins. At this moment the line should not be fully outstretched backward. It must be given the most energy when the rod tip is pointing obliquely forward. With a single air-cast, the line can be laid out nicely in this way.

The switch cast

As its name implies, the switch (roll) cast means that the fly line is rolled out onto the water. This cast comes into use mainly on shores with limited space for back casting. It must also be mastered if you want to learn the effective Spey cast properly.

Your rod should have a good spine. During the back cast, it is brought calmly to a position pointing obliquely backward. Now the line must hang in a soft curve alongside you. In the forward cast, the rod is strongly accelerated forward and downward until it is parallel to the water surface. The line then rolls out across the water in a beautiful bow.

The Spey cast has several advantages. It permits a long cast even where the back cast is difficult because of dense shore vegetation; it is not affected much by strong wind; and it demands relatively little muscle power during the actual cast.

The Spey cast

Like the roll cast, this cast is used on shores where vegetation restricts the possibility of casting backward. It also resembles the roll cast in other essential respects. The important thing is that the fly should be placed in the right position before the forward cast, so that the hook does not catch on the line when the casting direction is changed by 45°. Hence, the fly is often allowed to float straight downstream with the current. A "double" Spey cast exists, too, but here we shall concentrate on the single Spey cast, as it also provides the basis for the double one.

Just as with the roll cast, you lift the line from the water by moving the rod to a position pointing obliquely backward. With an accelerating underhand cast, the line is brought backward and upstream on your outer side. But not so much that the fly line's tip soars into the air – it should nudge the water surface, thus adding force to the forward cast. The greatest transfer of energy should occur when the rod is pointing obliquely forward. However, the rod's own action does most of the work. This cast, as well, must be performed gently and harmoniously in a single sweep. It is easiest to carry out with a floating DT line.

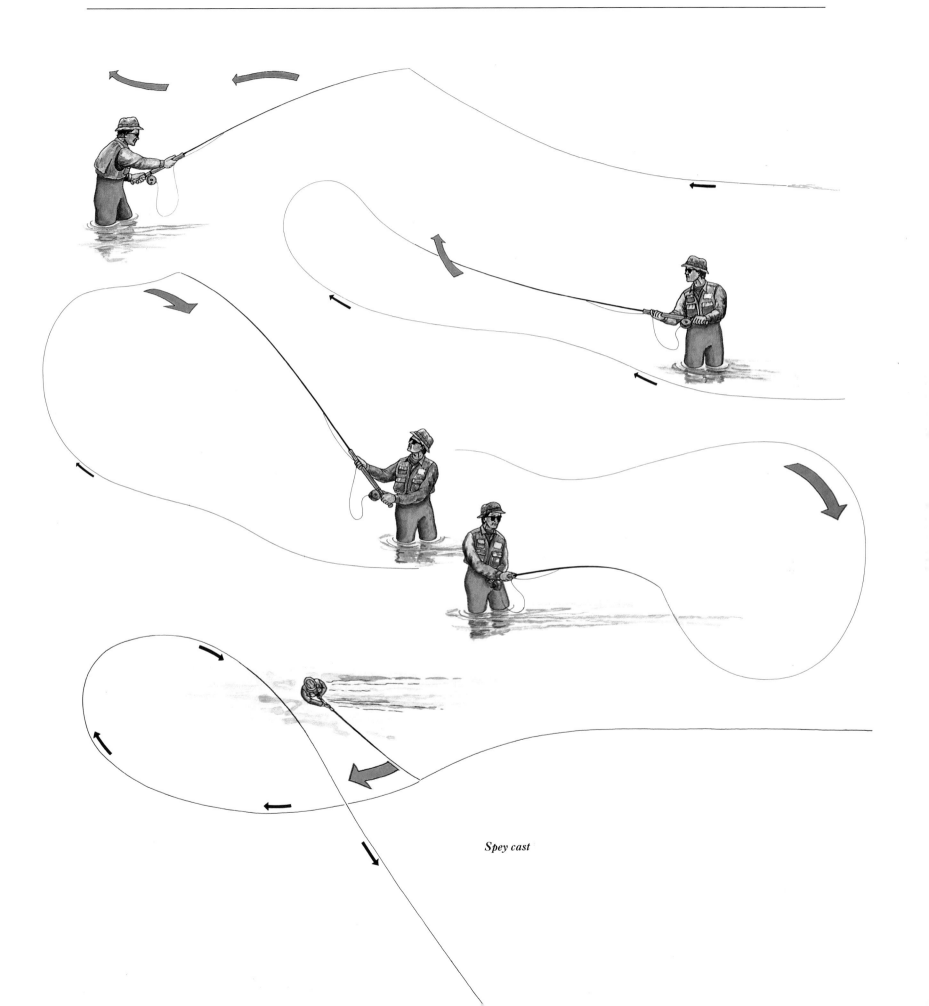

Spey cast

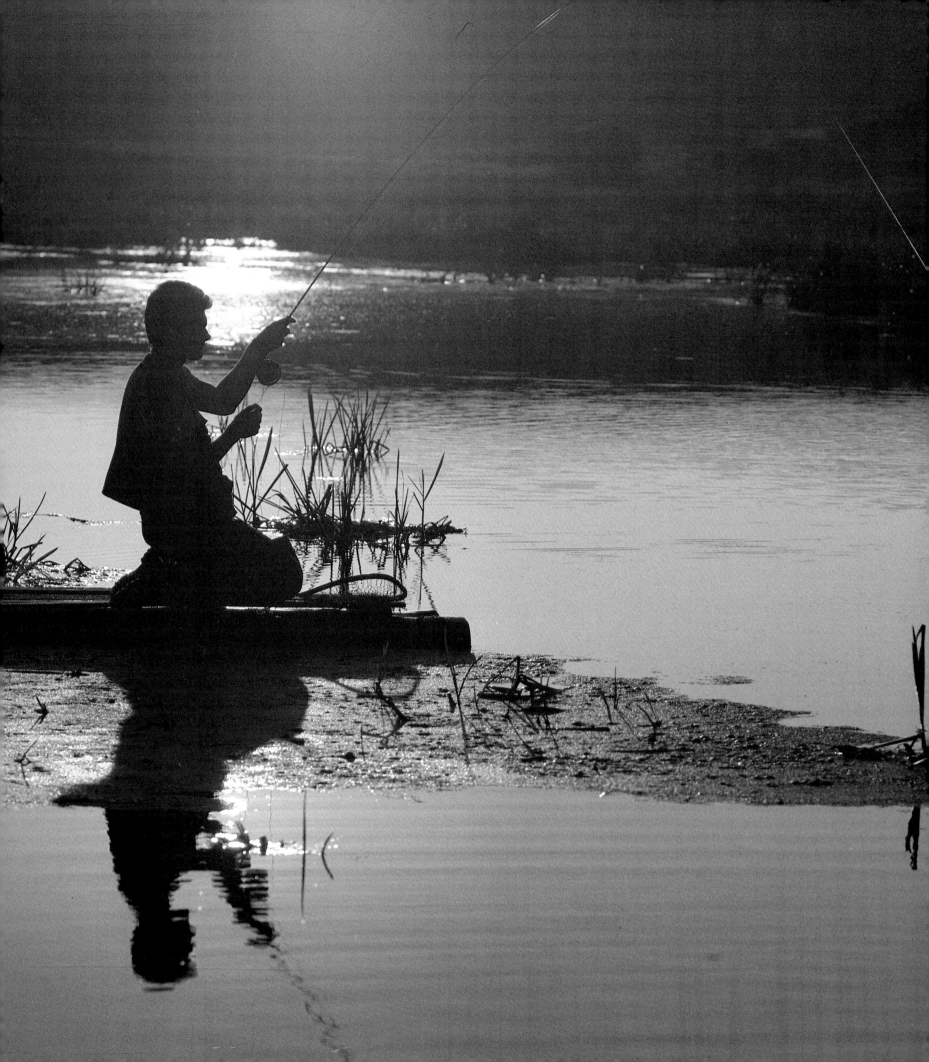

Flyfishing in still waters

*Lake flyfishing
is an established and
fast-growing branch of the sport,
even though thousands of streams
are full of salmonoid fish. But most of these
are in remote places where a fisherman
may travel only during the summer
holidays. The early and late fishing
seasons are devoted to the ever increasing
put-and-take areas located only an
hour or two from home.*

Rapidly expanding numbers of flyfishermen are well on the way to charting all the earth's flowing waters. While crowding increases on the "classic" streams – of which the sport's pioneers spoke so enthusiastically in books that remain highly readable – the destinations of flyfishermen are becoming distant and exotic.

Unknown territory in the flyfishing world is thus getting scarce and, if Glasnost applies to us too, we may soon learn whether it is true that giant trout exist in the Soviet rivers running north to the Arctic, where fish of 30-40 kg (66-88 lb) are rumoured.

But for those who stay around home, fish have thinned out in the currents of many countries, despite improved management of their habitats. Flyfishing continues to grow anyway, and its practitioners demand the opportunity to fish at a reasonable cost, which also means at a reasonable distance from their origins.

Until now, they have often been satisfied, although most flyfishermen live in urban industrial regions. However, things would be far more difficult if we insisted on pursuing the sport in its "classic" form, along streams with natural stocks of salmonoid fish. The prerequisite has been, and is, that we take advantage of a vast reservoir of fish – in our lakes.

Lakes offer virtually unlimited possibilities of flyfishing, apart from the insistence of a majority of us that our fish should have adipose fins. In Scandinavia alone, for example, there are thousands of lakes with more or less intact stocks of salmonoids, and further thousands whose water quality makes stocking – especially of rainbow trout – a meaningful, indeed profitable, enterprise.

This is a revival of lake flyfishing in the sense that our pioneers, at least in Great Britain, sometimes fished for both sea trout and ordinary brown trout. At any rate, it is the best explanation for the fast growth of flyfishing. In Great Britain, where many reservoirs have been built to collect fresh water for urban needs, a kind of revolution is in the air: reservoirs are stocked with fish and provide recreation for tens of thousands of new and old flyfishermen.

Put-and-take lakes have enabled flyfishing to go on developing in several parts of Europe. Most of the numerous young people who try flyfishing as a hobby gain their first experience on these still waters. And they are right to do so, since one ought to get through the commonest beginner's mistakes before making an attempt on wild waterways, where the fishing is usually much harder.

You cannot learn to flyfish by reading a book about it. But

Reading the waters

People who grow up in districts with abundant waterways soon learn to "read" them as fish do. The fish are where the food is, and the most, as well as largest, fish can be found where the underwater menu is marvellous. Here they stand in the current, or scour a small area, since they need not waste energy on hunting. The current brings them all they can eat, an endless conveyor belt in a free restaurant.

As a result, some places in a river or stream are better than others – especially where several waterways run together, or where backwaters form that concentrate the food. Adult grayling and whitefish, for instance, assemble there, at times in great schools; and it is there that the flyfisherman encounters the biggest fish. Such trout are usually solitary, because trout defend their territory with zeal and they seldom allow smaller competitors to eat at the same table.

These optimum feeding spots amount to only a fraction of the water surface's total area. Certainly much of a productive waterway can provide food during several months of the year, but not enough of it to support big fish, let alone entire schools of adult fish. However, this is sufficient for small fish until they reach a size adequate to compete for the better feeding places.

Thus, a flyfisherman must be able to "read" a waterway for the movements and colour changes that show where its special fish-food resources lie. At times when plenty of insects are hatching, the fish themselves reveal these places by rising greedily. If they do not rise, it can be worth the trouble to watch such places discreetly, as any fish there will give themselves away sooner or later.

Another means of detection is to test a place with a "tempter", one of the favourite dry flies or nymphs that usually yield results even when fish are not rising. Most flyfishermen have, or eventually acquire, a little hoard of such helpmates, which can provoke a fish to strike even if it is temporarily selective – that is, bent on eating a special kind of insect in a particular stage of life.

An experienced flyfisherman has learned his "reading" and soon finds where the fish are feeding, whether or not he is on familiar waters. This is not difficult, at least on small streams. Although it may happen that only small fish take the fly, this does not mean that the water has been read wrongly. Sometimes food is scarce even in the right place – and then the big fish, especially when they are fully grown trout, go back to their hideouts in deep holes under

Two common and popular species for flyfishing in still waters are the brown trout (above) and the rainbow trout (left).

a good book can provide facts and suggest experiments that pay off. Unfortunately books about lake flyfishing are rare, at least in comparison to those about fish in flowing waters. Once you do manage to learn the correct tactics and strategy for flyfishing, though, you can often catch a lot of fish – and big fish at that.

the main current or the root systems of shore trees.

The large fish in streams are almost perfect economic machines. Hunting has to pay off, in other words to yield more food energy than the hunting consumes. When not enough food exists at their favourite feeding places, the fish do not eat at all, preferring to wait. But when the menu improves, they show up instantly to chase away smaller fish and feast on the goodies brought by the current.

This behaviour is notably typical of large trout, which – during intense insect hatchings – can be seen "swinging" at the surface as they eat: first a part of the head appears, then the back, and finally the upper tail fin, a sequence repeated three or four times in a row. Having risen to the surface when insects are dense, they take an insect at every "swing". After eating as many as five insects, they glide back to the bottom and soon rise again. For a big trout, it is not economical to rise for a single insect: several must be eaten each time to restore the energy that is spent.

Moreover, this behaviour gives the flyfisherman his chance of catching a "dream fish". Such a trout rises so regularly that its return to the surface can often be predicted exactly. A "swinging" trout is also virtually blind, as the movement restricts its field of vision, allowing the fisherman to wade within easy casting distance.

Yet the "reading" of water, and the fishing tactics used at clearly identifiable feeding places, are peculiar to waterways where we can find fish at the same places year after year – and can even catch the same individual fish more than once, at least in the case of trout. For trout are able to spend their whole lives in one limited section of a stream, as long as it contains plenty of food.

In the still waters of lakes, meres and ponds, the same fish species have other habits. Here they seldom meet currents that transport food to particular feeding places. Certain areas do frequently produce abundant fish food, but the fish have to locate those areas at the moments when the supply is greatest. They succeed in doing so, yet how they do it is difficult for us to explain. The fact is that still waters are much harder to "read" than flowing waters.

Standing for the first time on the shore of a wide lake can be frustrating, even discouraging, to a flyfisherman. Where, beneath its vast surface, can the fish be – or are they everywhere? Just as in rivers, the fish do exist at particular places, and these may vary. But long experience on a given body of still water is not necessarily essential to successful fishing, because we have some reliable rules to follow.

Even for a seasoned flyfisher-
man, it is sometimes very hard to
tell where the fish are. But just as
in running waters, there are special
places where, for various reasons, fish
can be found: for example, at stony banks
and underwater beds, vegetated shores,
lee edges, deep edges, coves, islets, channels,
promontories, inlets and outlets.

Intercepting the fish

To begin with, you must outwait the fish. It is bound to rise eventually, if the weather is suitable. Rainbow trout which are set out in "catchable" sizes, as is normal, tend to have sharply defined periods of striking, and a few usually break the water surface even if not much food is there. Valuable observations can then be made: risings that are fairly frequent follow a pattern, as though it were a "food patrol".

The rainbow trout in still waters usually appear in small shoals of up to five or so, regularly scouring a particular area of the lake. They take any food on the surface, and thereby reveal their route. Moreover, they show the flyfisherman which tactics are best – where they come closest to the shore and can be reached by a fly cast, or where they can be intercepted by means of a boat or float-ring.

Large lakes contain a lot of these patrol routes, followed by many groups of rainbow trout – so many that it could take years to chart them. In such lakes, the trout seemingly even change routes according to the wind, something that the flyfisherman is wise to note in his diary. But in waters which are less calm and not as windblown, the patrol routes are often identical, day after day and night after night. It may be worth adding that the real heavyweights commonly begin their patrols as the dusk fades, and frequently do so very close to land.

The present author has watched this behaviour in several small rainbow-trout lakes and tried to chart it during long periods of intensive, successful fishing by dusk and night. Groups of up to four big fish could be seen or heard – it was often too dark to observe their rising – long after the smaller rainbow trout had stopped rising. The routes of these heavyweights also passed quite near land; they moved about as fast as a jogger, and one could watch them rise as one ran along the shore.

Conceivably this behaviour of large rainbow trout at dusk and late evening was associated with the threat posed by fishing. In all of the lakes where observations and experiments were made, fishing is very popular. Probably the more sizeable and shy rainbow trout did not dare to begin hunting near land until the lake became peaceful, other fish having given up for the night. It is also likely that food was most plentiful near land during the dusk and early evening; the observations were made in August and early September, when caddis flies were abundantly hatching and fluttering around the bushes on shore.

(Left) Put-and-take fishing in lakes, ponds and meres has become a widespread alternative to the more difficult fishing in streams that are often far away.

Insects that rush back and forth on the water surface, such as caddis flies, often seem to be very attractive for fish, and are thus well worth imitating.

Waiting out the fish can be a profitable tactic. Brown and rainbow trout, for instance, frequently follow a pattern in their rising. By placing the dry fly on the fish's patrol route, you have a good chance of getting the fish to take.

If you are a good caster, you can also try to lay out the fly at the end of a series of rises. After the second rise, showing which direction and speed the fish are moving with, the fly is laid out quickly where the fish are expected to appear next – at the third, and perhaps last, rise.

In any case, patrolling behaviour is typical of all rainbow trout, and the flyfisherman's tactics are clear: wait them out, keeping an attractive dry fly in their path. Sooner or later they return, whether it takes three minutes or more than ten minutes. A dry fly is your best weapon by far, provided that it can wait for the fish – whereas a nymph or streamer must be kept moving, and therefore risks being in the wrong place at the right time!

All of the twenty-odd rainbow trout caught during these experiments took dry flies. Half of them were caught during evenings when not a single rising was seen or heard: there were no caddis flies on the water, yet the fish were patrolling anyhow. If they saw something edible on the surface, they took the imitation – a dry "Nalle Puh" ("Winnie the Pooh") tied on a No. 8 dry-fly hook, and quite a mouth-

The predominant kind of sportfishing is then often trolling.

However, intensive search over wide areas is necessary to find the quarry – at any rate, the trout and salmon. This sort of hunt is scarcely possible with a fly rod. What can be done is to try an established trick, namely hanging a big salmon fly in the swirls that form behind an outboard motor running in low gear. The propeller wake attracts fish, as trollers know – and the trout and salmon are as glad to take a salmon fly as a long, thin wobbler.

While trolling with a fly can be rewarding, it is not the sort of fishing that a flyfisherman dreams about during the dull winter months.

In smaller lakes, a profitable approach is often to wait out the brown trout. But these behave differently from rainbow trout. Commonly they are loners, as also in flowing water. They oversee and defend a territory which is usually much more limited than the patrol routes of rainbow trout, although considerably wider than the feeding grounds of brook trout. Turn after turn, they can mark an area of only 15-20 m (50-65 ft) in diametre, or patrol a shoreline for just 50 m (165 ft). This tends to occur in the evening as dark falls.

Consequently, flyfishermen find brown trout less accessible than rainbow trout, where both exist together. There are many such small-lake territories where no brown trout have ever been caught, since the trout always feed beyond range of the fly. On the other hand, we often succeed with the trout that patrol back and forth along the shore. They usually begin to appear late in the evening, yet are then relatively easy to catch on flies, if the fisherman is discreet: what he needs is not a long cast, but a good hideout behind a bush or boulder.

The shore patrols of brown trout at dusk are especially characteristic in small forest meres, of the kind that Scandinavia has in tens of thousands. Their quagmire shore waters are often far more extensive than the visible surface indicates. Trout hide there by day and sneak up for supper at dusk.

These trout, too, must be waited out. Whoever comes stomping into the quagmires at dusk is sure to have a fishless evening. The fisherman should be there much earlier in order to avoid scaring the trout, and should stay quiet. Making coffee and smoking a pipe are allowed, as long as one keeps one's feet under control. In sum, waiting out the fish is a highly reliable method, especially at times when abundant insects are being produced and attract fish to the surface.

ful, originally used in dry-fly fishing for big sea trout in Norway's river Aurland.

Waiting out the fish is thus a very handy rule of thumb, especially for rainbow trout. If they do not show by day, they often do so towards evening, notably just after sunrise if the weather is calm and the air rather warm.

Limited territory

In huge lakes, it can be extremely hard to locate the trout, and even pointless to try waiting them out. They simply do not show themselves, frequently because they eat almost nothing but small fish in large schools, such as vendace.

Wind direction and lee edges

Even quite small lakes have a wind side and a lee side – and therefore, when the wind blows, a lee edge. This is the boundary between the smooth water and the water with waves stirred up by wind. In larger lakes, particularly those with islands and many coves, such lee edges are numerous. They function in the same way as current edges in flowing water. The fish food which is transported by the faster water in currents, and by the wind-driven water in lakes, eventually ends up in the lee edges, and the fish know it.

The phenomenon is clearest towards the close of the fishing season, when insects begin to be scarce. Then the remaining insects may form small drifts, often made of midges and other "small fry". They attract even big fish to patrol along the lee edges.

The latter behaviour is especially typical of rainbow trout – and in some mountain regions, of landlocked Arctic char, which are also great consumers of small insects. But one can frequently see rainbow trout patrolling back and forth along lee edges, though they evidently catch very little. The explanation might be that they, like brown trout, are eager to have a "roof" over their heads if any can be found, in this case the rippled water from where they can look out at the smooth surface and notice even morsels of food on it.

Thus, the lee edges are well worth trying, particularly if the fish refuse to show themselves and suggest some other fishing tactic.

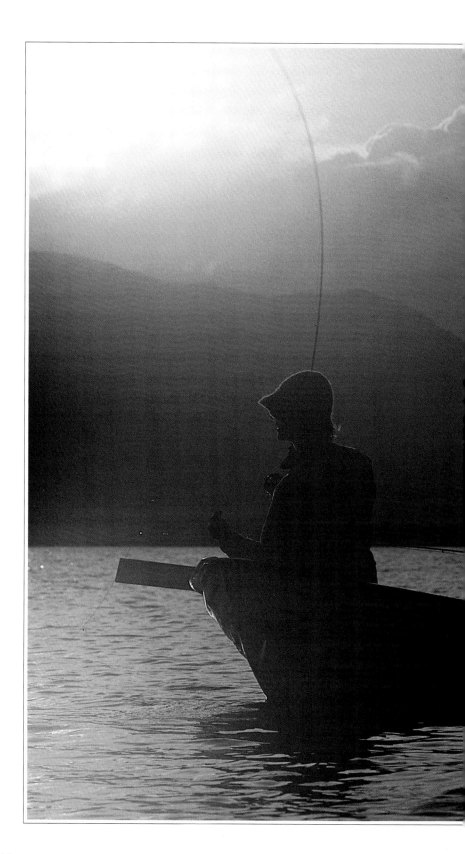

On really large lakes, a boat is often essential in order to get out to the fish. Moreover, on some big lakes in Great Britain, "dapping" is a common method. It makes use of "blow lines", which are very thin and light, enabling the fly to be carried across the water by the wind.

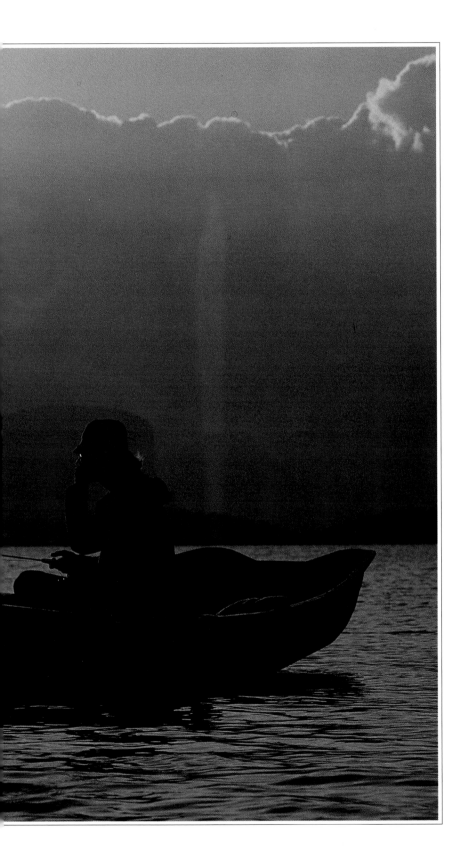

Charts and bottom topography

Bottom charts can tell us more about the fishing water than what we see with our naked eyes. Every lake has its own landscape beneath the surface, and even a simple chart can give the flyfisherman good indications of fishing spots. In some countries, when you buy a fishing licence, you usually also get a chart of the lake and its depth curves, sometimes actually printed on the fishing licence.

Such a chart is invaluable for flyfishing. The invisible boundaries between shallow and deep waters are often areas where rainbow and brown trout, char and grayling, and other salmonoids gather to seek food. The same is true of channels that unite larger lakes. When the wind blows along a channel, it functions like a funnel, collecting and concentrating the fish food, which makes it worth a try.

There are, of course, times when none of these thumb-rules will work. For example, in the spring it is frequently useless to wait for a rise. No fish show up, the water is too cold, and the scanty food stays in the bottom's slime and gravel – where the fish stay as well. Nor may the wind give any good indications.

But a flyfisherman has to do something even without help. One clever option is to find a headland between two coves, and try a sink-tip or a slow-sinking line, with a big shaggy nymph or a little Muddler Minnow on the leader. You may guess that there are fish in the coves, while knowing that they are hard to catch – yet you also know something else. Fish are like people in at least one sense: they often get the idea that "the grass is greener on the other side". So they decide that the other cove contains more food; and to get there, they must pass the headland, where your nymph is dangling...

Still-water fly fishing equipment

Something like ninety percent of all the fish caught on flies in streams are taken at a distance of 8-12 m (25-40 ft). Farther away than that, it is much harder to see what the fish is doing with the fly, and more difficult to hook the fish. At over 20 m (65 ft), we seldom succeed.

When fishing in still water, it is much more important to be able to cast far, especially with nymphs and streamers. These depend on the fly being kept in motion all the time, which means that the line is straight.

There is also something that makes longer casts profitable when fishing in still waters: the mere fact that the water is still, and occasionally quite smooth. It is then difficult to get near the fish without frightening them. Currents make it easier for the flyfisherman to hide – he can sneak or wade very close, even to large shy fish, by exploiting the disturbed water's camouflage and the "dead angle" of the fish's field of vision.

Water troubled by waves and gusts of wind can also be used to advantage when fishing in still water, but the "dead angle" seldom can be. For the fish are moving and it is rarely possible to sneak up on them from behind.

Still-water fishing therefore imposes certain demands on the flyfisherman's casting ability, and consequently on the equipment. A long rod of 9.5-10 ft (around 3 m) is adequate, able to cast a light line such as a WF 5 when the wind permits, as it often does when fishing in still water. With a long rod and a light WF line, you can cast farther than 20 m (66 ft) if necessary, yet fish discreetly – which is much more important on calm lake water than in the rough waters of streams.

Another reason for choosing a long rod is that many lakes, not least in the Scandinavian mountains, are relatively shallow and call for wading. But wading at any depth makes it hard to cast with a short rod – the fly tends to hit the water during the back cast, so that the forward cast scarcely resembles what you intended.

Body waders should reach up to the armpits. Thigh waders, which reach only to the crotch, are used less often and only in calm stream waters. Otherwise you might miss many fine fishing opportunities by being unable to wade far enough out to reach underwater precipices which fish usu-

ally prefer, notably the tricky and very easily frightened Arctic char.

In regard to other details of equipment, besides flies for still-water fishing, you should be warned against the advice in many fishing books about the length of the backing line. More than 50 m (165 ft) may be needed at times, and to lose your first four-pound trout because the backing line is too short would be infuriating, to say the least. A proper length is 100 m (330 ft), though there are times when even that can be too short.

When fishing in lakes, a long rod and light line are preferable. With this combination, you can cast long and also present the fly discreetly, as is often necessary in order to induce the fish to take. A landing net, of course, makes it easier to land the fish calmly and securely when the fight is ending.

Fishing at the right depth

Sinking lines are used more often in still waters than in currents, except for salmon and sea-trout fishing in deep, cold rivers. There are many situations, and many lakes, where the fly must be fished deep in order to make any contact with the fish. This is especially true in the early part of the season, when the water is cold and the fish seek food on the bottom. But frequently also during the season's warm periods, the fish become hard to reach, fleeing from the warm surface water to the cool bottom-layer. Then, too, a sinking line can come in handy.

However, even if the fly must descend to, say, 10 m (33 ft), it is wise to avoid fast-sinking lines. They maximize the risk of a very troublesome bottom-snag. A better method is to join a floating level-line of class 3 or 4 with a heavy "belly" of only 7-8 m (23-26 ft) made from a sinking line in the middle class range.

Such a line arrangement means that the sinking-line belly's tip will go deepest. The floating shooting line lifts the belly's other end, so that the belly cannot get snagged except, perhaps, at the tip. But nine times out of ten, only the fly gets caught and, if it does not pull loose, you can quickly tie a new one on the leader tip – which, if made properly, has broken nearest to the fly.

For deep fishing, a sinking belly in the middle class range is a good choice. It descends fast enough – that is, it stays at the same depth if you take home the line at the most suitable rate for fishing with nymphs or with small streamers. A fast-sinking belly (or the type called super-fast sinking) has to be pulled home too quickly to avoid a bottom snag, and then the fly will attract fewer fish.

But for moderate depths, say 2-3 m (6-10 ft), a sink-tip line is recommended. It has a sinking tip 3-5 m (10-16 ft) long, while the rest floats. Such a line is often a bit tricky to cast with – the heavier tip "slings" in the cast – and an alternative is a floating line with sinking leader. Nowadays there are braided leaders, from floating to very fast-sinking, and the sinking ones yield the same results as the sink-tip line's tip. They are rather expensive, but many flyfishermen prefer them anyway. One does not, after all, need to change the reel or line, but simply changes the leader to fish deep.

Even a floating line with a sinking leader can get caught during the cast. This effect seems very hard to avoid, if you want a line arrangement that protects against too many difficult bottom snags. An old trick is to put a few cloven lead-shot balls on the leader to the floating line. This works well, though the shot balls sometimes fly off in their own direction during the cast!

According to an ancient sportfishing rule, the fish is usually caught either at the surface or on the bottom. The same largely applies to still-water flyfishing, where experience tells us that 95% of the fish are caught with flies on, in, or just under the water surface – and the rest are caught by fishing as close as possible to the bottom.

Certainly there are exceptions. The most important thing, of course, is to fish so that your quarry can see the fly. A fish feeding in the bottom gravel may well rise to a fly that passes 1-2 m (3-6 ft) over its head, if only it glimpses the goodie – and so may a fish swimming at a depth of 1 m (3 ft) if it discovers an attractive dry fly. But the general rule, at the surface or on the bottom, remains a good fishing tactic.

Several other tricks make it easier for the fish to find the fly, even if you do not hit the centre of the rise-ring exactly when the fish creates it. One trick, when the fly – either wet or dry – has landed, is to wait a couple of seconds and then resolutely pull in the line by 30-40 cm (12-16 in), before taking a new pause of two or three seconds. If the fish saw the fly when it fell on or into the water, and wants to take it, the strike will usually come instantly. Otherwise the fly may have fallen in the "dead angle" behind the fish. But the fish will sense the first distinct pull, and as a rule it will turn round and take the fly like lightning.

In a word, letting the fly make noise can be profitable. A good recipe is to supplement reliable wet-fly patterns with a little Muddler head, so that the fly stays hanging in the underside of the water surface. When you carefully retrieve the fly, every little tug will form a ripple around its head – and these "bow waves" seem to attract fish, or at least enable them to detect the fly more easily.

We thus return to the subject of still-water flies. The fly is the most important piece in a flyfisherman's equipment – the only item in the collection that the fish are allowed to see, if the fisherman is handling his gear in the right way.

The float ring has created new opportunities for still-water flyfishermen to cover their waters effectively. Aided by flippers, you can move silently and calmly without scaring the fish.

Flies for still water

Every rule does have an exception, and there are quite a few instances in the rule-book of flyfishing. Yet on the whole, two clear differences exist between still-water flies and the flies that have been proven most effective in flowing water.

On the one hand, still-water flies are all bigger by two or four hook numbers. On the other, dry flies are predominant in flowing water, but play a secondary role in still water, where wet flies hold sway and, indeed, "lures" and streamers earn a much larger share of the credit – as reckoned in number and size of fish caught.

This contrast is hardly surprising. Most dry flies imitate mayflies, whose family has far fewer species in lakes, meres and ponds than in flowing water. Caddis flies are equally plentiful in all of these, although their species, too, are definitely fewer in still waters.

However, still waters frequently offer abundant fish food of another kind: the damselfly nymphs, water boatmen and other beetles, leeches, snails and molluscs, a rich assortment of land insects such as ants, sloebugs, wasps and crane-flies, as well as billions of midges in various stages of life. Not to mention, of course, a lot more fish fry – the kind of food that is often essential if trout, in particular, are to grow really big.

Stoneflies are a family which tends to be strongly represented in waterways that are clean enough, and which sometimes enables us to fish with dry flies as soon as the ice melts. In Southeast European waters like the Austrian and Yugoslav chalk streams, stoneflies may dominate the insect life during much of the season, but they do not occur at all in still waters.

These differences – and there are many more – lead rather inevitably to a choice of fly patterns only some of which are usable in both still and flowing waters, and are then also tied on hooks bigger by two to four numbers if used in still waters.

Occasionally I have tried with American models to compose a "deadly dozen" flies for fishing in streams. Eight or nine of them have been dry flies in sizes from No. 10 down to 18 or 20, while a dozen for still-water fishing have included only 3-4 dry flies. The rest have been wet flies, such as some ample servings of Muddler Minnow, Wooly Bugger,

and Bitch Creek Nymph. Nor have still-water dry flies been of negligible size. The successful Swedish dry fly Streaking Caddis, which imitates a caddis fly and is tied by muddler techniques, has also been included in the dozen for stream fishing, in size No. 8 – besides a wasp No. 10 and a flying ant No. 12.

An exception here is to have a dry midge of size No. 18 or 20 for the golden chances that arise towards the end of autumn, when food is getting scarce in small lakes and the rainbow trout are feverishly hunting what is left – especially midges.

Only two flies have been common to both of these "dozens", apart from the above-mentioned Streaking Caddis. One is Hare's Ear, an imitation of big mayfly nymphs and hatchers as well as big caddis-fly pupae. The other is a Muddler Minnow which sometimes can be an effective lifesaver in either flowing or still waters. But I freely admit that it is difficult to limit the range of favourite flies to just a dozen when fishing in still water. There, the fish are so diverse in diet that I often think every lake deserves its own "deadly dozen".

So a recommendation is that all still-water flyfishermen, when touring several different kinds of waters, take along a field kit in their baggage – namely a reduced set of flytying tools that makes it possible to improvise imitations of those insects and other goodies which the fish prefer at the moment. A collection of ready-made flies that can fully cover all fishing opportunities in all lakes would scarcely be transportable!

Nonetheless, we shall now try to pare down the list of favourites for still water, while also identifying – as far as possible – the insects that they imitate, and which fishing tactic is suitable to them.

The flies described here are a standard range for salmonoid fish. Very seldom do you need to dig deep in the box for "odd" flies, since all of those in the standard range are sometimes disappointing. This applies to fishing trips in many countries such as the United States, England, West Germany, Austria and Yugoslavia.

Choosing a fly can be difficult – sometimes very difficult indeed. But there are several reliable favourite flies that will tempt the fish in most types of still water.

But the rules of thumb for flyfishing in rivers are also valid in still waters, and to an even greater degree. Especially at times when the fishing is best, the fish may alter their food preferences repeatedly during a single day. You have to keep up with them and go on experimenting. This is just what makes flyfishing so inimitably exciting!

Large mayflies

The largest mayfly species in Scandinavia's still waters is *Ephemera vulgata*, the "green drake". Its colour, from dirty yellow to deep chocolate-brown, is darker than that of the "drake" in flowing waters, *Ephemera danica*. Yet many of the classic mayfly patterns are applicable to it. The kind found most effective by experienced flyfishermen in still waters is tied with burnt feather-wings, parachute hackle and a free rear body, on dry-fly hooks of sizes 10-12.

These imitations are used during early summer in north European waters. It generally takes a couple of days before the hatching starts to excite the fish – but then they often hunt the newly hatched mayflies with a frenzy, splashing almost violently as they rise. One can even see rainbow and brown trout jumping half a metre above the surface in attempts to snap up the flies, and their acrobatics frequently succeed.

During this period the fish are easy enough to catch, if you manage to place your fly on their beat. At the same time, a still-water flyfisherman has fine chances of hooking a real heavyweight – for the feast is shared by all the fish, big and small.

However, as a rule it does not last long. It may occur during several periods of varying intensity, depending on the weather. But the fish soon discover greater rewards in trying to snap up these mayflies before they hatch – particularly when they are just about to hatch, and are floating helplessly in the surface layer.

Large mayflies can be tied in numerous ways. This imitation of a "green drake" (dun), tied with parachute hackle, is quite effective – but the pattern must naturally be varied in colour and size, depending on which mayflies occur locally.

GREEN DRAKE (DUN)
Hook: dry-fly hook with downward eye No. 10-12
Tying thread: brown
Tail and reversed hackle: "wonderwing"-tied badger saddle hackle feather, with four fibres left and bent backward as tail antennae
Front body: medium-brown poly dubbing
Wings: two burnt pheasant breast feathers, 13-15 mm (0.5-0.6 in) long, tied back to back
Hackle: light brown cock, parachute-tied around the wing root
Head: black

The challenge may be to tempt the trout with an imitation of big mayflies.

The mayfly nymph

This nymph can be imitated quite well with a large Gold-Ribbed Hare's Ear, whose tail you may want to build with 4-5 fibres from a cock pheasant's tail feather. The result, though, has one drawback: unless greased, it does not float very long if at all.

Therefore, assuming that the same nymph is not to be used also as an imitation of large mayfly pupae (in that case without tail-strands, since the pupae lack such a tail), you can replace the nymph's front section with a more or less equally thick thorax of deer hair, and leave a little bunch of hair tips on each side while dressing it. These bunches imitate the wing rudiments of a hatching "green drake". But the most important thing with this tying method is to obtain an imitation hatcher which floats ungreased – and floats in the underside of the water surface, just like its real prototype.

One seldom needs other mayfly imitations, or for that matter any special version of the "green drake" such as a spent spinner – the form which falls onto the water with outstretched wings. It does happen that the fish feed wildly on spent spinners, but even then your dun imitations can be applied with great success. A slight trick is enough to make them work wonders: jerk the line to give them a bit of life. Experience shows that the fish, however hungry for dead mayflies, will always prefer them alive if the choice exists.

This nymph can be fished either weighted or unweighted. If greased, it floats and provides an excellent imitation of large, hatching mayflies and caddis-fly pupae.

GOLD-RIBBED HARE'S EAR (NYMPH)
Hook: long-shanked wet-fly hook or streamer hook
 No. 10-14
Tying thread: brown
Tail: a sparse bunch, 5 mm (0.2 in) long, of pheasant cock
 tail feather fibres – or, for small hook sizes, a little
 bunch of brown cock hackle fibres
Rear body: dubbed brown, gray, and black fur from a
 hare's ear, ribbed with round or oval gold tinsel
Front body: somewhat darker and thicker dubbing from a
 hare's ear, with longer hairs "pushed out" to imitate
 legs and wing cases
Head: clear varnish over the tying thread

STREAKING CADDIS
Hook: dry-fly hook with downward eye No. 8-12
Tying thread: black or brown, extra strong
Body: dark-beige or olive-green poly dubbing, amply tied
over the rear half of the hook shank and slightly down
into the hook bend
Wing and head: muddler-tied with brown or grey-brown
deer's hair, clipped so that the fly's underside is flat
and the wing/head shape is a pointed triangle

EUROPEA 12
Hook: dry-fly hook with downward eye No. 10-16
Tying thread: yellow
Tail: a short bunch of pheasant hen tail feather fibres
Body (2/3 of the hook shaft): dubbed fur from hare's ear,
or medium-grey poly yarn
Ribbing: yellow floss silk
Wings: mallard hen breast feathers, tied in sedge fashion
over the body and tail
Hackle: brown cock
Head: clear varnish over the tying thread

Large caddis flies

Imitations of caddis flies, whether the complete winged ones or the larvae and pupae, play an enormous and indeed predominant role when it comes to flyfishing in still waters. This is comparable to the significance of mayfly imitations in flowing waters, although caddis-fly imitations are responsible for much of the catch there as well.

Caddis flies are abundant in virtually all waters. There are several hundred species, ranging from very small flies that require imitations on No. 16-18 hooks to gigantic ones with a body length of 30-35 mm (1.2-1.4 in).

The best-known imitation in Europe is No. 12 in the French Europea series. Tied in various sizes on hook numbers 8-16, it imitates a wide range of caddis-fly species. For some years there has also been a Swedish pattern, now extremely popular in Scandinavia and spreading beyond Europe – the Streaking Caddis. This is simple but ingenious: a fat banana-shaped body of poly yarn, with a muddler head which is dressed so that the deer-hair tips on the

hook's upper side form the fly's wings, creating the characteristic "roof" of a caddis fly at rest.

Streaking Caddis is an unsinkable imitation, and this is important. For the fishing technique that makes it so effective is based upon adept manipulation of the line, which enables the fly to copy the slithering movement on the water surface that is typical of the big, egg-laying caddis flies and is apparently quite provocative to large rainbow and brown trout.

The most successful time for Streaking Caddis is at dusk and night – when the fisherman can no longer see the fly, but will surely hear the noise of the fish striking at it! A Streaking Caddis should then be kept moving with long, distinct pulls of 30-40 cm (1.0-1.3 ft) on the line, at intervals of 5-6 seconds. It should also be big, and tied on a dry-fly hook No. 8 or 10. Yet this clever fly is equally excellent for fishing in daylight, and it has proved able to tempt even huge grayling that are otherwise unreceptive.

The original version of Rackelhanen has brown wings and body, but many variants have been created. The most popular are one with an olive-green body and beige wings, and another with black body and white wings on hook size No. 16.

RACKELHANEN
Hook: dry-fly hook with downward eye No. 10-16
Tying thread: brown
Rear body: dark-brown or cinnamon-brown thick poly dubbing, amply tied over the rear 3/4 of the hook shaft
Wings: dark-brown or cinnamon-brown poly dubbing, which forms a backward- and upward-pointing V over the rear body
Head: a ball of dark-brown or cinnamon-brown, thick poly dubbing

Rackelhanen should be fished on a sinking leader, with half-metre-long pulls on the line so that it dives continually, then pops rapidly up to the surface.

Medium-sized caddis flies

This group of caddis flies was once imitated almost always with Europea No. 12. But that universal fly has recently met growing competition from a new favourite, Rackelhanen. Its Swedish name refers to a hybrid of two large wild wood-hens, the black grouse and capercaillie. The fly thus named is also a kind of hybrid – it imitates both the hatching pupa and the complete winged caddis fly.

The original Rackelhanen fly was invented by the well-known Swedish flyfisherman and rod-maker Kenneth Boström. It was made entirely of thick dark-brown poly yarn, apart from the hook and tying thread. This material gives the fly – especially if greased – an outstanding buoyancy which is important for its fishing technique. Rackelhanen must be fished with a "wet", slowly sinking leader, and with pulls of about 15 cm (6 in) on the line, which make the fly dive and then pop up again. It thus imitates a hatching caddis-fly pupa and, when you stop pulling, a newly hatched caddis fly that floats on the surface in readiness for its first flight.

Such a series of dives and pop-ups is evidently irresistible, in particular to grayling. Rackelhanen is tied today in all sizes and in endless colour combinations. Notably popular, besides the original colours, are an olive-green body with beige wings and a black body with white wings. The latter often comes on very small hooks, perhaps also imitating reed smuts and midge.

Good imitations of caddis flies are innumerable. Scandinavian flyfishermen experiment constantly with new patterns, but they have some reliable general favourites. In addition to the Swedish smash hits, there is Nalle Puh from Finland, composed by Simo Lumme in Helsinki and originally tied with bear-hair. Modern versions employ contemporary poly material, which seems to make the fly even better. Consequently, on hook sizes 8 and 10, it is a superb dry fly for sea trout in, among other places, the rivers of Sognefjord in Norway.

Caddis-fly pupae

There are a lot of imitations of the pupae as well, and the same patterns are used in lakes as in streams. We have already mentioned one of them, Gold-Ribbed Hare's Ear, which seems to work as nicely when imitating pupae as when the fish are hunting mayfly nymphs about to hatch.

Nalle Puh from Finland, too, has a pupa version – tied in sizes from hook No. 10 to 16, with the rear body usually dirty-orange or with olive-green dubbing. These imitations have rough, very shaggy bodies which, during the fishing, retain plenty of air in small glittering bubbles, thus adroitly copying the gas-filled coat of a pupa.

In the past two or three years, however, Nalle Puh has competed increasingly often with something called the Superpupa. This is a series of six or seven patterns, in sizes from hook No. 8 to 16. They have traditional shaggy bodies of rough poly dubbing or natural underfur. The trick is their body hackle, which winds over both the rear and front of the body, and is clipped over and under the hook shaft.

The Superpupa becomes a floating pupa imitation if it is greased – otherwise it sinks slowly. Like other pupa imitations, it can be tied in a great number of colour combinations. The best fishing results have been obtained with three versions: No. 16 with dark grey body and dark-blue dun body hackle, nicely imitating small caddis-fly pupae as

well as all sorts of other nymphs that are eaten especially by Arctic char; No. 14 with olive rear body and a very dark-brown thorax; and No. 8 with cream-coloured rear body, dark-brown thorax and light-brown body hackle. The last of these is fished primarily as a dry fly, either motionless or with short, cautious line jerks. It seldom arouses the fish in streams, but in still waters it has been a terrible killer.

Not only did the Superpupa become a new favourite – it also ushered in a whole new kind of flyfishing. That is, it turned out to be the best fly known until now for catching whitefish, usually a nerve-wracking ordeal. In many waters, whitefish are specialized to eat the drifting insects, largely caddis-fly pupae, which hover some centimetres beneath the surface. An ungreased Superpupa is cast upstream of the whitefish by 3-4 m (10-13 ft) in a stream, while in lakes it is placed 5-6 m (16-20 ft) in front of foraging schools of whitefish so that it can sink to the right depth before they see it. Moreover, it is enjoyed not only by whitefish: you will often get a "bonus" catch of sizeable trout and Arctic char.

All of this pupa fishing has been done with imitations which are presented in, or just under, the water surface. But caddis-fly pupae begin their journey to the surface from the bottom, and throughout the trip they are attacked by greedy fish. Commonly only a few percent of the pupae escape being taken and manage to hatch on the surface in order to reach their fourth and final stage. Yet these few are enough to ensure the insect family's survival.

Imitating a caddis fly that climbs out of the bottom gravel to start its adventurous voyage, though, is hardly easy. Indeed, it may appear hopeless to make a deep-sinking imitation work naturally. This has been done, but mainly in flowing water and by using Frank Sawyer's awfully ingenious Killer Bug. In lakes we should stick to the surface layer, where the fish also certainly come, sooner or later, in their quest for rapidly rising pupae.

The Superpupa is a terrific pupa imitation which, besides the original (below), also comes in variants: one with an olive-green rear body on hook No. 12-14 and, for Arctic char, one with a dark-grey rear body on hook No. 16.

SUPERPUPA
Hook: dry-fly hook with downward eye No. 8-16
Tying thread: same colour as the rear body
Rear body: cream-coloured, light or dark olive, or dark-grey poly dubbing, amply tied over 2/3 of the hook shank
Front body: dark-brown or black poly dubbing
Body hackle: cock hackle over both the front and rear body, light brown (if the rear body is cream-coloured) or blue dun, or (if the rear body is dark grey) dark blue dun. The hackle is clipped down over and under the hook shank.
Head: clear varnish over the tying thread

KILLER BUG
Hook: wet-fly hook No. 8-14
Tying thread and weighting: thin red copper wire
Body: three layers of copper wire, under an ample body of red, brown, and grey wool yarn (Chadwick No. 477)
Head: three or four turns of copper wire

Killer Bug was invented by the well-known English flyfisherman Frank Sawyer. This fly sinks fast and can therefore be made to imitate a caddis-fly pupa climbing from the bottom toward the surface. The copper wire is attached where the hook bend begins, then wound tightly forward to just behind the hook eye, and finally wound backward. When it reaches the hook bend, it is used to attach the Chadwick yarn, then wound forward again to just behind the hook eye. Lastly the yarn is wound forward and fastened with the copper wire.

NALLE PUH (PUPA)
Hook: wet-fly hook No. 10-16
Tying thread: beige, brown or olive green (according to the rear body colour)
Rear body: beige, dark orange or olive green, synthetic dubbing of rough, glittering materials. The rear body is tied amply, then "combed" so that it can retain tiny air bubbles (the above illustration shows, too, a variant with a silver-ribbed rear body).
Front body: thick, ample dubbing from hare's ear with pushed-out hairs
Head: clear varnish over the tying thread

WOOLY WORM
Hook: streamer hook No. 6-12
Tying thread: black
Tail: a short red tuft of red wool yarn, or a little
* bunch of red cock hackle fibres*
Body: black or olive-green chenille
Body hackle: grizzly (for a black body) or black
* cock hackle, fastened with the hackle tip at the*
* body's rear end and wound forward with the*
* feather's back side turned backward, so that*
* the body hackle fibres point upward and*
* forward*
Head: black varnish

Caddis cases can also be imi-
tated by threading a piece of
valve rubber over a long-
shanked hook, brushing glue
onto the rubber, and rolling it in
bits of cork. Then you wind on
black cock hackle and peacock
herl as legs and head.

Caddis cases

Many caddis flies are at the larval stage of case-builders, which put together a tube-shaped dwelling that covers and protects their rear bodies and part of their front bodies. When they move – slowly and clumsily, since they drag the case with them – you can see their heads and legs projecting from the case's front end.

Some birds strip caddis cases before eating them. Fish cannot do this, but swallow them whole, and this unavoidable "house consumption" explains all the rubbish – pine needles, wood bits, grains of gravel – which is often found in the otherwise empty stomachs of rainbow and brown trout.

Caddis-fly larvae are easy to imitate. The case-building larvae use whatever materials are nearest, and these are often pieces of vegetation, which enable us to imitate the worms with a weighted version of an American favourite, Wooly Worm. This fly has the right caseworm profile, being made of chenille – the best body material and available in numerous colours (mainly dark olive and black). A weighted Wooly Worm can and should be fished deep, with match-stick-long jerks of the line.

In certain lakes and streams, however, caddis-fly larvae choose a different building material: sand and gravel, which make them harder to copy. An old French method was to thread about 2 cm (0.8 in) of bicycle-tyre valve rubber over a long-shafted hook, brush the valve with glue, and roll it in gravel. It is difficult to cast, but its lumpiness can be avoided by imitating the gravel as well – namely with bits of cork, shaved off a wine cork with a rough file! The larva's head and legs on such a valve-rubber fly can be imitated with, for example, a "head" of wound peacock herl, or one or two turns of black cock hackle.

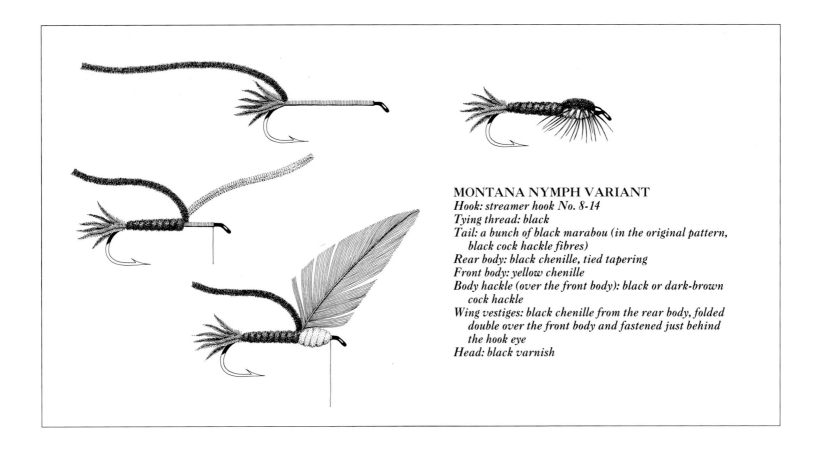

MONTANA NYMPH VARIANT
Hook: streamer hook No. 8-14
Tying thread: black
Tail: a bunch of black marabou (in the original pattern,
* black cock hackle fibres)*
Rear body: black chenille, tied tapering
Front body: yellow chenille
Body hackle (over the front body): black or dark-brown
* cock hackle*
Wing vestiges: black chenille from the rear body, folded
* double over the front body and fastened just behind*
* the hook eye*
Head: black varnish

Damselflies

This is another interesting family of "flyfishing insects". They play little role in flowing waters, but are extremely important – almost always as nymphs – for fishing in still waters. One should, though, take along one or two good representatives of the few exceptions, meaning imitations of complete winged damselflies.

For it happens that one sees fine rainbow trout which have specialized on, and developed a fine hunting technique for, "dry" damselflies. The fact is that damselflies like to sit on leaves, for example of water-lilies. They sit along the leaf edges with their heads bent out towards open water. Since they can see well and react very fast, the trout have to surprise them, from behind if possible. The fish does so by taking aim, flipping itself over the leaf with its mouth open, and catching the damselfly on the way back into the water on the other side.

But the flyfisherman seldom gets such a chance, as the main role is played by damselfly nymphs. These abound almost everywhere in Scandinavian still waters, except in the mountains – and the fish adore them. While they are not hard to imitate, you will have much more success with patterns that are impressions rather than imitations. The best by far is a Montana Nymph Variant, on which the oar-like gills are copied by a 5-millimetre-long tuss of marabou herl, which makes the nymph wave its tail realistically in the water. This fly is tied in two sizes, on streamer hooks Nos. 10 and 12, both weighted and unweighted. The fly is kept moving with short, distinct jerks or twists of the fly line, because a damselfly nymph moves jerkily.

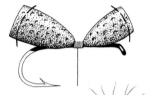

At left is shown the most easily tied imitation of flying ants, which tumble down on lakes and meres while swarming. A piece of punched polycelon is laid over the hook and wound fast at the middle of the hook shank. Then the hackle, of black or brown cock hackle, is wound on.

ANT
Hook: dry-fly hook No. 12-16
Tying thread: black or brown
Rear and front bodies: two balls of fine-fibred black or red-brown dubbing
Hackle: one or two turns of black or brown cock hackle between the dubbing balls
Head: black or clear varnish over the brown tying thread

McMurray Ant is another effective imitation of ants. The fly has superb catching ability, but can be hard to tie – or rather, manufacture – and it seldom lasts for more than one strike. It is made by sandpapering balsa balls and joining them with a stump of epoxy-glued whole nylon line. The balls are varnished and tied onto the hook shaft. Finally the hackle, of black or brown cock hackle, is wound on and fastened with the tying thread.

Ants

Ants, too, play an extensive role in still-water fishing, particularly in the thousands of small lakes in forest regions. Some years ago, a Scandinavian scientist made a study of the food habits of implanted rainbow, brown, and brook trout. It was found that no other food dominated their menu so heavily as did ants during the month of August. This applied to all of the lakes investigated, and the proportion of ants in the fish's food reached 80%!

The explanation is that flying ants swarm intensively at close intervals in late summer. They "rain" down on lakes by the billions – up to several hundred per square metre of water surface – and attract all fish to the surface.

At the beginning of an ant swarming, when the ants fall rather sparsely, the fish are easy to catch, being equally eager and unafraid, so that the competition for titbits of food is strong. But just a few minutes later, it can be almost impossible to hook a single fish, even though they rise madly. The real ants are then too numerous, and a fish is extremely unlikely to take an imitation ant by mistake.

But towards the end of the swarming, ants fall less densely again and the flyfisherman has his chance. Fish in lakes that are blessed with such swarmings become obsessed with ants, so for a long time – often several weeks – imitation ants remain by far the best flies to use, even on occasions when there are no ants or any other fish food on the surface.

Ant imitations are easy to tie. Two examples may be mentioned. One consists of a couple of "balls" of fine black poly dubbing, separated by a sparse black cock hackle. The wings are not important, but sometimes they are added, made of light-grey cock hackle tips and tied in a V shape between the poly balls. These imitations work perfectly – yet another example, the famous American pattern McMurray Ant, is also superb. Its rear and front body parts are of varnished balsa wood; however, it is harder to tie and much less durable.

It is not only in flowing water that fish can be easily frightened. Even when fishing in still water, one should act cautiously and try to keep a low profile.

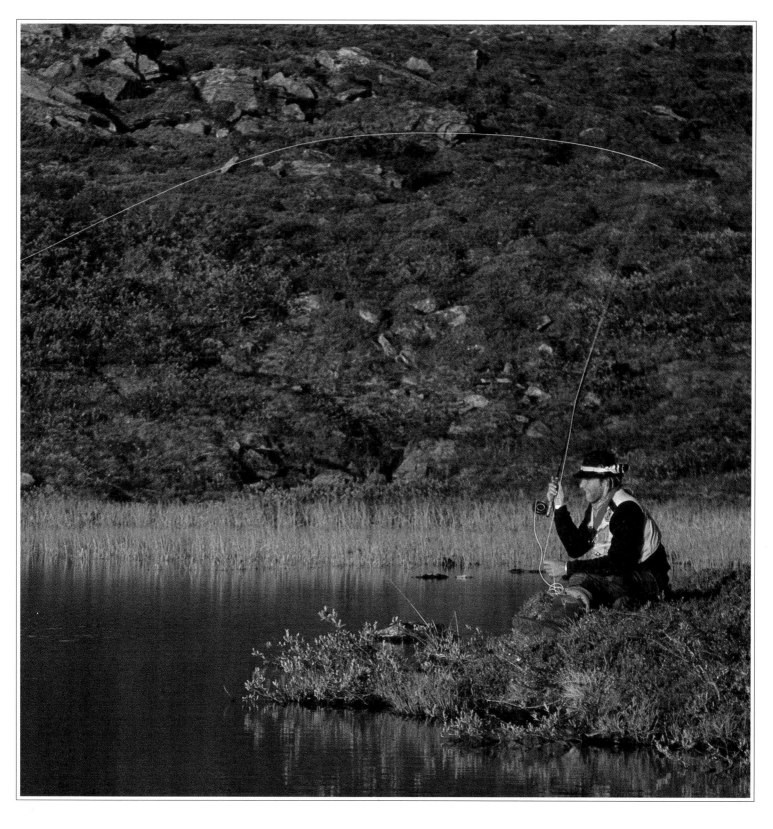

Ants must be fished as simply as possible, like freely drifting dry flies. Since the fish find them easily enough, no special tricks are required. Nor do you often need any other ant imitations than black ones of sizes No. 12 and 14. Black ants are the most common, and fish take them with joy, even if at times it is actually the much smaller red ants that are swarming...

Wasps

Besides flying ants, a great many other land insects become fish food now and then: crane-flies, sloebugs, bumblebees, wasps, peppered moth larvae, grasshoppers, and all sorts of small flies, beetles and so on.

The most important of these are definitely wasps, which may tumble down in such numbers during the summer and early autumn that they make the fish rise eagerly. A wasp rain can result, for example, from a thunderstorm or a frosty night that renders the wasps almost unable to fly.

It is frequently very hard to see whether wasps are the reason why fish are rising. Wasps themselves are quite difficult to see when they have fallen onto the water. Being heavy insects, they lie deep in the surface layer and may well be noticed only if you look straight down at them. But the fish can indicate what is going on by their powerful, gurgling whirls, like the wake of a energetic paddle.

Wasps are imitated in various ways – for instance, similarly to the simple ants made of poly dubbing, but alternating the black poly with dark orange in order to copy the characteristic stripes on a wasp's rear body. Another method resembles the McMurray Ant, using varnished balsa. Or a muddler technique is applicable, ideally with reindeer hair, which is easy to colour black and dark orange.

The popularity of wasps is greatest among rainbow trout. An insect that can evoke the same response is the sloebug, although this smelly creature is by no means as plentiful, and thus not so worth trying to imitate.

This wasp imitation can, of course, also be given wings, such as light-grey hackle tips that are tied on between the rear and front bodies. But ant- and wasp-eating fish will take the wingless variety just as readily.

WASP
Hook: long-shanked dry-fly hook No. 10-12
Tying thread: black
Rear body: a fat "cigar" of fine black and light red-brown poly dubbing, wound so as to create the typical wasp bar pattern
Front body: a smaller ball of fine-fibred black poly dubbing
Hackle: two turns of dark-brown or black cock hackle feathers between the rear and front bodies
Head: black varnish

Wasp imitations can also be made in the same way as McMurray Ant – with balsa balls that are sandpapered smooth and varnished in "wasp colours". The hook shank is then glued into a cut-out groove. Finally the hackle, of dark-brown or black cock hackle feather, is wound on.

BLACK & PEACOCK SPIDER
Hook: wet-fly hook No. 10-14
Tying thread: black
Tag (not on the original version): three or four turns of
DFM lime floss silk or wool thread, at most 2 mm
(0.08 in) long
Body: a cigar-shaped underbody of black floss silk, and
an ample overbody of twined peacock herl
Hackle: one or two sparse turns of long-fibred, black
hen hackle
Head: black varnish

Snails

The insects discussed above are basically worldwide – their species may differ from place to place, but the families they represent are found everywhere and the behaviour of fish in regard to eating them is surprisingly universal.

One kind of fish food that was described in a pioneering book, *Still-Water Flyfishing* by Tom Ivens, published thirty years ago, was the relatively unknown group of "pulmonate" (lung-bearing) snails which, during the summer, migrate in great numbers through lakes by drifting with the wind and waves.

It was soon discovered that such snails occur abundantly also outside England – in meres and ponds as well as lakes –

and that they are just as appealing to fish there as in the British freshwater reservoirs. In his book, Tom Ivens recommends an imitation named Black & Peacock Spider, whose greatest success occurred during August and September.

Ivens' fly does not closely resemble the snail – or slug – which it is supposed to imitate, but it is extraordinarily effective if fished very slowly in, or just under, the water surface. That the fish, whether rainbow or brown trout, seem to believe it really is a snail, has been well-proved by the present author. Many of the fish in such catches have turned out to be stuffed with pulmonate snails, and nothing else.

CORIXA
Hook: wet-fly hook No. 10-14
Tying thread: brown
Body: amply tied of white floss silk, ribbed with
round or oval silver tinsel
Wing cases: a bunch of pheasant cock tail feather
fibres, tied in at the hook bend, folded forward
and fastened at the head
Legs: thin peacock herl, one on each side of the
body
Head: clear varnish over the tying thread

Water boatmen

Yet another insect that fish in still waters love to gobble is the water boatman – in Scandinavia and Great Britain alike, as well as in the United States, New Zealand, and several other countries with freshwater salmonoids.

The most common imitation of water boatmen is British in origin. But success does not always follow with this fly on the leader. For these insects do not occur in all lakes, and only on special occasions do the fish concentrate upon eating that particular family. However, such occasions are memorable indeed, arising mainly when the water boatmen are swarming. They normally live underwater, but have to come up at regular intervals to renew their air supply, and then they make miniature "wakes" on the surface. When swarming, they fold out the wings hidden under their shoulder-scales, and ascend from the water like Polaris missiles, heading for dry land in order to mate.

After mating, they return in thousands to resume life in the water, and may then form a "rain" of water boatmen. This recalls a hailstorm, as insects fall all over the surface with short, sharp plopping sounds – and the fish react with the same enthusiasm as when ants are swarming. But you have to be lucky to experience it.

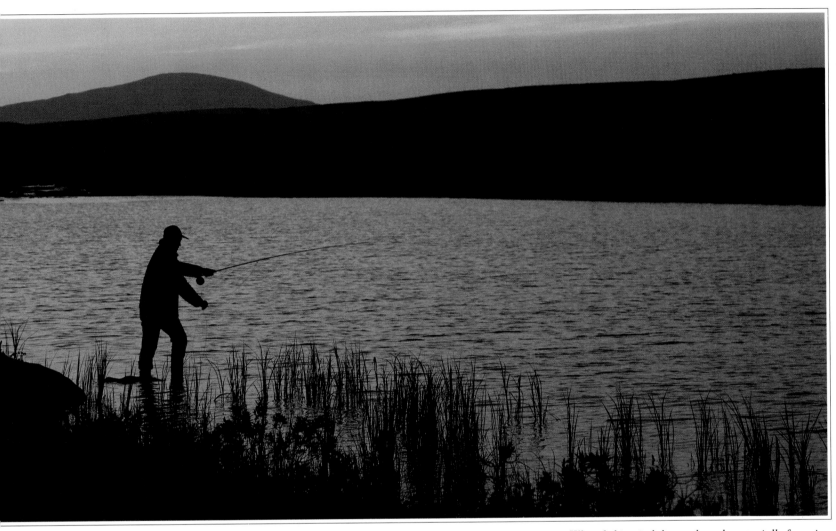

When fishing in lakes and ponds, especially for rainbow trout, "lures" can give very good results.

Lures

Lures are often large and unlike any known insects. In flowing waters they offer little to the flyfisherman, but they can be exceedingly effective in still waters. When fishing the latter, therefore, you should always take along at least three such odd patterns of different sizes: a Wooly Bugger, a Bitch Creek Nymph – both of them heavily weighted – and a Muddler Minnow, which is the one that can also sometimes give good results in flowing water as well.

Wooly Bugger, which has a fine British counterpart named Dog Nobbler, is tied on a streamer hook No. 8, 10 or 12. The other two patterns call for streamer hook Nos. 8

and 10. Nobody knows what a Wooly Bugger or Dog Nobbler is supposed to represent, but perhaps the fish take them for leeches. Anyhow they are frequently murderous, especially when fishing for rainbow trout.

If tying the flies yourself, be very careful about the placement of the weighting. It must lie as far forward as possible, just behind the hook eye. Dog Nobbler, for example, is frequently provided with a head that consists of a divided, epoxy-glued lead shot, varnished and decorated with painted fish eyes. Its weighting is ideal: the fly begins to dive toward the bottom immediately on hitting the water, with

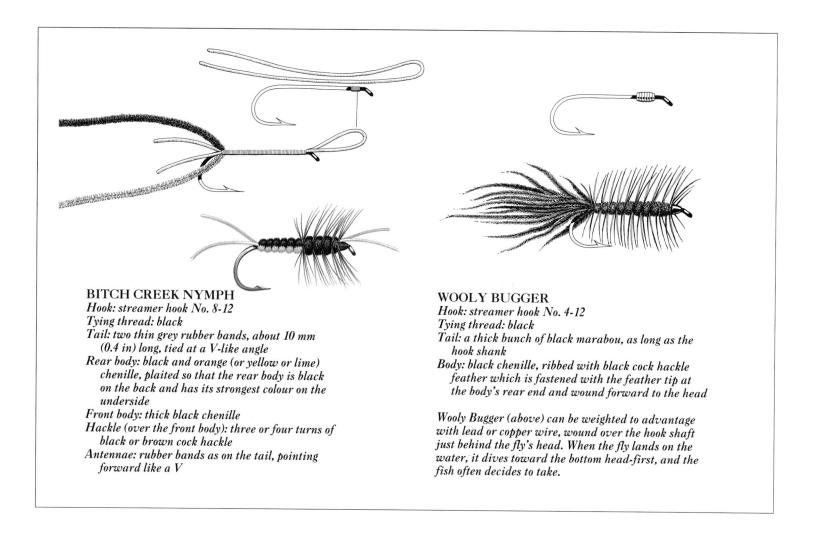

BITCH CREEK NYMPH
Hook: streamer hook No. 8-12
Tying thread: black
Tail: two thin grey rubber bands, about 10 mm
 (0.4 in) long, tied at a V-like angle
Rear body: black and orange (or yellow or lime)
 chenille, plaited so that the rear body is black
 on the back and has its strongest colour on the
 underside
Front body: thick black chenille
Hackle (over the front body): three or four turns of
 black or brown cock hackle
Antennae: rubber bands as on the tail, pointing
 forward like a V

WOOLY BUGGER
Hook: streamer hook No. 4-12
Tying thread: black
Tail: a thick bunch of black marabou, as long as the
 hook shank
Body: black chenille, ribbed with black cock hackle
 feather which is fastened with the feather tip at
 the body's rear end and wound forward to the head

Wooly Bugger (above) can be weighted to advantage
with lead or copper wire, wound over the hook shaft
just behind the fly's head. When the fly lands on the
water, it dives toward the bottom head-first, and the
fish often decides to take.

its head first and its marabou tail fluttering. Thus it attracts the fish instantly, without your needing to move the line. More than a third of the many fish caught by the present author on this fly have taken it on the first dive.

Dog Nobbler, like Wooly Bugger with a solid lead-wire weighting just behind the hook eye, is consequently a kind of jig-fly or fly-jig. The up-down path which these flies follow homeward seems to be much more provocative to fish than the traditional horizontal path.

The best colours are a black or dark-olive body, a black hackle and a black marabou tail – or conceivably even more dangerous, a body of twined peacock herl.

Bitch Creek Nymph has a distinctive type of equipment for provoking fish to strike: four thin grey rubber bands – two at the tail and two at the head, both pairs being tied in V shape – which move vigorously when brought home in jerks. This fly is a wide favourite during heat waves, and is usually allowed to sink to a depth of 4-5 m (13-17 ft) before the line is manipulated.

Muddler Minnow, finally, is fished almost free of weighting, since it needs to be buoyant and pop up to the surface after each pull on the line. It then fishes best, but you can fish it deep with a sinking weight-forward line. It can also be tied in rather light colours, and with a silver body. In the latter form, it imitates many of the small fish that are so common in both still and flowing waters – the minnows.

Unusual fish species

Few fish will refuse a delicious fly if it is served right in front of their noses. Whitefish can be caught on flies, and one of those in European waters is a source of fine sport – the ide. Sometimes it greedily attacks any fly that imitates fish fry, but otherwise it can be tricked only by a dry fly which is presented very discreetly. Today, ides caught on flies in Europe are usually "side-products", notably in Scandinavia where they are occasionally abundant in waters with salmon and sea trout.

Among freshwater fish, the pike and – in Europe – the perch are what, together with salmonoids, persuade most flyfishermen to exchange their angling rod for fly rods. In the United States, on the other hand, it is bass and bluegill, even though perch exist there and so do three species of pike.

Flyfishing for pike requires ample equipment, the same as in one-handed fishing for salmon: rods of 9-11 ft (2.7-3.4 m) and reels that have a durable braking system as well as holding a line of class 8-10 plus a couple of hundred metres of thick backing. Such powerful gear is not for the sake of the wind – unless the fishing is done in a brackish sea like the Baltic, or in large lakes. The problem is that the most effective pike flies are big, lumpy ones, tied on very thick leader tips. Such a tip, of 0.35-0.40 mm (0.014-0.016 in), is essential to prevent the leader from tearing off in a huge pike's toothy grip.

Pike fishing with a fly has become ever more popular, especially in northern Europe. And during one season, early spring, flyfishing is also by far the most effective method of catching pike as a sport. The reason is that pike, when they seek shallow water before spawning, move in a leisurely and dignified manner – they are presumably unwilling to perform any violent manoeuvres, and risk harming their reproduction by spilling eggs or milt. Though not eager to hunt, they do strike.

Consequently, for the spinning and bait-casting fisherman, the best bait is a small or moderate-sized one, which can be pulled very slowly in the water without losing its vitality. But almost no spinning bait can be pulled as slowly as a fly. The ideal fly for pike fishing is a plastic tube, 10 cm (4 in) long, covered or ribbed with silver or gold tinsel, and having one or more wings of soft hair, which "breathe" or

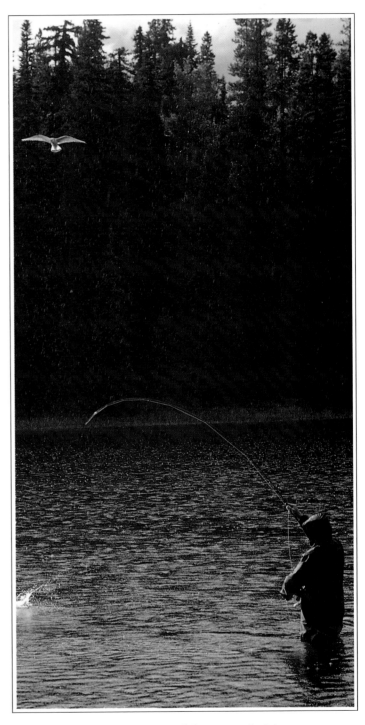

Good flyfishing is offered by many fish species which have no adipose fin. Most of them live in lakes and other still waters, but several can be found in flowing waters as well.

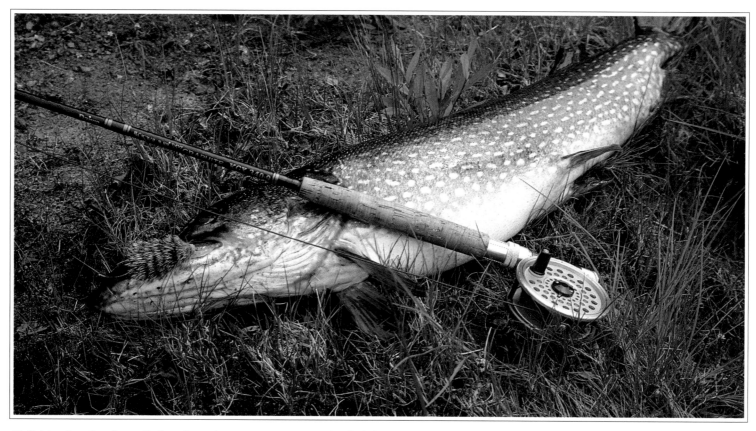

Flyfishing for pike often calls for relatively strong equipment and a thick leader, since the flies are large and difficult to cast – and a pike's teeth are sharp as knives.

pulsate at every little pull on the line.

When several wings or bunches of hair are tied on the tube, they increase the fly's ability to sway in the water, whereas the same fly with only one bunch of hair tends to lose its balance and tip in the direction of its weight – namely back towards the treble hook. Previously, this type of fly was often tied on two or three streamer hooks of size No. 6-8, in a tandem or triple arrangement, with a common "matuka wing" of soft hair. But the simple plastic tube is easier to handle, and the treble hook is at least as effective.

The fly's colours can very well be bright, particularly in springtime. My own pike fishing has succeeded best with a fly that has a bushy white wing, a silver tinsel body, and two tufts of red hair as a beard and tail. Such a fly should be fished with a slowly sinking line, as a fast-sinking line must be taken home too rapidly and does not interest the pike as much. A slowly sinking line can be taken home in leisurely jerks, without the fly either sinking to the bottom or rising to the surface.

When a pike takes a fly during the spring before spawning, it does so almost lazily, gliding forth and closing its jaws around the fly. It then offers unimpressive resistance, and even females weighing 10 kg (22 lb) or more will tire after a few minutes. But once the spawning is over and the pike resume hunting, they take their prey in the true pike tradition – with a lightning leap. How fast the prey move is rather unimportant. A fly which is slowly jerked home can nevertheless be profitable, though hardly better than the well-tried wobblers, spoons and spinners.

As a result, pike can be fished with a fly throughout the season, except for very hot periods when the pike stay deep. Fishing deep with a fly is always difficult, and this includes pike fishing.

Yet pike are also open to dry-fly fishing, unlike most of the other unusual flyfishing species. Certainly they do not make a habit of eating insects, but they gladly attack somewhat larger prey that sometimes stir up the surface – such as frogs and voles. A swimming vole is not hard to imitate,

The popper is a typical bass fly. It is taken home with short, sharp pulls on the line, so that the angled head creates sounds and air bubbles – it "pops". This enables you to catch even perch and pike, for example.

POPPER
Hook: long-shanked, strong dry-fly hook with downward eye No. 2-8
Tying thread: same colour as the body or head
Tail, body and wings: a bunch of hair attached just in front of the hook bend, with sides of one or two saddle hackle tips reaching 2-4 cm (0.8-1.6 in) behind the hook bend
Head: balsa wood, filed down to a rounded cone with its tip backward. A groove is cut in its underside for epoxy-gluing to the hook shank; then the head is varnished and decorated.

either: a bushy, muddler-tied deer-hair fly, mounted on a simple low-water salmon hook, clipped to the shape of a mouse, with a rubber band for a tail, works fine if it is taken home in short jerks. Even big pike, especially in confined waters, can be tempted by such a morsel; and so can big trout that are otherwise quite shy.

Perch fishing with a fly is most successful in high summer, when the water is warm and schools of perch hunt near the surface. At that time, perch can also be fished "dry" with an imitation of, for example, a bumblebee or wasp – insects that are regarded as delicacies by virtually all fish.

Large- and small-mouthed bass, which now exist not only in the United States but also in Spain and elsewhere, are also dry-fly fish, and to a much greater extent. Bass can be fished with many of the traditional nymph and streamer patterns, as well as with special surface flies called "poppers". These have a small head, made of varnished balsa wood, abruptly chopped off in front. It "pops" when jerked in the surface water, and this sound is apparently very attractive to bass – even if an occasional pike, or brown or rainbow trout, also lets itself be fooled.

Poppers can be fished with ordinary light flyfishing equipment. In the United States, however, a special fly line has been invented for just this sort of fishing. It is a weight-forward line with a short head, known as "rocket taper".

PIKE FLY
Hook: double or treble, with a 63-mm (2.5-in) plastic tube
Tying thread: red
Body: Flash-a-Bou mylar hose, drawn over the plastic tube
Tail: a 15-mm (0.6-in) tuft of red hair, attached to the tube's upper side
Wing: a strong bunch of long white hairs (or a bunch of black under one of white), reaching 1-2 cm (0.4-0.8 in) behind the tube
Hackle: a 15-mm (0.6-in) tuft of red hair, attached like a "beard" on the tube's bottom side, just behind the head
Head: clear varnish over the tying thread

Flyfishing in streams

*In small waterways
such as streams, brooks and
tributary rivers, the dominant fish are
often stationary brown trout, grayling
and other salmonoids – even if
they are sometimes accompanied by
salmon and sea trout, which are not feeding
but migrating to spawn. Here, fishing is
done primarily with flies that imitate
the quarry's food of insects,
crustaceans and lesser fish living
in the same waterway. We thus use dry
flies and nymphs as well as wet flies
and, to a lesser extent, streamers
and bucktails.*

A waterway's character and geographical location are decisive for the kind of salmonoid fish to be found there. Of course, it has always been difficult for human beings to accept that all fish – especially those in fresh waters – have a limited natural distribution. When we learned the rather simple craft of squeezing eggs from fish and raising trout or salmon fry, we immediately started spreading them into waters where they had not existed. If they were able to spawn and get enough food, they accepted the new environment.

This is why salmonoids occur at all in the Southern Hemisphere – for instance in New Zealand, Tasmania and Australia as well as in South America, where some of the world's best trout fishing is now found. These places have never possessed natural stocks of salmonoids, which originally were confined to our Northern Hemisphere.

The English, in particular, have made a great and laudable effort to implant trout almost everywhere in their former colonies. Residents who had long been away from "good old England" needed at least a few trout to swing their rods at! But the introduction of trout to new waters has not been entirely a positive trend. In many places the new species have prospered enough to completely eradicate the original ones. As a result, several excellent and rare fish species have been lost to posterity. Good examples are the numerous subspecies of the cutthroat trout *(Salmo clarki)*, which spread over North America by adapting themselves to the existing water system and its environment.

The massive stocking of salmon and trout from artificial hatcheries has also "diluted" the valuable gene pool of the few surviving wild fish, an inheritance which has taken millennia of adaptation to evolve and which cannot be recreated once it is gone. Often we know nothing about the gene pool of cultured fish, which are commonly degenerated and domesticated after having lived in confinement for generations. Incurable damage has been caused by the uncritical stocking of such unknown material through the years.

The rainbow trout *(Salmo gairdneri)* has thus come to inhabit most of the world, where conditions are suitable for it. But even the European brown trout *(Salmo trutta)* has crossed the seven seas and can now be found in America as well as Australia. The grayling *(Thymallus thymallus)*, whose farming is a little more complicated and therefore of smaller commercial value, has not travelled so widely, and exists mainly in the places where nature originally put it.

Still more fish than these, however, are encountered in the small waterways. In the far north, besides grayling,

brown and rainbow trout, we have Arctic char *(Salvelinus alpinus)*, whose colourful relative from eastern North America, the brook trout *(Salvelinus fontinalis)*, has been implanted similarly in many parts of the world.

Holding places

All of the above-mentioned salmonoids live more or less permanently in the same waterways. Some fish may occasionally make visits to a nearby lake, but they are otherwise bound to the stream where they hunt and reproduce. When we fish for them, we must therefore remember that they have a constant need of cover and of food. So we have to look for them where they can fulfil both of these requirements.

This sounds easy in theory, but is harder in practice, due to the great differences between waterways. Each has its own character, and not until we get to know it can we "read" the water and find the fish. Not only that – there are also significant differences between the fish species. Moreover, the fish seldom occur at the same places in summer as in winter. Consequently, locating them in a new and unfamiliar body of water may strike us as a daunting task.

It isn't, though: with a little common sense, as well as some knowledge of fish and their living habits, we can go a long way. To begin with, there is a vast distinction between a slow chalk stream and a rushing river. For example, the current lee is very important to the fish in a river, but not in a chalk stream. Thus it is easier to find the fish in a fast current, where the holding places are clearly visible in its lee. Such places can hardly be noticed in a chalk stream, whose fish occur virtually everywhere – and may hold in the most surprising spots – so that we have to approach the water with extreme caution.

In the Alps of Central Europe, waterways have long been divided into a trout region and a grayling region. In the former, far up in the mountains where the brooks crash down the cliffs, the red-spotted brown trout is the sole ruler of the cold, rushing melt-water. Farther down as the slopes flatten out, we enter the region dominated by grayling – even though trout can sometimes be caught there as well.

This division is not exactly applicable to other parts of the world, but it tells a little about the fish and their demands on the environment. While brown trout can certainly be discovered in the quietest waterways, grayling never occur up in the mountains.

As was noted earlier, grayling often form small shoals at calm places in a waterway. By contrast, trout are definite loners and do not tolerate other fish in their territory. They also want "a roof over their heads" – being able to hold under a precipice, bank hollow, or overhanging tree. Thus,

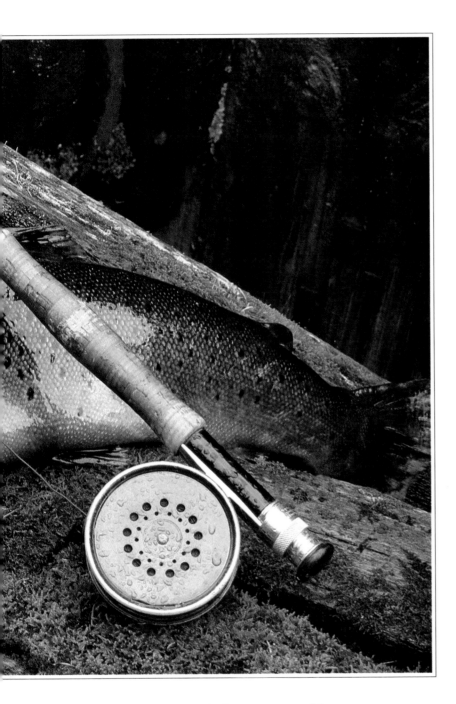

Trout – the flyfisherman's classic quarry, and for many of us the prime target in running waters – can be found almost anywhere in the world today.

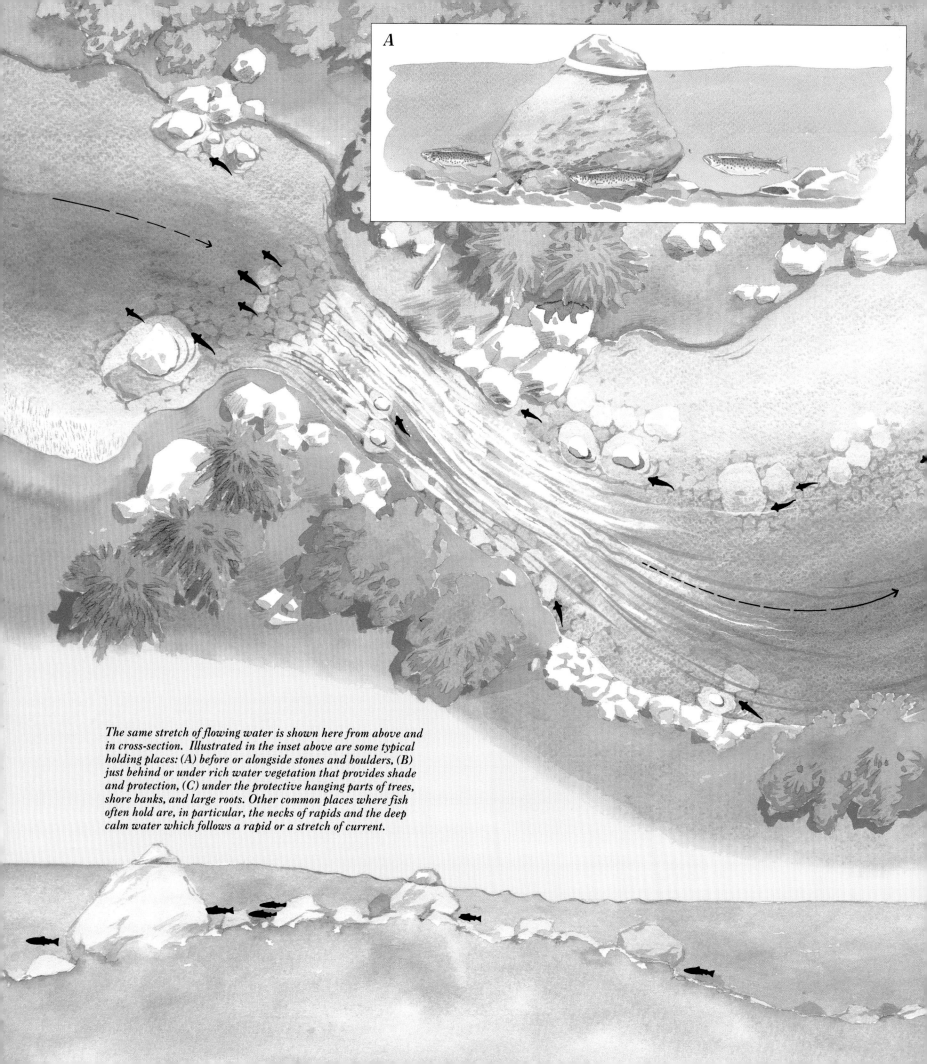

A

The same stretch of flowing water is shown here from above and in cross-section. Illustrated in the inset above are some typical holding places: (A) before or alongside stones and boulders, (B) just behind or under rich water vegetation that provides shade and protection, (C) under the protective hanging parts of trees, shore banks, and large roots. Other common places where fish often hold are, in particular, the necks of rapids and the deep calm water which follows a rapid or a stretch of current.

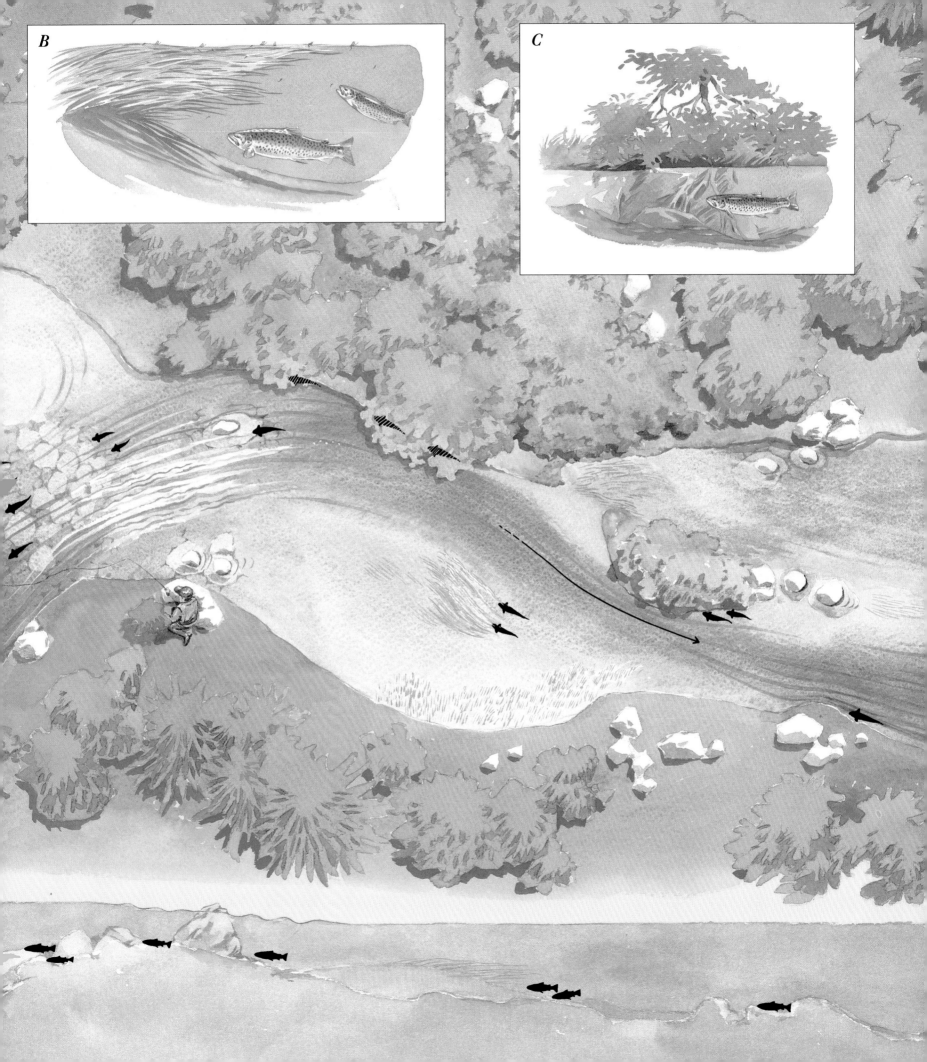

B

C

they are closely tied to shores or at least to fixed structures; yet grayling prefer to stay near the bottom in deep water. Further, whereas grayling are mainly active by day, trout tend to be nocturnal, and big ones are notably shy during the daytime, when they stay well hidden in their holding places. At night they may hunt in amazingly shallow water, where they are also easy to frighten!

An intermediate case is the rainbow trout: seldom clearly nocturnal, but not a shoal fish either. The rarer brook trout prefers a solitary life in deep water, but is normally the greediest of all trout species – a characteristic which it shares with the cutthroat trout, mentioned above, so that both of them are vulnerable to overfishing. In other words, they cannot take the same fishing pressure as does the brown trout, which is shy and soon learns to avoid the fisherman's bait.

These are, to be sure, generalizations that must be adjusted to suit the given fishing waters. But all fish have in common the fact that their holding places differ between summer and winter. In summer, when the water is warm, they gladly move to a stream whose water contains more oxygen. In winter the opposite is true, since their metabolism is slower in the cold water. Then they leave the fast streams and gather in calm places, where they can stand in the current lee to save energy.

It is impossible to specify all the types of holding places in a small waterway, so only the real "classics" will be described here. Among them is the calm water in a pool, below a rapid or a stretch of current. The fish stay in the pool's deep, quiet water and benefit from the food that is brought continually by the current. Usually the fish can be found at the deep upstream end during the hours of light. As darkness falls, the fish often retreat to feed in the shallow water at the pool's lower end, where the current is stronger.

The necks of rapids, with deep and relatively calm water just above a waterfall or rapid, are further good holding places. So is the area where water from a fall pours down into a pool, or even simply a pocket of deep water. Frequently the fish stand all the way into the spray! And large stones or cliffs in the main stream are invariably potential holding places, worth being fished carefully. The fish seldom stand behind stones – where the water tends to be too rough – but generally stay in front or along the sides. There and at the front, a current lee provides the fish with a good vantage point to watch for food brought by the current.

In calm waters, the fish are more bound to the deep

channels, especially at the bends where the current has dug into the banks and often hollowed them out. Brown trout are notable lovers of such dug-out banks. Fish also like to linger near the channels that are formed by areas of vegetation. Here the current collects drifting insects and crustaceans, which thus become easy prey.

Trees that have fallen into a stream offer the fish both cover and current lee. A lot of fish may also be found in large pools with quiet backwaters. Except during the cold season, however, fish seldom hold in the backwater itself, but frequently stay just where the current enters or leaves the pool. The backwater exhibits instead, for example, pike and perch. Unlike the salmonoids, these fish do not really belong there – they merely look for places where the current is weakest.

As a whole, the fish are more shy and cautious in small waterways than in big ones. The more water runs over and around the fish, the more secure they feel. In a small stream, therefore, we must be very careful when getting close to the water and the fish. It is best to keep a low profile, moving slowly and wearing clothes that merge into the surroundings as much as possible.

Then the point of readiness has come to start fishing, which can be quite exciting in brooks and streams. Everything happens at close range, making it essential to have full control over both flies and fish. At the same time, small waterways are good schools for the inexperienced fly-fisherman, who can learn many things about the fish there – and can later apply the lessons to larger, more limitless waterways.

Fish are frequently difficult to see in flowing water, but they may be detectable if you approach the water very carefully.

"Tailing": the fish eats on the bottom and shows only its tail fin above the water surface.

Types of rise

One very important thing a flyfisherman should be able to do is read different "rise forms". When the fish takes an insect at or near the water surface, it leaves rings or ripples on the surface. These serve to show the fisherman what sort of insect, and in which stage, the fish takes. On this basis the fly is chosen to catch the fish with.

The rise form is the visible sign of the fish's activity, and it can have quite diverse appearances – depending on the insect species, the fish's size and the water movement. In any case, the rise itself is the essence of flyfishing: it means direct eye contact with a hunting fish. Hardly any other sight can be so stimulating, or indeed so frustrating if you fail to catch the fish, which either flees in fright or goes on rising nonchalantly.

It has to be emphasized firstly that a flyfisherman should always wear polaroid glasses. They not only protect the eyes from a wildly moving fly, but also filter out many of the irritating reflections that prevent you from seeing into the water. Hence they are at least as important as the rod, reel, line and fly – in fact more important, as they provide the best possibility of watching the fish under the surface even if no activity appears on the surface.

If we look farthest down into the water, a glimpse of the fish's side as it turns in the current is often all we see of it. Yet this captivating "wink under water", in the words of Skues, indicates that a fish is making a quick detour in its hunt for nymphs or other prey – a fish, therefore, which can be caught.

(Above) "Head and tail" means that the fish takes
nymphs and pupae just in or under the surface layer.
First you see the head, then the back fin, and finally
the tail fin over the water. However, big brown trout
and steelheads often display only their backs.

(Below) When a fish takes, for example, nymphs just
under the surface, the water over the fish moves up
and forms "bulges" on the surface. In this form of rise,
you very seldom see part of the fish above the surface.

When trout, and other fish in running waters, rise to take an insect that drifts on the surface, they fall back with the current. Thus you see the fish rise downstream of the holding place. To give the fish time to climb to the surface, you must therefore lay out the fly a good way upstream of the assumed holding place. Keep in mind, too, that deep fish need more time to rise than do fish near the surface.

When the water is relatively low, a phenomenon called "tailing" can be observed. In this rise form, the fish almost stands on its head in the vegetation to shake loose insects and crustaceans. It will then stick the tip of its tail out of the water, a characteristic sign. Now and then it moves downstream to pick up the creatures shaken loose, but it rapidly returns.

If the fish is hunting higher up in the water, you can frequently see it flickering in the light or lifting the water. As a result, swells are formed in the surface, leading us to speak of "bulging fish".

Commonly the fish proceeds to take the nymphs and pupae that are hanging motionless in the surface film before hatching. You see the fish "head and tail" – as first the head, then the back, and finally the tail emerge from the water, like a porpoise rolling at the surface. Here we also use the phrase "porpoise rise". When this is witnessed, you know that your leader should still be carrying a nymph, not a dry fly.

A fish takes sizeable prey such as small fish by using its jaws, but it consumes insects and other small animals by sucking them into its mouth, out of the current that flows constantly over its gills. The mouth and gill covers create a pressure drop that sucks the water in; then the mouth closes and the water is pushed back through the gill openings. Any food in the water is sieved out by the gill rakers and is swallowed.

If it is impossible to figure out what the fish are presently taking, trial-and-error is often necessary. Experienced fishermen know that a lot of flies may have to be tried in a day before finding the "right" one for wary trout.

Surface rising

When taking an insect at the surface, a fish usually sucks in some air as well. The air subsequently forms small bubbles on the surface, giving a sure sign that the fish took a winged insect at the surface – in other words, not a nymph or pupa just under it. If so, there can be no doubt that the time has come for a dry fly!

Exactly what happens on the water can be seen much more easily with a pair of binoculars. Moreover, it is always worth carefully studying what the current brings along. By combining the two sources of information, you are as well-prepared as possible, and can really pick out your fish.

We say that a fish "rises" when it takes insects on the surface. The resultant ripples, which spread downstream with the current, were once named "tell-tale rings" by an Englishman. But such rings can look very differently: they may be big or little, violent or controlled. At the violent end of the spectrum, we have fish that are in a hurry to take insects. These may be newly hatched duns, which can lift from the water at any moment and thus evade the fish. Or they may be egg-laying caddis flies that flutter over the surface, or large grasshoppers that are eager to reach dry land. All of them stimulate energetic rises, with big rings and loud splashing.

The same can happen when a fish takes small insects in a

(Above) A splash rise occurs when fish rapidly chase insects that are lifting from the surface or fluttering just above it. A spray rise may occur even when the fish hunts under the surface, if it suddenly swerves at high speed to swim in another direction.

(Left) A sip rise is the commonest form of rise, producing only rings on the water surface. The rings are deceptive as their size gives no clue to the fish's weight.

(Right) "Cruisers" are fish that more or less regularly patrol the relatively calm areas of a current. Just as when fishing in lakes, one can estimate in advance where the fish will rise the next time, and lay out the fly in its path.

strong current, where it must act fast. It may also be a little fish that has difficulty in sucking up insects. Sometimes you then find it jumping out of the water to take the insects on the way down, so that you have to wait a bit for the counter-strike! Conversely, we often encounter very big fish which make no noise, but only leave tiny ripples on the surface, leading us to speak of "sipping" fish or a "sip rise". This latter phenomenon is typical when many small insects are hatching simultaneously on a calm surface. There is plenty of food even for a big fish, which otherwise might not be interested in small prey. It hovers just under the surface to suck in the insects at a leisurely and rather cautious pace. Such hatchings occur among the *Caenis* mayflies, and among the small reed knots that cover the surface at times like a carpet – or what the English call a "blanket hatch".

On very quiet stretches of current, you may meet "cruiser" fish that methodically patrol their territories to find insects on the surface. Identical behaviour is common in lakes – and there, too, it is necessary to foresee the spot at which the fish will rise the next time. Then you lay out your dry fly and wait with mounting excitement. Normally, though, a fish rises at a particular place in the waterway, giving you a natural target. Otherwise the dry fly cannot be positioned properly – that is, far enough in front of the fish, which must have time to rise to it.

A fish rises to the surface by angling its breast fins so that the current presses it upward. After taking an insect, it turns the fins downward and swims back to the bottom, assisted by a stroke of its tail. Thus, while climbing to the surface, it drops back with the current. So you see it rise a ways downstream from its holding place. And this means you should lay out your dry fly a good distance farther upstream than you perhaps thought necessary at first, or else the fish simply won't have time to rise for it!

As a rule the fish rises from the bottom, but it may let itself come up with the current to just under the surface if there are enough insects, and if the current is not too strong. Trout do so often, whereas grayling always stay on the bottom.

In this connection you should remember that, the deeper a fish is holding, the longer time it needs to rise to the surface. Consequently the fly must be served farther upstream of the rise rings. Moreover, the fish will only rise to the insects within a narrow region, the "feeding lane", which is directly above it. Insects and flies that drift towards it outside this region are ignored. The fish does have a wide "window" and can easily see them approaching from the side, yet it will not touch them. Too much energy would be required to move sideways in a strong current, and the fish may also find it difficult to judge the distance and speed to such food. It therefore keeps its breast fins still, and takes only what passes right over its head.

Essential equipment

Flyfishing in streams is not dependent on heavy or expensive gear. It seldom calls for really long casting, and the fish are normally not so large as to demand costly fly reels with refinements like disc brakes. Neither need the equipment tolerate salt water. In sum, you can start your career as a flyfisherman on a small waterway without investing a fortune.

A single basic outfit can get you far, but serious flyfishermen soon discover that at least some extra gear is necessary. Waterways change during the season, so the fishing does too – from the high levels of springtime to the low, clear waters of summer with their careful, fastidious inhabitants.

The infrequent need for long casting means that the fly rod does not have to fulfil many conditions. A cheap glass-fibre rod is good enough, although you will naturally get more enjoyment out of fishing if you buy the best that you can afford. The more expensive carbon-fibre rods from well-known manufacturers cast better than do cheap glass-fibre rods. However, they do not necessarily catch more fish. For a fish is caught by the fisherman, not by the equipment! Whether you allow yourself to be seduced by attractive fishing gear, however, is quite another matter.

The rod's length is determined entirely by the kind of fishing water – whether it is large or small, open or overgrown. In general you should always choose the longest possible rod. A long rod has definite mechanical advantages, with a higher back cast and better line control in both the air and water. A good standard length for all flyfishing in streams is 9 ft (2.7 m). This will let you keep the line free from high grass, bushes and trees. It also permits such a high back cast that you can easily keep the line out of the water even if you sometimes wade in deep. In addition, this is a good length for being able to mend and control the line, leader and fly while fishing.

A shorter fly rod is relatively poor at dealing with all these tasks. However, it makes life much easier if you have to fish in fairly small brooks which are overgrown with trees and bushes. Then a long rod can be almost impossible to handle.

The line that carries the fly out to the fish must also match the rod – in other words, have the same AFTM class, in order to be cast properly. If the line is too heavy, the rod will be overloaded and the cast is shorter. Conversely, too

light a line will not load the rod sufficiently and the cast is less accurate.

The AFTM system is based on the weight of the line's outermost 30 ft (9.15 m), since it has been established that this length is what usually strains the rod. When fishing in small waterways, however, one often casts with a shorter and lighter line, which strains the rod less. This line cannot make the rod work as it is designed to do. A good idea is therefore to choose a heavier line class than recommended, if you are fishing mainly with short casts.

For relatively short casts, you can use both double-tapered (DT) and weight-forward (WF) lines. A DT line, unlike a WF line, can be turned round when one end is worn out. On the other hand, a WF line is superior for fishing dry flies downstream. It enables you to easily shake out further loose line through the eyes, something that is almost impossible with a DT line.

Streams are seldom especially deep, so a normal floating line is usually quite acceptable. If fish are holding near the bottom, the fly or leader can simply be weighted. During high spring water, though, it can be worth trying some type of sinking line to get down deep enough. This is particularly true when fishing streamers and bucktails. Then you can use a fully sinking line with an adequate sinking speed, depending on the current strength and water depth. The greater the latter are, the faster the line should sink.

But in many cases a fully sinking line is not very practical. If the stream contains a lot of big stones, the line will easily get caught on them. The alternative is to use a sink-tip, whose end takes the fly down to the fish. Its floating main line does not get caught on stones, and facilitates control as well as mending of the line.

The leader's length, just like the rod length, depends entirely on the conditions. It can vary from as short as 3 ft (0.9 m) to as long as 12 ft (3.6 m). The longest and thinnest

For a flyfisherman, the rod is absolutely the most important piece of equipment. It must not only act as an extended arm when casting and presenting the fly, but also be able to work as an efficient lever when playing a hooked fish.

leaders, of course, are used only in low clear water with shy, easily frightened fish. One must also keep in mind that the leader tippet should be extra long when fishing with very thin leaders. For the longer the tippet, the more elastic it is – a property that can be extremely useful, especially if your strike proves too hectic!

In normal fishing with a floating line, a good standard length is 9 ft (2.7 m). If fishing with small flies, you need only lengthen this leader with an extra-thin tippet. But using a big wet fly, streamer or bucktail, on a fully sinking or sink-tip line, is quite another matter. The priority is then to get the fly down to the fish. Current pressure on a long leader will lift the fly up from the bottom, away from the fish. So here one uses a short leader of at most 6 ft (1.8 m). The deeper the water, the shorter the leader – and the fly will in all probability reach the fish.

Short leaders can also be handy in dry-fly fishing. For example, in small overgrown waterways, a long leader is simply bothersome – just like a long rod. Instead, a leader of 6-7 ft (1.8-2.1 m) should be used.

The fly reel is the least important part of your equipment when flyfishing in streams. It acts only as a storage place for the thick fly line. Although one rarely encounters really big fish in these waters, one should always have at least 50 m (165 ft) of thin backing line innermost on the reel. Then you are safe even if an unexpected monster pops up to take the fly.

Suggestions for equipment

A good all-round set-up for flyfishing in streams will include a rod of 8-9 ft (2.4-2.7 m) in AFTM class 5-6. This rod can not only serve small dry flies and nymphs easily and elegantly. It also has enough strength for fishing with heavy nymphs as well as small streamers and bucktails. A floating WF line will fill most needs, and a sink-tip takes care of the rest. The reel should hold the fly line and 50 m (164 ft) of 20-lb backing line.

When summer is at its best, the water levels are often lowest. The water is then clear and the fish are shy. These conditions can require extremely small flies and hair-thin leader tippets; so you need extra light gear to handle them. A rod of 7-8 ft (2.1-2.4 m) in class 3-4 is suitable. It lays out dry flies of sizes 18-24 like dust grains on the water, and is flexible enough to play fish even on a leader of 0.12-0.14

mm (0.005 in)! No actual backing line is necessary, since the current pressure on a whole fly line will be sufficient to break the thin leader. Still, you should not choose the smallest "midging" reels for such fishing; they look very elegant, but their minimal diametre gives a braking effect that is too strong when the line rushes out. Do not use any reel less than 3 in (7.5 cm) wide.

When fishing with big heavy nymphs, or if you have a big streamer or bucktail on the leader, there is a need for stronger equipment. A rod of 9-10 ft (2.7-3.0 m) is enough, as it can withstand both the high spring water levels and any huge trout that happen to take the fly. For the same reasons, the reel should hold 100 m (328 ft) of 20-lb backing line in addition to a WF sink-tip line.

When fishing with big wet flies and streamers in deep and rapid waters, you should use a short leader, since the pressure of the current lifts up the leader and fly toward the surface – away from the fish, which often holds nearer the bottom.

Techniques and methods

Downstream wet-fly fishing

Fishing wet flies downstream is the oldest and commonest method. The line is cast across the current, or obliquely downstream, and the fly follows the flow freely until it drifts into a soft bend at your own bank. Often the fish takes just as the outward fishing is ending. Also illustrated here is the fly's drift when mending.

Naturally we begin with the most classic of flyfishing's many methods. The first true flies – long before dry ones appeared – were wet flies, and they were fished downstream. This approach involves simply laying a cast across, or obliquely down, the stream toward the opposite bank. As the current takes the line, the fly follows a curve in towards your own bank. You then take a step or two downstream and repeat the procedure. Thus you work your way down through the most promising stretches of water.

Here is a perfect method for the beginner. For if the cast is not laid out well, the current immediately stretches the line and leader again. Besides, many fish get hooked of their own accord during downstream wet-fly fishing. So the method can hardly be more elementary – and still it is capable of refinements that make it amazingly effective in the right hands.

When a fly line is laid straight across the current, it will be pulled downstream in a wide curve. If the current is strong, the pull is so violent that the fly travels across the surface. This is not attractive to fish, and you must compensate for the current's effect by mending the line. The technique is to lift the line from the water and to shift it

BUTCHER
Tying thread: black
Tail: red feather fibres
Body: flat silver tinsel
Ribbing: oval silver tinsel
Wings: blue mallard wing feather
Hackle: black hen feather fibres
Head: black

TEAL & RED
Tying thread: black
Tail: golden pheasant tippets
Body: bright red wool
Ribbing: thin oval silver tinsel
Wings: teal flank feather
Hackle: brown hen feather fibres
Head: black

MARCH BROWN
Tying thread: black
Tail: brown-speckled partridge feather fibres
Body: grey dubbed hare's fur
Ribbing: gold wire
Wings: pheasant hen wing feathers
Hackle: brown-speckled partridge feather fibres
Head: black

This hairwinged wet fly – with dubbed wool body, hen hackle, squirrel-tail hair wing and black head – displays no special pattern but is a type of fly that has become increasingly common recently. The USA in particular has a tradition of tying soft-hackled wet flies with hair wings. Even in many of the classic wet flies, it can help to replace the feather wings with thin hair wings, which last longer and make the fly at least as attractive to the fish.

upstream, reducing pressure on the current. You may have to do so several times as the fly swings through the current.

Until now, we have been describing the classic "wet-fly swing", which is as effective for trout and grayling as it is for salmon and for sea trout. The only difference is that, in streams, we try to imitate the fish's food with our flies. Depending on the current speed, the line can be mended either upstream – if a fast current threatens to tear the fly out of the water – or else downstream. The latter applies if the fly happens to drift into calm water, where it will stop and sink rather lifelessly. This is avoided by mending the

line downstream so that the current can take the line and fly again. You are then helping the current instead of fighting it.

Thus, when fishing in streams, mending the line is as important as making fine, exact casts. If you can't mend the line, you can't fish effectively either!

The fly may be allowed to drift straight across the current by itself, or it may be jerked now and then with the rod tip. Fishermen disagree as to which of these techniques is best, but this depends basically on the fly's size. Small flies imitate small insects, which obviously lack enough strength to

fight a fast current, and will therefore drift away rather life-lessly. But big flies imitate big insects or even fish fry, which can easily travel against the current. Consequently, small flies (size 12-14) should be fished with no rod move-ment, whereas larger flies (size 8-10) should be given extra life with the rod tip.

Many of the classic wet flies that are fished downstream were originally imitations of drowned or drowning mayflies. Examples are March Brown and Blue Dun, which should thus be fished by "dead drift" – with no rod movement. But it is more sensible to invest in fly patterns that represent fish fry to a greater extent. These are illustrated by Alexandra, Bloody Butcher and Freeman's Fancy, all with bodies of silver or gold tinsel. A downstream wet fly can be made more functional by replacing the original feather-wing with a more mobile and durable hairwing.

This kind of fishing is often regarded with some disdain as a sort of "fishing machine", covering the waterway mechanically and without any real enjoyment. That may at times be so, but never need be. It is up to the fisherman whether the fishing is to be inspired or routine. Those with insight do not fish through the stream inch by inch, but con-centrate on the spots or holding places which look most pro-mising – or on fish that reveal themselves in various ways.

If you have noticed a fish or know a good holding place, here is a useful trick. Lay your fly a fair distance upstream of the fish or holding place, with a slack line. This gives the fly time to sink a little, before the current stretches out the line and leader. When the line tightens, the fly moves up in the water and swings out towards midstream. Often the strike comes just then, as though you were pressing a but-

ton – so effective is the trick if done right. The best flies to use are wet ones with a silver or gold body and a thin hairwing. The leader must be thin, of 0.18 mm (007 in), so that the fly can sink and move freely in the current.

When fishing out, you should make sure that the fly always fishes at the proper speed. If it starts to drag in the surface, decrease the force on it by lowering the rod tip; and if necessary, mend the line upstream. But if the fly drifts into calm water, raise the rod tip; and if this is not enough, mend the line downstream. Eventually the fly will arrive at your own bank, or downstream of you. Then you can begin a new cast.

If the water is deep and being fished from a bank, it should be fished thoroughly before taking in the line for a new cast. This can be done by pulling the line in small jerks with your left hand. Sometimes surprising results are achieved by taking in the line a little faster. A fish may rush in to snap up the fly and disappear!

On a taut line with a wet fly downstream, many fish are hooked in the actual strike. They take the fly and travel with the current, but soon realize their error. The fly does not "taste" right and they reject it. Then the strike must be quick – though not violent. It should be a controlled tightening of the line, rather than a literal striking action.

Frequently the fish can be seen taking the fly in a swirl just under the surface, whereupon you must immediately tighten the line. At other times you can only feel, or see, a gentle tug on the line – so you have to react even faster. There is always more time to spare if you see the fish take than if you simply feel it. Keep your eyes open in order to hook the fish solidly!

The fish didn't have time to reject the fly. It was hooked with a lightning-quick strike and landed after a nerve-wracking fight.

Upstream wet-fly fishing

The method of fishing a wet fly upstream is used mainly when the fish is very shy. It is also notably effective, since you are behind the fish and cannot frighten it as easily.

Here is another of the classic methods in flyfishing. It has a lasting association with the Scotsman Stewart and his now legendary "spider" flies. Stewart fished along streams in the Scottish highlands, where the insect life was poor but sudden floods, or spates, were frequent after rainstorms. Thus the fish were seldom large and, though always hungry, they were shy and easily frightened in these small waterways.

As a professional fisherman who lived on his catches, Stewart recognized that downstream wet-fly fishing would not do under such conditions. He began to fish with wet flies in the opposite direction, and tied them so that they were specially adapted to this kind of fishing. His spider flies are simple, with a sparse but very soft hackle, whose fibres truly come alive in the current. They were the fore-runners of the now well-known "soft hackles", which can be said to represent the fish's food rather than actually imitating it.

Upstream fishing has several clear advantages, but also demands more of the fisherman. This is perceived as soon as you try it. For the current is a real problem here, as it brings the fly right back to you – and frustratingly fast, if you have not yet learned to control the loose line.

Nonetheless, you can then approach the fish from behind, where it is least attentive. And the fly is presented

This wet fly represents a type that was first tied by James Leisenring. It is thus often called the Leisenring wet fly, and has old traditions in the USA for upstream wet-fly fishing. Its body is of natural hair fibres spun on double silk thread, and the hackle is tied of soft hen feather.

Pete Hidy's flymph is another North American fly. The body is tied like Leisenring's wet fly, but is sometimes ribbed with silk or metal wire (often brass). The hackle is of hen feather and the tail is tied with cock hackle fibre or summer duck. Flymphs – a cross between fly and nymph – must be fished with a floating line just under the surface.

Stewart's spider flies are as simple as they are ingenious. They have only a floss body and soft, sparsely tied hackle, giving them a very lively movement in the current. These famous spider flies are among the true classics of upstream wet-fly fishing, and were the origin of "soft hackle" flies.

in the same way as the fish is accustomed to seeing food: drifting freely with the current. Even if upstream fishing is more demanding than downstream fishing, it is a far more effective method in trained hands.

The fly is laid with short casts upstream to the presumed holding places or observed fish. As the current brings it back again, you must take in the loose line and raise the rod tip, so that you always have full control over the fly and its journey through the water. With short casts, raising the rod tip while the fly drifts is sufficient – but with longer casts, loose line must be taken in as well. A long, soft rod of 9-10 ft (2.7-3.0 m) in class 5-6 is ideal for this exciting method, since you thus obtain the best possible line control.

The strike is made when you see the fish turn with the fly. Good eyesight is therefore essential. Here you do not have, as in downstream fishing, the chance to feel the fish

strike – for the line is not taut. If you don't see the strike, the fish will almost always have time to spit out the fly. But if you are quick enough, the fish gets hooked even more solidly than in downstream fishing, where you cannot avoid occasionally pulling the fly out of the fish's mouth. So this is another advantage of the present method.

Upstream dry-fly fishing

Althogh it was not Halford who "invented" the floating fly, this Englishman's name will forever be associated with the emergence of dry-fly fishing, which he systematized in order to make it an exact science. The purist members of his imitation school thought that dry-fly fishing with exact copies was the only proper form of the sport.

However, as we have already noted, this view soon developed into fanaticism. Imitations were tied of numerous insects – primarily mayflies – which occur on the southern English chalk streams, and these were imitations not only of the species, but also of both sexes and their stages of development in each species! The school went so far in many places as to ban all other kinds of fishing.

Dry-fly fishing is usually considered the most exciting form of flyfishing, since one can follow the whole course of events clearly. The advantage of upstream dry-fly fishing is that dragging flies can be avoided to some extent. The illustration shows this method with a curve cast.

Although fortunately we are no longer so narrow-minded, it must be admitted that dry-fly fishing is among the most fascinating pastimes imaginable. Here one sees the fish first, then one tries to figure out what it eats. A corresponding dry fly is chosen and presented as correctly as possible to the fish. If everything is done well, the fish rises to the fly and sucks it in – right before the fisherman's eyes, as exciting as can be.

Dry flies of American type have soft wings from the flank feathers of ducks, mainly summer duck. Some well-known examples are the Cahill series, of which Light Cahill is perhaps the most renowned.

"Spent spinners" are mayflies that fall down dead on the water surface with outspread wings after laying eggs. The wings of their imitations can, of course, be tied with feather sections in the time-honoured way, but are increasingly being replaced by synthetic materials, and thus tend to be called "spent polywings". On spent spinners the tail and wing are separated into two equal parts with figure-of-eight tying.

A classic English dry fly. In this type of fly, the wings are made of quill sections. Some good instances are Black Gnat, Coachman, Greenwell's Glory and Blue Dun.

Parachute-tied dry flies have the hackle tied in horizontally, wound around the wing root. Here, too, it has recently become ever more common to use synthetic materials in the wings, making "parachute-tied polywings". They can imitate a large number of species, and are thus quite handy and effective on many waters.

Some people regard dry-fly fishing as a simple, easy method. For the whole sequence of events is visible, in contrast to wet-fly fishing where, instead, you need a sort of "sixth sense" to tell you where and how to fish. Yet dry-fly fishing makes clear demands of good casting technique and line control. Whereas a few fish can often be caught by wet flies even with poor technique, dry-fly fishing is uncompromising in its own way. If you cannot present a dry fly lightly, elegantly, and at just the right spot – and if you cannot make sure that it floats freely over the fish without dragging, you won't get any fish. That's just how simple it is!

Dry-fly fishermen soon discovered the advantages of fishing upstream, and this method is still required on most of the classic English chalk streams. One locates a rising fish and sneaks up on it from behind, to within casting distance. The fly is placed far enough upstream so that the fish will have time to notice the fly and, hopefully, rise to it.

The main problem is "dragging" flies. These are dry flies that do not follow the current freely, but make furrows on the water surface. This is because the fly, leader and line do not drift with the same speed. When the fisherman stands on land or in the water, the current pressure on the line and leader will soon be transferred to the fly. It starts to drag immediately, no longer drifting freely like a natural insect, and is therefore usually rejected by the fish.

If you cast a dry fly straight upstream, this problem tends to be minimal. Then the current pressure is normally the same on the line, leader and fly, so they drift with the same speed as the loose line is taken in with your left hand.

Casting straight upstream to a fish that rises, however, will take the line and leader right over its head. This is bound to displease it and, in most cases, it will be frightened and stop rising. To avoid spoiling the opportunity, you should present the fly a little from one side. Lay it at an angle against the current, so that the line and leader do not hit the water over the fish.

As a result, though, the current will push differently on the line, leader and fly. If you leave it at that, the fly will very soon begin to drag, with greater pressure on the line than on the fly. But this can be prevented in various ways, with more or less advanced "trick" casts.

The simplest solution is to cast out a curved line instead of a straight, stretched one. Then the fly undergoes at least a short delay in floating freely downstream before the current has stretched the line, and hopefully the delay will be long enough for the fish to take the fly. Casting a curved

line is fairly easy. Most simply, the rod top is shaken from side to side when the line is stretched in the forward cast but is still in the air. This is commonly known as the serpentine cast.

It is much harder to produce so-called "curve casts". We speak of left-hand and right-hand curve casts, or positive and negative ones. The basic idea, of course, is to give the fly extra time to drift freely. Yet curve casts require such fantastic casting ability of the fisherman that most of us give up. They need training and a good understanding of the dynamics of the cast. Here we shall have to pass over these specialized techniques.

Grayling is a very popular quarry for flyfishermen in some parts of the world. In northern Scandinavia and the Alps, it can be tempted with a dry fly fished upstream.

Downstream dry-fly fishing

Fishing upstream with a dry fly can be justified on many good grounds, as we have seen – when the conditions are right for it. But by no means are they always so. Often a better method is to fish the same fly downstream, quite contrary to the classic and puritanical dry-fly school. Halford would turn in his grave if he could watch such a method being practised on his beloved chalk streams.

The English chalk streams, whose banks were the original cradle of dry-fly fishing, are relatively small and narrow waterways. They provide every reason to fish the fly upstream. Yet when fishing in larger and broader waterways, we frequently meet fish that simply cannot be reached by casting a dry fly upstream. It is then necessary to fish straight across the current, or even downstream, in order to get at the fish.

In large, broad streams, it may be hard to reach the fish if you are fishing a dry fly upstream. Then often your only chance is to fish downstream. A stop cast as illustrated here, or the similar parachute cast, is frequently essential to prevent the fly from dragging as soon as it reaches the water.

Henry's Fork Hopper is a typical American grasshopper imitation. Its body is tied with deer hair, and the wing with brown-speckled feather fibres. The deer hairs are folded backward at the head and clipped off on the fly's underside. These hollow air-filled hairs give the fly its excellent floating quality.

Here is another grasshopper imitation, loved by trout especially in the USA. This type of fly is characterized by the Muddler head, tied with deer hair and trimmed to the right shape.

Bivisible is an example of a Palmer-hackled dry fly. The hackle is wound over the whole body, from tail to head. This fly can be tied in many colour variants, but all have white hackle closest to the head.

Dry flies with bushy hackle are definitely good all-round imitations, and float very well even in fast currents. They are also easy to tie and to vary in colours. To be really effective, they are often tied with two hackles, wound in sequence.

Humpy is still another high-floating fly for downstream dry-fly fishing. It has a big bushy hackle of cock feather, as well as a tail and "body cover" of deer hair. This makes the fly float nicely even in strong current.

Goddard's Caddis was originally tied as an imitation of large caddis flies, but in the USA it is also used on waters where fish eat grasshoppers. It is tied mainly with air-filled deer hairs that make it float high, enabling it to rush across the water surface like a caddis fly or terrestrial insect in a hurry to reach land.

When fishing a dry fly across the stream, you may well have to mend the line upstream at intervals. Still better, though, is to learn the "reach" cast: after the cast has ended, but while the line is still in the air, you hold the rod upstream with an outstretched arm. Thus the dry fly receives a further delay before it begins to drag. Obviously the longer your rod and arms, the longer time the fly will spend drifting freely down towards the fish.

For fishing more directly downstream, the reach cast is not very helpful. Then you should use the parachute cast, whose name tells a lot about how it is done. Quite simply, the forward cast stops too soon, making the line stretch out while high up in the air. Holding the rod tip aloft, you let the fly line fall lightly and elegantly onto the water. The leader, which weighs almost nothing, follows passively along and comes down in a heap. This enables the fly to float freely a while longer, as you calmly lower the rod top and finish with your arms outstretched as usual.

The parachute cast is as indispensable for downstream fishing as the reach cast is for cross-current fishing. In both cases, you can lengthen the fly's free drift by releasing a few metres of loose line through the rod rings. For this to work, the line absolutely must be a weight-forward line, whose thin shooting line is easy to shake out.

As noted previously, fish take only the insects which are on the water surface within a rather narrow region overhead. If the cast is too long, downstream dry-fly fishing allows you to correct it by simply pulling the fly back into place! Once the desired path of drift is attained, you decrease the pressure and release some loose line. This must be done fast, since the line is now taut all the way to the fly.

The same technique can pay off when you need to skate a dry fly across to the fish. Until now, we have tried to make the fly drift as freely and peacefully as possible, and this is certainly the only good rule in most cases. But if, for example, there are big caddis flies, or insects that flutter about on the water surface, then a dragging dry fly is often the only thing that works.

Getting an upstream dry fly to drag realistically is out of the question. Natural insects invariably fight against the current – not along with it. The current threatens to push them downstream, which they actively oppose. This behaviour is best imitated by fishing downstream with a dry fly that alternately drags and drifts freely.

The technique can be guided by raising the rod top with a taut line at intervals to release more loose line. But watch out – the strikes become violent when the fly is fished in

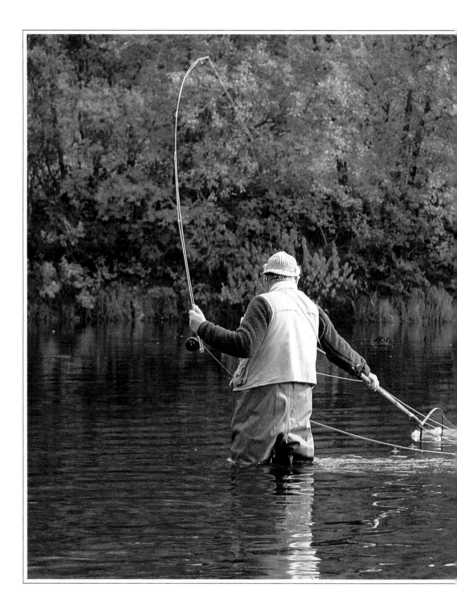

this way. Here you need a controlled strike as well as a strong leader!

Strikes are relatively complicated, in either upstream or downstream fishing with a dry fly. Indeed they vary from fish to fish, and between different fishing waters. Thus, both fast and slow strikes can be useful in dry-fly fishing. Yet this can be quite frustrating to a beginner: the fly may be torn out of the fish's mouth, or will already have been rejected by it, if the strike is respectively too fast or slow. Luckily, there is a kind of system to follow. Calm fish should be hooked with a calm strike, and quick fish with a quick strike.

In downstream dry-fly fishing, you can easily imitate the insects that fight against the current, by raising and lowering the rod tip. This allows the fly to drag against the current at the surface, or to drift freely a bit downstream. The fish may then take violently when they no longer can stand the temptation.

For instance, a trout that is holding in a quiet pocket on the edge of a strong current may be in a hurry to take insects on the surface. It shoots up, sucks in the prey and darts back to the depths. Naturally a dry fly will be taken in the same way, but since the fish is accustomed to a fast pace, it is quick to spit out the fly – so the strike must be made instantly.

The opposite is true of a fish that holds in calm water and sucks in spent spinners and other small insects. Knowing that it has plenty of time, it rises slowly to the surface and lingers confidently, sucking in the helpless insects. A dry fly is taken with equal laziness, and a fast strike would be sure to tear the fly out of the fish's mouth. Consequently, the fisherman must control himself – if possible – and delay the strike until the fish is on the way down with the fly. This can be as difficult as it is exciting!

These two general situations are easy to deal with in practice, as we can decide in advance which type of strike should be used. However, one is often forced to make the choice during the strike itself, and that may be even harder.

In calm waters, the fish sometimes makes a side-detour to take a good morsel which it has seen from a distance. It has to hurry, and its strike is more violent than usual. The same happens if the fish rises at the last moment for a poorly placed dry fly which drifts far to the side. We may have decided in advance that this particular fish requires a calm strike, but now we must make a new decision in a fraction of a second! Similarly, if the fish takes hatching insects that can lift from the water at any time, it may act speedily and require a quick strike.

In general, small fish are fast and big ones are slow. So the rule of thumb is that big fish should be given more time to take the fly and descend with it. This can be difficult to follow in practice – especially if you have been fishing all day for small trout and grayling, which call for quick strikes and may make you unable to change your style. If you then happen to confront the biggest fish of the day, or even of the year, it is worth taking a pause. But once the situation is clear to you, there should be less trouble in adjusting. You can always close your eyes and count to three as the fish takes the dry fly!

Finally keep in mind that, if the fish takes the fly on a long cast, the strike must be made faster than usual. The longer your line is, the longer time it needs to transfer the strike to the fish. Conversely, with a short line you can hook the fish at a more relaxed pace.

Nymph fishing

While puristic dry-fly fanaticism was at its height along the southern English chalk streams, a prominent lawyer strolled by those waters, deep in fresh thought. Professionally he was accustomed to reasons and logical proofs – an ability which he extended to his observations on the fishing waters.

G. E. M. Skues became the next pioneer of flyfishing. He realized that the trout in his chalk streams did not by any means always take the winged insects on the surface – even if Halford wished that they did! Quite often, the fish instead took nymphs just under the surface.

These facts led Skues to tie the first true nymph flies. They not only sank like wet flies, but were also imitations as exact as the dry flies of that time. With them, he fished precisely as though they were dry flies; the only difference was that they were presented freely drifting under, or in, the water surface.

When fishing with a nymph, the fly often must be given time to sink down to the depth where the fish stand. So you have to place the weighted nymph as far up as the current allows, to give a more realistic presentation. But it may be hard to detect when the fish takes the nymph, so you must pay attention and try to see whether the fish suddenly darts away to the side, or if the floating part of the leader suddenly dives.

Such "wet-fly fishing" did not appeal to Halford and his disciples. As a result, Skues had to struggle for years before his method was accepted as a worthy alternative to dry-fly fishing. As luck had it, he succeeded.

The next step towards modern flyfishing was made by Frank Sawyer, a riverkeeper on the River Avon. His job afforded much time to study fish in their natural element. Thus he discovered that the trout were often active along the bottom, when no activity was occurring at the surface. Obviously the fish consumed food, so they ought to be catchable.

This is a type of nymph which imitates stonefly nymphs. It comes from the northwestern USA, where it is very popular in fishing for cutthroat trout, rainbow trout and brown trout. The body is often a combination of dubbed material and plastic strips in different colours. The wing cases are of either plastic or tied-down feather sections, the tail and antennae of stiff fibres. Usually it is weighted or tied on a heavy hook.

This Skues nymph is tied with a sneck-bend hook and shows how Skues himself tied it. The nymph has a small dubbed rear body with a conspicuous dubbed breast section, but also soft antennae and a soft hackle. It must not be weighted, as it is usually fished in the upper water or in shallow currents.

Frank Sawyer's classic Pheasant Tail is a very simple but effective fly. It imitates small, not yet developed, nymphs. The fly is weighted with copper wire to sink fast to the bottom, and is thus well suited to upstream nymph fishing, since it must be fished without any extra movements.

Here are two types of caddis-fly pupae with dubbed bodies. These bind microscopic air bubbles to themselves, giving them a silvery appearance like the hatching insect. The imitations can also be provided with "lively" wing cases or hackle, and the body can be ribbed with wire. Such flies may be fished at all levels in the current, depending on how much they are weighted.

Just as Skues tied his nymphs as imitations of fully developed mayfly nymphs, Sawyer created the astonishingly simple Pheasant Tail Nymphs, representing smaller nymphs that were not yet fully developed like adults. He had noticed that these always held their legs to the body when swimming. For the same reason, in contrast to Skues, he omitted the hackle from his flies. Instead, he weighted them so that they would sink quickly to the bottom and, therefore, to the fish. Sawyer fished his nymphs upstream towards observed fish, without making any extra movements.

Oliver Kite, also a denizen of the Avon, developed this technique further with his "induced take". If the fish will not take a freely drifting nymph, the cast is repeated and the fly is lifted up in front of the fish's nose – like an escaping insect. And not many fish can resist that!

Nymph fishing has long been reserved for the calm, crystal-clear chalk streams, where fish are easy to perceive and the classic upstream presentation is both possible and suitable. Yet these conditions do not always exist elsewhere. In many places the current is too fast for this technique. In most cases, we have no chance of locating the fish before

casting to it, either because of the fast current or because the water is too deep and murky. Here, we need new methods, or else modifications of the old ones.

In almost every way, nymph fishing is a cross between dry-fly and wet-fly fishing. You can fish upstream or downstream, with a floating or a sinking line. The flies vary from the biggest to the smallest, and are fished underwater like wet flies, but are tied as pure imitations like dry flies. Such a range of variations is enough to confuse even the most zealous beginner at flyfishing.

There is, however, a certain system in the methods and their use. Pure upstream fishing can be done only when the current is not too strong. Under calm conditions, you can fish with a floating line, long leaders and weighted flies. You cast to observed fish or presumed holding places. At all events, the aim is to place the nymph so far upstream of the fish, or holding place, that the fly has time to sink to the right depth.

Once the nymph is at the fish's level, the problem is to detect a strike. This is easy enough if you can see the fish and fly clearly. If only the fish is visible, you must watch for it to make a quick turn aside, when the fly is presumed to be nearby. The white gape of the fish's mouth is a sure sign that it has taken the fly or a natural insect. Whatever happens, you must tighten the line instantly, so that the fish will not have time to spit out the fly. It may hold a very small nymph in its mouth for a long while, and then it is usually hooked well – all the way down in its throat.

If you see neither fish nor fly, you can only rely on the visible signs at the water surface. The line tip or the leader's floating – possibly greased – section may suddenly be drawn under the water. Life is definitely made easier by using a "strike indicator", consisting of a little cork ball, a piece of foam rubber, or a stub of poly yarn. This works like a float and reacts immediately if the fly is taken. Its location along the leader depends on the fishing depth.

Upstream nymph fishing with a floating line and a long leader can be done with any size of nymph. If you choose to fish downstream, you must remember that only relatively large, powerful insects are able to fight against the current. Small mayfly nymphs have no chance, so it is understandable why the flyfishermen on the classic chalk streams always fish their small nymphs of size 14-16 upstream. Anything else would involve an unrealistic presentation of the fly.

Notably active and strong swimmers are the big caddisfly pupae, which like to oppose the current. Therefore, imi-

When a large trout takes drifting midge pupae in the surface layer, often only its back fin and part of the back appear above the surface.

tations of them can be fished downstream to advantage, meaning nymphs of size 8-12. According to the current, they are fished with a floating, sinking, or sink-tip line. Here a sink-tip is preferable to a fully sinking line, since – like a floating line – it allows regular mending of the line, which in turn enables the fly to fish correctly. Just as in ordinary downstream wet-fly fishing, the fly should not normally drag.

In really strong currents, nymphs must be fished upstream, using strong equipment, a fast-sinking line, a short leader and large weighted flies. The flies are usually imitation stoneflies of size 2-8. As such fishing is a little violent, its practitioners are not very numerous. The fly is transported upstream with short casts, enabling it to sink before it passes right in front of the fisherman. While the line is sinking, the current pulls it away, so the point is to hold as much as possible of the line out of the water as the fly sinks. This is best done by holding the rod top high with outstretched arms.

If everything else has been done right, the big nymph will have reached the correct fishing depth when it is just in

front of you. Only then does it begin to fish. You must therefore let the nymph drift freely over the bottom as far as possible, by lowering the rod top at the pace of the fly's drift. Most fish take when your line and arms are stretched downstream, since the fly then starts to climb and swing out of the stream. The strike feels violent in the hard current, but the fish is often poorly hooked. Thus a certain percentage of fish is always lost by this method, but it is still the only one that works well in strong currents.

Finally, a word about the rather unusual form of nymph fishing which occurs each summer in Alaskan rivers. It uses so-called "roe flies" that imitate, in colour and form, individual fish eggs. During the summer, thousands of Pacific salmon migrate up these rivers to spawn and die. On the journey upstream, they are accompanied by grayling, Arctic char, and rainbow trout – which intend to eat the roe left by the spawning salmon. This annual drama is a fascinating sight. Like small grey-black shadows, the roe-eaters flit among the large salmon at the spawning grounds. When the female salmon releases some roe, they dash forward and partake of it, before the male salmon chases them away.

As the salmon are so plentiful, the roe is a very important supplement to the diets of other fish in the rivers. For the same reason, roe flies are extremely valuable to the fly-fishermen who swing their rods in Alaska during these periods. The round, fluorescent flies should not be missing in any fly box!

Roe flies are fished exactly like the nymph fisherman's other imitations, by "dead drift" right over the bottom. Normally you can get by with a floating line and long leader, but in some reaches of water it can be necessary to fish with a sink-tip line. As a rule, the current is strong just over the spawning bottoms.

These flies can be weighted so that they sink quickly to the fish, but then they do not sway freely with the current. So it is better to weight the leader – by fastening lead shot to one of the blood knot's loose ends, or winding lead wire round the leader just above the lowest knot. The fly will thus come down to the bottom and, at the same time, drift freely with the current. This approach can also be used to advantage with any other nymphs.

Streamer fishing

Fishing with streamers and bucktails is both the easiest way of flyfishing, and the method that yields the biggest fish! This may sound paradoxical, but it isn't. There are two reasons: you can do nothing wrong with a big streamer or bucktail, and the fact is that big fish prefer big flies.

Streamers and bucktails represent various small fish, and are tied on long-shanked hooks. In addition, they may be pure fantasy creations. A streamer is tied with soft feather-wings, of saddle hackle or marabou, and it is intended for fishing in relatively small and calm waters. By contrast, bucktails are provided with hairwing – originally hair from a deer's tail, whence the name – and they are consequently suitable for fishing in broad, fast waters. Historically, streamers belong to the American east coast, while bucktails come from the west coast. But apart from that, they are fished in the same way.

The nice thing about small fish compared with tiny insects and crustaceans is that, to a great extent, they can oppose the current. Being strong swimmers, they commonly dare to enter more open and rapid water. As a result, the flyfisherman can fish his flies almost anywhere he likes: up or down or across the stream, either fast or slow. The fly will be equally attractive in all cases, and you need not worry about whether the fly will drag. At the same time, with big flies, we address the largest fish in the water, which of course are notorious fish-eaters. Really large fish have long ago given up eating small insects in favour of more substantial young fish. Otherwise they would never have reached the size that makes them so desirable to us!

Trout are the commonest guests of our fly rods when we fish with streamers and bucktails. Grayling prefer insects and other small creatures, although this does not prevent large grayling from occasionally taking a small streamer. When it comes to trout, one can get the feeling that not even the largest streamer is large enough.

The great majority of small fish in flowing waters are definite bottom-dwellers. This applies not least to the minnows – already mentioned – and the sculpins, which exist in many fast rivers around the world. They not only live on the bottom, but actually spend most of their time resting on it.

All this means that the flyfisherman's long-shanked flies should be fished as deep as possible, with a sink-tip or fully sinking line. Only in the smallest, shallowest waters can you get by with a floating line. On the other hand, you can fish rather daringly with these big flies: fast or slow, upstream or downstream. There are unimagined possibilities of variation, in contrast to the usual fishing with wet flies or nymphs.

It is more than a matter of using your imagination. If the fish does not take a freely drifting streamer, try instead taking home the line very quickly. Now and then you can even "awaken" a lazy trout by letting the fly splash down right on top of its head. One must admit that this is not an elegant manner of flyfishing, but it can be extraordinarily productive.

Normally we fish streamers and bucktails as imitations of the small fish that exist in the given waterway. They are tied, and fished, with maximum realism. However, the usefulness of these long-shafted flies hardly stops there. They are also effective in provoking the waterway's spawning fish to strike.

As noted in Chapter 2, trout are aggressive fish that defend individual territories in the stream. They are aggressive all year round, but this behaviour becomes ever more manifest as the spawning time approaches and they defend their territory with fury against any intruder. The flyfisherman can take advantage of this situation when the fishing season is coming to an end and the trout's spawning time arrives. Then the fish may be hard to attract with ordinary imitation flies since, having feasted all summer, they are fastidious and well-nourished. Besides, they are ever less interested in food and increasingly concerned with spawning.

It is then time to serve a big, colourful streamer or bucktail – a fly whose size and hue can, by themselves, give the fish an impression that some possible rival is encroaching on its territory.

This method of fishing can be pretty exciting. It is important to have a good knowledge of the locality, so that you know exactly where the fish are holding. You have to seek them out with streamers and bucktails of large size, and present the fly right in front of them repeatedly until they react. Often nothing happens on the first cast, so you must continue stubbornly. For the more glimpses the fish

Big fish gladly take big flies. Towards the end of the season, when trout are no longer so interested in small insect imitations and try to defend their territory more actively, a streamer or bucktail can be quite effective.

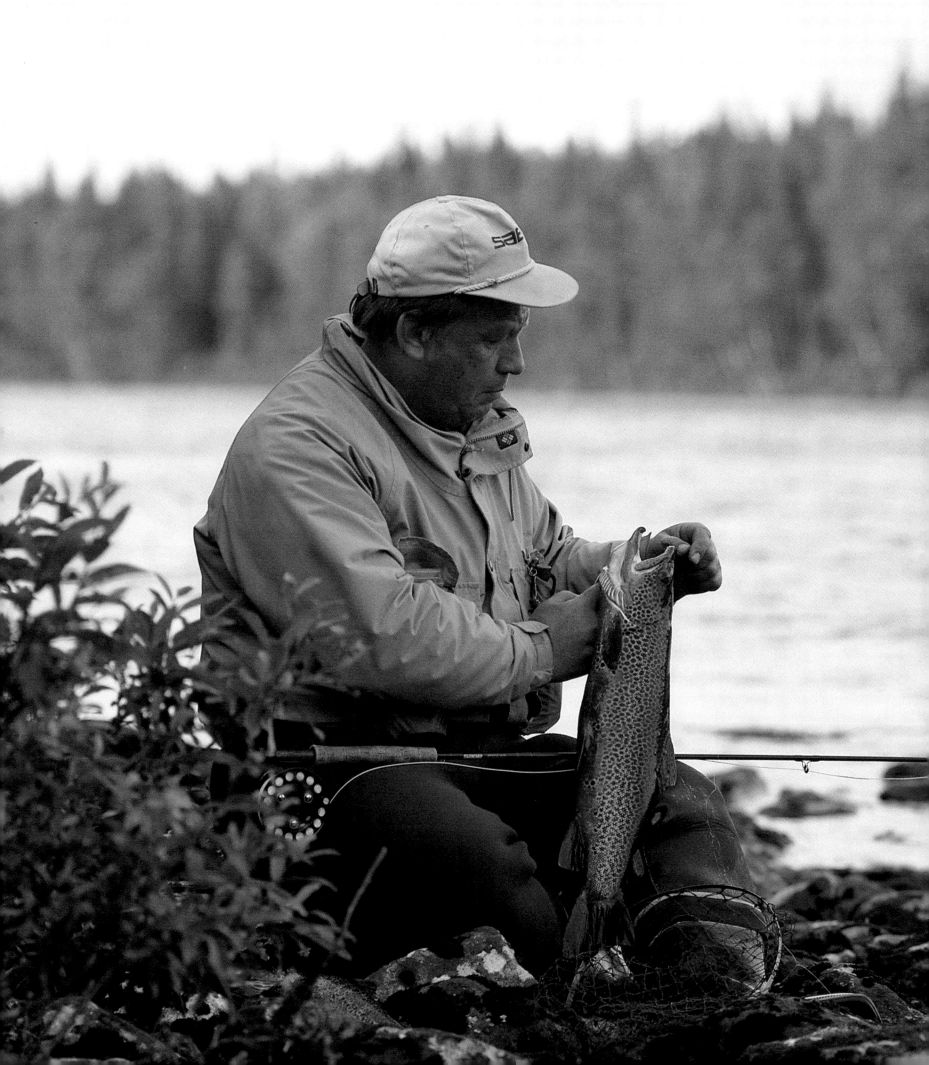

In recent years the word "streamer" has wrongly come to mean all flies tied on long-shanked hooks with long featherwings or hairwings. A traditional streamer, however, has only wings made of long hackle feathers, tied in at the head. The body is often of floss or flat tinsel, ribbed with oval tinsel.

Bucktails, as the name implies, were originally tied with deer-tail hair. But today they are tied with various types of hair, for example from calf tail, squirrel tail, polar bear or goat. The body is tied, just as in a streamer, of floss and/or tinsel – the wing and hackle being tied in at the head. One may also tie in a tail of coloured or plain feather fibres.

Thunder Creek is an American type of fly meant to imitate small fish fry. Since the food of fish can vary around the world, this fly should be tied in the colours that best resemble small fish in your own water. The wings are tied in three steps: a thin bucktail wing on the hook shank, bent backward; then a dark bunch on the upper side and a light bunch on the underside, both pointing forward; finally the bunches are bent backward and fastened with tying thread.

Long-shanked hooks of streamer type, with marabou-feather wings, have become ever more popular. The advantage of this amazingly soft wing material is that it gives a lifelike impression in the water, often attracting fish to take. Such wings create little air resistance, so you can swing out rather large flies even with a relatively light-actioned rod.

It is typical of Matuka streamers that the wing feathers are wound along the whole body. The fibres on the undersides of two hackle feathers are removed, and the wing is placed on top of the hook shaft and fastened at the head. Then the ribbing is wound carefully forward through the wing and is attached at the head. Finally a false hackle is tied in.

The rainbow trout – whose seagoing variant is the steelhead – belongs to those species that gladly take a well-served streamer or bucktail.

gets of the fly, the more irritated it becomes. Finally it cannot endure the temptation and tries to chase away the fly.

At first you frequently feel only a strong blow against the fly, without hooking the fish. The fly has thus only been hit, not taken in the fish's mouth. Yet there is a good chance that one of the following casts will result in a solid strike by what may be the season's largest trout. In any case, such fishing is fascinating once the quarry has been aroused.

In Alaska and British Columbia, every year sees a rather special kind of streamer fishing for large rainbow trout and Arctic char. It takes place when extensive schools of salmon smolt begin their migration downstream toward the Pacific Ocean. They are often smolt from sockeye salmon, which emerge from lakes in the water system – of which the predatory fish are well aware. So the latter gather at the outlets of lakes to feast on the young salmon. If you stumble upon such a smolt migration, you are sure to have exceptional fishing experiences for quite a while. Sparsely dressed streamers and bucktails are the only thing worth putting on your leader.

In several places farther north, trout are regularly caught with mice or lemmings in their stomachs. These small rodents provide the fish with huge chunks of concentrated protein, yielding a colossal spurt in growth. Thus, during good years for mice and lemmings, they are the sole diet of many large trout, and you need to "match the hatch" by serving a delicious deer-hair "mouse" that floats on the water surface. This mouse is fished dragging, and the fish takes it with a savage strike.

An important point is to fish near the banks, where the fish are accustomed to seeing mice or lemmings tumble in. Big flies are required, so you have to give the fish plenty of time to take the fly before tightening up on the line. Otherwise you will only tear the mouse out of its mouth. Whoever has tried this fishing once is sold on it for a lifetime!

If you fish a deer-hair mouse in quiet parts of a stream, it is often attacked by pike, which offer an entertaining sort of fishing. Pike are not distinctive stream fish, and avoid the fast sections of a waterway, but they can be abundant in sections with deep calm water. Here you may also find small schools of perch that gladly take a little silvery streamer.

Catch and Release

Whatever the method of fishing, stocks of fish in streams are fairly vulnerable. The quantities of food, and therefore also of fish, are strictly limited. In addition, every waterway has only enough holding places for a certain number of fish, especially when they are trout. As a result, we obviously cannot catch more than a small number of fish in small streams, and then only if the streams are in their natural condition.

Today, most waterways are far from being in as good condition as they should be. Damming, regulation and pollution have gone mad among them. In many places, this has meant that no natural reproduction exists any longer. A lot of waters contain only stocked fish. Thus a natural waterway with natural fish stocks is an extremely valuable resource that should be treated with great care.

Rational fish management, in the latter case, is not conducted by harvesting any surplus, but by protecting the fish that are there already. The best approach, of course, is to leave the fish in peace – with no sportfishing. But the next best, and most realistic, is to put back the fish that are caught. This policy is what Americans call "Catch and Release", or "No Kill".

"Catch and Release" is undoubtedly the future basis of fishing management. With a steadily rising pressure on our fishing waters, there is no alternative, unless we degenerate to plain "put and take". Sportfishermen simply cannot afford to continue harvesting the last stocks of wild fish.

"No Kill" is not a form of snobbery, as many Europeans unhappily believe. It is a rational form of fishing management that has been used professionally in the United States for the past 10-15 years, and with good results. There, most fishing is open to whoever has obtained a fishing licence in the given state. Only in a few places is fishing subject to private ownership as in Europe.

The fight is over. A tired-out fish slides slowly up from the sea, ready to be landed...

This status has made possible a coordinated, more effective fishing management in large water systems, as well as a test of "No Kill" and its effects on a suitably large scale. The American fishing authorities can, whenever they think necessary, impose new and stricter regulations for a particular fishing area. They can immediately raise the minimum size, decrease the allowed number of fish caught, put a waterway under protection – or introduce "No Kill".

The whole process has been gone through in the United States. It began with virgin waters that offered fabulous fishing to the relatively few sportsmen of those times. There were plenty of fish, and big ones. Yet after World War II, the fishing pressure really began to grow, and many such waters were fished out. The authorities set out quantities of new fish, and once again there was a quarry to catch. This was straightforward "put and take" fishing. Next, however, critical voices spoke up. People did not want to have fish regardless of the price. They wanted quality fish – born in the wild and raised in natural waters, not in fish farms. It took a long time before the authorities reacted, initially with stronger restrictions on fishing, and later by introducing the first clear "No Kill" stretches on special waterways.

These stretches soon became popular, since big fish were still to be found there, offering a real challenge to the more demanding sportfishermen. At the same time, many scientific studies showed that the natural fish stocks were growing healthily under this radical form of fishing management. "No Kill" spread subsequently to numerous other waters.

There is no point in introducing "Catch and Release" if flyfishermen do not know how to handle the fish that are caught. All too many will die after being released. But if the fish are handled properly, they will quickly regain strength – and be able to give some other fisherman a lively experience later on. As Lee Wulff once expressed it: "A trout is too valuable to be caught only once!"

The following rules should therefore be followed when releasing fish:

– Use barbless hooks, which make the releasing much easier. They hook the fish better than ordinary hooks do, and are still a lot easier to remove. Press down the barb, file it off, or use true barbless hooks. If a barbed hook sits deep, clip off the leader near the hook and leave it there; the fish will then get rid of it.

– Fight the fish as quickly as possible. This prevents the formation of too much lactic acid in the fish. Never use a leader which is thinner than necessary for this. Super-thin leaders are not "sporting": rather the opposite.

... and to be put back. But be careful to handle the fish properly and to let it gather strength before you return it.

– Let the fish stay in the water as long as possible when the hook is to be removed. Never touch the fish with dry hands, which can injure its protective layer of mucus. Use a landing net of knotless cotton, which is most gentle for the fish. If the fish is to be photographed, hold it with one hand by the tail and the other hand under its front body. Be careful not to squeeze the fish, and never touch its gills!

– Revive the fish before releasing it. Hold its head upstream in flowing water, or move it back and forth in still water, so that fresh water passes over its gills. Not until the gills pump regularly again, and the fish can keep its own balance, is it ready for releasing. The fish should be able to swim out of your hands by itself.

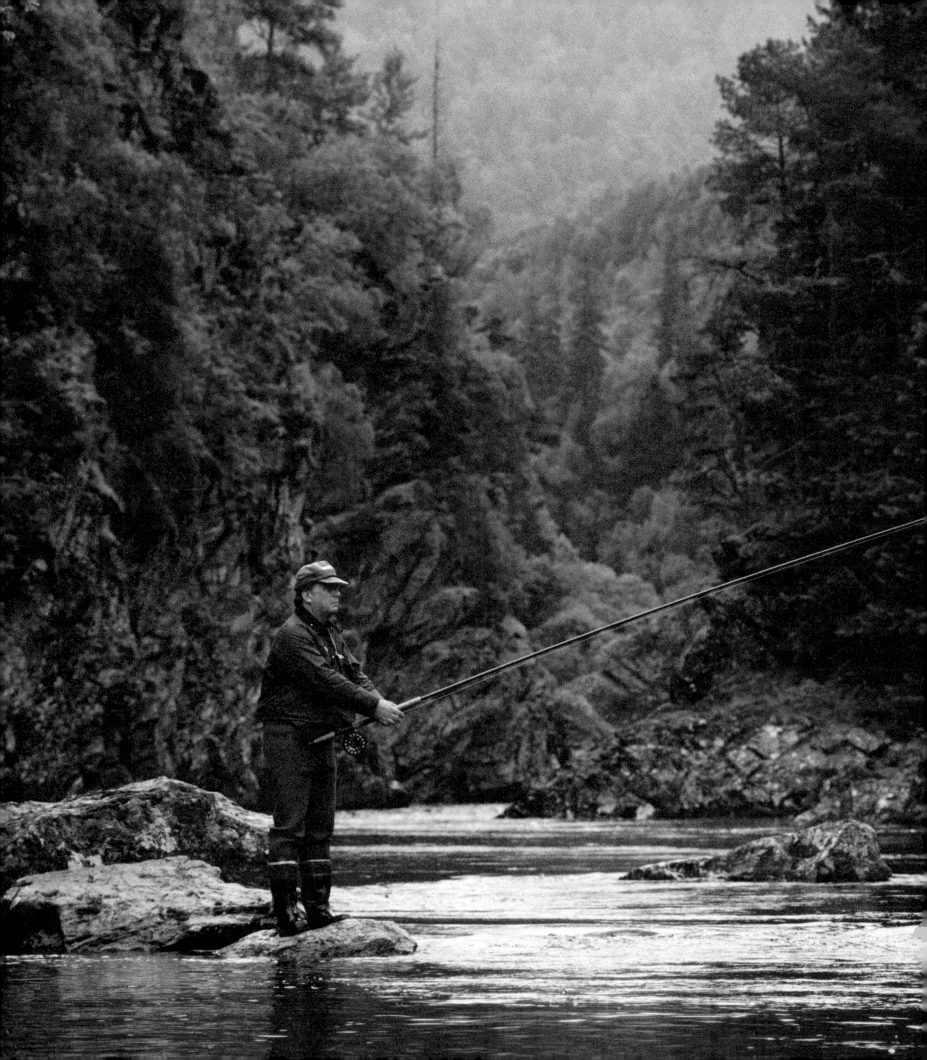

Fishing for salmon and sea trout

Salmonoids and related
species do not feed in fresh water
after returning from the sea. Therefore, we
can only speculate about what to offer
them in order to entice
them to the hook. Some writers
suggest that these fish have varying
motives for taking a fly – and such factors
as boredom, anger, curiosity,
and memory reflex have been proposed.
Although we shall probably never know the
real answer, it is tempting to theorize
and the present author is
no exception.

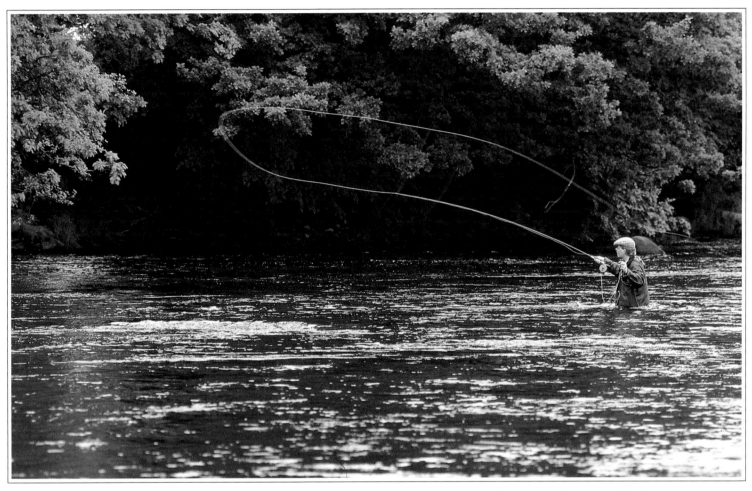

Good casting technique, and long experience on the same river under varying conditions, are typical attributes of a successful salmon fisherman.

I would compare salmon and sea trout to a half-sleeping cat which lies down in the sunshine and pays little attention to its surroundings. Of course, unlike the salmon, a cat will feed when it is hungry, but at times it is provoked to attack something that it has no intention of eating – such as a leaf blowing in the wind. Some reflex action is triggered by the sight of a moving object and induces the cat to chase it. This may have less to do with the object's colour than with its movement, and possibly its resemblance to an ailing prey.

However, many wild cats survive by being able to run fast, and must be continually on the alert – even practising when they are not feeding. Fish, particularly salmonoids, rely on their speed of interception to get a meal. Possibly on occasions they take a fly when their reflexes have been triggered to attack something that they neither want nor need as food.

Thus, before fishing for salmonoids, it may be very important to learn not only how to cast well, but also how to think and act like a hunter, and to study animals in order to acquire a sense of their behavioural rhythms. One can even make notes of the feeding times of birds, fish and animals such as cattle and sheep. With trout and other fish which feed in fresh water, it is worth observing their feeding times and diet. We cannot directly do so with salmon and sea trout, but we must be aware of the rhythms of wildlife – as well as getting to know the water that we are fishing in.

The future of salmonoid fishing

Another general point to remember is that the future of the wild Atlantic salmon species is severely threatened today. Our fishing should therefore be conducted responsibly, which may mean a limit on catches and the methods of catching. The late British king George V summed it all up by saying: "The wildlife of today is not ours to dispose of as we please. We have it in trust and must account for it to those who come after us."

There is still a great magic in seeking salmon with a fly, and the thrill of the take never pales. Yet unless conservation measures are applied, we may have already lived through the golden years of salmon fishing. Surely mankind will not be so foolish as to let this sport slide into obscurity through wanton neglect!

Throughout most of Europe, the two main species of anadromous fish, *Salmo salar* and *Salmo trutta*, are better known by their common names: salmon and sea trout. But the prefix "Atlantic" must be added for salmon, while the European sea trout is perhaps better identified as a sea-run brown trout. This enables us to distinguish them from the five species of Pacific salmon, belonging to the genus *Oncorhynchus*, and from the sea-run rainbow trout known as the steelhead.

The majority of flyfishermen consider the Atlantic salmon to be the leading sportfish. With experience of many species of salmon and sea trout, however, I am not sure that this accolade is well-deserved. The fresh-run sockeye and coho salmon in Pacific rivers are hard fighters, as is the steelhead. And where else in the world would you find salmon that grow to the size of the chinook or king salmon, nearly 100 pounds (45 kg)?

The techniques of angling for salmon originated largely in Europe. Much of the folklore that has grown up around salmon was created by the British. Not only were they in the vanguard as sportfishermen for salmon, but their influence and expertise contributed a great deal to developing the Scandinavian resources.

Large Atlantic salmon are the ultimate challenge for many flyfishermen.

Equipment

As far back as two hundred years ago, it was casually assumed that, if trout take small flies, salmon can be expected to take larger flies. This, of course, we no longer find logical. On their return to fresh water, all salmon species cease to feed, and they stay in the rivers only in order to rendezvous with a partner on the spawning beds. Nature demands simply that one spawning pair produce another spawning pair within five or six years. Although a few Atlantic salmon may survive to spawn again, the Pacific species all die immediately after spawning.

Both Atlantic and Pacific salmon have proved to be a valuable food resource, and have been irresponsibly exploited by commercial fishermen, who have long been legally entitled to catch as much as they can. The laws are slowly being improved and enforced so as to curtail such over-exploitation, but there is also a wide appreciation of the value of salmon as a sporting resource.

Today there are notable developments in the restriction of fishing methods, commercial as well as sporting. Often it is required that only flies be used. Fish farms are supplying more of the market needs, and in North America all kinds of bait-fishing for salmon are forbidden. More of the Scottish, Irish and Scandinavian fisheries are gradually imposing a fly-only rule. Still, it may take time to convert the anglers who think more about the value of a prize than about the method of catching it.

Although fish farming to supply the public is a comparatively new and fairly profitable business, artificial rearing of salmon has been going on for several years. Man has made some attempt to replace fish where he has overfished, but mainly on a haphazard basis without training.

Patience, watchfulness and powers of concentration – these are qualities a salmon fisherman needs.

There are still numerous countries in which many forms of angling are permitted. Nonetheless, many of us feel that flyfishing not only offers a greater challenge, but also represents a better sporting method of catching these lovely fish. It is now several years, for instance, since I have fished for salmon with any other lure than a fly. On many rivers the methods of flyfishing can be very effective, although on a few rivers they are less productive than certain forms of bait-fishing.

It is, then, angling with a fly that will occupy us here. This is a superb way of enjoying sport with worthy fish – and once you have mastered some of the basic techniques, it is much easier than might be supposed by beginners.

Much of the tackle used in flyfishing for salmon and sea trout was invented in England. About 150 years ago, back-breaking rods of up to 20 ft (6 m) were fashionable. Leaders were of plaited horsehair and twisted silkworm gut. The most dramatic changes in tackle have taken place since World War II. Today carbon-fibre (graphite) has ousted glass, split cane, greenheart and hickory as rod-building material, while reels have become far lighter and more effective.

Silk lines and twisted flax are virtually things of the past. Modern synthetics give us every required combination in floating and sinking lines. The Association of Fishing Tackle Manufacturers (AFTM) has standardized much of this tackle, so that specific line sizes and weights can be made compatible with rods. Perhaps the greatest benefit that synthetic fibres have brought is in the field of transparent monofilament. Based on nylon, it has eliminated the need for gut or horsehair casts, and some remarkably high breaking strains are produced with minimal diametres.

Traditionally the fly rod was, and still is, double-handed. It may be anything from 12 ft (3.7 m) for fishing a river of modest size, to 17 ft (5.2 m) for a broad river. Much of the flyfishing in Britain and Scandinavia is done with double-handed rods. But North American anglers, who often fish from canoes, have shown a marked preference for the single-handed rod. At least one noted American angler, Lee Wulff, takes great delight in extracting massive salmon on a toothpick-like fly rod of only 6 ft (1.8 m) weighing less than 3 oz (85 g).

European anglers are still convinced that their way is best, while those in America share an equal conviction that

any rod over 9 ft (2.7 m) is quite unnecessary. These prejudices are often deep-rooted and have little other foundation. I am reminded of a Scottish proverb: "Convince a man against his will. He's of the same opinion still!"

There is something to be said for each point of view. I have fished frequently with both types of rod, and firmly conclude that the double-handed rod is sometimes better suited in tactical terms, but that a single-handed rod seems more sensible at other times. On many Scottish rivers I would confine myself to a double-handed rod until the end of the main snow melt. Yet as soon as the rivers start falling to summer level, and for tactical reasons which I shall discuss later, I would adopt the single-handed rod. In the large, strong Norwegian rivers, a two-handed rod of 14-16 ft (4.3-4.9 m) is most common throughout the season.

It will be a happy day when both European and North American anglers discard their prejudices and recognize that, to be an all-round flyfisherman, one should have each type of tackle available during the whole season.

The choice of tackle

In making your initial choice of tackle, however, it is important to decide where you will do most of your fishing, and at what time of year. A lot depends on your location and the size of the river. A Norwegian river in June, for instance, may be nearly at flood level from melting snow – whereas a river of similar size in Scotland or England may already be thinning down to summer level, long after the main snows have melted.

The best choice for spring fishing on Scotland's famous river Spey, and in large Norwegian rivers during summer, is a 15-ft (4.6-m) double-handed carbon-fibre rod. With this I would carry at least two reels: one with a slow-sinking shooting-head line of size 11, and the other with double-taper fully floating line of similar size. The DT line is almost essential in order to do a proper Spey cast, while the sinking shooting-head line may be cast overhead for long distances. I would also carry a range of flies varying from 2.5-in (63 mm) tubes to size 6 or 8 doubles or trebles, without much concern for pattern.

One can also bring a net, gaff or other implement to extract fish from the river. Many prefer to wade the river with as little encumbrance as possible. For early spring or late autumn in Scotland, and during the summer in Scandinavian rivers, good tackle includes the following items:

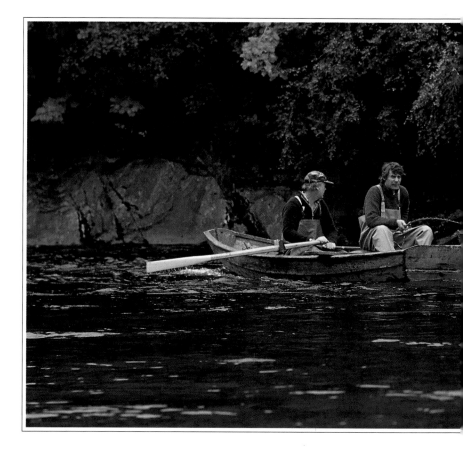

- A stout pair of felt-soled breast waders, preferably in neoprene.
- The 15-ft (4.6-m) double-handed fly rod.
- Drum fly reels of 3.75 x 4 in (95 x 102 mm) with adjustable drag.
- A 30-ft (9.1-m) shooting-taper slow-sinking line of size 11, and another of fast-sinking type, attached to oval monofil backing.
- A 30-yd (27-m) double-taper floating line of size 11, spliced to at least 150 yds (137 m) of 25-lb test backing.
- A big box of flies, as outlined here.
- Spools of nylon monofil, between 10-lb and 25-lb test.
- A pair of scissors.

Additional accessories could be a wading stick, net gaff, and so forth. Indeed, if you do not know your river intimately, it makes good sense to have a wading stick. This should have a weighted bottom, so that it is always at hand and does not

float on the surface. If floating, it can make trouble and foul up some of the line which you intend to shoot.

As an alternative and back-up outfit, for such fishing in early spring or autumn, I recommend a single-handed rod of about 10 ft (3 m) with a smaller fly reel, and a forward-taper line of size 7 with an 8-lb test leader. This is a much-loved outfit for late spring and summer fishing on the small or shrunken streams of Britain. Moreover, it is fantastic fun to play a salmon on a light, single-handed rod. And there can be little doubt of the tactical value of such an outfit when the rivers have shrunk to their bare bones, with fish that are shy of all but the most slender leader.

An important aspect of tackle selection and use is your mastery of the best knotting techniques. All knots cause a loss of strength in your leader, and bad knots can be so inefficient that they may reduce the strength by more than half. It is a good idea to learn knots so thoroughly that you can almost tie them blindfolded.

Traditional salmon fishing from a boat with a double-handed rod.

One of the worst knots that may accidentally be induced into your leader is politely known as a "wind knot". Sometimes it may occur in very windy conditions, when the leader gets tangled and a single overhand knot is produced. This makes the leader extremely fragile to sudden loads, and might well break it when a fish is being played. Such knots can be termed "bad casting knots", since they can usually be avoided. All you need to do is open up the loop of the line a little, and lower the rod tip immediately after the power stroke in the forward cast.

Selecting flies

A classically tied Butcher.

Most discussion of the effectiveness of salmon and sea trout flies is speculative. Since the fish do not feed after returning to fresh water, they may have no interest in whatever we offer them, and no strict logic will tell us what size or pattern of fly will be the best in any given circumstances.

However, salmon can indeed occasionally be caught on a wide variety of fly patterns. Ancient lore suggests that we use big flies in extensive, deep and cold waters – and small flies in limited, shrunken rivers when the water is warmer and the fish are confined to shallower areas. In practice, there is a whole range of techniques which defy the basic rules, although we should never be dogmatic about them.

It is wise to arm yourself with a wide variety of fly patterns, in varying weights and lengths. Sometimes the weight of the fly is more important than its overall size. At other times you may want as small a fly as you can find. Generally, there is a lot to gain by having as large a selection as can be carried comfortably.

For fishing in early spring on many of Britain's classic rivers, I use a heavy sinking line and a tube fly, mounted on brass tubing to enable it to sink well down in the water. If the river is full with melting snow or recent rain, it may contain some suspended matter and thus lack the crystal-clear quality of a river at normal height. In addition, the water temperature may be a little above freezing, and this could be an occasion for the large fly if fished as slowly and deeply as possible.

Alternatively, the same river in late May or June might need little more than a light floating line, and a single-hooked fly of size 10 or 12 which is lightly dressed and has little weight or drag effect. Still, there are no fixed rules, and I have frequently seen a complete reversal of tactics bring about an unexpected success.

In making your choice of fly pattern and size, it pays off to keep in mind the laws of nature. Nothing in the wild which is preyed upon by other species has a garish appearance. The prey usually has some form of natural camouflage and does not look out of place in its environment. This fact should dictate the choice of fly in very clear water. Do not select a fly which is conspicuous, and it is a good idea to make your flies ever more subdued in colour as they get smaller. In high turbid water, however, you may well need to confront the fish with a more garish lure – and perhaps even intimidate the fish, presenting the lure where it will threaten the fish on an eye-to-eye collision course.

THUNDER & LIGHTNING
Tag: oval gold tinsel
Tip: yellow floss
Tail: golden pheasant crest feather and Indian Crow
Butt: black ostrich herl
Body: black floss
Ribbing: oval gold tinsel
Body hackle: orange cock hackle
Front hackle: blue guinea hen or blue jay
Wing: brown feather sections from brown mallard
Topping: golden pheasant crest feather
Sides: jungle cock
Head: black

This is how a classic salmon fly is tied. Thunder & Light-ning is a good example of dark flies, which work best by evening and night or in bad weather (hence the name?) and when the water is murky.

At right is shown a Silver Doctor. This light fly is most suitable in fine weather and when the river water is clean and clear. It belongs to the Doctor series and is also a good instance of a Mixed Wings fly.

The colour of flies

On the above basis, I find it helpful to use a colour of fly which matches the overall colour of the river bed. Some rivers are generally brown, like weak coffee without milk, and these call for a dark-brown or black fly. The Spey responds well to this type, and patterns such as the Monro Killer, Thunder & Lightning, and Stoat's Tail are all effective. Other rivers, for example those flowing off bare rock or limestone, are often crystal-clear at times of normal flow, absorbing much ultraviolet light. They may have a blue or green tinge, making flies of the same hue more suitable.

During early spring and late autumn, though, your river will probably be higher than normal, and unusually turbid due to rainwater. I would then recommend slightly brighter or garish flies in yellow or orange for very cold days, and less conspicuous flies for warmer days. Good examples of flies for high, cold water are Yellow Dog, Tadpole, Willie Gunn and Collie Dog.

Nonetheless, the final act of deluding a fish into taking your lure is often unrelated to your choice of fly pattern. It may have something to do with the size of the fly, but usually the decisive factor is how you present the fly. Unfortunately, a fisherman who accepts the advice that he is fishing with the wrong fly might become furious at the suggestion that his casting and presentation are poor. In spite of that, the tactical and technical requirements are most likely to cause failure. And if there is a prerequisite in salmon and sea trout fishing, it is knowledge of the best techniques needed for any given situation.

(Left) When choosing a fly, you should naturally take into account its size, colour and dressing, but the presentation is often what determines whether the salmon will take.

In warm low water, the current is frequently slow. The fish are then eager to rise and take the fly, which can be fished just under the surface with a floating line.

The river level is still low, but the current is faster. Now a sinking line is needed so that the fly will not drag on the surface.

In high cold water, a rapid current is common. The combination of a fast-sinking line with large tube flies is then necessary to get down to the bottom, where the fish lie.

The water's temperature, level and current speed are factors that influence the fish's choice of holding places. A floating line and small flies are useful mainly during the warm months, when the water is low and the current therefore slow. But in the early season, with high and cold water, the current is strong and the fish take the fly at a greater depth. You must then often fish with a fast-sinking line and large flies.

Casting and presentation

Experience shows that this kind of fishing depends mainly on the ability to cast a long line and on intimate acquaintance with the water being fished. The one-week-per-year salmon angler is severely restricted, and his difficulty is compounded if – like so many of us – he likes to try a different river each year. At no time will he ever fish a single stretch of water and get to know it under all its conditions. Yet he will never be able to fish it to full potential until he has tried for several years on the same stretch.

It is not intended here to teach the complexities of casting. A videotape may be more helpful than a book, but the best way to learn is from a professional instructor – not an enthusiastic amateur, however talented – and to spend as long as is needed to master the techniques under his supervision. Anglers often spend surprising sums of money in fishing rents, travel costs and hotel bills, only to prove themselves incompetent at casting when they arrive at the water.

For double-handed fishing, you must be able to cast at least 25-30 metres (80-100 ft). Such distances may not be achieved immediately, but it should not take long to accomplish them comfortably in the overhead mode. It is then very important to master both the single and double Spey casts. These will enable you to fish areas of water that are obstructed by overhanging trees or high banks, and where the overhead cast is impossible.

Letting the rod work

The novice should learn that it is the rod which must do the work – and that style, not brute strength, will make the cast look good and be effective. Ladies and small men often

An experienced salmon fisherman knows that he must let the rod do the work, if he is to fish for a whole day with a long double-handed rod. Every cast has to be as energy-saving as possible.

seem to be better stylists, while large and powerful men apparently work hard but do not achieve the right distance or style. But if you have both style and strength, you may well be on the way to becoming an exceptional salmon fisherman!

If you have no experience at all, it will pay to begin with a double-handed rod and a floating line. This gear is more quickly mastered than the single-handed rod or a sinking line, although the techniques are basically the same. The rod must act as a spring when casting, and as a lever when playing the fish. Thus, to get the best from your rod, you must use its springiness – and this is where many problems occur.

Some fishermen simply wave the rod about, using more muscle than they need. It is the flex of the rod that propels the fly line. No matter how much energy you expend, if you merely wave the rod and do not load it as a spring, you cannot cast far or with great style. Good casting is not an art, but a craft that any able-bodied person can soon learn.

The next difficulty, getting access to good water, has already been mentioned. Direct access to the best waters is not easy, even if you can afford the rent. But it is wise to get the best you can, and to remain a regular tenant over the years until you know the best times of year and the best places for fishing. Such knowledge is not easily won, either – and that is why many of the classic salmon waters have gillies, or guides, to assist the visitor and ensure that he fishes only the most productive areas.

This problem is less serious for anglers in Canada, Iceland and Scandinavia, where the more severe winters usually delay the first thaw until May. Then the melting snow makes the rivers rise, and the fish start to run. On many of these rivers, the season is confined to June, July and August. But in Britain, Ireland, and some other European rivers, one can fish in open season throughout the year by moving round a bit. The classic British rivers tend to open in February and close at the end of October, yet some open in January and others do not close until the end of November or even in mid-December. This poses tactical issues for the flyfisherman, although it does give him a longer season, and perhaps a better chance of finding some good water at modest cost.

It might be expected that an experienced salmon angler like myself would be most frequently asked about the tactics needed to catch salmon. Surprisingly, the commonest question is: "Where can I go and when?" It is also the hardest to answer satisfactorily.

The holding places

Another familiar puzzle is the definition of a pool. This may seem literally obvious, but not everyone knows what it means in the average salmon river, rock-girt and rain-fed. Usually we must see a river at fairly low level in order to identify these areas – where water rushes down from one cataract, levels out in a calmer and deeper section, and then speeds up before tumbling into the next pool below. A pool may be anything from a few metres long, on a small spate river, to several hundred metres long on a big river. It starts at the neck as the water cascades down over a firm riverbed. The top portion of the neck is called the stream or run, while the portion that trails away is the glide. The very bottom of the pool, before the river rushes away to form the neck of the next pool, is the tail.

It makes sense to fish most rivers from the inside of a bend. But there are notable exceptions. The flows and depths of a river vary as it progresses seaward. Water tends to flow in a straight line under the force of gravity, and its influence on obstacles will increase with the volume of water and the height of its fall. Therefore, at any bend in a river, the ground tends to be least solid on the inside bank. The main stream is usually forced down the outside of a bend, while the inside curve contains the calmer water.

Where a river turns sharply, and unless it flows over bedrock, the continuous floods may scour out a deep depression near the inside bank. This area may well harbour good stocks of migratory fish. Thus, as a rule, many rivers do fish better from the inside of a bend. You can cast into the fast water with certainty that your fly will then swing into the calmer water where the fish tend to lie.

With experience on one stretch of water, you will learn the precise places where the fish lie at any given height of water. In many cases, you can predict the chance of success from your knowledge of the ideal water height for any specific pool. This knowledge is extremely important in fishing any water to its full potential. In times of flood, of course, the fish tend to lie under the bank where, at other times, you find dry land or can wade out.

While the bends and curves in a river help us to "read" the water, we still have a lot to learn about its depth – the portion that we usually cannot see. Many rain-fed rivers vary tremendously in depth, and are also influenced by the type of riverbed. Good rivers for flyfishing are often comparatively shallow. Solid rock may take thousands of years to erode, whereas gravel may be shifted by each flood.

The best way to learn the geography of a river, or of the section which you want to fish regularly, is to put on a wetsuit and explore it underwater at different heights. The next best way is to study its contours at a time of very low water. Even then, unless you can move or think like the fish, you are not likely to sense how subtle changes in the flow will determine where the fish lie at various heights of water. Such knowledge could help in the presentation of your fly, although not dramatically altering your catch.

A knowledge of where the fish are, in a river or pool with a given water depth, tends to be what distinguishes the successful salmon fisherman from the "always unlucky" ones. This knowledge is attained almost exclusively by fishing regularly in the same river for a long time.

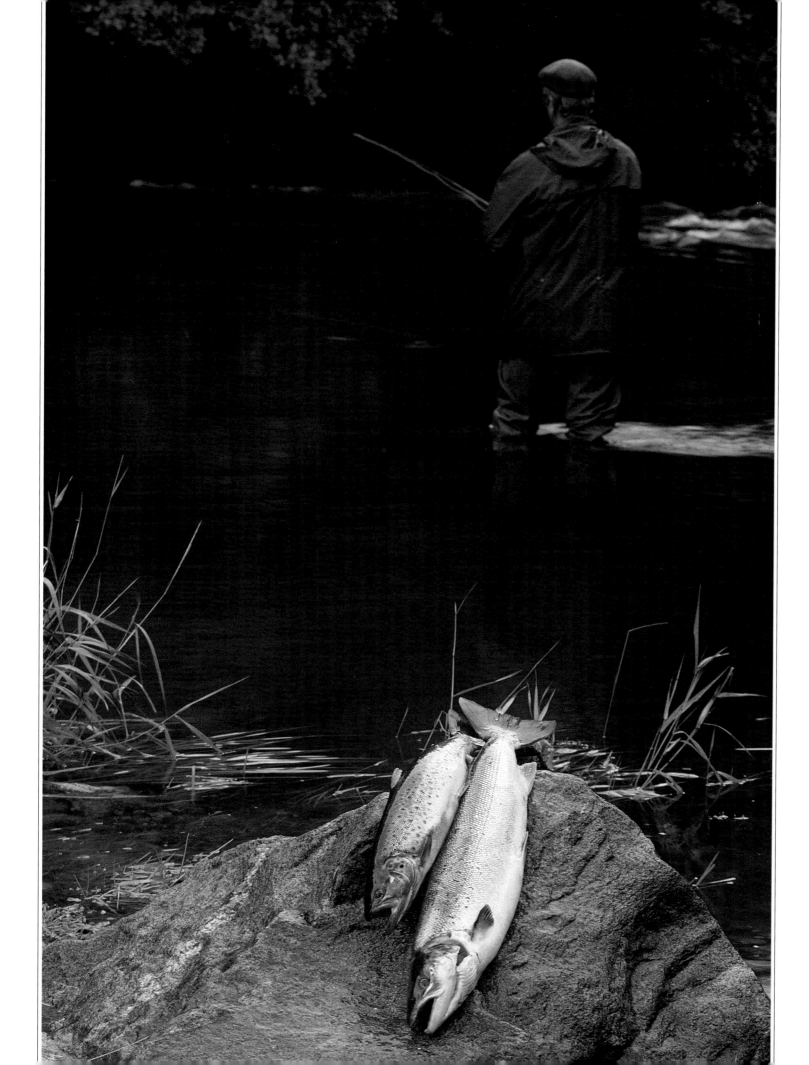

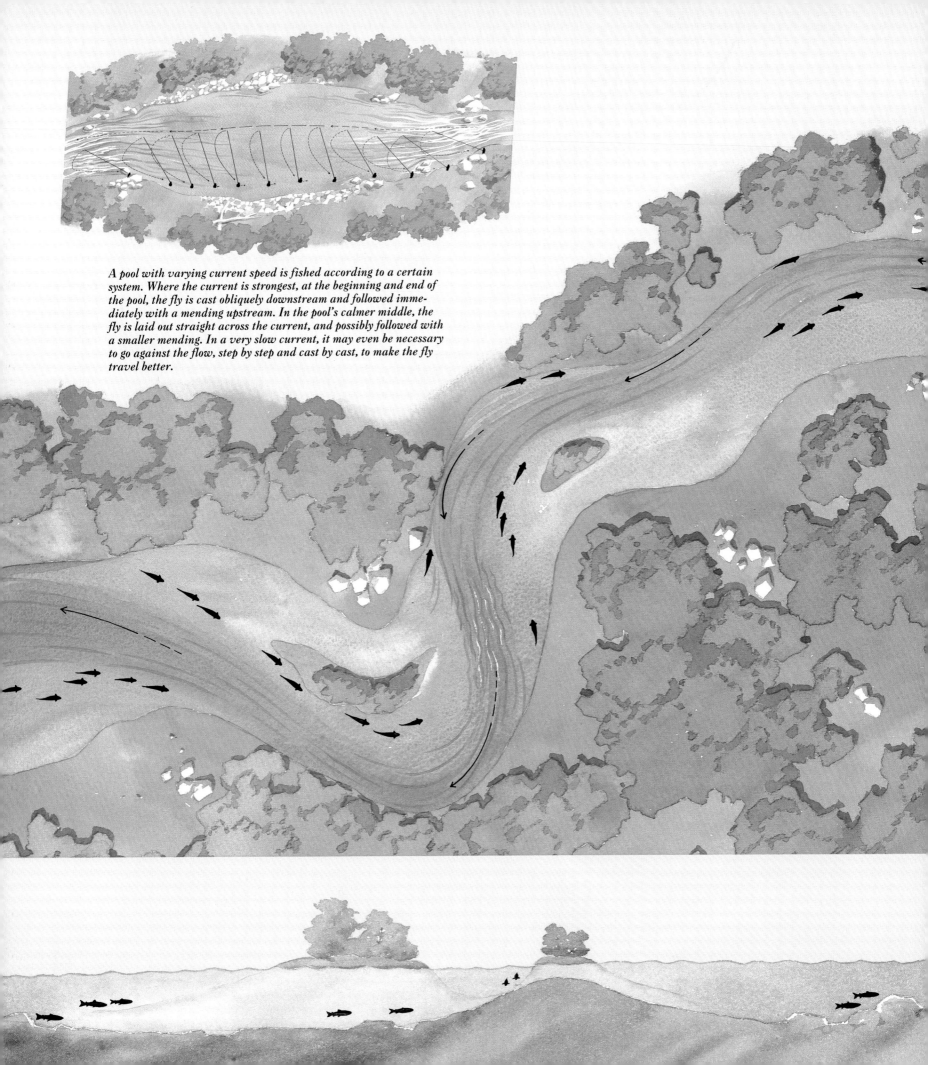

A pool with varying current speed is fished according to a certain system. Where the current is strongest, at the beginning and end of the pool, the fly is cast obliquely downstream and followed immediately with a mending upstream. In the pool's calmer middle, the fly is laid out straight across the current, and possibly followed with a smaller mending. In a very slow current, it may even be necessary to go against the flow, step by step and cast by cast, to make the fly travel better.

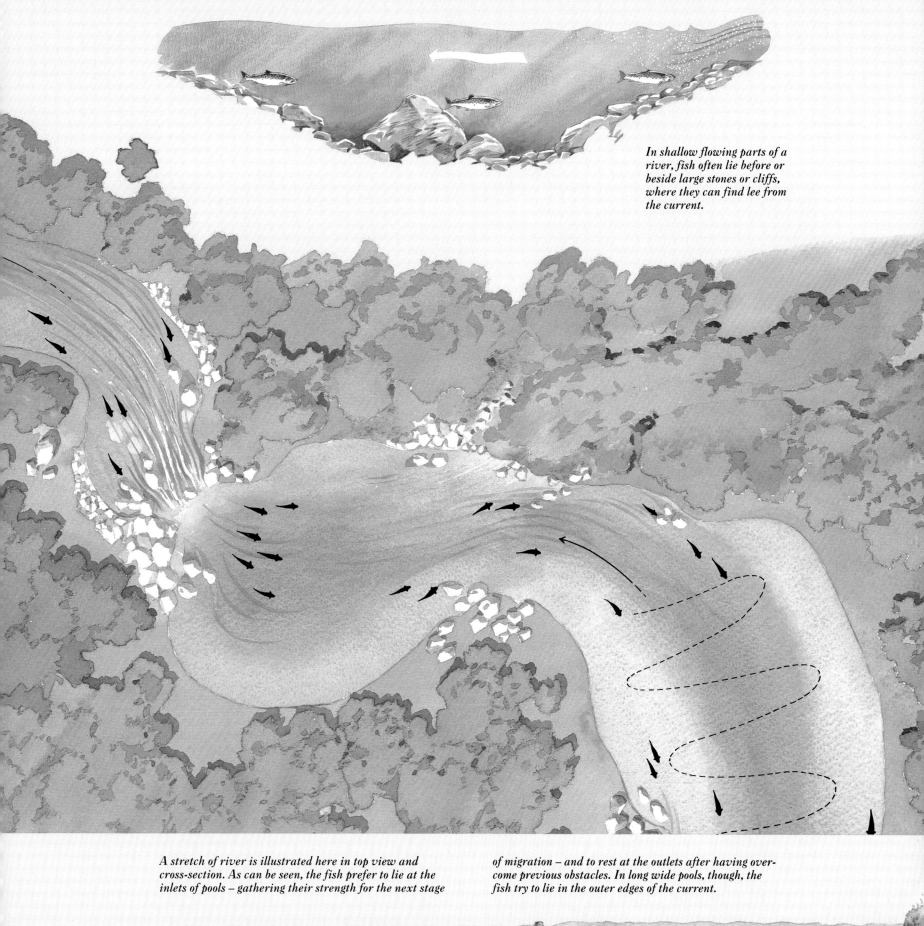

In shallow flowing parts of a river, fish often lie before or beside large stones or cliffs, where they can find lee from the current.

A stretch of river is illustrated here in top view and cross-section. As can be seen, the fish prefer to lie at the inlets of pools – gathering their strength for the next stage of migration – and to rest at the outlets after having overcome previous obstacles. In long wide pools, though, the fish try to lie in the outer edges of the current.

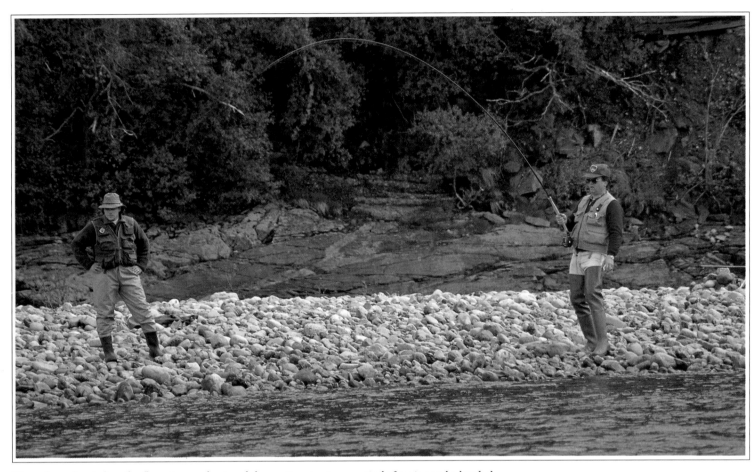

The salmon has taken the fly, yet many long and dramatic minutes remain before it can be landed.

The taking times

At least one British salmon writer has observed that it is impossible to overfish a salmon river. What he meant was that it is not easy to put fish permanently into a non-taking mood, and that they may always – at some time of their own choosing, for some unknown reason – suddenly "come on the take" and grab the first lure they see. In any case, we must evaluate the condition of the fish. A fresh fish entering a new lie for the first time, and taking a brief rest, may be quite likely to snatch at the first thing to antagonize it. Until we know why salmon take our flies, we are naturally only speculating – but experience shows that fresh-run salmon are very vulnerable in this respect, and that many are caught when running without staying long in a lie. Here I

feel that it is almost impossible to overfish the lie or the river. But where the fish have run into holding pools and stayed for some time in a lowering water, it does seem possible to over-intimidate them into a non-taking mood.

There are undoubtedly many instances, in salmon and sea trout fishing, where "familiarity can breed contempt". Moreover, what can we gain by continually flogging a stretch of water when there is a total lack of response? It may make better sense to rest, as well as giving the fish some respite.

The idea of resting a stretch of water, of course, poses hard questions. On many rivers, it is impossible to tell exactly what is happening under the surface. Only by

having a fish-counting device at the inlet and outlet of every pool could we determine just what stock it contains from one minute to the next. But since the stock is often a matter of pure speculation, it may be that resting a pool will reduce the chance of familiarity breeding contempt. Indeed, the next time your fly is shown to the fish, some new stock may have moved in, or one of the old residents may have changed its mood.

It is not strictly true that one can never predict the taking times of the fish. Those that settle into lies for several weeks are known to be residents. You may even recognize some of them by the positions in which they show, by their leaping style, and by their size or colouring. However, it is important not to overfish for them – and to fish at times when "all of nature is in tune", as suggested by a knowledge of the behaviour and feeding times of other animals.

Although salmon and sea trout are known to be nonfeeders in fresh water, some memory of their heavy marine feeding may trigger a reflex and make them respond at some times of the day better than at others. One of the most predictable taking times, throughout the season and in any kind of weather, is the last hour of daylight.

The weather in Scotland may vary greatly during April and May. One day might have air and water temperatures around 5-8° C (41-46° F), while another may have the air at 15° C (59° F) and the water at a magical 10° C (50° F). In any event, when fishing with a fully floating line, it is very important that the air be warmer than the water. Choose a day when the opposite is true, and you may well draw a blank.

As emphasized above, the angler who does best with salmon and sea trout is usually one who lives on, or near, the river he is to fish. He gets to know all its moods and whims, ignoring the temptation to try a new river every year. For this reason, I am now reluctant to try new waters. Age does not leave me enough time to learn them as intimately as I know, for instance, the Castle Grant beat of the Spey, or the Upper Floors beat of the Tweed.

A salmon often rises calmly and slowly towards a fly in the sub-surface. If it decides to take, which is far from certain, it usually does so heavily and decisively rather than violently.

How to tie a tube fly is shown here. The example is Garry, an all-round pattern that has proved to catch salmon throughout the year, but is perhaps most effective in the early season when the river water is at a high level and low temperature.

GARRY SPECIAL
Tag: oval silver tinsel
Butt: black ostrich herl
Tail: golden pheasant crest feather
Body: black floss
Ribbing: oval silver tinsel
Body hackle: sparsely tied black
 cock hackle
Front hackle: blue guinea hen
Wing: red and yellow bucktail
Head: black

Practical flyfishing

Suppose that you are fishing early in the season, and the river is at nearly perfect height, with a water temperature of around 4° C (39° F) or perhaps a bit warmer as in Scandinavia. You are using a 15-ft (4.6-m) rod, a sinking line, and a garishly coloured 2.5-in (6.3-cm) tube fly. Taking up a position that enables you to cover the lies, you make your first cast.

Initially a few short casts should be made toward the opposite bank, pulling a yard or two of line from the reel at each cast, until you have enough line out. But it should be remembered that a longer cast will allow the fly to get farther down in the water – and that by holding up the rod tip, immediately after the cast, you will keep more line off the water as the fly begins to swing, so that it will sink farther.

Do not be in too much of a hurry to strip back line for the next cast. Let the fly dangle for a few seconds, then casually pull in the first two or three loops of backing. Sometimes during the cold weather of the early or late season, fish will slowly follow the fly and take it only as it is being withdrawn upstream. On occasion, especially in the autumn, my fly has been snatched while hand-lining back at full speed.

These slow tactics offer the best chances in cold weather, but it may be useful to speed them up a little as the water warms. However, salmon – notably the Atlantic salmon – react much less quickly than do sea trout, which can grab a fly and take you down to the backing in a single rapid movement. Besides, Atlantic salmon differ in behaviour from the same species in North America, which often display real pyrotechnics. All Pacific salmonoids, particularly when fresh-run, are fairly savage on the take, whereas the more ponderous Atlantic salmon of the early spring are rarely willing to snatch and flee like summer sea trout.

In sink-line fishing, you should always try to hold the rod high. As seen in the upper illustration, the fly then has a chance to sink properly toward the bottom. If the rod is held too low, as in the picture below, too much of the line will float on the surface due to friction, keeping the fly "hanging" a little under the surface.

Salmon can take a fly in various ways, and opinions on what to do after the take are almost as numerous as salmon fishermen. Shown here are four common ways for salmon to take. The fish nearly always rises upstream to inspect the fly and possibly take it. Then the fish usually falls back with the current in some direction. Only in the third example does the fish continue upstream after taking the fly.

Though the fish often hooks itself, you should always make a clear strike as soon as you feel it on the rod. No matter how it takes the fly and how you hook it, you should let it work against the rod during the whole fight. Give it as little chance as possible to rest, ideally by playing it in the faster part of the current.

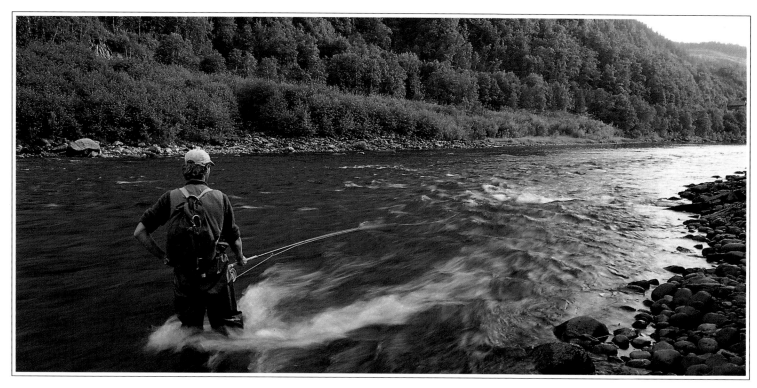

Will the salmon take the fly – and if so, how?

Hooking and landing

There are several opinions about what to do when a salmon takes the fly. Some anglers, especially those who have read a great deal on the subject, seem to be obsessed with feeding line to the fish at the moment of the take. Others, who may have caught a lot of fish, apparently believe that you should hold hard when you feel the fish and let it hook itself. The present writer prefers the latter view. Possibly a fish in very cold water will get hooked on any slack line fed to it, but I see no reason to do this at any other time. I agree with the idea of holding hard, or even striking, at the instant when the fish is felt pulling on the rod tip.

Exactly what you do after hooking the fish depends to some extent on its mood. It may soon take the initiative and do unexpected things, such as rushing away downstream and threatening to break the line. But usually it stays in the pool where it was hooked, so you need only give line when it pulls strongly, and win back some line when you feel it trying to rest. The fish should be kept active, and preferably in the faster current. Do not let it get so far downstream that it can lean on your tackle to resist the current.

But neither should you stay opposite the fish simply in order to keep a side-strain on it. This might lead you far downstream from your starting point. Normally I like to play and land a fish from the place where I was standing when I hooked it. Naturally there are times when you have to move, but a good rule is to stand fast.

Before long, in fishing for salmon or sea trout, you will realize that certain conditions must be met if you are to catch fish by design rather than by accident. The angler who has got to know the water in all its moods – and who has learned to cast far – will, in the long run, score heavily over the inexperienced novice. Yet perhaps the main requirement is a "command" of the water. What counts is not merely casting out to the fish, but being able to make your fly move over the fish in such a way that it is more likely to be taken than refused. Achieving effective water command is possible only with expert advice from your gillie, guide or boatsman, unless you have long personal experience of the water you are fishing.

(Above) Mending in a river with low water and moderate current, where the main aim is to lessen the stronger midcurrent's effect on the line – and thus vary the speed of the fly. Slighter mending is sufficient here.

Mending the line

One of the first lessons a salmon flyfisherman should learn, particularly if he is to fish mainly with a floating line, is the technique of mending the line. This refers to the movement which you give the line after it is cast and has fallen on the water. Normally a sinking line cannot be mended significantly, so it is important to make a good straight cast that will minimize the central current's influence on the line.

Of course, when fishing a river with a floating line, you are always casting across flowing water where the current's strength varies from one side to the other. Often the central current forms a "belly" in the line, and – as shown by the

illustrations – this gives the fly an unnatural movement. A very strong central current may cause so much belly that the fly is whipped round in a fast-moving arc, which is frequently quite unattractive to the fish.

But by switching the line upstream, mending its belly formation shortly after it has fallen on the water, you can slow down the fly and enable it to swing round more gradually. Sometimes the current speed varies widely – and the angler who can continually read the situation, mending or modifying the curves in his line, will have greater success than one who merely casts the fly across the flow and leaves it to fend for itself!

Mending in a river with high water and fast current is often done to decrease the speed of the fly. In waters where the current is irregular and varies in speed, you should keep adjusting the line's curve with bold and slight mendings.

In general, a longer rod improves your chances of creating effective mends. Especially on fast water, an upstream mend is often needed to slow down the fly. But sometimes, in very sluggish water, a downstream mend may be best. This increases the belly in the line, giving the fly more movement and speed to make it attractive.

When fishing with a sinking line, however, there is very little time in which to mend the line. If a sinking line is to be mended at all, this should be done just after the cast, before the fly and line can sink down in the water.

An understanding of the degree of movement which your fly must have in relation to the current, and thus the speed and angle at which it should be fished, will come only with experience. As already noted, a fly that passes too quickly over a lie may not incite the fish to take, while a fly that passes too slowly may be recognized as a trick or may fail to trigger the fish's attack mechanism.

Besides, what triggers a suitable response at one time may not do so at another. There are also variables of air and water temperature and clarity, climate, barometric pressure, oxygen content, and the general mood of the fish at a specific time of day or night. All of these add to the possibilities, and it is still true that no perfect formula can ensure the downfall of fish.

Methods

There are various distinctions between methods of salmonoid fishing. The most common methods on the British, Scandinavian and North American rivers are fishing with a sink-line and with a floating line. The former is most effective when the river is high and cold, whereas the latter is best for a low warm river.

In addition, numerous other approaches are used according to the conditions at hand. For example, on North American rivers it is normal to fish for salmon with a dry fly and a technique called "riffling hitch". In parts of the Scottish highlands, local methods such as "dibbling" are very popular. Large rivers like the Tweed in Scotland, and the Alta in Norway, tend to be fished best from a boat, as when harling.

Fresh-run fish

During the early season, the prime time for salmon fishermen, you can expect to catch some of the freshest fish of the entire season. Some of these may be bearing sea lice – the hallmark of fresh-run fish. It is assumed that sea lice can survive in fresh water for only 48 hours, but they have been known to do so for up to seven days under laboratory conditions. Even then, a fish with sea lice must be regarded as excellent, both for sport and on the table. However, you may get a poor fight from a fresh-run fish, especially when the water has warmed a little and when the fish may have run a long way in a short time. Such fish might be already partially exhausted from their swim, needing several days to get back into prize-fighting trim.

Another fish that may be encountered during the early months is called a kelt. This is an Atlantic salmon which entered the river during the previous year and spawned already during that autumn. Not all such fish return quickly to the sea. Many die, as do all the Pacific salmon species – and other kelts linger in fresh water, not returning to the estuary until March or April, particularly after a hard winter. Kelts are recognizable by their lean and lanky appearance, ragged fins, and distended vent. One should also look for maggots in gills, and not be fooled by an overall silver appearance – somewhat like that of fresh fish. Such kelts are merely in the process of donning their seagoing coat.

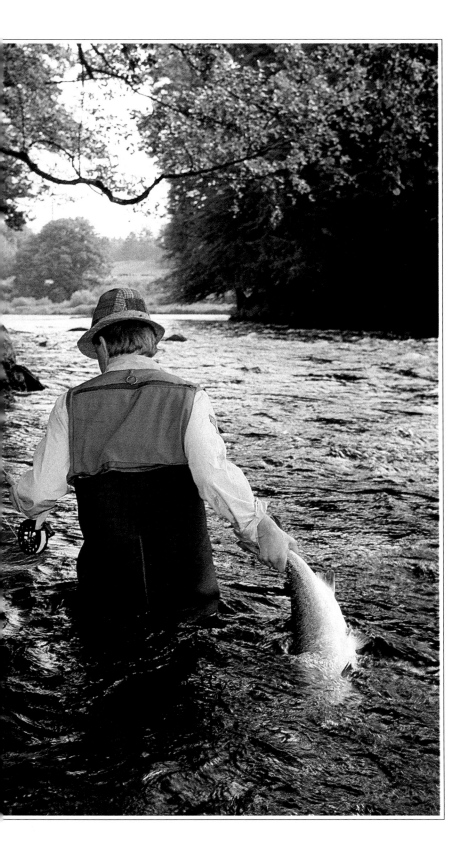

When hooked, a kelt does not normally fight as hard as a fresh salmon. But well-rested kelts may prove to be more stubborn fighters than is generally appreciated. The law in several countries is that all kelts must be returned to the water, although there are instances in North America where it is permitted to keep them. In any event, they are fairly useless as food.

Late spring salmon

Some Scottish rivers are famous for their early runs of salmon in January, February and March – a period often curiously called "spring" by anglers. Others become better for the sporting angler when spring turns into summer, from April to June. This is the heyday of the flyfisherman who enjoys fishing with a floating line, and when wading is more comfortable, with a general sense of spring in the air. There may still be lots of snow on the mountains, and a strong flow of water in the rivers – but for many of us, this is the peak of the season.

During the past few years, I have almost given up the early season so that I can concentrate on the latter period of better weather. This is a wonderful time to be alive on many of Scotland's classic rivers. Although the spring run on several of them is no longer as prolific as it was thirty years ago, the stocks build up gradually as summer arrives, and the big migrations of fish often do not come until late summer or early autumn.

However, in many other countries with stocks of Atlantic salmon, the season tends to be much shorter. In Norway it is confined to June, July and August, while in Iceland and North America it is more or less the same. There the angler is limited to the fine-weather season, and the styles of fishing are dictated only by the condition of the water. North American anglers often fish from canoes, making it easy to use a single-handed rod and small flies. Nevertheless, there must be situations where the American angler decreases his chances by adhering almost ritually to the single-handed rod.

The choice between treble, double or single hooks for flies is a popular subject in angling magazines. I like to have

The salmon could not resist the fly, fished with a single-handed rod and a floating line.

*High water level and a
strong, fast current.*

*Normal water level and
medium current.*

*Low water level and a
weak, slow current.*

A knowledge of bottom conditions and holding pools is
essential for successful salmon fishing. Above is shown an
area with high water level and strong current. Fish then
lie rather close to the shore, so the fisherman can – and
perhaps should – stand on land. At centre we see the same

stretch of river with normal water level. Wading may be
necessary to reach the fish. At bottom the river appears
with a low water level. Waders are now frequently a pre-
requisite for going in deep enough to fish the current, even
if it runs at the opposite bank as in this example.

GENERAL PRACTITIONER
Butt: oval gold tinsel
Tail: red breast feathers from golden pheasant
Body: orange seal fur or floss
Ribbing: oval gold tinsel
Body hackle: orange cock hackle
Wing: golden pheasant tippet feathers under,
 red breast feathers from golden pheasant over
Head: red

Shown above is how to tie General Practitioner, a very popular and effective fly in brownish and murky rivers. At right we see another orange-coloured fly, which has many salmon from well-sedimented rivers on its conscience: the Palmer-hackled Chillimps.

all three types on hand, and their relative merits should now be considered. Advocates of the treble hook rightly claim that it offers wonderful hooking potential. That a fish can take a treble hook, and then pull against the rod and line without becoming hooked, seems impossible. Of course, we all know that fish can and do fail to become hooked – but it may be reasonable to assume that they do so less frequently with treble hooks.

The problem with a treble hook – and this may be news to you – is that, for a given size, it experiences relatively great drag, or water resistance, when dangling in a current. The smaller treble-hooked flies tend to rise well up in the water in a strong current, and may lose effectiveness by skating on the surface or too near it. Interestingly, many North American anglers make use of this as a technique. They even put a half-hitch (sometimes called a riffling or

A simple trick can pull out a fly that has snagged on, say, a stone during sink-line fishing. By releasing line in the water, a downstream belly is formed. Then the line is tightened up with a subsequent strike, and the fly will frequently be released from its snag.

Newfoundland hitch) on the fly, so that it hangs at right angles from the leader. But in most North American salmon rivers, they are often limited to the use of a single-hooked fly, which may also have to be barbless.

The fewer hooks involved in a salmon fly sometimes cause it to swim a bit deeper. This can sometimes be an advantage, and the angler should be aware of the varying tactics made possible by using different hook styles, in order to use them when conditions dictate.

For much of the fishing in April and May, it is advisable to have already changed from a sinking line to a full floater. There may be occasional advantages in using a sinking line

or a floating line with sinking tip, but these are not easy to cast, and I consider them virtually needless on most of the rivers I fish. In this chapter I will therefore concentrate on fishing with a floating line.

The months of April and May in Scotland correspond very closely, as regards weather, with the months from June to August in North America, Scandinavia and Iceland. On the other hand, it is true that August may be a disappointing month anywhere. Consequently, if I had to restrict my salmon season to a specific period, I would choose the period from April to July.

At left is shown how to tie a hairwinged salmon fly, Blue Rat. The fly above is a hairwinged Cosseboom. Hairwinged salmon flies, which come originally from North America, are much easier to tie than the classic English salmon flies. It has thus become ever more common to tie even classic patterns with hair wings. These hardly fish worse, and are far cheaper.

BLUE RAT
Tag: oval gold tinsel
Tail: a bunch of peacock herls
Body: rear part of light-blue floss,
* front part of peacock herl*
Ribbing: oval gold tinsel
Wing: blue and gray hair
Sides: jungle cock
Cheeks: blue kingfisher
Hackle: grey cock hackle
Head: red

Low-water flies, as the name indicates, are used for low water levels, especially in summer. Since hairwing flies became accepted on European salmon rivers, however, low-water flies have declined in importance, since a sparsely tied hairwing fly fulfils the same function. Shown above are Blue Charm (left) and Silver Blue (right), tied as low-water flies. Both of these classic "killers" can, of course, also be tied as fully dressed and as hairwinged variants.

Summer fishing

One basic difference between Scotland and Scandinavia, as regards fishing, is the size of fly to be used. In Scotland during June, most of the snow has already melted and the rivers are fining down to summer level. A similar river in Norway or Iceland, however, still has a large run-off of melt-water; although the sun is high and air temperatures may be above 20° C (68° F), the water may be little more than 5-8° C (41-46° F). Often, therefore, the Scottish angler who is fishing water around 15° C (59° F) uses flies of smaller sizes (8-12) while the Scandinavian fisherman is still using big tubes and trebles up to 3 in (7.5 cm) long – the type used in Scotland during February and March.

Tactics in Scotland at this time may involve fishing mainly in the early morning and late evening. Certainly little can be achieved by fishing over low water on a hot sunny day when the air temperature soars over 20° C (68° F). Even in Norway, where the fresh fish are then entering the rivers, it might pay to delay your main effort until the sun has sunk behind the lofty mountains – or even, in the region which enjoys the midnight sun, to defer all fishing until evening and continue through the night. Some of the northernmost rivers, such as the famous Alta, are fished only between 6 PM and 6 AM.

Fishing for sea trout

Although salmon and sea trout have been treated above as similar species, they differ subtly in behaviour, and sometimes so much that entirely different tactics are needed when fishing for a specific species. Certain writers even suggest that the two types of fish cannot be related when discussing tactics. However, in reality you will often catch sea trout when fishing for salmon, and vice versa.

Handtailing is perhaps the most gentle and sportsmanlike way of landing a salmon. The fish is held by the tail so that your little finger points toward the tail fin. A woolen finger-glove improves the grip greatly and is especially helpful if the salmon is large.

This sea-trout fly, the Glödhäck, is a Swedish pattern that has proved to be extremely effective on the classic river Emån. It is characterized by a black hair for the wing, black hackle, and black dubbed body, with an orange "rump" and a ribbing of oval silver tinsel.

Heggeli is an old Norwegian fly pattern for sea trout, and has given very good results in most rivers. Notably for night fishing, it has become a widespread favourite. It has a black tail of tippets, silver body ribbed with oval silver tinsel, brown hen hackle, wing of brown-speckled mallard shoulder feather, and sides of jungle cock.

(Below) A sea trout usually takes the fly near or in the surface. The fly should be fairly small, size 6-10. Unlike salmon, sea trout actually feed also after starting their spawning migration, so they tend to take decisively and can seem quick, even violent.

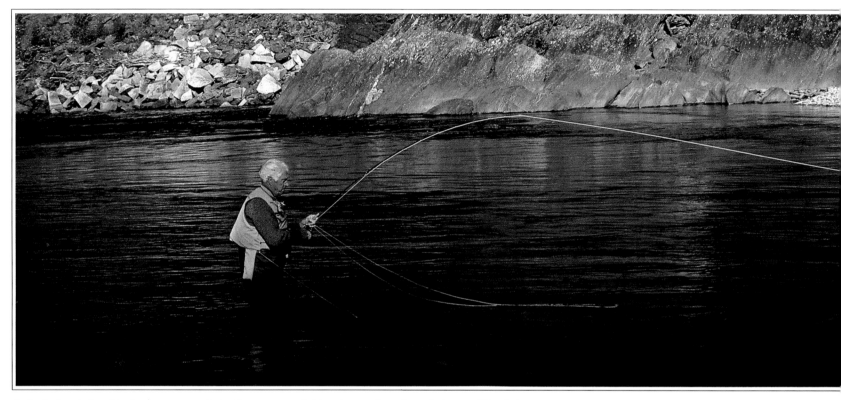

A single-handed rod is the commonest choice for sea-trout fishing, just as for salmon fishing in North America.

On most British rivers, sea trout begin to run only in late spring. They are often regarded as a summer fish, and in many places they are not encountered until July. At this time northern Europe has long periods of daylight, and fishing with a fly can offer greater rewards at night than at any other time.

Sea trout, particularly those that have been in a river for some time, are very shy. On their first run into fresh water, they may be quite easy to catch – but after only a short interval, it may turn out that they can only be caught at night. In midsummer, on the rivers of northern Europe, this may mean starting as late as 10 PM or so.

On normal waters, you should usually begin with a single-handed rod and a floating line, using flies of sizes 6-10, and fishing in the traditional style – casting across the current and letting the fly swing round. The water's sporting potential will tend to be indicated by the amount of surface activity among the sea trout. Takes are often savage, and the fish present some huge thrills as they charge about, trying to throw your hook.

Such sport may last until midnight and complete darkness. But sometimes a dead silence falls, leading you to conclude that the fish have gone down and ended the game for the night. However, this may be only a "half-time" pause by the fish, so that you can take a brief rest and resume fishing – with a sinking line and a big lure as long as 3 in (7.5 cm). This "second half" may be just the time to catch the larger sea trout, and you may be able to continue fishing until dawn.

Nights with a cold wind, or air colder than the water, should be avoided. Moonlight is not advantageous. The best nights are those with balmy breezes from the south-west, a little moisture in the air, and a myriad of insects dancing in the shadows of late evening. Sometimes, later in the season, the darkest nights offer the best sport of all.

Yet at other times, it is frequently possible to catch sea trout along with salmon. Despite notable differences in tactics, sea trout may respond in much the same manner as do salmon. Indeed, although salmon rarely take after dark, it happens on rivers like the Spey that a fish is caught in late

Dry flies are often used for salmon fishing in North America, and when fishing for sea trout in a few Norwegian rivers. Among the best-known dry flies is the Wulff series, created by Lee Wulff. Here we see Grey Wulff, which floats very well due to its tail and wings of hair, and to its bushy hackle of cock feathers.

GREY WULFF
Tying thread: black
Tail: bucktail
Body: dubbed grey wool
Wings: bucktail
Hackle: grey cock hackle

Pacific salmon

Of the five principal species of Pacific salmon known in western North America, the most important for sportsmen are the chinook, or king salmon (also called the tyee in parts of Canada), the coho or silver salmon, and the sockeye or red salmon. The others, the pink and the chum salmon, are plentiful but not very interesting for sport, and make only low-grade canned salmon.

My experience of fishing for these species has been confined to Alaska. There I have found that the coho, sockeye, and chinook can provide exceptional flyfishing when they are fresh-run. It is rare to see anyone using a double-handed rod, and only occasionally might one be needed. A light single-handed rod of 9-10 ft (2.7-3.0 m) is usually sufficient. Balance this with a floating line of size 7, sometimes with a sink-tip, and a test leader of 8-10 lbs. Then you can have some super sport, particularly with the coho and sockeye. The chinook does not respond very well to small flies, so it is advisable to use a sinking line and large lures, on extra-strong leaders of 20-25 lbs, in case you tangle with a monster weighing over 50 lbs (23 kg).

Much the same techniques as with Atlantic salmon are used for fishing with a floating line. But it pays to go very deep for the chinook, and to fish as slowly as possible. The fight from a chinook is about the same as from big Norwegian salmon, although it lacks the same lustre and cannot be compared on the table. Perhaps the highest gourmet marks are earned by the fresh-run sockeye. Indeed it is this species, when caught at sea, which goes into expensive cans of "prime red salmon". None of the other Pacific species get beyond the "pink salmon" label.

The most popular sea trout on the west coast of the United States is the sea-run rainbow trout called the steelhead. Among the most highly favoured by American flyfishermen, it is reckoned to be the "fightingest" fish on that continent. Many of the biggest specimens are taken with bait-fishing techniques, but a flyfisherman can get good results with large flies on sinking lines.

Most of the Pacific salmon species, however, are not seriously fished after they have been in fresh water for some time. Sockeye, for example, undergo a great physiological change soon after entering fresh water, acquiring the colour of goldfish with a green head. They are then pretty useless for food and sport, although they can be very eager fighters when fresh from the sea.

Perhaps the greatest sport is provided by the coho, or sil-

evening and you do not know what it is until you have netted it. Usually I do not care whether it is a salmon or a sea trout, for both are equally welcome on the table!

Salmon are commonly caught with dry flies in North America, but rarely in Europe. At times a dry fly is very effective for Scandinavian sea trout, even in the middle of the day – yet salmon can seldom be induced to succumb. Only a few times have I caught salmon on a dry fly which was intended for trout, and there have been a few more occasions when I caught sea trout.

The king salmon is a first-class fighter, and is readily coaxed with a large fly fished deep and slow.

An American method of salmon fishing is the riffling hitch. By attaching the fly to the leader with the knot shown above, the fly can be made to imitate an animal that swims on the surface across the current.

ver salmon. It resembles Atlantic salmon more closely, and fights like a tiger when it is fresh from the sea. While it responds well to smaller flies and lures fished on a single-handed rod, it may sometimes react better to a sink-tip floating line than to a full floater.

Many Alaskan rivers have favoured fly patterns. But the fish are ready takers to most lures, and a "Happy Hooker" or "Street Walker" is not always needed for success. To be sure, these patterns are highly decorative, as are many patterns for Pacific salmon in Alaska.

The Bristol Bay area of Alaska abounds with salmon rivers, and a visit by European anglers may prove less expensive than they expect. In fact, comparing the rent of a

Roe flies are a very common type in Alaskan rivers. Resembling individual roe eggs in colour and shape, they are not only useful when the Pacific salmon come up annually by the tens of thousands to spawn, followed by roe-eaters: normally grayling, Arctic char and rainbow trout. Such flies tied on large salmon hooks can also be quite effective for steelhead and Pacific salmon.

This fly, Babine Special, has a body of orange-red fluorescent chenille, a front hackle and waist hackle of white and red cock hackle respectively, and a red head. Since it is to be fished at the bottom, it should also be weighted with lead or copper wire.

private beat in Scotland, Iceland and Norway, then adding travel and hotel costs, it is quite likely that Alaska offers better value for the European fisherman. All fishing in Alaska is free, and you need only a state visitor's licence (about 20 US dollars), besides transport to a suitable location. Accommodations range from a simple tent to highly equipped lodges with all modern conveniences, which are situated on some of the best rivers. These, and a daily fly-out facility to remote rivers, are where the expenses begin to climb.

Alaska is definitely the place to go for that once-in-a-lifetime fishing trip. However, this must be carefully planned according to the type of fish you want. The chinook come in first, usually around mid-June to mid-July. They are quickly followed by the sockeye and chum salmon, in July and early August. The coho tend to arrive last, providing best sport in August and September. Throughout this time, of course, there is superb fishing for wild rainbow trout and Arctic char. It all adds up to an unforgettable experience.

Still-water salmon and sea trout fishing

Catching migratory fish in still waters is not possible at many places in the world, but it can be done effectively on a number of Scottish lochs and small Norwegian fjords. Of course, the water must not be too deep and you have to know that it contains fish. Usually a boat offers much better chances than fishing from a bank. On the whole, still-water fishing calls for a special skill, and may be less simple than it seems at first.

Quite often, a short line on a single-handed rod will catch salmon, while a long line will get the sea trout. Flies tend to be very small in comparison to river flies. The best results with salmon are frequently obtained just as the fly is approaching the boat and is suspended on the crest of a wave, as you prepare for the next cast. But sea trout may respond best to a long cast on a very long leader. Sometimes it pays to use a light fly line (AFTM class 5-6) and a leader with up to 20 m (65 ft) of fine monofilament of about 6 lbs test. The best response is often made to a fly near the surface, and a light line enables you to bring the fly up to the surface soon after a cast.

It is important that the water has a good wave on the surface. A windless day may well produce no results. If you have a boatman, he will doubtless row slightly upwind, so that the track would take you in a crosswind direction. If you cast with the wind, the boat's movement will slowly swing the flies round in a neat arc.

I prefer to fish still waters with two flies, but there is no reason not to use three, or even just one. Sometimes in mid-summer, I also use two flies when fishing in a river – yet there can be problems in playing a fish if it has taken the dropper. Then the tail fly is dragging about, and may get caught in weeds or another obstacle. Usually I put the salmon fly on the tail, and a sea-trout fly on the dropper, although the fish are certainly less concerned about this than we are. When fishing at dusk on a late June evening, you will indeed frequently get salmon on the sea-trout fly, and sea trout on the salmon fly.

Saltwater flyfishing

*Flyfishing in salt water
has grown from an infant to a giant
in the past few years. Where only a few
anglers practised the art, principally in the
Florida Keys three decades
ago, there are now fishermen who
are journeying to all parts of the world to
fish new and untested waters. The
unexplored frontier
for the sport is undoubtedly
in the Pacific. Australia, New Guinea,
Fiji and many other islands in this region
are already being sampled. The results
have been outstanding!*

Tackle has improved dramatically. Rods for graphite are available that are light enough even for women to easily cast, making it comfortable to fish with larger and stronger tackle, which is often needed to subdue these powerful fish. Reels developed just for salt water are now so over-designed that they will handle far more than will ever be demanded of them. Fly lines have improved, with special ones developed just for saltwater use. In the world of fly patterns there are now several hundred, where a few years ago anglers only used several dozen basic flies. Even the materials that today's saltwater patterns are made from have changed. Vast improvements have occurred.

For many Europeans shut off from fishing private waters in their countries, and for other fishermen around the world who see their fresh waters deteriorating or disappearing, flyfishermen are looking to other areas where they can enjoy their sport. Salt water offers unlimited opportunities for this. Flyfishermen can effectively catch fish in waters to about 60 ft (20 m) deep with new tackle and flies. In waters less than 10 ft (3 m) deep, fly tackle is often more effective than other types of artificial lures. In very shallow waters (2 feet or less) realistic flies can be presented so quietly that often the flyfisherman can catch fish better than someone using any other tackle, or even bait! This is especially true with wary species such as bonefish which, when feeding, will frequent waters so shallow that their dorsal fins often protrude above the surface. Under these conditions many fish are extremely wary and will flee at the slightest splash of a lure or bait. The silent entry of a fly is often the best way to present to such fish.

Great fighters

Salt water also offers other bonuses. Most fish sought by fly rodders in fresh water do not have many predators. The fish they seek are at the top of the food chain and it is they who are doing the chasing. But in the sea, nearly every fish is being eaten by another that is larger and more fierce. While some bottom-living species, when attacked, can retreat into a cave or under a rock, most saltwater species can only escape by going away. And they must swim faster and farther than the predator or they will be eaten. Such an environment produces fish that are much superior to freshwater fish, as far as speed and endurance are concerned.

All of this is a plus to the flyfisherman. When the hook is set in most saltwater species (other than some bottom-living types), the fish give a far better fight and run off more line than almost any freshwater species. The first time an angler hooks a 5-lb (2.3-kg) bonefish and watches the line melt from his reel as this relatively tiny fish pulls off more 100 yards (30 m) of backing in that first burst of speed, he cannot believe that it is the same fish that took his fly. To battle a tuna, trevally, large mackerel, or any swift open-sea fish is a delight and surprise to the angler who first hooks one of these speedsters. And because of their strength and speed, special tackle is often required to subdue these fish.

There are two basic kinds of flyfishing in the sea: inshore and offshore. Inshore waters are those within about a half mile (1 km) or so of the coast, and usually not more than 12-15 ft (4-5 m) deep. Waters deeper than that are generally regarded as offshore, and usually require different tackle and different fishing techniques.

In colder seas, such as off the coasts of Europe and the northeastern and northwestern United States, flyfishing is not productive for much of the year. Even when it is, generally the numbers of species and times that you can catch them on flies are limited. There are some bottom species in all of these estuaries that will take a fly; mackerel, bluefish and some other species may appear during warmer months. But the most exciting world of saltwater flyfishing is confined to waters where temperatures in the sea rarely drop below 60 degrees and often are 80 degrees or warmer. The closer one gets to the equator, the more opportunities exist for year-round flyfishing. In these warmer seas, food is abundant all through the year and there are many predators that take flies. Many of the species that inhabit these warmer oceans in cold weather will migrate briefly north and then return as the water temperatures drop.

Sharks belong to the true big game of the seas, and can be caught with flies in many parts of the world. Offering a long hard battle, they are superb to play on a fly rod.

Flyfishing inshore

When fishing the shallows, two basic approaches are taken. In very shallow, clear waters, such as the flats along the coasts of Africa, Florida, the Bahamas, Yucatan and islands in the south Pacific, many species of fish live in slightly deeper waters, but move into the shallows to feed. Such species include the famous bonefish, permit, tarpon, snook, trevally, threadfin salmon, barramundi, snappers, groupers and channel bass. Much of this is sight fishing, among the most interesting of all kinds of fishing. The angler either wades or else is propelled in a boat (usually with someone poling it) across the flats (shallow saltwater areas are often called flats); it is a combination of hunting and fishing. Both the angler in the bow of the boat, armed with a fly rod, and the person poling the boat are looking for fish. Once the fish is seen, the poler attempts to position the boat so that the angler can make a productive cast. This hunting/fishing offers great appeal to many fishermen, and is a major reason why tarpon, bonefish and permit are among the most publicized and popular of all species sought with a fly rod in salt water.

Noticing the fish

Sight fishing, and knowing how to look for and see fish in the shallows, require some skills. Fortunately, most of them are easy to master. First, the angler needs the proper equipment, so that he can see. A hat is essential, preferably one with a dark under-brim. This cuts down glare reflected from the water and allows the angler to see much better; hats with bright under-brims reflect the glare from the water into the eyes. The other piece of equipment that helps the angler's vision penetrate the surface is a good pair of polarizing glasses. These help to remove most of the glare from the surface. While it is a personal choice, most experienced "flats fishermen" prefer brown or amber-tinted glasses, rather than gray or green-tinted ones. The brown or amber builds contrast and makes it easier to see these fish. It should be remembered that tarpon, bonefish, permit and many other species have silvery sides, which act much like a mirror. When a tarpon, whose back is dark green, swims over light sand it is very easy to see: the back stands out against the light sand. But when the same fish cruises over

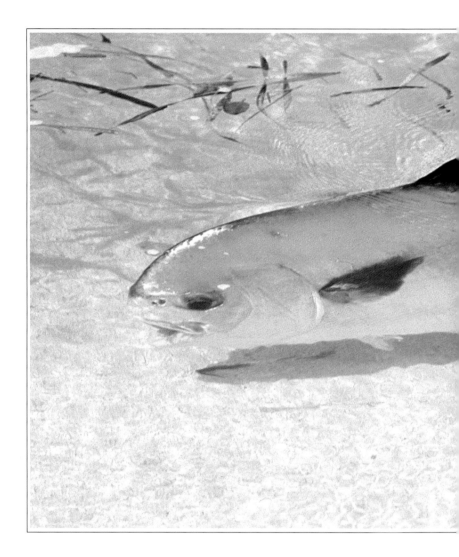

dark-green turtle grass, it becomes very difficult to see. This is true of all flats fish that are silvery in colour.

Fortunately, there are some skills you can learn that help you to see fish with mirror-like sides. You look for any fish swimming in very shallow water differently than when they are moving in deeper water. A fish swimming in water less than 1 ft (30 cm) deep will create wakes, ripples and small swirls on the surface. Indeed, some fish stand on their heads to root out a bit of food. This means the tail may protrude above the surface, so the angler should look intently at the surface. Anything that moves will instantly be noticeable.

When the fish are in water deeper than that, the angler

cattle, the walker would interrupt his vision and be seen. By looking at the bottom, any movement of fish between the bottom and the viewer is instantly noticed.

The angle of the sun is also important when looking for fish in the shallows. The best angle is to have the sun at your back, or at the back and a little to one side. That is when the least glare occurs on the water. Sometimes it pays to plan your approach according to existing conditions. If there are white clouds in the sky, it is a good idea to move across the flats so that these clouds are not in the direction of movement. By approaching the clouds, the angler will be looking at the glare on the water, and even polarizing glasses will not penetrate the white reflection. Near islands or tall growth, the fish will be much easier to see if the angler looks in the direction where their dark green is reflected on the surface. This type of background allows the viewer to look clearly at the bottom.

Any unusual disturbance of the surface is also an indicator. If waves are moving in the opposite direction from the wind, something is pushing them. Often bonefish, especially, can be discovered by observing that some waves are moving in a different direction. And nervous waters (any small ripples) are a tip-off that something is creating the disturbance. Many kinds of fish, such as bonefish and sea trout, muddy the water as they root on the bottom. Try fishing where the mud is most dense or bright in colour. That is where the fish are active. By fishing a sinking fly through mud, you can often get terrific fishing. Once in Belize, we found a large mud, and caught bonefish for more than two hours on nearly every cast, using weighted bonefish flies. Casting into the muddiest area of the water, we allowed the fly to fall to the bottom. Then it was moved along in little hopping motions. Rarely did the fly travel more than a few yards before a bonefish found it.

Many fish can be caught near rays, such as sting rays and mana rays. Rays often get their food by descending to the bottom, where they pound their heavy wings against it. This frightens shrimp, crabs and other food morsels from the grass and mud, which attempt to flee. The ray then grabs what it can. Rays are slow-moving, but predator species are much swifter and will often hover over the ray. If a shrimp or crab slips out from under the pounding wings, the predator often grabs it before the ray can. This means that the hovering predator is in a feeding mood. The ray creates a long streak of mud that is swept away by the current. By locating the muddiest water, and casting a fly a foot or so uptide from it, the fly can be retrieved over the ray, and into

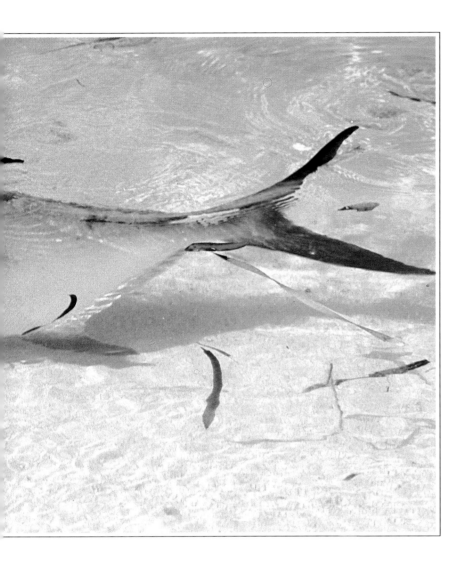

Like many other species on the "flats", permit have silvery sides that can make them almost undetectable to us. Being very shy, they are also considered difficult to attract to take.

should look at the bottom. If you look at the surface, you will often miss seeing fish that are cruising below. To understand this, visualize someone looking at a person walking along a road. The viewer does not see the cattle in the field behind the walker. But if the viewer were looking at the cattle and the person walked between him and the

the mouth of a predator. Fish also have a tendency to follow rays – even in deeper waters. Anytime a flyfisherman notices a swimming ray, it should be checked to see if a predator species is following it. Mutton snappers are extremely wary fish (more so than permit, which are famous for being difficult to fool) but can be caught with flies rather easily, since they have a habit of cruising over a ray and can then be deceived.

Planning your catch

Perhaps the main factor in successfully hooking a saltwater fish, especially in the shallows, is how you approach and make your presentation. A noisy approach or a loud splash of the fly or line near the fish will frighten it. Because these predators are in the shallows and they know they can be seen easily, they are wary and will flee to the depths at the slightest indication of alarm. So the approach to such fish must be silent and carefully planned, and the presentation of the fly must be very correct.

When feeding, most predators working a flat approach it from the downtide side. Therefore, if the tide is flowing from the north to the south, the fish will enter the flat usually from the south, working into the current. The reason is that the tide carries the scent of their prey to them. It is amazing how far fish can smell shrimp, crabs and other food. In fact, some experienced anglers will anchor uptide on a white sand spot. They deposit chum (cut shrimp, conch crab or other fish food) in a sealed pipe drilled with holes to carry the scent to the fish but not allowing them to eat it, or scatter the bait on a white spot on the bottom. Smelling the bait more than 100 yards (30 m) downcurrent, fish will come into the white sand. This makes them easier for the angler to see, so an accurate cast can be made.

It is good to understand that fish feed in the shallows much as a bird-dog hunts. The dog goes into a field downwind, lifts its nose and catches the scent of the birds as it manoeuvres through the field. Fish do the same thing. Entering a flat from the downtide side, a fish moves into the current, picking up the scent of shrimp crabs and other food. It wends itself back and forth into the current. Armed with this knowledge, an angler has an advantage. By wading or moving in a boat from the uptide side, the angler is in a good position to cast to approaching fish.

Presenting the fly correctly

Of paramount importance in both fresh and salt water is the awareness that, when a fly is offered to a fish, it expects to pursue this baitfish, crab, shrimp or other food source. It does not expect to be attacked by a prey species. Yet we often wrongly give that impression when we present a fly to a fish.

Any fly which is retrieved so that it approaches the fish from the rear, or is brought back directly at the fish, is an unnatural occurrence and the fish will usually not strike. The very best method of retrieving to a fish is in the natural way. If the fish is swimming or facing into the tide, the angler should either wade or move the boat to one side and in front of the fish. Then a cast can be made upcurrent and a few feet to the far side ot the fish. As the fly is retrieved, the current draws it down to the fish. A few feet (1 m) in front of the fish, the fly makes a turn and begins to move upcurrent, back toward the angler. A fish is used to seeing prey species drift toward it on the current and then suddenly, realizing the danger, turn and move away. Such a retrieve is the best of all. Another good method: if a fish approaches you, throw the fly several feet (2-3 m) to one side and in front of the fish – not in a direct line with it. As the fly is brought back, the fish notices it appearing to escape.

Three incorrect or bad retrieves are often made. The angler casts well to the other side of the fish and begins to bring the fly back, but the current sweeps the fly downstream of the fish, and it comes from the side appearing to attack the fish. If a fish is swimming away from you, never throw over its back and retrieve it straight toward the fish. And perhaps the worst retrieve is to throw a fly to a fish lying directly below you, so that the fly lands behind the fish and approaches it from the rear – this almost always results in the fish fleeing.

A typical scene from the tropical and subtropical shallow flats, where flyfishermen challenge permit and bonefish – among other species. The inset picture shows a tailing bonefish that stands on its nose digging out morsels of food with its tail protruding above the surface.

Flyfishing offshore

Flyfishing in water deeper than 10 feet (3 m), and on the open sea, requires different techniques than fishing in the shallows. In most cases something is used to lure the fish to the angler. Then a fly is presented. One common method is trolling a lure until a fish is hooked and brought near the boat. Many species tend to swim in schools, and others follow the hooked fish to the boat where the angler can make his presentation. Chuggers, sometimes called bloopers, are another way of luring fish within range of the fly caster. A large, floating casting plug devoid of hooks, with a scooped face, is thrown out on the surface. By giving hard jerks on the rod, the lure makes a loud gurgling sound, which many fish find attractive. As they rise to attack the plug, the fly is dropped nearby, usually resulting in a strike. Another method of luring fish is to chum. Ground or chopped pieces of fish, or sometimes even small whole fish, are sent overboard on the tide. Fish are lured to the food source, where the angler can make his cast. This is perhaps the most commonly used method of luring fish within casting range on open water.

Another method is used by billfishermen seeking marlin and sailfish. A hookless bait or artificial lure (called a teaser) is trolled on the ocean to attract a billfish. The angler has a partner who manipulates the teaser. The fish attacks the bait and mauls it, while the teaser is pulled closer. When the enraged fish is lured within a few feet of the boat, the teaser is jerked out of the water and the fly is placed in front of the billfish – which usually attacks it.

The use of lead-core shooting heads, and extremely fast-sinking fly lines that are loaded with lead dust, also allows anglers to fish to depths of 60 feet (20 m) if the tide is not running too strongly. This is often slow fishing, but anglers who are willing to cast the fast-sinking lines and allow them to descend into the depths are catching some very large reef species.

In flyfishing at sea, the quarry is often teased close to a boat by suspending small live fish in the surface layer. Then they are removed and a fly is substituted.

Poppers are used mainly in the USA when fishing for cobia, shark and sailfish. These bugs, having a flat or bowl-shaped front part, are often made of plastic, cork or balsa wood. But foam rubber material has become ever more common, since even big bugs are then easy and simple to cast. Popping bugs emit their sound when they scuttle across the surface as you take in the line fast. This sound may be fairly loud and probably makes the fish think some large prey is fleeing. It certainly seems attractive to many saltwater species and often triggers strikes.

Divers are bugs tied with deer hair. For fishing in shallow water, this Dahlberg Diver is superb, although bugs are usually heavy and hard to cast. Most typically, they have a deer-hair head that is trimmed to slope backward in a conical shape. Like many other bugs, this one has a hook shield of monofilament nylon line, so as not to snag on underwater plants. It can be fished floating – by taking it in with jerks at the surface, to make a popping sound – and as a streamer, whose slithering movements seem very attractive to fish.

Sliders are a variant of popping bugs, with a conical front body. Due to its streamlined, rocket-like tip, the fly is easy to cast even in windy weather. It also moves more quietly and calmly in the water, which is most useful if you are after shy fish in the shallows. This type of fly is meant to imitate small, wounded prey fish at the surface – that is, rather easily caught ones. The colour of a slider has little importance, where-as its size and the way it is fished at the surface often determine whether or not the fish will attack it.

Saltwater flies

Size, colour, shape, and sink rate are all important factors when considering flies to catch saltwater fish. Size is per-haps the most important. Some fish, such as bonefish, have a small mouth; others, such as cobia, snappers and groupers all have large mouths. Offering a 5-in (13-cm) fly to a bone-fish is almost certain to result in a refusal. And presenting a very small fly to a big fish with a large mouth will rarely convince the fish to strike. Bonito, for example, roam the world's seas, and they seem to prefer feeding on small 2-3 in (5-8 cm) slim minnows. A streamer fly that imitates these baits will do well. Cobia, sharks, and many other species all want larger flies. Cobia are a good example of where size is often vital to drawing a strike. Even a big 10-in (25-cm) bulky sailfish fly will often be refused by this fish. But a large popping bug that makes considerable noise will often result in a powerful strike. I believe that the popper, though smaller than a streamer, creates so much disturbance that it persuades cobia and other species that here is a much larger prey – and so they strike. Barracudas often scorn streamer

flies, but a 0.5-1.0 (2-3 cm) popping bug that is manipulated quickly across the surface will often cause them to hit. Apparently such a disturbance creates the impression that here is something large and edible that is rapidly getting away.

Frequently size is more important in fly patterns than how the fly is dressed. For some species, however, colour often plays a key role in whether the fish will strike. Striped bass and European bass often like a certain colour better than others. This can vary during the same day, so it pays to experiment with these fish. Sea trout and weakfish will often prefer a chartreuse or bright yellow colour. Fish that live on reefs, where the fly is fished at least 10-30 ft (3-9 m) down, can often be caught sooner on flies that have the dressing made from fluorescent colours, which can be seen in their true tints at greater depths. Snook seem to go for bright yellow combinations. Many offshore species are best caught on streamer flies that have a blue or green back and white belly. Almost all streamer flies fished in open waters are better if their belly is white, the colour of every prey species that predators feed upon.

Coastal flyfishing along the shallow coasts of northern Europe is sometimes extraordinarily rewarding. Common catches are garfish (see inset), sea trout, mackerel, cod and coalfish.

Surface flies

The most popular surface flies are popping bugs. They were made originally of cork, then of balsa wood, but lately the use of closed-cell foam plastics has increased. These are much lighter and easier to cast, and fairly large bugs can be made that weigh far less than those of the same size in cork or balsa wood. The buoys used by commercial fishermen to mark their traps and pots are an excellent material to fashion popping bugs from. Tough, very light and easy to work with, they make superb popping bugs.

Poppers come in two different designs. The standard bug is one with a flat or cup-forward face. On the retrieve, the line is stripped quickly and the bug moves forward, pushing water and making a popping sound. This is very attractive to many species of saltwater fish. The other type of popping bug is called a slider, shaped more like the cone on a rocket or the front end of a bullet. This pointed bug makes little disturbance on the surface. In situations where fish are wary, or easily alarmed when in shallow water, the slider can be manipulated without a great deal of disturbance, which may frighten the fish. The slider is usually tied to resemble a minnow or baitfish. It represents an injured minnow, struggling on the surface – appearing to be an easy meal for a predator. Many experienced anglers, myself included, feel that the colour of a popping bug is not important. What is important is the size of the bug and how it is manipulated on the surface.

Deer-hair popping bugs are rarely used in salt water, but are a favourite of many freshwater fishermen. The deer-hair bug is bulky, difficult to cast against the ever-present sea breeze; and after being fished for a while, the deer hair soaks up water. This makes it heavier and more difficult to

This streamer, of the synthetic material organza, is very common for coastal flyfishing in southern Scandinavia. An organza streamer nicely imitates a little silvery prey fish, and is thus extremely effective in catching, for example, sea trout. Like most streamers, this one is usually tied on straight-eyed hooks 3-5 cm (1.2-2.0 in) long.

Ullsocken is a Swedish fly that has long been used in the country's southern salmon and sea-trout rivers. But coastal flyfishermen discovered that it can also be fished as an imitation of a ragworm. Not least the sea trout, which seek shallow coves during the spring in order to feast on these hairy worms, find it hard to resist the fly. Its tail is tied with red wool, the body of peacock herl or floss, and the hackle of brown cock or hen hackle feather.

The above streamer has been given a wing of marabou feathers, and represents an effective type for several species. It can naturally also be tied with hair wings, but its movement in the water is then less lively. The fly can be fished either superficially or deep – for sea trout, garfish, mackerel, cod, coalfish and many other species. The wing colours may be varied, yet green, red, yellow, orange and/or blue flies have proved good.

cast, and it doesn't work as well on the surface. However, one deer bug is superb in shallow saltwater situations around the world: the Dahlberg Diver. This has a body and wing of a baitfish, but the head is made from spun deer hair and clipped. The result is a cone-shaped head that slants back to a large collar. When manipulated on the surface, the bug makes a popping sound. Yet if the retrieve is constant, the bug dives under the water and swims in a wobbling motion. Thus, the lure can be worked as a popper, streamer, or sometimes a combination of the two. It can be popped several times, then made to dive and swim a short distance. The retrieve is stopped and the bug slowly rises to the surface, where the retrieve can be repeated over and over. The bug is almost always dressed with a monofilament weed guard, which allows it to be cast into or near brush, without fear of getting it snagged in the trees.

Streamers for deeper water

There are also lures that work in the water column, not on the surface or bottom. These are the most familiar to fly-fishermen. Most are called streamers, and are meant to imitate minnows or other baitfish, shrimps or crabs. Some are dressed lightly and without weight, to travel just under the surface. Others are weighted, usually with lead wire or lead eyes, to drive them deeper. Many are imitations of baitfish, usually with a white belly and a green, gray or blue back. The addition of large eyes to some of these streamer flies seems to increase the number of strikes. Large, weightless eyes can be placed on streamers by painting an eye on a duck feather attached to the forward portion of the fly.

Lead eyes are often useful in getting flies deeper in the water. These are miniature dumb-bells made of lead, in five sizes from 1/100 ounce to 1/10 ounce (0.28-2.8 g). They offer two attributes. By using various weights of lead eyes, you can control how deep you want the fly to dive. And eyes on flies, in my opinion, always help draw strikes. These eyes can be painted in any colours.

One streamer that has become very popular in saltwater flyfishing is the Bend Back. This is a standard streamer, but tied on a hook that is slightly bent. The wing is tied in reverse style. This causes the fly to ride with the hook up – nestled inside the wing, which makes it nearly snag-proof. A Bend Back can be tossed into mangroves or other brush and very carefully retrieved without snagging. It can also be fished close to the bottom with the same benefits.

Another method commonly used in tying flies that will not catch on weeds or obstructions is the use of a monofilament weed guard. This is a loop of stiff nylon monofilament, usually 15-30 pounds in test. It comes from the back of the hook down under the point and is attached at the hook eye. This mono loop also allows flies to be fished where they would snag without it. A further method of making weedless hooks is with stainless-steel trolling wire, tied on the hook just behind the eye, then bent downward to form a metal guard that protects the hook point. When a fish grabs a fly with a nylon or monofilament weed guard, the material is soft enough that it collapses on the strike, allowing the angler to hook the fish. But both materials are strong enough to push the fly away from weeds or snags.

This typical tarpon fly, like all other flies for saltwater fishing, obviously should be tied on a corrosion-resistant hook. The long wings made of hackle feathers must be tied on the hook back, and the shank wound tightly with coloured tying thread or stainless tinsel. The fly can also be given a hackle just in front of the wing.

Black Deceiver is an example of a dark, contrasting all-round streamer for fishing in deep water. Its wing is tied with black hackle feathers and, on the outside, black hair. Some long strips of silver tinsel are also tied into the wing. The head has painted eyes to give the fly a more realistic look, which can often bring a strike.

Joe Brooks' Blonde series of flies are now classic all-rounders for saltwater fishing. They are typical bucktails and have brought good memories to flyfishermen around the world for many years. Their colour variants include being tied entirely of black or white bucktail, or with an orange tail and red wing, or a white tail and green wing.

Tides

One prerequisite to successful saltwater fishing with any tackle is an understanding of the tides. Unlike fresh water, where rivers flow and lakes are static, gravitational pull affects large bodies of salt water, causing movements of current and changes in water height.

What is not generally realized by light-tackle and fly-fishermen is why tides are so important. Baitfish are a major source of food for many predator species that flyfishermen try to catch. Minnows and other small fish in the sea have no home. In a river, when a flood occurs, the minnows that live in a certain pool hide behind rocks or under cut banks, away from the current. They attempt to stay in the pool where they were born. But saltwater baitfish make no such attempt. They were born in open waters and they allow the current to take them wherever it may. It would be foolish for them to burn energy and try to stay where they are, when there is no reason to do so.

Thus the tide moves the baitfish – and predatory fish know this. They prefer places where the tidal flow moves the bait or concentrates it. The fish must understand tidal effects in order to survive, while the angler must learn the effects on the bait and predatory species if he is to consistently catch fish.

While the sun is much larger, the moon is much closer to the earth. The gravitational pull of the moon is the main cause of tidal flows on Earth, but the sun also has an effect. When there is a line-up of the moon, sun and earth, a major gravitational pull occurs. When the sun and moon are at right angles to the earth, a lesser gravitational pull occurs. In most places, the seas rise slightly higher and fall slightly lower than the week before; the following week they will not rise as high or fall as low; then the effects are repeated. In other words, every other week there is an extra high and low "spring" tide, followed by a week of "neap" tides that are not as pronounced.

It is useful to remember that tides repeat themselves every two weeks. If you were at Rum Bottle Bank on Saturday morning, and fishing was great on a high falling tide, you should not return the following Saturday – for the tides would be almost opposite. But if you go back two weeks later, you find almost identical conditions, unless there is a major weather change such as strong wind.

It is easy to tell when there are spring tides and when there are neap tides. On weeks with no moon or a full moon, the spring tides occur, and the rise and fall are much greater. When there is a quarter-moon week, the tides will not rise and fall as much.

How do tides affect flyfishing? Many shallow-water species will not come up on flats until these are flooded with water. In most situations around the world, flats-feeding fish, such as bonefish and permit, will move up on a flat as the tide is rising, and retreat as it begins to fall. However, some flats do have better fishing on falling tides than rising tides. This is a good reason why guides are often useful.

In a small bay that fills on a higher tide and exits through a narrow opening, the flyfisherman has an advantage. As the water pours in, filling the bay, it will carry baitfish. As the bay empties, the tide will flush the bait along with the water. Fish know this, so they feed at the inlet side when the tide is coming into a bay, and on the outside as the water is leaving through its natural funnel mouth. In areas where flooding tide rises and drowns mangrove and other rooted plants along the shoreline, baitfish swarm there to feed. The predators do not try to chase them at this stage of the tide, but locate a depression or ditch that is among the last places to drain from the root system. Here is a natural funnel, and the baitfish will wait until the last moment before coming out of it. Locate these outlets and fish the last half of the falling tide, and you stand a good chance of hooking predatory fish.

The Flyfisherman's dream waters

*Salmonoids are still
ranked highest among our catches,
but several other kinds of fish are becoming
ever more interesting. Except in the very
deepest waters, nearly all
predatory fish can
be caught with a fly and fly rod.
Committed flyfishermen have developed
into the most lively travellers of our time,
and it is not unusual that
summer fishing for salmon in Alaska is
followed by winter trips to the tropical flats
for bonefish. A flyfisherman on the move is
thus always in high season – whatever
the place and species.*

All of us naturally have our own favourite waters, which best suit our individual temperaments for one reason or another. Even so, there are certain fishing waters that pop up again and again in the historical literature and the many current sporting magazines. These are often waters that have meant a lot for the development of flyfishing, or have recently brought modern flyfishing a big step forward, or else simply offer a marvelous opportunity for good fishing.

In the Northern Hemisphere, flyfishermen originally sought only salmonoids in flowing waters. But today, our fly rods are being swung over almost every type of water – and at species which were previously thought to be out of the question. Our equipment, too, has undergone significant improvement during the past few years, and this is the immediate reason why flyfishermen have been able to take command of new, different waters. If we choose, we can now cast farther, and fish deeper, than ever before. Thus we can adapt to conditions everywhere from the smallest streams to the wide stormy oceans.

Sadly, a number of the fishing waters that are most significant in historical terms cannot be included in the following "world tour", since they have fallen victim to man's rough treatment of nature. Yet such former dream waters may belong to the Happy Hunting Grounds where those who once experienced their grandeur still wander along the banks to challenge their denizens with simple flies, twined horsehair line, and split-cane rod in hand. Blessed be their memory!

Scandinavia

Among the colder parts of the world, we find some of the indisputably best fishing waters for salmonoids in the far north of Europe. Here, ideal conditions have been established by nature for large, strong stocks of big salmon,

Scandinavia has some of the world's best fishing waters for salmon or sea trout, as well as for large trout: (1) Karup Å, (2) Gelså, (3) Mörrumsån, (4) Emån, (5) Storån, (6) Kaitumälven, (7) Gaula, Orkla and Stjördal, (8) Leardalsälven and Aurlandsälven, (9) Tana, (10) Alta, (11) Kuusinki, Kitkajoki and Oulankajoki, (12) Laxá and Grimsá.

trout and grayling. Not that we have always understood the value of these resources – and many of the region's finest flyfishing waters have been abused, or even devastated, through the decades.

Denmark

Beginning in southernmost Scandinavia, the flat confines of Denmark hold outstanding trout streams. One of them is Karup Å, which annually yields fish of 10 kg (22 lbs) to its faithful worshippers. Most are caught during the evening and night hours, when good local knowledge is needed to walk safely on the swampy ground along the banks. The fishing is done with a floating line by night – and with a sinking line by day, since the fish then seldom rise to a dry fly.

The former world record for rod-caught sea trout comes from the Karup Å. It was a silvery female of 14.4 kg (31 lbs 12 oz), caught in 1939 – although not on a fly. The biggest fly-caught sea trout in Denmark, from the Gelså farther south, weighed no less than 13.85 kg (30 lbs 8 oz). This

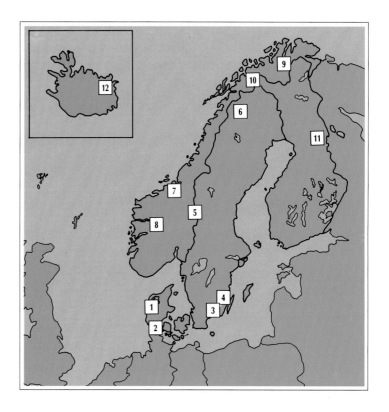

catch is only a few years old, and shows that there are very large sea trout in the nutritious Danish waters.

Also belonging to Denmark, but lying just south of Sweden's southern coast, is the rocky little island of Bornholm. It offers fine winter fishing for sea trout, at times both abundant and sizeable. During the winter, the fish thrive in the cold, brackish Baltic water, which they prefer to the mixture of cold and salty waters of the coasts farther north and west.

Sweden

At least as big are the sea trout in Sweden, for which the rivers Mörrum and Em have long been particularly famous. Quite a few sea trout are landed there at over 15 kg (33 lbs), and fish around 10 kg (22 lbs) are almost daily food. Both of these streams offer, in addition, excellent fishing for Baltic salmon. The big sea trout and the salmon migrate away in the Baltic to hunt the herring schools, which give them a record-breaking growth. Notably during the winter months, many big sea trout swim along the southern Swedish coast, available for anybody who wants to tempt them with a large streamer or bucktail.

In the northern parts of the country, there are naturally a lot of fine trout waters, both still and flowing. The trout and grayling are plentiful, though often not very big. Streams like the Storån – where, by the way, Frank Sawyer fished with great success – and the Kaitum River have earned a firm place in the hearts of many trout fishermen.

Norway

Without a doubt, Norway is the flyfisherman's El Dorado when it comes to big Atlantic salmon. This mountainous country, whose long coast is always in contact with the constantly warm Gulf Stream, has more than 220 salmon-rich rivers. These waters definitely yield the world's largest Atlantic salmon – many of them over 10 kg (22 lbs), some

A record salmon caught in the Mörrumsån, weighing 22.9 kg (50 lbs 8 oz).

over 20 kg and a few over the magic 30-kg mark. The biggest salmon caught on a rod in Norway weighed all of 36 kg (79 lbs 6 oz).

It is difficult to make a small selection of Norway's salmon rivers, but certainly the area around the city of Trondheim offers a range of truly productive waters. Names such as the Gaula, Stjördal, Orkla, Namsen and Surna inevitably arouse strong memories among the flyfishermen who have wet their lines there. And all of these have become still better in the wake of restrictions on professional fishing, which went into effect in Norway during 1989.

Farthest into the Sognefjord, northeast of Bergen, lie two other renowned rivers – the Laerdal and Aurland. Even though at least the Lærdal has very good salmon fishing, they are also well known for yielding sea trout on dry flies.

If we proceed northward in this long-stretched land, we first meet the Alta, legendary for its huge salmon. Then, on the border between Norway and Finland, we reach the Tana – Scandinavia's most productive salmon river. The former is colossally expensive to fish in, and the latter is colossally large.

The northernmost district of Finnmark, too, is obviously worth a visit. Here you have a good chance of catching sea-going Arctic char on both wet and dry flies. But the chief attraction is the grayling, which can be very big in this area. Fish of 1 kg (2.2 lbs) are common in many waters, and those of 2 kg are nothing impossible. Around Råstojaure on the border between Sweden and Norway, the waters are famous for numerous and large grayling. Besides, the fishing for mountain trout is superb.

Iceland

In fishing for salmon and trout, Iceland occupies a special status. This semi-arid volcanic isle is not as unfertile as it might at first seem. The petrified lava is full of minerals which, along with a water temperature that is high by Scandinavian standards, make the rivers and lakes very nutritious. And the main beneficiaries of these conditions are salmonoids.

Salmon are the fish that have brought Iceland world fame. From all over the globe, salmon fishermen come to fight these creatures – which, in spite of their numbers, are rather small in size. A salmon of 10 kg (22 lbs) is considered very big in Iceland, whereas in the great Norwegian salmon rivers it may correspond only to the average weight. Yet

Icelandic rivers such as Grimsá, and Laxá in the district of Adaldal, regularly reveal truly big salmon as well.

If you want to catch a lot of salmon, and to do it on light equipment with a floating line and small flies, Iceland is the right place. Unfortunately the relevant local prices are in dollars, and this has pushed them up to a level which even the natives find it hard to pay. The problem is, ironically, almost self-inflicted. For the excellent salmon fishing is largely due to the fact that Iceland has forbidden net-fishing for salmon and reserved the fish entirely for sport-fishing.

We are lucky that the island also offers bountiful fishing for trout, and at a much lower cost. It is not exactly cheap, but fish of 1-2 kg (2.2-4.4 lbs) are common in many of the waters. One of the best-known trout streams is the Svartá.

Finland

The "land of a thousand lakes" is richly endowed with trout streams. Among the best-known is the Huopana, where there are still plenty of large trout, even though not as many as in the past. Three more streams with big trout exist in the Kuusamo district of eastern Finland – the Kuusinki, Kitkajoki and Oulankajoki. Here the fish migrate up from lakes on the Soviet side of the border to breed, and about a thousand trout weighing 1-9 kg (2-20 lbs) are caught every year. The 1989 World Championship in Flyfishing was held in the same area.

Greenland

In the far north between Iceland and Canada lies the world's largest island. Hundreds of rivers and lakes exist in Greenland, and flies are gladly taken by their steel-hued and red-bellied char, of the seagoing Arctic type. These fish seldom weigh more than 1-2 kg (2.2-4.4 lbs), but are so strong and full of fight that they seem much bigger than they are, when we land them among the turquoise icebergs that drift majestically in the fjords.

In spite of the great numbers of salmon in the nutritious Davis Strait, there is only one salmon-bearing river in Greenland: a little one with a small, variable stock of generally small salmon. The temperature in Greenland's water systems is simply too low, and there is an extreme shortage of suitable spawning sites.

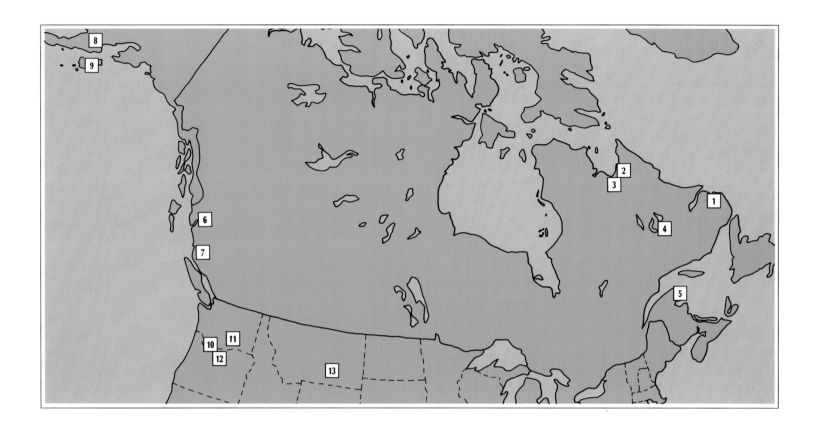

North America

Canada

In North America, the best fishing waters lie mainly in the east and west: (1) Eagle River, (2) George River, (3) Whale River, (4) Minipi, (5) Gaspé Peninsula, (6) Skeena, (7) Dean River, (8) Iliamna Lake, (9) Kodiak Island, (10) Columbia River, (11) Kalama River, (12) Deschutes River, (13) Yellowstone River.

On the other side of the narrow Davis Strait, salmon live under significantly better conditions in Canada. Not least in Labrador, productive salmon rivers abound, the Eagle being probably the most renowned. It is typical of Labrador's salmon rivers, however, that the migration upstream consists mainly of small salmon. In nearby Quebec, whose two best salmon rivers – the George and Whale – empty into Ungava Bay, the salmon are often somewhat bigger.

The northernmost parts of both Labrador and Quebec also provide exciting flyfishing for what must be the world's largest seagoing Arctic char. Fish of 5 kg (11 lbs) are common, and there are opportunities of fighting in the 10-kg class. But doubtless the rare and exotic brook trout is what draws most flyfishermen to this region. The Minipi water system is notably well known for its unusually large brook trout, the biggest weighing over 5 kg. A long series of world

records is held by the Minipi, which certainly yields the biggest trout in the world caught on dry flies. During the high season in mid-July, fish of 3 kg (6.6 lbs) are landed on dry flies almost daily. Virtually nowhere else in the world can one experience such stable dry-fly fishing for really big fish, in spite of the variable weather.

Newfoundland, Nova Scotia and New Brunswick, too, feature good and well-organized salmon fishing. Especially the Gaspé peninsula, in the Gulf of St. Lawrence, teems

with big salmon. Among the classic salmon rivers in this part of Canada are the Matapedia, Miramichi and Restigouche.

The inner regions of Canada contain many locations with fine fishing for grayling, besides innumerable large lakes with sizeable lake trout. These, however, live in such deep water that they are mostly inaccessible with flyfishing equipment.

We must therefore move to British Columbia, the country's beautiful Pacific province, in order to resume top-class flyfishing. Our interest is concentrated around the powerful Skeena water system, which originates high up in the Rocky Mountains and empties into the ocean near Prince Rupert. The Skeena is one of North America's leading producers of Pacific salmon – but in spite of that, the main target of flyfishermen is the seagoing rainbow trout, or steelhead. The sizes of steelhead caught here are unique in the entire world.

The Skeena's strong central channel is murky and milk-coloured. Only on occasion does the water become clear enough for effective flyfishing. We thus find much better conditions in the smaller, clearer tributaries. Names like the Babine, Bulkley, Kispiox and Sustut can make any self-respecting flyfisherman jump with joy. It is in these rivers that the record fish are landed: steelhead weighing 10-15 kg (22-33 lbs). Most are taken with a sinking line and large flies, in September and October when the water is relatively cold. But actually, if the circumstances are right, August can provide dramatic flyfishing with a floating line and small flies.

British Columbia has, of course, several other excellent fishing waters. One is the Deen River, lying south of the Skeena. Its fish migrate upstream early, so the summer fishing is its chief attraction.

Proceeding northwest, we reach Alaska – bought by America from Russia for a song towards the end of the last century. Alaska reveals an incredible wealth of salmonoids. The five Pacific salmon species range from the great king salmon to the leap-happy coho, and there are two species of mountain trout, in addition to Arctic char, lake and rainbow trout. All these can be flyfished during a short summer of four months, from June through September.

The fishing is nevertheless far from being equally good everywhere. If you want a wide range of alternatives, the area around the extensive Lake Iliamna is definitely the best choice. All species are represented here, as well as some of the world's biggest and wildest rainbow trout.

These, like the steelhead, migrate out into the lake and feast during the summer. As egg-eaters, they follow the myriad Pacific salmon which migrate up from Bristol Bay to spawn and die.

On the other hand, if you are looking for a fight with really big silver salmon, or coho, it is better to go out on the islands of varying size in the Gulf of Alaska. Silver salmon are Alaska's toughest fighters, and they often weigh 5-10 kg (11-22 lbs) in that area. Reputable places are Kodiak and Afognak Islands in the south, and Montague Island in the north of Prince William Sound. However, it is a sad fact that this very area was the victim of the "Exxon Valdez" oil-pollution catastrophe in 1989.

United States

Turning instead southwards along the Pacific coast, we reach the states of Washington and Oregon. Despite the construction of many large hydroelectric dams on the Columbia River, fishing is still good there for steelhead – though often implanted. It is hard to single out any of these waters, but some that should be named are the lovely little Kalama River in Washington and the classic Deschutes River in the deep wilds of Oregon. The latter is as perfect for flyfishing as can be imagined.

Farther into the United States lie Montana and Wyoming, and the "Mecca" of American trout fishing – Yellowstone National Park. Several of the classic waterways, such as the Yellowstone, Madison, Firehole and Bighorn, flow in this highland. Every year, thousands of American and foreign flyfishermen make their pilgrimage here to catch rainbow, cutthroat and brook trout in the clear, cold, pure waters. The fishing often becomes ever better and calmer as September approaches, when the crowds of tourists have tapered off.

In the northern part of the Rocky Mountains flow several classic trout streams, in majestic natural surroundings.

Central America

Just west of Florida lie the Bahamas, which are also attractive for tarpon and bonefish. Only about 120 miles (200 km) south, on the other side of the narrow Straits of Florida, is Cuba. With the Bay of Mexico to its north and the Caribbean Sea to its south, Cuba is endowed with plenty of exciting fish species. There are tarpon as well as bass in the dense mangrove swamps, and bonefish along the chalk-white coral shores. The flat southern coast offers very good opportunities for flyfishing.

A shorter distance west of Cuba brings us to Mexico and the Yucatan Peninsula, which divides the Bay of Mexico from the Caribbean. Here you can fish with the old Maya ruins at your back, and a fly is gladly taken by the bonefish, tarpon and several other saltwater species. Along the Pacific coast, too, Mexico has excellent places for flyfishing. The golden mackerel and sailfish can give advanced flyfishermen a lifetime memory.

Moving down into the Central American countries, one soon reaches the small land of Belize. Its group of Turneffe Islands is best known to flyfishermen, once again with tarpon and bonefish as the main actors. Farther south in Costa Rica, the Atlantic shore features the world's best tarpon fishing in its estuaries and lagoons. The Pacific coast is also successful with flyfishing for sailfish, although primarily to be done by experienced saltwater flyfishermen.

South America

On our way towards the equator, we first arrive in Venezuela, which is a new area in terms of sportfishing. Here you can find admirable possibilities of fishing for smaller tarpon in the estuaries, and for bonefish on the little atolls in the Caribbean. Deep inside the country – near the Amazon River, where the heat is almost intolerable – there are peacock bass. They eagerly take bass bugs on the surface or large streamers under the surface, and fish of 5 kg (12 lbs) are by no means unattainable.

For the bass and saltwater flyfisherman, this region offers many good opportunities. Among the best-known places are: (1) Florida, Lake Okeechobee (for bass) and the "Flats", (2) Bahamas, (3) Cuba, (4) Yucatan Peninsula and (5) Belize.

In the southeasternmost part of the USA, Florida's warm lakes harbour the country's biggest large-mouthed bass. This is a fine sporting fish that has been seriously discovered by American flyfishermen in recent years. Notably huge bass exist in the enormous Lake Okeechobee, on the edge of the Everglades swamp.

Florida is most significant for its role in the development of modern saltwater flyfishing. Its broad "flats" were the scene of the first attempts with a fly rod to make contact with the sprinters of the sea – those shy, fast bonefish and gigantic tarpons. From there, saltwater flyfishing spread like rings on water to the rest of the Caribbean. But Florida still yields the world's biggest tarpons, weighing nearly 100 kg (220 lbs).

The southern Andes have several trout rivers, such as (1) the Alumine. Farthest south is a fantastic sea-trout river, (2) the Rio Grande.

New Zealand is famous for its excellent fishing for brown trout, rainbow trout and king salmon, as in (1) Lake Taupo and (2) Rakaia.

Chile and Argentina

It is a biological fact that no natural stocks of salmonoid fish have ever existed in the Southern Hemisphere. The ability of countries like Chile and Argentina to offer first-class trout fishing is due, instead, to implantation of rainbow and brook trout at the beginning of our century.

In the southern part of the Andes, we find superb trout fishing. However, Chile is probably best known for the sizeable rainbow trout in its large lakes at high altitudes. By contrast, Argentina lies on the other side of this mountain chain and has several rivers that are perfect for flyfishing. Among them are the Alumine, Chimehuin and Malleo.

Farthest to the south, Tierra del Fuego – the "land of fire" – is attractive for the big sea trout in the powerful river Rio Grande. Fish of 5 kg (12 lbs) are common here, and much larger ones are quite obtainable.

Summer in the Southern Hemisphere is at its peak when winter is worst in the north of the world. So the fishing season is opposite – it begins in November and ends in April.

New Zealand

Even in the trout paradise of New Zealand, the fishing season generally occurs at a time just the opposite of what we are used to. But we have to distinguish between this country's northern and southern islands in regard to fishing, as well as between the conditions for rainbow and for other trout.

The two islands are very different in both climate and geology. It is warmer and more hospitable in the north, colder and much more mountainous in the south. This explains why rainbow trout are said to predominate on the northern island, and brook trout on the southern island. It is obviously a truth with exceptions, but still a good rule of thumb.

On the northern island, by far the best fishing is on Lake Taupo, a large body of water 30 miles (50 km) long. Here one can fish both in the numerous river inlets – preferably at night with phosphorescent flies, for rainbow trout that hunt smaller fish – and in the lake's tributaries for fish that are migrating to spawn. Most famous among the latter is the

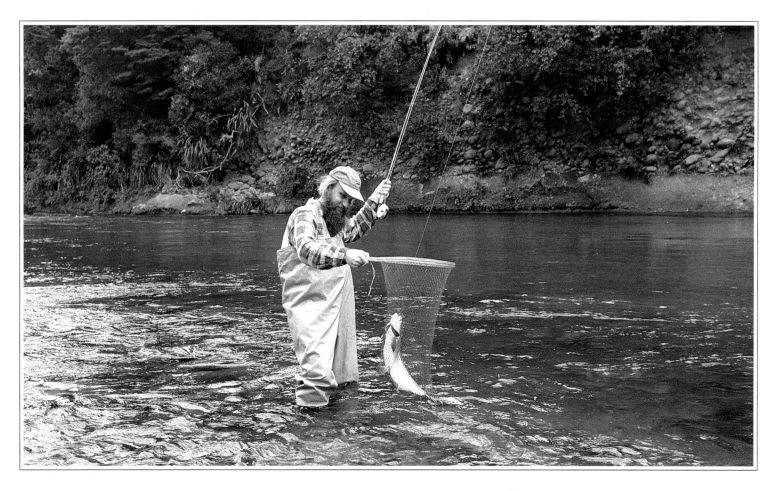

A big rainbow trout is netted in one of Lake Taupo's many tributaries.

Tongariro, which annually yields more than 100,000 rainbow trout caught on fly rods, the majority with weighted nymphs and roe flies. Farther up this river, there are also very big brook trout, shy fighters of over 5 kg (12 lbs).

The primary trout fishing in Lake Taupo has been created entirely by man. Just as in South America, no natural stocks of salmonoids occur in New Zealand: the trout were imported from Great Britain and North America around the turn of the century. They multiplied so rapidly that the lake's own stock of small fish disappeared. Then the fishing declined a lot, but it was saved by setting out food fish. Today both rainbow trout and small fish, both implanted, dominate Lake Taupo.

On the southern island we find a rough landscape with deep fjords and high mountains, known as the "Southern Alps". The landscape is strongly reminiscent of Norway –

and indeed there are salmon, though unfortunately not the Atlantic species. Instead, king salmon have been implanted in some places and, notably in the river Rakaia, flyfishing for them is purposeful and quite successful. However, interest is focused on the many large brook trout, which thrive in the local lakes and waterways.

Much of this sport is sight fishing, by observing the fish first and then fishing for it. The fish weigh 1-3 kg (2-7 lbs) and are extremely shy in the crystal-clear water. Thus, the southern island's lakes and streams are not suitable for inexperienced flyfishermen, who probably have more success on the northern island. The same applies to the little island of Tasmania, which lies west of New Zealand and just south of Australia. There, the main fishing occurs in several very nutritious lakes, whose sizeable trout are shy and selective.

Europe

England

As we know, the cradle of flyfishing lay in Europe – more exactly in southern England with its clear, food-rich chalk streams full of large and timid trout, where Halford and Skues developed dry-fly and nymph fishing. Their haunts were the streams Test and Itchen, which thus became world-famous. Even today, flyfishermen come from all over the world to this area and wander in the great masters' footsteps, savouring some of the atmosphere from the early days of the sport.

The fishing is, of course, not what it used to be. While the Test and Itchen still flow southward to the Channel coast, they are now but a shadow of their former grandeur. Man has left deep marks in the chalky earth, and modern agriculture has taken a toll as in so many other regions. Rain-soaked grounds have been drained, making it necessary to irrigate them during dry periods. In addition, the intensive fish farming is both a pollutant and a consumer of large amounts of water.

The chalk streams, originally characterized by their stability, have become unstable. Their water level and temperature were once constant all year round, yet are now out of balance. But it is not only agriculture and fish farming that have produced disorder in the natural environment: flyfishermen, too, have made a contribution. We are responsible for the fact that there are more "tame" rainbow trout than wild brook trout in these streams. The Test teems with small rainbow trout that have escaped from fish farms, and with big implanted trout from the fishing clubs. In several places, outright put-and-take fishing has arisen for rainbow trout weighing around 2 kg (5 lbs).

Scotland

Fortunately, the trends are not so sad everywhere in Great Britain. In Scotland, the centre of salmon fishing, it was a couple of centuries ago that the first salmon were caught on flies. This fishing is still done with the longest two-hand rods and the greatest possible enthusiasm.

Scotland is in the enviable position of providing a chance to fish for fresh-run salmon nearly throughout the year.

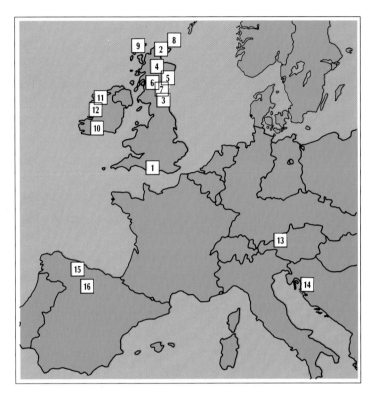

Much as in North America, the best fishing waters in Europe – apart from Scandinavia – occur mainly in certain areas. The classic "dream waters" certainly include (1) the Test and Itchen, (2) Thurso and Helmsdale, (3) Tweed, (4) Spey, (5) Dee, (6) Tay, (7) Loch Leven, (8) Orkney Islands, (9) Hebrides, (10) Blackwater, (11) Moy, (12) Lough Corrib, (13) Traun, (14) Gacka and Unec, (15) Narcea and Sella, (16) Orbigo.

From January until November, the salmon migrate up the rivers. The season usually begins in the north on rivers such as the Thurso, Helmsdale and Oykel, to finish on the classic Tweed at the border of England. Other renowned rivers are the Tay, Dee and Spey, where thousands of salmon have taken their last fly.

The Scots live with salmon, but this region has still more to offer. A good example is Loch Leven, which has long been a favourite destination of flyfishermen from the whole of Great Britain. It is well known for abundant, pugnacious trout, and its traditional drift fishing has been polished to perfection. This method of flyfishing from a drifting boat is also extremely widespread in Ireland. Moreover, it was from Loch Leven that some of the first specimens of *Salmo trutta* were sent across the Atlantic to North America at the turn of the century.

The two small groups of islands west and north of Scotland, the Hebrides and Orkneys, offer superb flyfishing as well. In particular they have sea trout and lake trout, but there are also scattered salmon. The same is true of the Shetlands, and of the Danish Faeroes up in the North Atlantic. But there you must be prepared for rain, mist and high wind as you fish for trout.

Ireland

Across the Irish Sea to the west, there are wild salmon and trout to be caught in rivers and lakes that are still in good condition. Ireland has many salmon-bearing waterways, although most of them are spate rivers – small ones that rise rapidly after sudden hard rain, then fall equally fast, and may even run dry when there is little rain.

Despite this variation, you can experience rich salmon fishing (and at a cheap price) in these small rivers, however uncertain the results are made by the unstable water supply. When the rivers rise, the salmon come up too. And when the water gets lower and clearer, the fish take madly – for a time. After that, the fishing declines and the salmon are again virtually impossible to make contact with. There are, nonetheless, a few large salmon rivers in Ireland with a more constant water supply, and thus more stable fishing. Examples are the Moy in the west, and the Blackwater in the far south.

But Ireland is best known for the trout fishing in its large lakes. Places like Lough Mask and Lough Corrib are world-famous for their fishing opportunities, primarily with mayflies during May and June. This sport brings flyfishermen from far across Europe, and often yields the year's biggest trout – caught either with dry flies, or by "dapping" with a blowline and natural insects.

Austria

A better and more inviting climate is found on the European mainland. Industrialization has ruined most of its sal-

Flyfishing for spring salmon at Castle Grant on the legendary river Spey.

mon and trout waters, but there remain individual ones of high quality. For instance, the Austrian river Traun has long boasted the same importance for German-speaking fly-fishermen that the Test has had for the English. The Traun is difficult to fish and contains large, shy, selective trout and grayling, which can give the cleverest flyfisherman a lot of trouble. Nor has the tooth of time passed lightly over this waterway, and today it is hardly comparable to what it was in the days of Charles Ritz.

Yugoslavia

Conditions worthy of paradise can be found by flyfishermen in Yugoslavia, whose chalk streams are attracting ever more attention. Prominent examples are the Soca and Unec, but especially the legendary Gacka near a beautiful national park named Plitvice. Here, some of Europe's largest rainbow and brown trout swim in almost unbelievably nutritious water, at a temperature around 10° C (50° F) that gives the fish a record growth rate.

In Yugoslavia's clean waters, you can also find an amazingly exotic salmonoid: the soft-mouthed trout, which exists nowhere else in the world. This fish has a grayling-like head and a trout-like body. It is an ideal hybrid that developed in the isolated currents of the Adriatic Sea after the last ice age. What can be more fascinating than a *Salmothymus* for the flyfisherman who has seen everything?

Spain

In the southwestern corner of Europe, and notably along the Atlantic coast, Spain provides plenty of thrills in fly-fishing. There are still a few rivers with good resources of salmon and sea trout, even though the fishing has become worse in recent years. Among the best known are definitely the Narcea and Sella.

For trout fishing too, it can be worth a visit to this part of the world. The rugged but beautiful Pyrenees contain several waterways thar are rewarding in this respect – as are some of the fine streams that descend on the southern side of the Cantabrian Mountains in Asturia. Another Spanish river that has given lifetime memories to many southern European flyfishermen is the Orbigo.

Index

A Book of Trout Flies, 18
activity periods, 132
 brown trout, 132
 grayling, 132
 rainbow trout, 132
Aelian, Claudius, 7
Africa, 210
AFTM (American Fishing Tackle
 Manufacturers' Association), 70,
 141f
Alexandra, 146
Alps, 129
American Trout Stream Insects, 18
Ant, *116*
ant falls, 47
ants, 47, 107, 116f.
Arctic char *(Salvelinus alpinus)*, 128,
 112, 161, 165, 205, 224, 225
Art of Angling, 8
Art of Tying the Wet Fly, 18
A Treatyse of Fysshynge Wyth an Angle, 7
Australia, 128
Austria, 107, 233

backing line, 73, 103, 142, 143
baitfish, 146, 219
Bare Hook Nymph, 63
barracudas, 215
barramundi, 210
bass, 67, 123, 125
 European, 215
 peacock, 228
 striped, 215
bass bug, 67
beetles, 47
bend back flies, 65
Berner, Dame Juliana, 7
Bitch Creek Nymph, 107, 121, *122*
Black Doctor, 13
Black Dose, 13
Black & Peacock Spider, *119*
bleak, 52
Bloody Butcher, 146
bloopers, 214
Blue Charm, 13
bluefish, 208, 211
bluegill, 123, 125
Blue Rat, *199*
Blue Winged Olive, 32
boat, 212
Boström, Kenneth
bonefish, 208, 210, 215, 219, 228
bonito, 215

Book of St. Albains, 7
bottom topography, 101
Bowler, Richard, 8
breeding costume, 26
Bucknall, Geoffrey, 19
bucktails, 18
buffalo gnat *(Simulidae)*, 42f.
bulging fish, 136
bumblebee, 125
bumble puppies, 17
Butcher, 7, *145*
buzzer, 42

caddis flies *(Trichoptera)*, 36, 107, 110f.,
 138
 case-builders *(Phryganea,
 Leptoceridae)*, 36, 114
 free-living larvae *(Rhyacophila)*, 36
 net spinners *(Hydropsyche)*, 36, 51
 pupae, 107, 160
Canada, 165, 181, 225
Cardinal, 55
casting, 80 ff.
casting plug, 214
Catch and Release, 166
Catskill School, 18
Central America, 228
 Bahamas, 210, 228
 Belize, 211, 228
 Costa Rica, 228
 Cuba, 228
 Yucatan, 210, 228
channel bass, 210
channels, 101
chuggers, 214
chum depositing, 212, 214
clothing, 78
cobia, 215
Collie Dog, 179
colour, 59, 60, 67, 179, 215
Compleat Angler, 7
Corixa, *120*
Cotton, Charles, 7
crabs, 211
crane flies, 47
Crazy Charlie, 65
Crossfield, Ernest, 13
cruiser, 139
crustaceans, 30, 48f, 136
 Asellus, 48
 Gammarus, 48, 51
 mysids, 48
 shrimps *(Crangon, Palaemon)*, 48, 211,
 212

current edges, 100
current lee, 129
curve cast, 152
cut banks, 219

Dahlberg Diver, 217
daily rhythm, 22f.
Dalton Hutchinson, Robert, 14, 16
damselfly *(Odonata)*, 40, 115
 nymph, 115
Davis Strait, 224, 225
Denmark, 222f.
"dead angle", 102
dead drift, 146, 161
defending territory, 24
dibbling, 194
dispenser (for leaders), 78
Dog Nobbler, 121, 122
double haul cast, 82
dragging, 152
dragonfly *(Odonata)*, 40
dragging flies, 67
drift, 48f.
dry fly, 10f, 17, 57, 63, 138, 203
Dry Fly & Fast Waters, 18
dry fly fishing, 10f., 98f.
 downstream, 154ff.
 upstream, 150ff.
*Dry-Fly Fishing in Theory and
 Practice*, 11
duns, 34, 138
 history, 10, 11
dusk (fishing at), 97ff.

Esmond Drury, 200
El Manuscrito de Astorga, 10
ethology, 59
England, 19, 107, 231
 chalk streams, 10, 11f, 30, 152, 158,
 176, 231
Europe, 231ff.
Européa 12, *110*
Européa Series, 110, 111
eutrophication, 30
eye protection, 78

fat reserve, 26
Faeroes, 233
featherwing flies, 14
"February Reds", 38
feeding sites, 24f
field bit, 107
Field, The, 10
Field Sports in the North of Europe, 14
Finland, 224
Fishing Gazette, 17
Flick, Art, 18
flies, 54f., 75f.
 different parts of, 77
 for salmon and sea trout, 176ff.
 for saltwater fishing, 215, 216
 main groups, 75, 77
 sinking, 211
 weighted, 63
Floating Flies and How to Dress Them,
 9, 11
floating line
 fishing with, 192ff.
float-ring (belly boat), 79
Fluefiskeriets anvendelse i Norge, 14
fluorescent colour, 60, 215
fly box, 78
Fly Fishers' Guide, 9
Fly Fishers' Entomology, 9
Fly Fishers' Legacy, 9
Fly-Fishing and Fly-Making, 17
fly-jig, 122
fly materials, 14, 54
flymph, 18
fly patterns, 54f
flytying history, 7, 8
fly vest, 78
foam rubber, 58
Forest and Stream, 17
Francis, Francis, 10
Freeman's Fancy, 146
freestone stream, 30f.
fresh-run fish, 194

gaff, 78, 174
Garpen, Don, 65
Garry Special, *188*
General Practitioner, *197*
Glo Bugs, 65
gobies, 51
Goddard, John, 19
Gold Ribbed Hare's Ear, *109*
Goofus Bugs, 58
Gordon, Theodore, 17
Gordon Quill, 17

grasshopper, 47, 138
grayling *(Thymallus thymallus)*, 24, 93,
 110, 128, 129f., 139, 145, 157, 161, 162,
 223, 224, 233
Great Britain, 92, 120, 181, 194
Green Drake (dun), *108*
Greenland, 224
Greenwell's Glory, 7
Grey Wulff, *203*
groupers, 210, 215

hackle, 57
hairwing flies, 14
Halford, Frederic M., 9, 10f, 17, 55,
 150, 154, 158, 231
Happy Hooker, 204
Hardy, 9
Hare's Ear, 107
harling, 194
hat, 78, 210
hatching insects, 157
head and tail, 136
headland, 101
Hewitt, Edward, 18
herring, 52
holding places, 24, 129ff.
 back waters, 132
 channels, 132
 neck of rapids, 132
 pool, 132
 salmon and sea trout, 181
 stones or diffs, 132
hooking, 191
hooks, 65, 75f.
 for caddis imitations, 110
 for catch and release, 167
 for salmon flies, 195f.
 for still-water fishing, 106
 history, 7, 8
 keel hooks, 65
hook sharpener, 78
How to Dress Salmon Flies, 13
hunting garb, 26

Iceland, 181, 195, 200, 205, 224
imitation school, 150
induced take, 63, 159
inshore fishing, 208
Ireland, 19, 173, 181, 233
Irresistibles, 58
Ivens, Tom, 19, 119

Jennings, Preston, 18
jig-fly, 122
Jimmie, 13
Jock Scott, 12, 13

Keene, John H., 17
Kelson, George M, 13
kelt, 194f.
Killer Bug, 112, *113*
Kite, Oliver, 12, 63, 159
knife, 78
knots, 75, 139, 175
Kolzer Fireflies, 58

LaBranche, George, 18
lake flyfishing, 19, 92ff.
lamp, 78
landing, 191
landing net, 78, 167, 174
leaders, 74f.
 fast-sinking, 65
 for catch and release, 167
 for fishing in streams, 141f.
 for salmon flyfishing, 203ff.
 for still-water fishing, 105
 history, 173
 tapering, 74f.
 weighted, 161
leeches, 52
lee edge, 100
lemmings, 165
Leonard, Hiram, 9
Leisenring, James E., 18
line basket, 78
line grease, 78
lines, 65, 101
 colour, 73
 double-tapered (DT), 73, 141
 floating line (F), 73, 141, 192, 194, 195
 for fishing in streams, 140f., 142f., 156
 for nymph fishing, 160
 for salmon flyfishing, 174f., 198, 203ff.
 for sea trout fishing, 202
 for still-water fishing, 102, 105
 for streamer and bucktail fishing, 162
 history, 7, 8, 11, 173
 line classes, 70f.
 long-belly line (WFL), 73
 "saltwater tapering", 73
 shooting taper (ST), 73
 sinking line (S), 63, 73, 141, 194

sink-tip (F/S), 73, 141
tapering, 73
weight forward (WF), 73, 141
Lumme, Simo, 112
lures, 106, 121f.

mackerel, 208
March Brown, 7, *145*
mayflies *(Ephemeroptera),* 30f., 38, 51, 57, 61, 63, 146
"Blue Winged Olive Dun" *(Ephemerella ignita),* 32
dusk mackerel *(Ephemera vulgata),* 32
drake mackerel *(Ephemera danica),* 32
hatcher, 107
may duns *(Heptagenia),* 32
nymph, 107, 159
"olives" *(Baetis),* 32, 63
"pond olives" *(Clocon, Procloeon),* 32
white midges *(Caenis),* 32, 139
mayfly (large) *(Ephemera vulgata),* 32, 108
dun, 108
nymph, 109
spent spinner, 109
measuring tape, 78
mending, *85,* 144ff.
floating line, 192f.
sinking line, 193
mice, 165
Mickey Finn, 60, *61*
midges *(Chironomidae),* 19, 30, 42f, 100, 107
minnows *(Phoxinus phoxinus),* 51
Minor Tactics of the Chalk Stream, 12
Montana Nymph Variant, *115*
muddler, 55
Muddler Minnow, 65ff., 101, 106, 121, 112
Munroe Killer, 179
mutton snappers, 212

Nalle Puh (Winnie the Pooh), 98, 112, 113
needlefish flies, 65
Netheravon school, 12
New Zealand, 120, *128, 229*
night (fishing at), 97f.
no-hackle dry flies, 55, 57

No kill, 166f.
Norway, 14f., 174, 176, 194, 195, 200, 205, 223
North America, 173, 194, 195, 203, 225ff.
nymph, 32, 40, 58, 63, 101, 136, 158ff.
nymph fishing, 102
downstream, 160
history, 11f., 18
upstream, 160
Nymph Fishing in Practice, 12

offshore fishing, 208, 214
Ogden, James, 10
Om flugfiskeriet, 14
On the Nature of Animals, 7
Orvis, Charles, 9
overhead cast, 81f., 86
double-handed, 180
oxygen content, 22, 30

Pacific salmon, 203ff.
parachute cast, *85,* 156
parachute flies, 61
patrolling fish, 97f., 99, 139
pelagic school fish, 52
perch, 123, 125, 165
Perfect, The, 13
permit, 210, 212, 219
Pheasant Tail, 12, 63
Pheasant Tail Nymph, *64,* 159
pH value, 30
pike, 123, 165
pike fishing, 123f.
Pike Fly, *125*
polarizing glasses, 134, 210
polywing spinners, 61
pool, 181, 219
popper, *125*
popping bug, 215ff.
Practical Angler, 9
presentation (of the fly), 18, 179, 212
Pryce-Tannatt, 13
Pullman, G., 10
porpoise rise, 136
put-and-take, 92, 166f.

Rackelhanen, 111f.
ragworms *(Nereis),* 52
ray, 211f.
mana ray, 211f.
sting ray, 211f.
reach cast, 156
reading the waters, 93ff.
Red Tag, 7
reels, 73f.
disc brake, 73
for fishing in streams, 142
for salmon flyfishing, 174f.
history, 8, 12, 173
"midging" reel, 142
slip brake, 73
spool, 73
retrieving the fish, 212
Rhead, Louis, 18
riffling hitch, 194
rise, 93
rise forms, 134ff.
Ritz, Charles, 233
rocket taper, 125
rocks, 219
rods
carbon-fibre, 70
double-handed rod, 86ff.
fast action, 70
for fishing in streamwaters, 140, 142f., 149
for salmon flyfishing, 173, 174f., 197, 203
for salmon flyfishing in still water, 205
for sea-trout fishing, 202
for still-water fishing, 102
glass-fibre, 70
history, 7ff., 17, 173
medium action, 70
one-handed fly rods, 70
single-handed rod, 80ff.
slow action, 70
split-cane, 70
two-handed fly rods, 70
roll cast, *84*
Ronald, Alfred, 9

sailfish fly, 215
Salmon, 12, 67, 225, 233
Atlantic salmon *(Salmo Salar),* 26, 170ff., 223, 231
Pacific *(Oncorhynchus),* 161, 171, 188, 203, 205, 225f.
rainbow, 17
sockeye, 165
salmon flies, 12, 13, 99